THE USES OF AIR PHOTOGRAPHY

THE USES OF AIR PHOTOGRAPHY

Edited by J. K. S. St Joseph
Professor of Aerial Photographic Studies and Director in
Aerial Photography in the University of Cambridge

New edition, with contributions by
D. E. Coombe, P. F. Dale, A. G. Dalgleish,
Lord Esher, Sir Frank Fraser Darling, R. W. Hey,
M. D. Knowles, J. Milton, R. M. S. Perrin,
J. Rishbeth, Sir Ian Richmond,
J. K. S. St Joseph, R. M. S. Watson

John Baker · London

Second edition 1977
John Baker (Publishers) Ltd
35 Bedford Row, London WC1R 4JH
©1966 and 1977 University of Cambridge
Committee for Aerial Photography

ISBN: 0 212 97016 X

Printed in Great Britain
by Page Bros (Norwich) Ltd, Norwich

Foreword

Recognition of the value of air photography as a medium for teaching and research in many different disciplines led the University of Cambridge, in 1949, to constitute a Committee to promote the further development of the subject. A year earlier a Curatorship in Aerial Photography had been established, a post that in due course came under the general direction of the Committee. From its inception the Committee has deliberately sponsored annual programmes of air reconnaissance: indeed, the principal distinguishing feature of the Cambridge Collection is that the photographs come from flights specifically planned for research. At first, the Collection of photographs was housed in a small room in the Museum of Classical Archaeology. Growth was rapid and a move had to be made to separate premises in 1953, which in turn were outgrown, so that a further move became necessary in 1967. Need to adapt the Committee's premises for other uses led, in 1976, to another move back to the centre of Cambridge, where the Collection is more accessible than hitherto. The present quarters provide accommodation for the Collection of photographs, now a third of a million negatives, with prints to match, with supporting indices and maps, as well as a demonstration room, offices, photographic darkrooms, and fire-proof film store.

In 1962 the Committee was assigned an Auster aircraft to be used for research. With the growth of the Committee's work this was replaced in 1965 by a twin-engined Cessna 'Skymaster', having the range to undertake reconnaissance flights over any part of the British Isles, and with space to accommodate a modern precision survey camera. Vertical photography of selected areas has become an important part of the annual programmes sponsored by the Committee. In 1962, when the flying began to be undertaken from the University's own aircraft, the Committee was fortunate in enlisting the services of Mr A. G. Douglass as pilot: the success of the venture owes much to his skill and patience. In 1965, a newly established Senior Assistantship in Research in Aerial Photography was filled by the appointment of Mr D. R. Wilson, who has been increasingly responsible for the photography over the last few years.

The number of requests for reproductions of photographs in the Cambridge Collection, both from within and from outside the University, continues to grow, with corresponding increase in the multiplicity of interests assisted by air photography. The Committee's work has thus come to serve not only the University, but many institutions and scholars elsewhere. For a number of years the Committee's flying programmes have included surveys requested by the three Royal Commissions on Historical Monuments, by the Ancient Monuments Inspectorate of the Department of the Environment, the Nature Conservancy Council, the Soil Survey of England and Wales, and by the Ministry of Agriculture and Fisheries. Similar surveys have over the years been undertaken outside the United Kingdom, for example in Ireland, under the sponsorship of the National Museum at Dublin, in Denmark in collaboration with Aarhus University, in the Netherlands at the request of the Dutch State Archaeological Service, and in northern France by permission of the Ministry of the Interior.

Many photographs from the Cambridge Collection have been published in books and journals. While these are often of specialised interest, they hardly provide a general picture of the development of the subject. This book, largely written by past and present members of the Committee, affords some account of the varied applications of air photography, and incidentally, of the scope and nature of the Committee's work. Changes in the applications of air photography in some fields of study required that eight chapters be rewritten for a second edition. Of the remaining five chapters, four are differently illustrated as new or better photographs have become available, and some have undergone minor revision, as the text or the changed photographs demanded. Thus the chapters on Geology and on Contemporary Planning remain the same in substance and emphasis, but with some new plates, while that on Zoology is unaltered in any respect. In the interval since the first edition the authors of Chapters 11 and 12 have died and their contributions are printed virtually unchanged.

J. K. S. St Joseph

Committee for Aerial Photography
Mond Building
Free School Lane
Cambridge
CB2 3RF

June 1976

Contributors

D. E. Coombe	Lecturer in Botany in the University of Cambridge and Fellow of Christ's College
P. F. Dale	Directorate of Overseas Surveys
A. G. Dalgleish	Deputy Director (Mapping), The Ordnance Survey
Lord Esher	Rector, Royal College of Art, and past President of the Royal Institute of British Architects
Sir Frank Fraser Darling	The Conservation Foundation, New York
R. W. Hey	Lecturer in Geology in the University of Cambridge and Fellow of Churchill College
† M. D. Knowles	Sometime Regius Professor of Modern History in the University of Cambridge
J. Milton	The Conservation Foundation, New York
R. M. S. Perrin	Lecturer in Soil Science in the University of Cambridge and member of the Geologists' Pool, R.E.
† Sir Ian Richmond	Sometime Professor of the Archaeology of the Roman Empire in the University of Oxford
J. Rishbeth	Reader in Plant Pathology in the University of Cambridge and Fellow of Corpus Christi College
J. K. S. St Joseph	Professor of Aerial Photographic Studies and Director in Aerial Photography in the University of Cambridge and Fellow of Selwyn College
R. M. Watson	East African Wild Life Society, Kenya

Contents and Illustrations

13 Contemporary Planning

Note

In the description of the illustrations the reference number of the particular photograph, the date of photography, and, for vertical photographs the approximate scale, are given whenever known. References in the form of one or more letters followed by one or more digits are to oblique photographs in the Cambridge University Collection. Vertical photographs from the Collection have an additional prefix, either 'RC8-', which indicates that the photograph was taken with a Wild RC8 survey camera, or 'K17-', when a Fairchild K17 camera was used. The source of the remaining photographs can be obtained by referring to the acknowledgements (p.10).

For photographs taken over Britain, the normal National Grid reference of the main feature, or, for vertical photographs, of the centre of the plate, is printed within brackets after the place-name or county. For photographs of Ireland, the grid used is that printed on the $\frac{1}{2}$-inch to a mile Ordnance Maps of Ireland.

Certain of the illustrations in this edition (Photos 3:2–5) are stereoscopic pairs of vertical photographs. These have been printed side by side in the correct relationship for viewing with a pocket stereoscope.

Acknowledgements

Photographs 1:1–8, 11; 2:5; 3:1; 4:1, 2, 4; 5:1, 4; 6:1–7; 7:3, 5–7; 8:5; 10:1–9; 11:2–6, 8, 9; 12:1–8; 13:1–11 are from the Cambridge University Collection; of these 1:4; 3:1; 6:2–4, 7; 7:5; 11:2, 8, 9; 12:3, 4, 6–8; 13:1, 2, 5, 6, 10 are British Crown Copyright, the remainder being the copyright of the University. Also Crown Copyright are: 2:1–4 from the Directorate of Overseas Surveys, and 1:10; 3:3, 4, 6; 5:5, 7, 8; 7:4 from the Ministry of Defence (Air), of which 3:3 is published by permission of the Commissioner of Lands, Aden, and 3:4, by permission of the Surveyor General, Ministry of Land and Natural Resources, Zambia.

Photograph 3:5 is reproduced by permission of the Director of Surveys of the Government of Kenya, who holds the copyright; 3:2 by permission of the Ambassador Irish Oil Co.; 4:3 by permission (no. A.23/76) of the Geodetic Institute, Copenhagen; 4:5 Mitchell, Beazley Ltd; 5:2, 3 Fairey Air Surveys Ltd; 5:5 the Government of Tanzania; 5:6 United States National Aeronautical and Space Administration; 7:1 Mr C. V. Dadd; 7:2 the Editor in Chief, Annual Reviews Inc., California; 8:3 the National Parks Branch of the Department of Northern Affairs and National Resources, Canada; 9:1–8 Dr R. M. Watson; 11:1 the Librarian, All Souls College, Oxford; 11:7 the Marquess of Hertford. Photographs 8:1 and 2 were kindly supplied by the Director of the Kenya National Parks and are reproduced by permission of Dr Glover; photograph 8:4, which was taken by Aero Photo Inc., Quebec, and supplied by Dr D. E. Sergeant, by permission of the Fisheries Research Board of Canada.

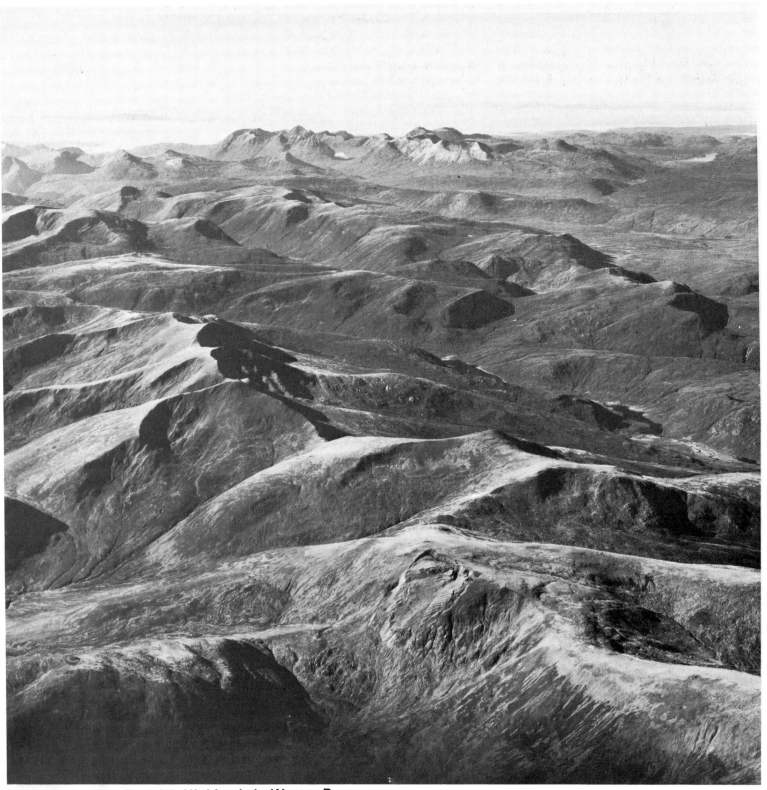

Photo. 1:1 The Scottish Highlands in Wester Ross

1 The Scope of Air Photography

J. K. S. ST JOSEPH

Professor of Aerial Photographic Studies and Director in Aerial Photography
in the University of Cambridge and Fellow of Selwyn College

More than a century has passed since the first air photographs were taken from a balloon over Paris (Crawford 1954), but for many years, until about 1914, such photographs were so rare that they were regarded as curiosities. The sixty years since then have seen the development of air photography into a precision instrument for survey and research the world over, while in recent years photography from man-made satellites may record on a few photographs whole countries, or the weather systems that may cover them. The rapid growth of the subject has been made possible both by the development of modern aircraft and by continuing improvement in cameras, lenses and films, specially designed for air survey. In the war of 1939–45, the use of electrically-driven remote-controlled roll-film cameras yielded air photographs in numbers undreamed of a generation earlier, while the development of precision instruments for preparing accurate contoured maps from overlapping vertical photographs has provided a new means for the rapid survey of large areas. In the present decade the use of high flying aircraft or of satellites has made possible the monitoring of conditions on the earth from almost any height-band up to 1000 km.

Methods of aerial surveying have been elaborated and expanded. For aerial photography a wide variety of films is now available and combinations of different emulsions may be used to achieve multi-spectral imagery of a subject. For many purposes, including mapping, panchromatic film, which is easy to use and relatively cheap, yields all the required information. Colour films enhance the verisimilitude of the image, while the 'false colour' film, sensitive to the infra-red end of the spectrum, can yield startling results in the early detection of plant disease, to quote but a single example of its use. Moreover, photography is no longer the only method of 'remote sensing'. Devices exist which record radiation outside the visible spectrum. Infra-red linescan, operating in two narrow wave bands, will respond to minor differences in temperature at the surface (Photo. 1:8) to yield a 'thermal picture' of the terrain. The system offers particular assistance in the detection of water pollution or to the monitoring of high tension power lines. Developments of military radar which have the advantage of being independent of weather and of lighting conditions, are being used to record different aspects of the natural landscape as well as man-made features. Other methods of sensing, designed to detect variations in the earth's magnetic or gravitational fields, are in use for geological and similar surveys.

Whereas a map shows selected and conventionalised features, an air photograph makes no selection and employs no conventions. Thus a photograph will record not only the features commonly delineated on a

Photo. 1:1 The Scottish Highlands in Wester Ross, looking west-north-west from a point (NH 298418) on the northern side of Glen Strathfarrar.

The panorama illustrates the topography of this geologically complicated area rather like a model in relief. In the centre foreground is the mountain Sgùrr na Ruaidhe, and above it a chain of corries forming the northern side of a series of peaks, the nearest of which is Sgùrr a Choire Ghlais (1083 m). These corries drain into the eastward-flowing river Orrin. The smooth southern slope of Glencarron Forest may be distinguished in the middle distance. All this country is composed of Moine schists. The distant summits (40 km away) are, to left of centre, Liathach (1053 m) of Torridon sandstone, and, on the right, Beinn Eighe, distinguished by its scree-covered slopes of white Cambrian quartzite. The dark line in the farthest distance, across the North Minch, is the Isle of Lewis, more than 100 km from the camera. The photograph was taken from about 2500 metres.

BOW 54 *3 October 1973*

map, but a wealth of minor and often transient detail never found on the largest general survey. This information constitutes an almost inexhaustible store of knowledge which will be valuable in any project involving field-survey. Geology, geography, ecology, agriculture and archaeology are but the principal subjects that gain from the application of air photography to their problems. The best results are obtained when reconnaissance is planned in relation to the questions awaiting solution. Thus, high altitude vertical photographs in overlapping series may be required for regional mapping, for general study of land use, or for geology, while low-level oblique photographs may prove best to record the past and present activities of man where these have fashioned and scarred the face of the land. Since photographs neither select nor conventionalise the information they present, special techniques of interpretation have been developed to serve the multiplicity of interests concerned.

Photographic interpretation has been developed to a high degree of ingenuity and skill to meet the needs of military reconnaissance.* This same expertise can be harnessed for non-military purposes to record the activities of Nature and of man. The value of air photography for detailed and rapid survey of remote, unmapped regions is now widely acknowledged by all involved in such affairs. The method has long served official departments or commercial firms concerned with the use of land and the exploitation of natural resources. The photographic cover that has accumulated over several decades as a result of such air surveys in many different parts of the world, increasing in amount year by year, is to be found in the various collections maintained by Government agencies and by commercial firms. The photographs often have a value far wider than the immediate purpose for which they were taken, and strong arguments might be advanced for the preparation of a systematic guide or catalogue to all such material. The problem of retrieving information from existing collections has been greatly increased by the achievements of American space programmes carried out by the National Aeronautics and Space Administration. Orbiting satellites, carrying cameras devised to photograph the earth's surface at regular intervals, can gather a large amount of information in a very short time. The film, whether developed in the satellite and transmitted to earth by television, or whether returned to earth by a recovery procedure, provides records of the surface of a

kind never available before. The scale and resolution of the photographs naturally impose their own limits on interpretation, but features such as a motorway or the runway at a large airfield can usually be distinguished, while variations in tone may enable quite small differences in vegetation or in soils to be recognised.

As with all photographs, limitations imposed by the present facilities for retrieving information may be the chief hindrance in the use of this material. A catalogue giving particulars of the type of film, the date of exposure, the area covered, the quality of the image and the degree of interference by cloud, provides essential particulars. However, the relevance of the imagery for scientific study may only become apparent as it is used, and the value of the photographs may be greatly increased when they are compared with subsequent cover, and the results combined.

The large photographic collections already mentioned mainly comprise cover obtained in the course of regional surveys, when the requirement may involve flying with great precision on predetermined heights and courses to yield vertical photographs in overlapping series, often at a relatively small scale. The photographs in the Cambridge University Collection are in complete contrast: they include both oblique and vertical photographs, taken from a light aircraft at a comparatively low altitude in the course of flights planned to meet special needs of teaching or research. These flights have ranged extensively over the United Kingdom and Ireland. Almost the whole of the United Kingdom has already been photographed from the air, much of it time and again, either by the Royal Air Force or by survey firms. Vertical photographs taken from a considerable altitude to meet the needs of regional planning may under favourable conditions also serve the geologist and the geographer and provide much information about the overall pattern of human affairs. However, for botanical studies, or for details of the complex pattern of land use, very great value may be derived from surveys planned with regard to the solution of particular problems. This may involve photography at a large scale, under carefully chosen conditions of weather or

Photo. 1:2 The Church Stretton valley, Shropshire, looking south-west (foreground at SJ 513018).
The valley is determined by one of the most important fault-lines in Britain. To right is the upland plateau of the Long Mynd: to left, the prominent hills of the Lawley, Caer Caradoc and Ragleth form the valley side, while to left again lie the successive escarpments of Hoar Edge, of Wenlock Edge and of the Aymestry Limestone.
Y 85 *27 July 1947*

* A full account of the remarkable contribution of air photography to military intelligence in the Second World War has yet to be published. The fine quality of some of the early photographs may be judged from Photo. 1:9, taken more than fifty years ago.

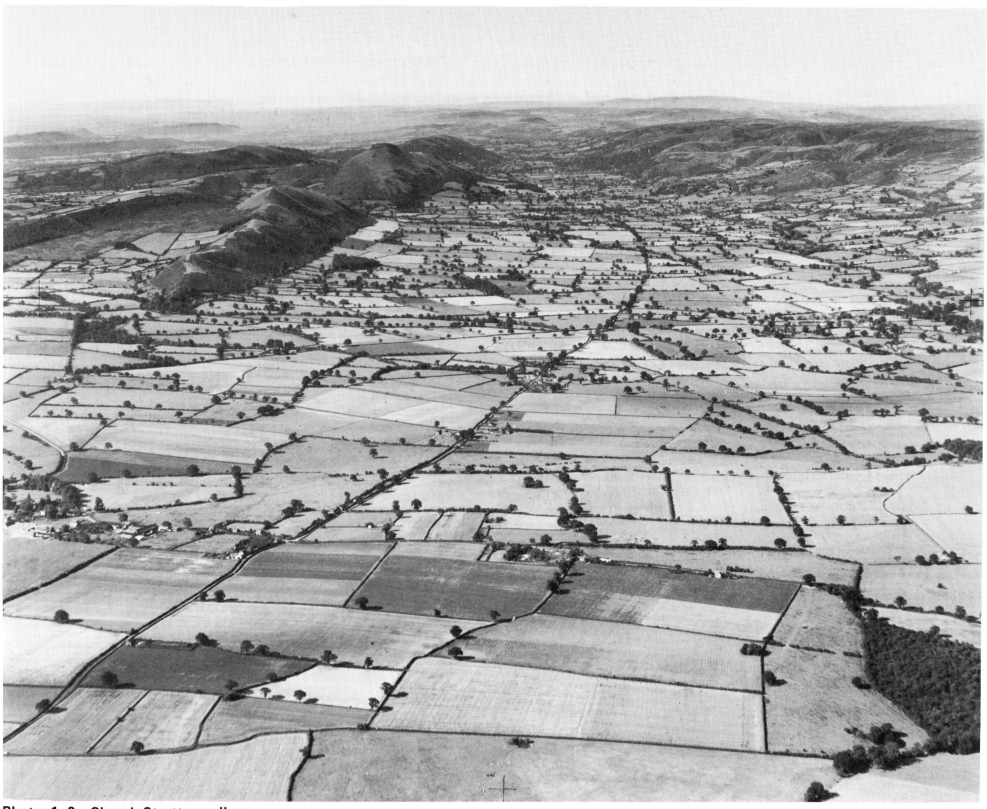

Photo. 1:2 Church Stretton valley

lighting, or at a particular season of the year. No regional survey can possibly meet all the specialised needs of those concerned with ever-varying natural conditions like coast erosion and deposition, or with research in ecology, in the study of plant diseases, or into the habits of wild animals, which may call respectively for photographs taken with regard to state of tides, or to the season and the stage of growth of vegetation. Special considerations of weather and lighting may be necessary to meet the needs of archaeologists and historians. Photographs that become available as a result of regional survey often prompt further specialised studies. Moreover, the scope of aerial photography and its applications are increasing: there is need both for more general survey and for detailed reconnaissance in support of particular research projects.

The land surface of the United Kingdom and Ireland is unusually favourable for such work. It includes a greater range and diversity of geographical and geological features and processes than almost any other part of the earth's surface of comparable size. This diversity is reflected in a wide range of soils supporting correspondingly varied vegetation, a fact not always appreciated, but essential to our understanding of the varied natural background to human settlement in these islands. Herein, too, is the clue to the many regional differences in the character of settlement in prehistoric and historic times. The long succession of human migrations that anciently swept across Europe to these islands, the varied natural environment, the present wide extent of arable land on which vegetation responds in sensitive fashion to buried features in the soil, all combine to provide in north-west Europe exceptionally favourable conditions for the study of history from the air.

No single survey of the country can possibly meet all the needs described in this book. Many subjects are, indeed, continually changing, and call for repetition and continuity of recording. Britain offers a special challenge to the air photographer by reason of her peculiarly changeable weather. In an average year, sustained periods of good weather favourable for air photography in Britain amount to no more than 400 to 450 hours. While summer offers the most settled conditions, spring and autumn have the highest proportion of days with good visibility. But the pattern varies: visibility may be limited not only by moisture and by smoke haze but also by salt nuclei in the atmosphere. The proportion of days with good visibility is higher in areas such as Ireland, west Wales and north-west Scotland, which are remote from industrial sources of smoke, than in the Midlands and in south-east England where, in certain conditions, smoke from major industrialised areas on the continent is added to that from our own heavy industry, causing a high degree of atmospheric pollution.

Within the hours of good photographic light, horizontal visibility in the first 500 metres above the surface is the principal factor limiting photography. Poor visibility masks detail and reduces contrast, but such conditions may sometimes have to be accepted if a record of transient phenomena is to be obtained at all. Vertical photography from 5000 ft (1500 m), the appropriate height using a lens of 6 in. (150 mm) focal length, to yield a scale of 1:10000, or oblique photography of features in relief, best seen when viewed across sun or even into sun, calls for a minimum visibility of 10 km. In the Midlands, this may be attained in winter on average not much more often than one day a week. Cloud may impose further limitations, particularly on vertical photography, for which clear skies are the ideal conditions. In England, diurnal heating commonly gives broken cumulus cloud in the height band 2000–3000 ft, so that early morning or evening flying may be necessary to achieve clear skies. At such times, shadows may be unacceptably long for precision survey photography, and often some compromise has to be made. An intensity of light adequate to provide a sharp image on panchromatic film occurs only for the period between two hours after sunrise and two hours before sunset, given clear skies. The period is progressively shortened if the intensity of light is diminished by cloud. Thus, in mid-winter, the light is adequate for photography on panchromatic film for about three hours only in the middle of the day. Use of colour film imposes even more limiting conditions: adequate intensity of light is likely to be present only between March and October, while absence of haze is essential if good colour saturation is to be achieved: visibility of not less than 25 km is necessary for really good results.

The chapters that follow, most of them by past or present members of the Cambridge Committee for Aerial Photography, describe some of the principal applications of this method of research still so comparatively novel that in many institutions and subjects its full potential is not yet realised. Since the photographs in the Cambridge Collection are conveniently to hand, many of the illustrations are of the United Kingdom. Most of the topics could well have been illustrated by photographs from elsewhere, while some uses of air photography, namely for animal counts,

Photo. 1:3 Partly submerged drumlins, Clew Bay, Mayo, Eire, looking east.

A sector of the archipelago of drumlins in Clew Bay. On the exposed west side of the outer drumlins (foreground) small cliffs have been formed by wave attack. Elsewhere sand and shingle spits are developing.
AJU 94 *11 July 1964*

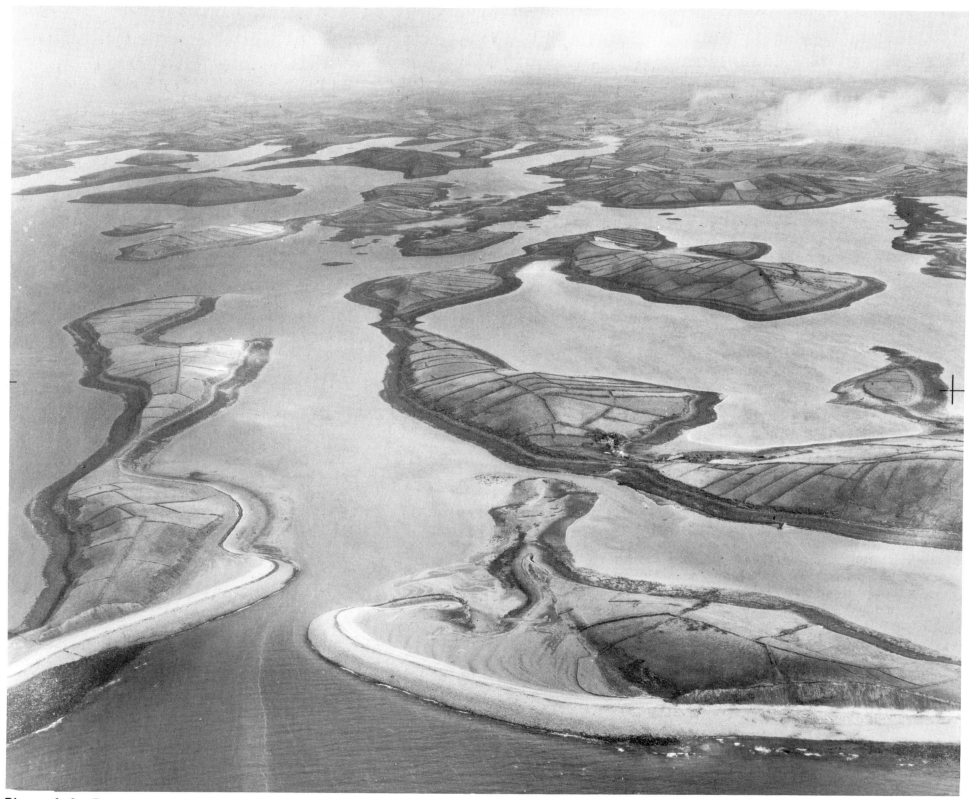

Photo. 1:3 Partly submerged drumlins

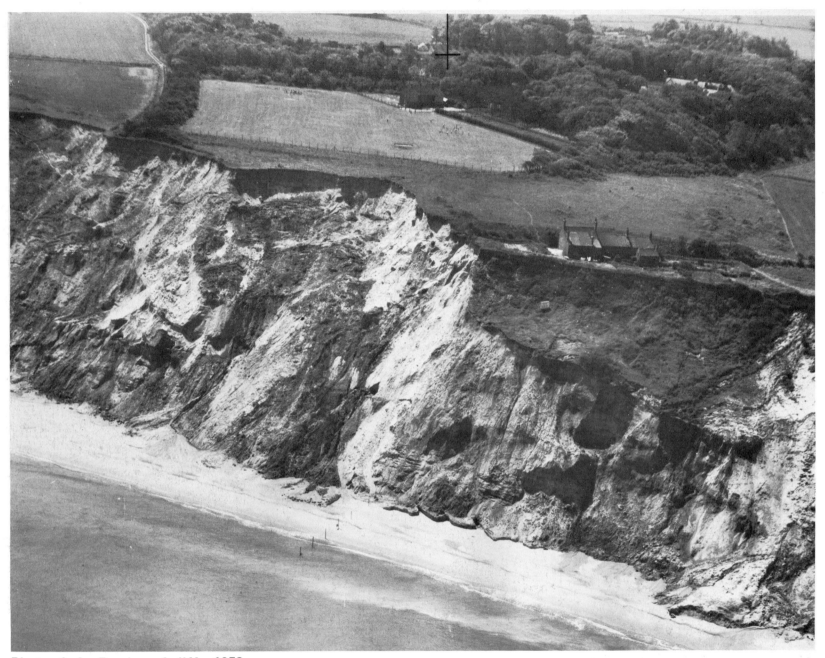

Photo. 1:4 Erosion of cliffs, 1958

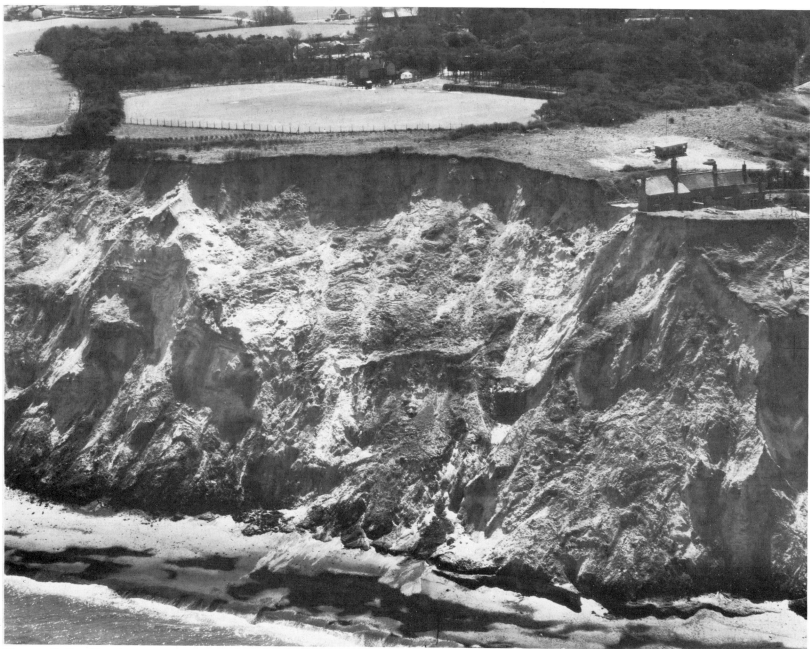

Photo. 1:5 Erosion of cliffs, 1965

Photos 1:4 and 1:5 Coastal cliffs near Overstrand, Norfolk (TG 261401).

Two photographs of the same cliffs taken at an interval of seven years. The rate of erosion may be judged by considering the line of the cliff-top in relation to a row of three cottages near the right-hand margin. Photography repeated at intervals is the only practicable means of recording the continually changing exposures of stratified sediments and boulder clay in the 15 miles of cliffs that comprise this geologically important section.

WK 42, AKT 95

5 June 1958, 27 April 1965

for regional surveys of special types of landscape or vegetation, or for the study of existing glaciers and ice-caps, cannot be illustrated within the limits of Britain. Photographs from other sources have thus been chosen, particularly high altitude vertical cover, which is not included in the Cambridge Collection. This introductory chapter provides a brief account of the variety of applications of the technique.

Interpreters are concerned with the whole range of natural and artificial features visible on the earth's surface, and their inter-relationships. The fullest information will be gained only if the exact position of the features is known: indeed, the use of air photography in cartography is fundamental to many studies. In countries that have long been mapped, the value of detailed surveys has come to be taken for granted, but in fact the development of air survey as a means of accurate and rapid mapping represents the greatest single advance ever made in the systematic exploration of the earth's surface. Photography under the right conditions will not only yield information for the construction of detailed maps, as Mr Dalgleish explains in Chapter 2, but when pairs of overlapping photographs are studied with a stereoscope, an appreciation of the relief may be obtained like a model in three dimensions. Moreover, a photograph, unlike a map, makes no selection, and so conveys far more detail of a landscape, and correspondingly richer material for interpretation than a map can ever do (Photos. 3:2 and 4:4). Overlapping pairs of vertical survey photographs may be used to establish the contours of a surface, and maps prepared by such means may present all the essential information furnished by measurement on the ground. Air survey conducted under carefully controlled conditions is in fact capable of yielding far more information about the vertical dimension than is commonly presented on maps. Ordnance Survey maps of the United Kingdom at 1:63360 scale commonly show contours at 50-feet intervals, and until the advent of air photography, only the contours at intervals of 100 feet, up to 1000 feet in altitude, and thereafter at every multiple of 250 feet, were actually surveyed on the surface. Precision air photography permits contours to be drawn at very close intervals (one-thousandth of the flying height) in a fraction of the time taken by surveyors on the ground. This means that many small but important aspects of physical geography, particularly of the Quaternary landscape, hardly appearing on maps at all, may be delineated in detail. The development of aerial photogrammetry has important practical applications, exemplified by accurate assessment of the water storage capacity of a valley, of the cubic content of large dumps of fuel, or of the volume of rock to be excavated for the construction of motorways and other major engineering works.

For the geologist air photography greatly expedites regional surveys designed to assess geological structure or mineral resources compared with painstaking work on the ground. An important function of air photography is to draw attention to those features of special significance which call for detailed study. By such careful analysis and selection, air reconnaissance can effect, as Dr Hey shows in Chapter 3, an immense saving of time for trained scientists working in the field, while in unknown, or ill-mapped country the photographs can be of great assistance to a surveyor by providing a base-map that he may use to position himself on the ground.

The quantity of geological information to be gained depends upon the nature of the surface, the variety and complexity of the geology, the extent of exposures and the degree to which the presence of different rocks may be reflected by variations in the vegetation growing over them. In Britain, as in much of lowland Europe, the covering of surface-soil and the highly artificial nature of the landscape inevitably impose limitations, but in areas of young mountain ranges like the Middle East, major structural features may be clearly visible, free of a covering of soil. The air photographs upon which a structural geologist has to work do not usually yield up their information so easily. The geology has often to be interpreted from careful study of the surface, seen in relief when air photographs are viewed under a stereoscope, while varying responses of vegetation to changes in the soil may provide clues to differences in the rocks beneath.

Reference has already been made to the covering of soil and rock-waste, or 'drift', to use the geological term, that frequently overlies and masks outcrops of rock. The formation of soils, variously derived by the weathering of rocks, involves many different processes by no means fully understood. This is a subject of fundamental importance in many studies, for soils reflect recent geological and climatic history, and for this reason

Photo. 1:6 River Severn in flood, above Gloucester, looking north-east (foreground at SO 842265).

This oblique photograph shows a six-mile length of the Severn at the peak of a mid-December flood. The whole alluvial plain is under flood-water, of which the surface is at a height of about 35 ft O.D. at Hard Bridge, near the centre of the photograph. The flood-water is held back by the narrows some 2000 ft wide below Ashleworth Quay, ¼ mile further downstream. The west bank of the river is picked out by a natural levee heightened in places for use as a towing-path; the east bank by an earthen wall to contain flood-water.

BLF 86 *12 December 1972*

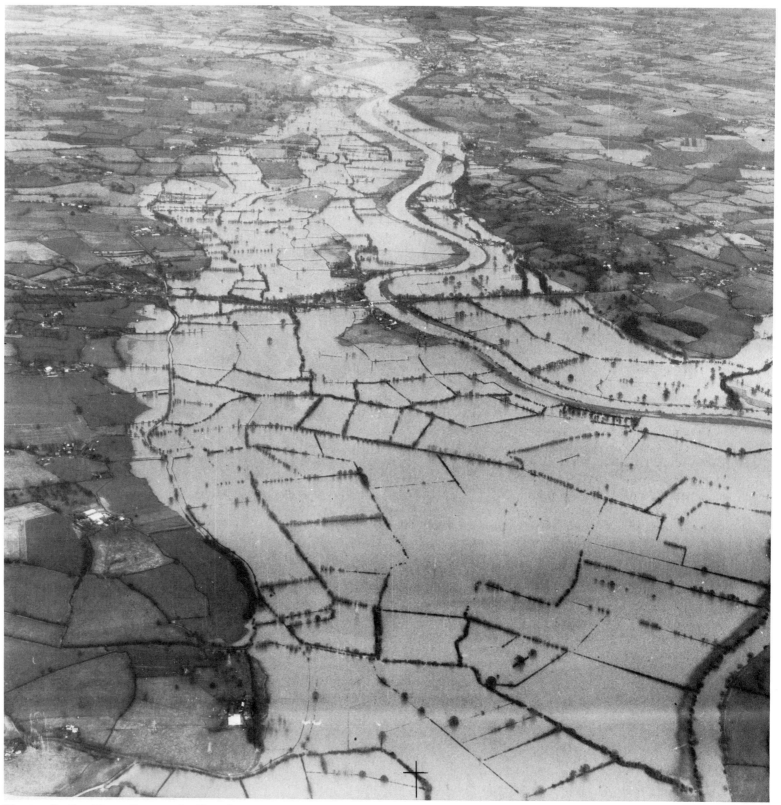

Photo. 1 : 6 River Severn in flood

they have particular interest for Quaternary research, concerned with the changing environment in the very recent geological past.

Soils may assume, or may have impressed upon them, structures or shapes characteristic of the conditions under which they accumulated. Examples are desert sand-dunes, gravels and screes, and the multiplicity of glacial deposits widespread in those regions of the earth recently covered by ice. The glacial deposits found in parts of Scotland, and over most of Ireland (Photo. 1:3) are so remarkably unweathered and little modified by human agency, as to constitute important material for study and interpretation. Here air photography has much to contribute, for the detailed topography of glacial deposits can be effectively illustrated in both oblique and vertical photographs, which may define their inter-relationships, not always apparent on the ground. In arable land, differences in colour of soil reveal the former existence of lakes and pools long vanished. This work has much more than academic interest, for analysis of the botanical remains contained in such soils may yield important dating evidence, so advancing our understanding of the complicated succession of events in the Quaternary period.

Air photography may also be employed to record geographical and geological changes in progress at the present time (Photos. 1:6 and 4:2). These are of considerable variety: landslips and soil-creep, the flooding of valleys, silting of estuaries, erosion of coasts, formation of sand-spits, and shifting of sand-dunes, besides effects seldom recorded, like the growth and development of volcanic cones. Valley flooding, of special importance in connexion with the siting of settlements and the agricultural use of land, and the accretion of silt in salt-marshes and estuaries, are not only topics of interest to geologists, but matters of immediate practical concern. There is no more effective medium than air photography for recording annual changes in intricate patterns of creeks and saltings, which have to be measured and understood before the principles determining the accumulation of silt along a shore-line can be established. In England land-reclamation round the coast-line of the Lincolnshire fens is a live issue, but land-shortage is also beginning to focus attention on much larger schemes of reclamation whether in embayments or in estuaries, such as Morecambe Bay, The Wash or the Dee, or on coasts where the off-shore profile is very slight (Maplin). The Dutch achievement in reclaiming much of the Ijssel Meer as arable land, and creating large fresh-water reservoirs in addition, outstrips most projects so far proposed in Britain. Coastal erosion and deposition, for example the growth of sand-spits, is also particularly suited to study by air photographs. Here the value of photographs in repeated series at known intervals is evident,

and the information so gained is increased out of all proportion when the results of successive surveys are combined. Major changes round our coasts occur seldom; the most striking recent example being the flooding after the North Sea tidal surge in January 1953. But for prompt measures to restore the shore-line this would have effected the greatest change in the coastal geography of East Anglia for several centuries. The recording of rock exposures on inaccessible or remote cliffs can be achieved by low-level oblique photography of the cliff-face, a method that has proved its worth on the Norfolk coast, providing records at known dates of the constantly changing exposures of boulder clay in this important geological section (Photos. 1:4 and 1:5).

For the study of physical geography and geology, air photographs offer great advantages compared with maps, since they record the earth's surface in a degree of detail seldom presented on maps, however large the scale. Systematic photography of land forms (Photos. 3:2 and 3:3) is of first importance for the understanding of geographical and physio-graphical processes. The seepage of springs, the erosion of streams, the incising of rivers, the formation of alluvial plains, the development of slopes, the study of land-slips and of soil-creep, are important aspects of the evolution of landscape. When studied regionally they have much to reveal about the history of rivers, particularly in relation to recent changes in sea-level. Coastal dunes, and the light soils of wind-blown, sandy heaths, like the Breckland of Suffolk, or the 'warrens' of north Lincolnshire, are environments often chosen for habitation by early man, while other evidence of human occupation in the early part of the post-Glacial period may be found in sand deposits and in caves related to old strand lines, formed when the sea was at a higher level than now. As man began to develop an agricultural economy, the cultivation of crops first came to be practised on fertile soils such as the loess of south-east Europe, or the gravels and silts of river-valleys, enriched by periodic flooding. Air photographs of these features are thus of value not only as a contribution to our understanding of the geographical processes involved but as a guide to sites of early human occupation. Comparison with photographs of similar areas where vegetation still exists in its natural state may permit a reconstruction of the geographical and physical environment

Photo. 1:7 Wytham Woods, Berkshire (SP 465087).
This vertical photograph taken in diffuse lighting shows the remarkable photographic distinction that can be achieved between different tree species in such mixed deciduous woodland.
V-T 36. Scale 1:1950 *9 June 1961*

Photo. 1:7 Wytham Woods

in which mankind developed. This is a subject in which the techniques of geology, geography, botany and archaeology all merge, with great profit to each, as studies in Quaternary research have shown.

The employment of air photography for surveys of vegetation is well established, and as a means of mapping rapidly major vegetational zones the method has no equal. Much of the world's vegetation has been interfered with or destroyed by human agency, and it would be of great scientific interest to record on air photographs the distribution of the main plant-communities in the few remaining continental areas where very extensive tracts of vegetation, such as jungle, forest, swamp and prairie, still survive in natural state. The information to be gained will depend much upon the scale at which photography is undertaken: coverage at a small scale would be needed to record main vegetation-zones, while photography of selected areas at a large scale (Photo. 1:7) could yield for the ecologist, as Dr Coombe shows in Chapter 6, abundant information of a kind not generally available without time-consuming surveys on the ground. In Britain, where little vegetation now survives free of human interference, all the more importance attaches to Nature Reserves and comparable areas, where such air surveys have been employed in connexion with special botanical and ecological studies. For such work air photography is indispensable: there is no method of comparable convenience for recording details of the vegetation in salt-marshes, peat-bogs, rocky shores, cliffs or inaccessible islands. The information to be gained depends much upon the conditions of photography, upon the season at which it is undertaken, and upon local circumstances. To obtain full value from the method as applied to biological problems, photography of the same area should be repeated at intervals to reveal changes in vegetation. Such repetition and continuity of recording is invaluable in planning the management of Reserves for scientific study.

The appearance of deciduous woodland varies much with the season of the year. Photography in winter may show the ground beneath the tree canopy, enabling the extent of undergrowth and scrub to be assessed, while photography in spring, when trees are coming into leaf, offers the best conditions for identifying different varieties. Here, colour photography comes into its own as a means of distinguishing the different hues of vegetation. Photography has often been used to measure the cubic content of useful timber in standing woodlands, and in respect of the detection of plant diseases, scientific management of vegetation is assisted by air reconnaissance.

The use of air photography for making a census of animal species and for the study of wild animals in their natural habitat is described by Sir Frank Fraser Darling in Chapter 8, while Dr Watson considers in Chapter 9 some of the special opportunities for research afforded by problems of game-management in a large African reserve. When very big herds are in question, accurate estimates of numbers are difficult to make even by an observer in the air. Photography can provide a record at a given moment of herds that may extend over miles of country so enabling an exact count to be made, while photographs at a large scale convey much information about the condition of the animals and the composition of a herd by age and sex. The study of wild animals in their natural environment is a subject that can be greatly assisted by air photographs. The pattern of big herds of migrating ungulates, the inter-relations of different species of animals, and their grazing habits, can be more effectively illustrated in air photographs than in any other way. Moreover, time presses; the next generation may witness the virtual extinction of unprotected herds of large land animals. All the more importance, therefore, attaches to opportunities now afforded by air photography, in Africa and elsewhere, for the study of animal communities in their natural habitat, and their effects on vegetation.

Other species can be studied by the same means; for example, seals and caribou in sub-arctic regions have been the subjects of aerial counts (Photos. 8:3 and 8:4). In Britain, opportunities for such work are much restricted, but air photography has been applied successfully to counting birds. The gulleries on the Ravenglass sand-dunes in Cumberland, and the oyster-catcher roosts around Morecambe Bay in Lancashire, where the birds are considered to be serious predators on the local shell-fish beds, have been treated in this way (Photo. 8:5). Instances of the fine detail that can be recorded from the air are provided by changes in the reed beds in the Norfolk Broads due to activities of the coypu, or by

Photo. 1:8 Grime's Graves, Norfolk (TL 818898)—infra-red linescan.

This record of these well-known prehistoric flint mines was obtained at 05.40 hours on 17 May 1973. The ground along the edge of the conifer plantation, and those parts of the infilled mineshafts that are in shadow were relatively cold, and thus emit less radiation than the ground elsewhere. The slopes of the spoil heaps facing south-east which are caught by the early morning sun are relatively warm. The infra-red radiation responding to this differential heating is reproduced as a pattern of light and dark tones on the photograph. The black rectangle marks a temporary corrugated iron shed protecting an excavated mineshaft. The roof, cooled by radiation to the night ground temperature, has not yet warmed in the oblique sunlight.

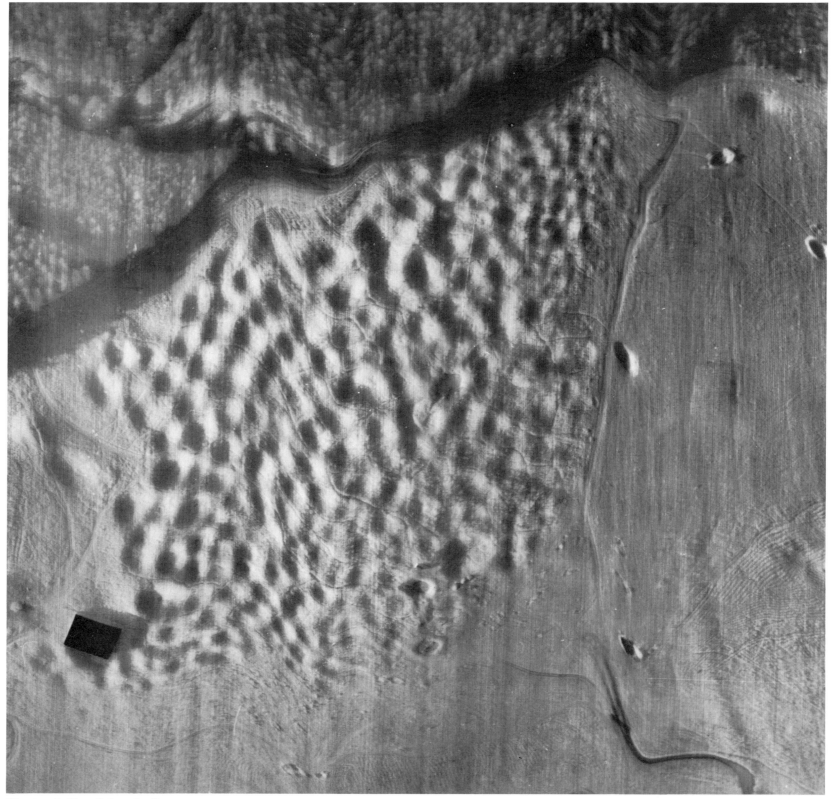

Photo. 1:8 Grime's Graves

Scale variable: flying height 700 ft., speed 110 knots

vegetational changes in the South Downs and elsewhere, caused by near-extinction of the rabbit population after myxomatosis.

The question of the application of air photography to the location of shoals of pelagic fish, and the distribution of the organisms on which they feed, remains uninvestigated upon a large scale. Given suitable photographic techniques it might be possible to distinguish the various bodies of water – Baltic, Arctic and Atlantic – in the North Sea. The circulation and mixing of these waters, of importance to oceanographers, is a factor determining the movement of fish. In the interest of international economy, and for the conservation and wise use of this form of food, this matter is manifestly worth attention.

Any account of the contribution that air photography can make to development and research in agriculture must involve some cross-reference to subjects already mentioned. Soil surveys, such as Dr Perrin describes in Chapter 5, are being undertaken on a wide scale in many parts of the world. Not only are they greatly assisted by air photography, but without it surveys in underdeveloped countries could not even be contemplated because of the labour involved. In countries with rapidly developing agriculture, regional surveys are indispensable for planning the best use of land and assessing its suitability for any given crop. The results are of value not only for agriculture, but for the scientific study of soils and of the rocks from which they have been formed by weathering. In Britain, where ice-action in recent geological time has greatly modified the land, soils over large areas are derived from glacial deposits, so that soil-mapping assumes additional importance as it may reveal the extent of different boulder clays, and thus of their parent ice-sheets. Soil erosion occurring in many parts of the world may be recorded from the air to yield information of great practical value in planning preventive measures or in combating the effects of this wastage.

In countries with long-established agriculture, increases in population bring ever-increasing conflict of interests in the use of land. Here air photography becomes important in planning the most effective agricultural use of 'marginal land', that is land not already intensively exploited for agriculture. In the lowland zone of Britain, such marginal land, comprising sandy heaths, peat-bogs and marsh, is of small extent: in the highland zone it often includes the main hill-slopes where the tide of agriculture has never reached, or reached in the Middle Ages and then receded. This constitutes our sole reserve of land remaining to be fully developed for agriculture. The use of land to full advantage may often involve the rationalisation of an apparently haphazard mosaic of small fields, the provision of adequate drainage, and the treatment of sour and infertile soils. When relatively large tracts of land are in question, the measures can be planned most effectively by reference to up-to-date air photographs, which are also a pre-requisite for the study of the unproductive moorland and bogs on our northern hills with a view to their improvement for sheep-grazing.

The use of air photography in connexion with crop-trials and for the assessment of plant disease, leading to treatment and control, is now established. Dr Rishbeth discusses in Chapter 7 the detection of potato-blight in the Cambridgeshire fens, work for which infra-red film has proved particularly suitable. Sugar-beet and cereal crops have been the subject of such studies in the United States, with valuable results; here colour film, and perhaps the so-called 'false colour' film, responding to differences in the chlorophyll content of the vegetation, may give significantly better results than can be obtained in black and white. The spread of diseases in trees may also be studied by air photography. For some years attacks of the wood-rotting fungus (*Fomes annosus*) on conifer plantations of the East Anglian Breckland have been followed in this way, while Dutch Elm disease, now prevalent in Britain, can in its early stages be detected from the air more readily than on the ground.

The extent to which air survey can assist the exploration of man's natural environment, as revealed by geology and biology, will be apparent from the six chapters that follow. Moreover, the environment is not static but ever-changing, and the changes can be revealed by air photography with telling precision and emphasis. For the last few thousand years man himself has been profoundly affecting his environment. Ever since primitive man started to make holes for storage or for shelter, to dig foundations for buildings in timber and stone, or to till the ground, he began to mark the surface of the land and continues to do so today at an ever-increasing rate. These varied traces of his activities have much to reveal about man's social and cultural development. While history depends on the written word, archaeology is concerned with every physical manifestation of human activity and provides the sole information for such studies until the emergence of literate civilisations, when the written word comes increasingly to be taken as the principal source of evidence. Air photography serves both archaeology and history alike, and knowledge is best advanced when the work of scholars in the two subjects can be interwoven and their results combined.

Evidence for the earliest periods of archaeology is mainly provided by implements and artifacts, for no man-made constructions ordinarily survive, certainly none visible from the air. However, from the Neolithic period onwards there are ever-increasing traces of man's existence.

Frequently the remains of one age are modified and overlain by those of another, and in the last two centuries man has come to exert such increasing control over his environment that there is wholesale destruction of ancient and historic sites as modern 'development' reshapes the face of the land. Archaeology includes the discovery and examination of all traces of human activities in past ages, principally his fortifications, habitations, and agriculture. Much evidence is plain to see, and can be studied on the ground, but in many phases of human development more ancient sites have been levelled or destroyed than the total still visible. Until the growth of air photography, discovery of these buried features was largely by chance, as when an occasional find revealed the position of an ancient site. Today, the speed of discovery is transformed, since air reconnaissance in competent hands can yield discoveries at a rate previously undreamed-of. Differences in colour and texture of the soil or vegetation revealing buried features are discussed in Chapter 10, but many visible constructions in earth or stone, surviving from past ages, may also be examined more rapidly and effectively on air photographs than on the ground. The study of remains of prehistoric peoples can be greatly assisted by surveys of primitive peoples still existing at the present day. Anthropological research in Africa, South America and Asia has much to gain from air photographs of native settlements and agriculture.

Air photography applied to the study of man's environment involves complete survey of a whole region, or a survey of selected features specified beforehand. With archaeology the aim is rather different, namely to discover and to photograph features not previously known to exist. Thus the flying is more in the nature of reconnaissance in which unknown features may come into view at any time. In this work much depends upon the direction and intensity of the lighting, the length of shadows (Photos. 10:4 and 10:9), and, when differences in growth and colour of vegetation are in question, the angle of view of the observer in relation to the incidence of sunlight, so that oblique photography comes into its own. Oblique photographs are, moreover, the easiest to take and the most economical of flying time: vertical photographs remain necessary for accurate rendering of plan (Photo. 10:6).

When this technique is applied to ancient constructions in North Africa and the Middle East, conditions are found to be somewhat different from those in north-west Europe. The arid climate and absence of vegetation may leave whole cities lying bare: their ruins only masked by a light covering of sand (Photo. 1:9). Excellent photographs exist, for example, of the desert trading-city of Hatra (Bradford 1957), in Iraq, surrounded by siege-works, or of Samarra, medieval Baghdad,

showing miles of processional avenues, palaces, store-houses, temples and other buildings so clearly that the photographs themselves serve as a plan. Apart from deserted Graeco–Roman cities of Greece and Italy, no prizes quite like this await the archaeological air observer in Europe. Conversely, the subtle variations in vegetation so sensitive to buried features are hardly to be found in the deserts of the Middle East. There, air reconnaissance may bring ancient sites to knowledge by recording their remains, which may have escaped attention hitherto simply by reason of their remoteness from the beaten track.

This multiplication of discoveries has come at a time of increasing demands upon the use of land. Never before has the land surface in many European countries been so subject to change by 'development' of all kinds, including new buildings, new communications, open-cast quarrying, and more intensive agriculture. Many of these activities cause deep disturbance of the surface, often extending into the sub-soil and thus effectively destroying any archaeological sites that lie there. Ancient monuments that are known can be investigated in advance of destruction, but planning based upon visible features cannot take account of unknown buried remains. Yet it is often the features that have remained unknown, and therefore undisturbed, that are now amongst the most important for study. At a time when land potentially rich in buried remains is being annexed for development of all kinds, and when the number of sites threatened with destruction far exceeds the number of skilled excavators, to have a comprehensive view of this problem becomes of first importance. Only so can the limited resources of archaeology be directed where they are most effective, and a delicate choice has to be made of what to salvage and what not. No means other than air photography exists for assessing rapidly the archaeological potentiality of a large area without visible remains.

In later periods, the material available for study becomes ever more diverse, and contemporary records immeasurably assist interpretation. If in the classical world, history and archaeology together may be said to have established the main framework of events, in the Roman provinces a great deal of detail has still to be furnished. Air photography has much to contribute: spectacular advances have been made in our knowledge of Roman military organisation in Syria, North Africa and Britain, and the system of land-division and agriculture in Italy and the Mediterranean provinces stands revealed in astonishing detail. In Roman Britain and northern Gaul many different aspects of both towns and countryside have been illustrated by this medium of research, and results in other provinces only await an extension of the method.

Amongst the most striking records of Dark Age remains are photographs of sites important in the history of Celtic Christianity in Ireland: Clonmacnois, Inchcleraun and Saint's Island in the Shannon basin; Drumacoo and Devenish, with their extensive earthworks suggesting streets and rows of buildings or cells, and Great Skellig perched on an isolated peak eight miles out in the Atlantic. In England, identification of increasing numbers of Saxon settlements will have much to contribute to studies of the origins of the English village. Of special sites, the revelation of timber buildings of an Anglo-Saxon royal centre at Yeavering and perhaps at Milfield and Sprouston, in Northumbria, affords tangible evidence, to be interpreted by archaeologists, of the life and social conditions described in *Beowulf* and the works of Bede. Equally far-reaching results are to be expected in mainland Europe if Saxon and Viking sites can be identified and photographed when under vegetation at a sensitive stage of growth.

Progress in land clearance in the Middle Ages as the tide of settlement moved against the natural forests, marshes and moorlands can be viewed through the medium of air photography. Movement was uneven as advance and retreat alternated in response to fluctuations in population and to other factors. The thousands of villages that flourished in the early Middle Ages and are now extinct, or have shrunk to a fraction of their former size, testify to economic and agricultural change repeated over many parts of Europe, a reflection of history in which the impact of regional events and local conditions are intertwined. Photographs of medieval towns and villages emphasise the importance, as Professor Knowles shows in Chapter 11, of studying a ground plan (Photos. 11:7 and 11:8) capable of revealing both the ancient 'fabric' of a village displayed in its street-lines, building-sites and property-boundaries, and also the control imposed on its development by a small number of features; a church, a religious house, a castle, a manor house, even a windmill. Economic history is particularly assisted by the evidence that air photographs can provide about activities such as agriculture, quarrying, and mining; while all major constructions like castles, town-walls and religious houses, which lend themselves particularly well to illustration by air photography, express in real terms the labour of countless thousands of individuals.

Many aspects of modern history, such as the development of agriculture and the evolution of communications are written large on the face of the land. Medieval trackways give place to the turnpike; the coach-roads, canals and railways, so novel when they first appeared, represent the more sophisticated transport of the modern age. There are,

too, the changes in social order: by the end of the Middle Ages the building and maintenance of castles was neither necessary nor practical as an expression of an individual's power and prestige, save for the very few. Great country houses and mansions are the chief remaining visible expression of the wealth and taste of the leading members of the social order of the seventeenth and eighteenth centuries. The extent to which, in England, these great estates with their fine buildings, their spreading deer parks and landscape gardens, transformed the contemporary countryside is by no means always realised. A glance at Saxton's county maps (*c*. 1575) gives a striking impression of the proportion of the land that came to be emparked in this way. This is a phase of social history that has now almost vanished from the contemporary scene, and with its passing much of beauty has passed too. The avenues of Boughton House, or of Wimpole Hall, in their heyday, or the skilful planning of the Stourhead gardens with their artificial lakes, show the boldness with which landscape could be transformed and beautified. Aspects of contemporary life in the humble peasant houses can be effectively illustrated by comparing sixteenth- and seventeenth-century plans like those of Norden or Clerke, with air photographs of the same villages today. The church, partly by reason of the solidity of its fabric, is the building most likely to have endured intact; the parsonage, manor-house and windmill, all important in village life, will ordinarily have suffered some change between complete renewal and decay; few sixteenth-century peasant houses, and hardly any that are genuinely medieval, will have survived the successive rebuildings that replaced clay, timber and thatch by the more durable brick and stone. More lasting than buildings are the earthworks of medieval fields in ridge and furrow, the marl-pits, quarries and fish-ponds, the common lands and marshes, exemplifying important aspects of rural life all too seldom described in contemporary records.

A most distinctive element in the English countryside is the detailed

Photo. 1:9 Samarra, Iraq. A small part of the medieval city that extends for some 25 miles beside the Tigris, 65 miles north-north-west of Baghdad.

The city, which was established in the ninth century by Caliph Mu'tasim, apparently had a life of little more than fifty years. The photograph provides a detailed record of great processional avenues, palaces, barracks and dwellings laid out with astonishing precision: they are now masked by a light covering of sand.

Vertical photograph. Scale c. 1:2600 *about 1919*

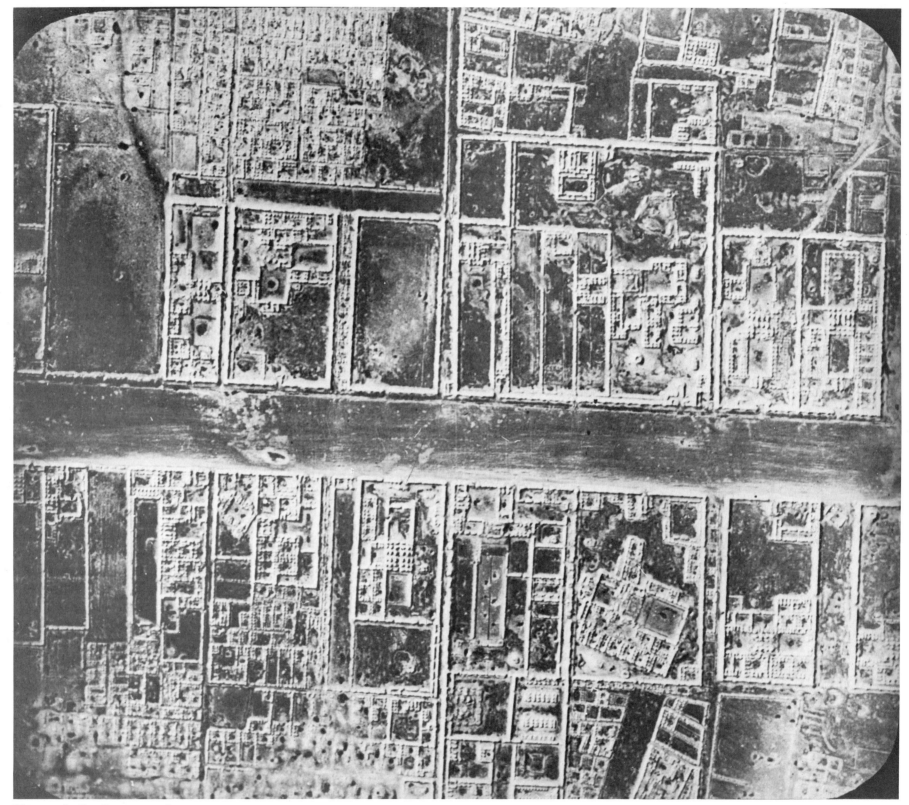

Photo. 1:9 Samarra, Iraq

regional variation due especially to the varied environment. The variety of materials and of building-practices, and the individual architectural styles exhibited by old buildings reflect the relative isolation of villages at least until the eighteenth century, circumstances in which many needs had perforce to be met from local resources. This regional variation, in which villages and fields are determined by the environment of geology and soils, accounts for much of the beauty of the English landscape. When seen against such a background, the solution of contemporary problems of planning calls for considerable knowledge of physical geology and settlement history. Here, air photographs are of the greatest value for they provide a record of the land, showing the most varied details of its use at a known time. Precision vertical photographs taken under carefully controlled conditions may be used for the preparation of large-scale maps. Oblique photographs, which are the easiest for the layman to appreciate, present features partly in plan and partly in elevation, rather in the fashion of an isometric drawing.

Problems of regional planning confront many countries of Europe, and Britain is not the least troubled amongst them by reason of her density of population, her industrial economy, and her shortage of land. Another generation will see the clash between competing interests in the use of land become still more acute. In face of growing demands of land for agriculture, land for housing, land for 'development', for public services and communications, for quarrying, for recreation, and for scientific study, planning that involves piecemeal apportionment of land is not enough. Nothing short of an overall national policy will serve the needs of these crowded islands, and the longer the formulation of such a policy is postponed the faster the situation will deteriorate. How pressing is the problem may be judged by the fact that each year 50000–70000 acres* are required to meet the needs of housing, of industry and communications, so that in seven years the countryside will have lost to such use the area of a medium-sized county.

Air photographs afford an up-to-date record of the surface, and are widely recognised as indispensable for planning, in view of the complex and interlocking considerations now involved in devising the best future use of a highly developed land pattern. Maps give little indication of the current use of land, while in areas of intensive development maps become rapidly out of date. The value of air photographs for planning will be more easily appreciated if some of the issues involved are briefly mentioned.

* Official figures from the Ministry of Housing and Local Government, quoted in *The Countryside in 1970* (H.M.S.O., 1964), 26

Changes in land use involve a number of important factors, aesthetic and practical. The impairment of the amenities of a landscape, and the contraction of open space, are matters upon which a value is not easily set. There can, however, be no doubt about the loss of fertile soil and of catchment-areas of unpolluted water as building spreads ever more widely. Soil and water are amongst a country's greatest natural assets, and their best use affords a nice exercise in planning. The greatest needs for water, whether for domestic consumption or for industry, by no means coincide with maximum sources of supply, and in deciding future policy both for new towns and for industry these facts have to be considered.

An age which sees many demands on land use cannot afford to neglect the areas of dereliction, a result of unplanned industrial development of the last two centuries. The tip-heaps and waste-land remaining from eighteenth- and nineteenth-century coal-mining in South Wales (Photo. 1:11) and in the 'Black Country', the spoil-heaps from the oil-shale industry of the central valley of Scotland, not to mention the scars of open-cast quarrying for ironstone, clay and gravel in midland England need treatment if these areas are to be brought back into effective use. Air photography offers the most rapid means of obtaining an overall view of the problem, as a basis for planning the reconditioning of such land.

In a highly industrialised society there are many other factors injurious to the environment. The disposal of solid and liquid waste and particularly of toxic matter is a cause of increasing public concern. The discharge of effluent into rivers and into the sea can be monitored by appropriate methods of aerial survey, perhaps using infra-red linescan to detect the slight temperature differences involved. Another serious aspect of this problem is pollution of the atmosphere, especially by discharge from industrial plant. In some instances the effect on vegetation is so

Photo. 1:10 Naarden, which controls the eastern approaches to Amsterdam.

An example of the art of the seventeenth-century military engineer at the climax of its development. The street-plan has its origin in the 'new town' founded about 1350, but the chief interest of Naarden lies in its fortifications, constructed in 1675–85 under the engineer Admiral Dortsman. The medieval town is cramped within defences comprising a huge rampart, from which there project six great spear-head bastions, faced in brickwork: outside this again a double line of water defences forms an exceptionally complicated pattern best appreciated from the air.

R.A.F. photograph 106G 3375 print No. 4067. Scale 1:8700 18 October 1944

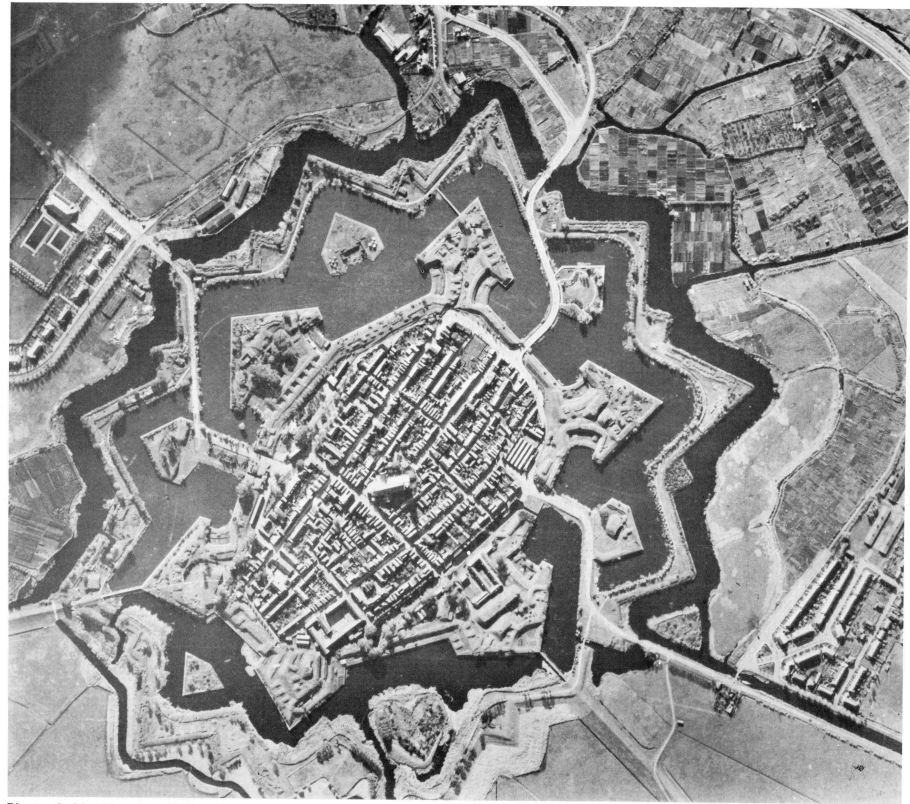

Photo. 1:10 Naarden, Holland

marked as to be clearly visible, while there are a number of processes in which small quantities of relatively toxic substances may be included in gaseous effluents. Where these may significantly effect vegetation, air survey can provide a check on the efficacy of safety measures.

Not only do towns increase in extent, but congested and impoverished areas within them fall to be redeveloped as buildings reach the end of their useful life, or as space becomes available through changes in ownership, or other reasons. Replanning the centre of an old town is a difficult exercise because of the many different and often competing interests involved. Here an air photograph offers great advantages over a ground-plan for it enables the whole of a town to be seen and studied comprehensively, when the importance of individual buildings not only in themselves but in their setting becomes clear (Chapter 12). In old towns, many of the churches and a select company of other buildings are the only genuinely medieval structures to have survived. However, the remarkable persistence of streets, of rights-of-way, property-boundaries and lines of town-wall, cause the medieval town-plan, in which is written so much history, to be largely preserved. This is because new building has nearly always proceeded piecemeal: exceptions, as when a town was cleared by fire, are rare. The present age is the first to proceed boldly with wholesale replanning of the centres of old towns. Whether in modern conditions due attention can be paid not only to economic factors, and to problems of pedestrian and vehicular access, but also to a town's long and complicated historical development remains to be seen. The high value of urban land and the infesting motor vehicle, are factors that have been changing the face of our towns: gardens are built over, verges and trees are removed, streets realigned to suit the needs of traffic, changes so gradual that their cumulative effect is not easily realised. As to traffic congestion, air photography has an important contribution to make, for it can provide for the information of planners a visual record of the state of traffic at a given time.

Air photography of residential areas has much to show of achievements and failures in planning. A facile contrast may be drawn between the gracious terraces and pleasing architecture of Regency Bath and the poor overcrowded housing in nineteenth-century industrial towns. By comparison, modern housing-estates, to which Lord Esher refers in Chapter 13, have to conform to specified standards of building, and of amenity, defined by legislation; but Photos. 13:10 and 11 enable the reader to make his own judgement of the result. Photographs of dormitory and residential areas of towns can be of considerable assistance to sociological studies. The categorisation of population in such areas by age, or occupa-

tion, or income-range, serves the needs of research in certain fields of economics and sociology, while distance and mode of transport between house and place of work are important practical factors in planning housing-estates and the roads that serve them. Vertical photography at a large scale can provide, very quickly, up-to-date information about the quality, size and type of housing, even to the number of square feet of floor-space, the outbuildings, garages and gardens, so saving the time of research-workers conducting individual enquiry. Such photographs might well be used on an occasion of wholesale revision of rates as a basis for assessment, with the advantage to the Local Authority of saving in time and cost.

Something of the versatility of air photography as an instrument of research will have become apparent from the many uses here described, and the list is by no means exhaustive. Two general fields of application may be emphasised: regional mapping of the earth's surface with a view to the exploitation of natural resources like oil, minerals, timber and water-power, and detailed planning of land use. The first field is the theme of several of the following chapters; the importance of the second is by no means generally realised because of the very rate at which man is changing his environment. In all overcrowded countries planning needs to be exercised on the broadest lines embracing every facet of land use. If the present yearly increasing rate of growth is maintained, the end of this century may see London so linked with neighbouring urban centres that all south-east England may become one vast extent of towns, housing-estates and dormitory suburbs. In the west Midlands, Birmingham–Wolverhampton–Coventry will grow to another such agglomeration, while south Lancashire, Tyneside–Teeside, and Glasgow with its neighbour towns bid fair to be others.

The most careful planning is needed now, if any countryside is to survive at all. The English countryside is Nature, not organised in green-belts and parks, but seen in wide tracts of farmland, in fields and woods, with scattered farms, villages and market towns, full of history and contributing so much to the beauty of landscape. Here air photography emerges as an instrument that helps to fashion policy. To whose long-term

Photo. 1:11 Dereliction of industry, east of Merthyr Tydfil, Glamorganshire (SO 060070).

A vivid impression of the wasteland that occurs along the north edge of the South Wales coalfield, with its wilderness of tip-heaps from past phases of coal-mining.
XX 27 *19 April 1959*

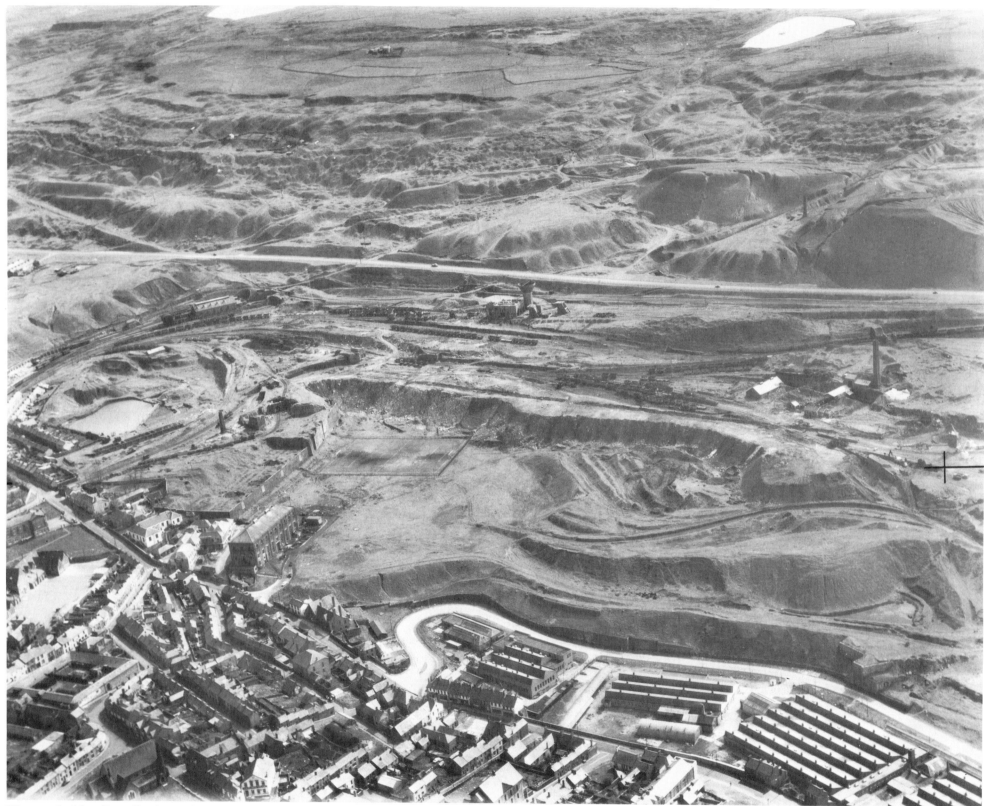

Photo. 1:11 Dereliction of industry

benefit is the achievement of a specified 'growth rate', if the result in another generation is a land with little countryside left? In the meanwhile, most careful scrutiny is needed of all projects involving extensive changes in land use. The establishment of National Parks and Nature Reserves and the preservation of the coast-line, all highly desirable within the framework of regional planning, will not be enough to meet the need for open space of a growing population. The fact must be recognised that the countryside is not limitless, and that its unique cultural landscape is irreplaceable.

Typescript received September 1975

REFERENCES

Bradford, J. S. P. (1957) *Ancient Landscapes*, 71–5 Plate xxiv
Crawford, O. G. S. (1954) 'A centenary of air photography' *Antiquity*, Vol. 27 206 Plate iii

2 Air Photography and Cartography

A. G. DALGLEISH

Deputy Director (Mapping), The Ordnance Survey

Modern cartography, particularly of the less developed parts of the world is so intimately bound up with the use of air photographs that all the ramifications of the relationship between maps and air photographs cannot be mentioned, let alone described, in the space of a short chapter.

In cartographic terms a vertical air photograph, such as is most commonly used in map production, is a central projection map of variable scale which is completely unselective in the type of detail it depicts. Consideration of the rules of simple geometry shows that the degree of scale variation will depend on the amount by which the terrain in question departs from a plane surface and on the amount by which the optical axis of the camera departs from the vertical. In other words, the metrical characteristics of a truly vertical photograph of flat desert land will be virtually identical with those of a conventional map of the same area. However, as the height variations over different parts of the terrain increase, the scale distortions in the photograph render it less and less acceptable as a substitute for a map. Photo. 2:1, which shows a rectangular grid superimposed on an air photograph of an area of considerable relief, clearly illustrates this relationship.

The cartographer's problem is therefore to devise means which will enable the inherent distortions that come from photographing an irregular surface onto a plane surface to be resolved sufficiently to meet the requirements of conventional mapping, and hence to allow details to be transferred from photographs to maps in correct linear relationship within the limits imposed by the chosen scale. If only single photographs are used, the transfer of detail from photographs to map must be confined to those features having approximately the same elevation and hence the same relative scale. However, if a sufficient number of identifiable points on the photographs are already plotted correctly to scale on a map, additional details can be transferred by simple graphical or optical projection techniques. This so-called single-image photogrammetry is widely used for the revision of topographical maps (Fig. 2:A).

The pictorial representation of the terrain recorded by a single photograph is similar to the view which is seen by the single eye peering through the camera view-finder, a series of two-dimensional images of three-dimensional objects. Common experience shows that any quantitative judgement of the third dimension requires the use of both eyes, and it follows that the same fundamental geometry will govern the use of vertical photographs in the determination of terrain elevations. In practice, the human eyebase is simulated at a greatly enlarged scale by each pair of successive camera exposures made along the line of flight of the photographic aircraft, the exposures being made at intervals calculated so that the terrain included in each photograph will overlap that depicted in its predecessor by approximately 60% (Photo. 2:5). To ensure that a given area to be photographed is covered completely by pairs of overlapping photographs, each successive strip is arranged to overlap the preceding strip by about 30%. Fig. 2:B illustrates this arrangement.

If any two overlapping photographs from a given strip are viewed through a stereoscope (Fig. 2:C) a three dimensional 'model' of the terrain within the overlapping portion of the photographs is seen, in which differences in elevation can be clearly distinguished (see the stereograms Photos. 3:2 to 3:5). This is certainly an advance over single-image photogrammetry, but to be of real use to the cartographer, ways must be found of achieving three aims: first, making the stereo-model susceptible of measurement, secondly, ensuring that it is in fact a true undistorted scale model of the terrain, and thirdly of establishing the scale relationship between the model and the ground in all three dimensions.

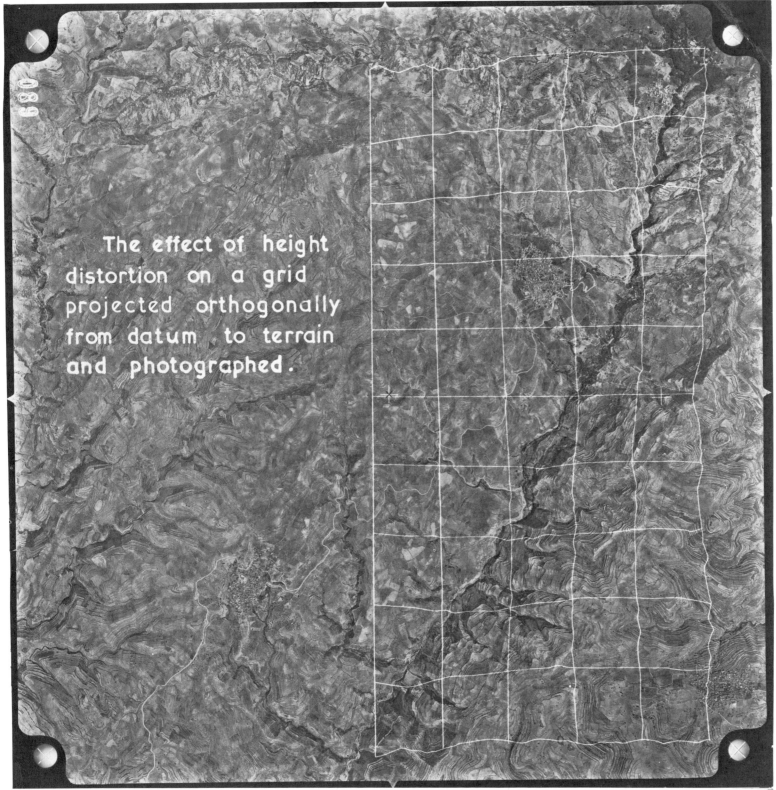

Photo. 2:1 The effect of height distortion

Attempts to find acceptable, economic and rigorous solutions to these problems have been exercising the minds and skills of surveyors, cartographers, mathematicians and instrument-makers for over half a century.

If the camera axis is truly vertical at the moment each exposure is made, the geometrical relationship which exists between objects on the ground and their images on a pair of overlapping photographs is a relatively simple one (see Fig. 2:D). Angles subtended at the nadir points of the camera axes by objects on the ground are identical to those which could be measured on the photographs between lines drawn from the photo-centres to the images of the same objects. There remains the problem of measuring the small quantities designated in the diagram as $pp' - qq'$, from which the elevation of ground objects can be calculated. For this purpose use can be made of a method of stereoscopic measurement discovered by Pulfrich at the turn of the century. The principle is quite simple. If, whilst viewing a pair of overlapping photographs through a stereoscope, we place two identical marks, one on each photograph, carefully located so that they coincide with the images of the same point on the ground detail, the marks will appear to fuse and to rest on the ground at the same depth as that of the point in question. If the marks are now brought closer together or moved further apart, the fused mark viewed through the stereoscope will appear to rise toward the observer or sink

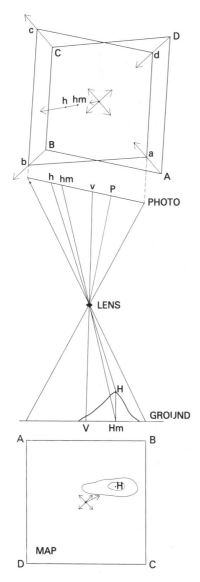

Fig. 2:A Single image photogrammetry.
When camera tilts are small, angles measured about the centre of the photograph to images of given points are equal to corresponding angles measured about the ground homologue of the photo centre to the ground homologue of the same points. This is the so-called 'angle-true' property of vertical photographs.

Fig. 2:B Flight lines of an aircraft on survey.

Fig. 2:C Schematic diagram of a stereoscope.

further away. By engraving the marks on transparent materials and arranging for their relative separation to be recorded by a suitable micrometer device we have a convenient means of measuring the small distance 'pp′ − qq″ (the difference in parallax).

The simplest form of this device is known as a parallax bar (Photo. 2:2) and by moving this over the photographs and altering the separation of the engraved marks, the fused images may be made to rest successively on the top and the base of a building. The difference in parallax measured by the micrometer may now be used in the solution of the height equation referred to in Fig. 2:D. The use of this so called 'floating' mark is now essential procedure with photogrammetric measuring instruments and quite apart from use for vertical measurements it provides an extremely sensitive and rapid method for the identification of point homologues from one photograph to another.

The ideal geometrical arrangement illustrated in Fig. 2:D is not easy to achieve in practice with sufficient precision for the simple methods outlined above to be universally applicable. In spite of many improvements in the design of cameras and mountings, a survey aircraft remains a relatively unstable photographic platform. The effect of small tilts and rotations of the platform and the residual optical and mechanical imperfections of the camera combine to distort the stereoscopic model as viewed through a simple stereoscope and hence to complicate the geometrical problem. Provided departures from the ideal arrangement

can be kept very small, their effects can, for some mapping purposes, be neglected entirely or else be allowed for by some slight complication of the transformation formulae and by a considerable increase in the amount of supplementary ground survey. Many adequate small- and medium-scale maps have been produced using such techniques. In general, all such maps are produced at scales equal to, or more usually smaller than, that of the aerial photographs.

For a cartographer to get the maximum benefit from the data recorded on air photographs a more rigorous reconstruction is necessary of the geometrical, or perspective, relationship which existed between photograph and ground at the moment of exposure. This requirement has been met by the development of air photograph plotting machines. The most significant developments in this field were made on the Continent. In Germany the Zeiss Bauersfeld Stereoplanigraph appeared as early as 1921, and other successful designs were produced by instrument makers in France, Italy and Switzerland. It is, however, unnecessary in this short chapter to describe in detail the various solutions of the perspective relationship problem, for although designs vary, the underlying principles are much the same. In general, a pair of overlapping near-vertical photographs are placed, one in each of two projectors which geometrically simulate the aerial camera. The projection may be made optically through lenses or mechanically by means of space rods simulating the rays of image-forming light in the aerial camera. Each projector can be rotated about three axes, and these rotations are controlled by means of screws according to a certain procedure until all rays from one projector intersect with their homologue rays from the other. This establishes the perspective conditions which existed when the photographs were taken, but without reference to the horizontal plane. The scale may be varied by moving the projectors closer together or further apart or by other means having an equivalent effect. The 'model' formed at the intersection of the rays can be examined stereoscopically and measured by use of Pulfrich measuring marks. After the stereoscopic model has been formed at a specified scale, the whole construction is rotated about

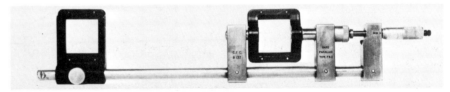

Photo. 2:2 The parallax bar

two common axes until the model is made to fit at least three points, the heights of which are known from ground survey and which have been previously plotted to scale on the map sheet. Detail may now be traced off.

Fig. 2 : E shows the working principles of the Multiplex plotter, one of the simplest in design. Images of the photographs are projected on to a small circular screen which has a measuring mark at its centre and a pencil-point directly underneath. The screen can be adjusted vertically to measure heights or moved about freehand to trace detail with the pencil. One photograph is projected with a red light and the other with a green, and the operator, who wears spectacles of complementary colours,

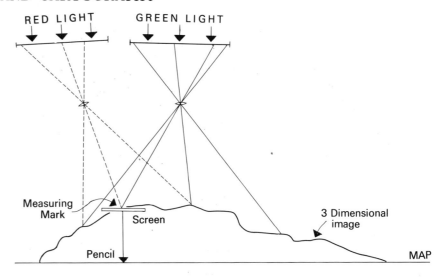

Fig. 2:E The working principles of the multiplex plotter.

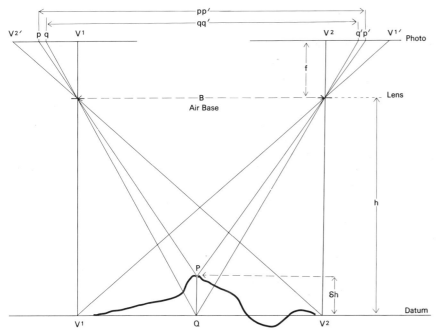

Fig. 2:D Measurement of parallax.

$pp' - qq' = \delta p =$ difference in parallax, and

$$\delta h = \frac{\delta p(h - \delta h)h}{fB}$$

when δh is small compared with h the formula may be simplified for practical purposes to

$$\delta h = \frac{\delta p \times \text{mean height of aircraft above ground}}{\text{mean of distances } V_2'V_1 \text{ and } V_2V_1' \quad \text{(measured on the photographs)}}$$

will then see one projection with his right eye and the other with his left. After the machine is correctly set, his eyes are presented with a stereoscopic model which he can scan directly with the measuring mark. Provided the measuring mark is kept in apparent contact with the ground, the detail is correctly traced off to scale and the heights can be read on a scale attached to the screen.

As already mentioned, in order to establish the scale and to relate the model to the horizontal plane, knowledge of the ground position and height of at least two points is necessary, together with the height of a third point well separated from the other two. However, once this relationship has been established, further projectors may theoretically be added without the need for more ground control, to extend the strip for an indefinite distance. In practice, owing to earth curvature and other factors, errors, particularly in height, accumulate as the 'bridging' proceeds, and further ground control becomes necessary in the middle and ends of long strips to enable discrepancies to be adjusted. Nevertheless, it will be appreciated that the amount of height control required by plotting machines is very much less than with simple methods in which only a parallax bar is used. Indeed, the plotting machine solution is straightforward, quick and very much more accurate. It is not uncommon to produce maps which meet all accepted accuracy requirements, at five to seven times the scale of the photographs in use, and with a contour

interval equal to 1/1500 of the flying height.

The better instruments cost between £7000–£25000 (at 1973 prices) according to their versatility and working accuracy. To justify the high capital cost of equipping a mapping organisation with sufficient machines to make the system viable, ways must be found to reduce costs in other directions. Two ways suggest themselves: first, to reduce the photographic scale and increase the enlargement ratio between the photography and the map, so cutting down the number of photographs used in any particular mapping project; and second, to devise a way to reduce the amount of expensive ground-survey needed to control the photographs without loss of accuracy.

As the scale of air photographs depends on the ratio of flying height to camera focal-length, and as there are obvious practical limits to possible increases of flying heights, pursuit of the first objective has led to the development of air survey cameras with shorter focal lengths and with a much greater angular field. At the same mapping accuracy the area covered by a modern super-wide-angle survey camera is twice as large as that covered by the wide-angle pictures which appear in this volume, at only four-fifths of the flying height.

To achieve the second objective, ways must be found which will obviate the need to relate each individual stereo-model to control points on the ground and will enable a cartographer to deal with strips or blocks of over-lapping photographs as single units, so that only these larger units need be directly fitted to points fixed by ground survey, which in the final analysis, control the scale and accuracy of all mapping work.

The processes for extending the effective range of ground control are variously described in the literature as 'bridging' or 'aerial triangulation'. The simplest form of control extension currently in use is the so-called 'slotted template assembly'. This system, developed in the U.S.A. during the Second World War, makes use of the angle-true property of lines radiating from the photo centre of vertical photographs, by drawing such lines through points of detail identifiable on surrounding photographs (see Fig. 2:A). The sets of radiating lines from each individual photograph centre are first traced on to separate squares of transparent plastic. The position of the photograph centre on each of these 'templates' is punched out and slots are cut radial to the centre along the directions to the various points chosen (see Photo. 2:3). Studs are now placed through the punched holes and slots, and the templates are fitted together in a flexible assembly allowing movement about the studs. If certain studs at points fixed by ground survey are attached to a plotting board in their correct geographical positions, the assembly will adjust

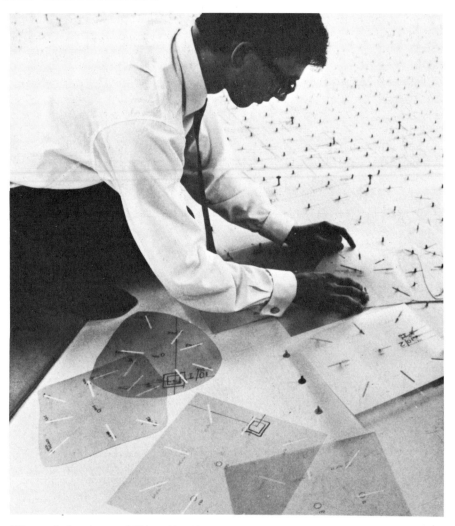

Photo. 2:3 Assembling slotted templates

itself to the scale so established. The positions of all the photograph centres and of all the points may now be transferred to the plotting board by inserting pins through the centres of the studs. The main application of this method is in mapping at small and medium scales or at scales smaller than that of the photographs. No heights are obtained and hence the method cannot be used as a basis for contour mapping.

In order fully to exploit the mapping potential of the plotting machines

40

previously described, control extension must include the provision of data in all three dimensions. In this field several lines of approach may be distinguished. First among these is the analogue method, already briefly described, where specially developed plotting machines are used to simulate the perspective geometry by optical and mechanical means: these need only a modest amount of mathematical manipulation in order to produce the required data. Such machines are, however, very expensive to manufacture (Photo. 2:4).

It has long been known that the process of control extension, which is concerned only with determining co-ordinates for points appearing in the stereomodels, could be performed by mathematical processes from measurements made directly on the photographs by a simple measuring co-ordinatograph. The calculations involved are lengthy and repetitive and this approach to the problem only became really possible with the advent of electronic computing facilities. This is now the most accurate of all photogrammetric processes capable of providing co-ordinates with a standard error of about six inches on the ground from 1/25 000 scale photography, and is gradually coming into more general use by the larger mapping agencies.

A third approach now commonly employed in many mapping agencies combines the use of normal plotting machines, to make co-ordinate measurements on pairs of photographs, with related computer programmes. The computer uses such measurements to join the models together into strips and blocks and subsequently to adjust the theoretical surface so generated to the actual ground surface defined by surveyed points.

The foregoing discussion has dealt mainly with the metrical qualities of air photographs and with the practical methods by which the cartographer can translate photographically recorded information about land surfaces into a conventional map which is familiar to all. Always the emphasis in development has been to extract and utilise even more of this information, a line of progress which still continues. The limit of data retrieval for cartographic purposes has by no means yet been reached, but sufficient progress has been made to show that the controlling factors are more likely to depend upon the limitations of cartography itself than upon the limitations of air photographs. Nevertheless, no amount of improvement in photogrammetric techniques will assist the cartographer to extract topographic information which is hidden from the aerial camera. Ground features below the tree canopy and details obscured by clouds or deep shadows are not recorded on the photographs, neither of course are the geographical names of features which are an essential

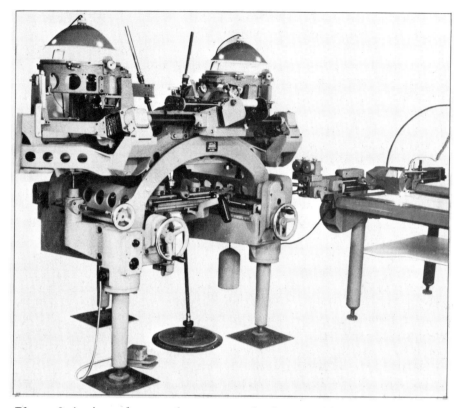

Photo. 2:4 A modern analogue-type plotting machine

element of topographical maps. All such detail must be collected and recorded by ground surveys which may, in some circumstances, cost more than the photogrammetric stages of map production.

In spite of these evident limitations aerial photography is universally used in the construction of topographical maps. To quote but one example: the Directorate of Overseas Surveys, which was set up in 1946 primarily to prepare the basic topographical mapping required for development planning and for the investigation of natural resources in the less developed countries of the Commonwealth, has mapped nearly two million square miles of territory at scales ranging from 1/2500 to 1/100 000 from aerial photographs. These maps which show contours, natural and man-made features and certain categories of vegetation are also used as the basis of a considerable number of specialist maps illustrating particular facets of land use and environmental factors in connection

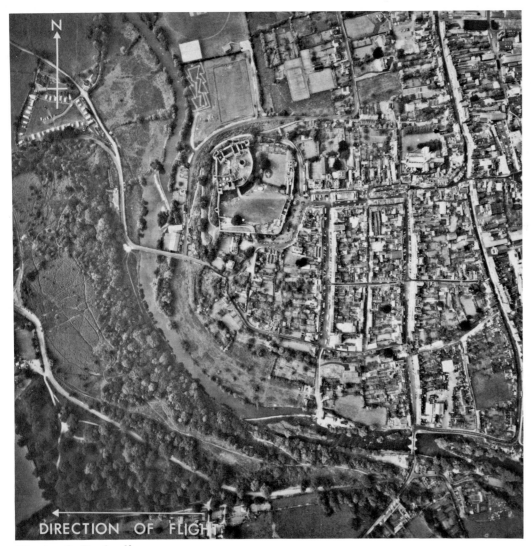

N

DIRECTION OF FLIGHT

Photo. 2:5 Ludlow

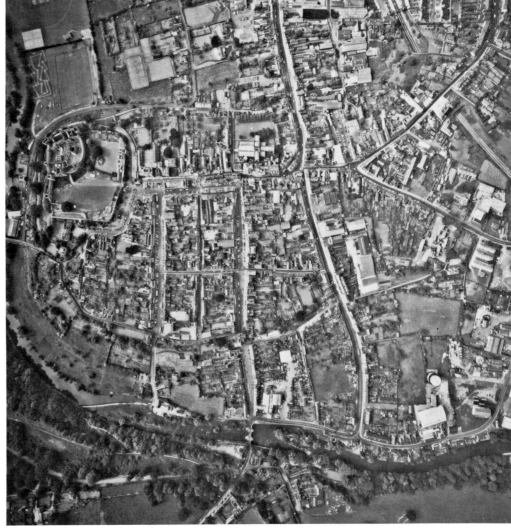

Photo. 2:5 Ludlow, Shropshire, (SO 512746) overlapping vertical photographs.

Successive exposures have been made at an interval calculated to give 60% overlap between them. Comparison of the appearance of any tall building in the two photographs shows very clearly the effect of parallax. When such photographs are arranged for viewing through a stereoscope, a three-dimensional 'model' may be seen, on which apparent heights are exaggerated, since the distance between the two exposures is greater than a normal eye-base. A 'parallax-bar' (Photo. 2:2 and p. 38) may be applied to the photographs to measure the difference in parallax, and from this measurement the heights of buildings or differences in ground levels may be calculated using the height equation (Fig. 2:D).

K17-P 268,269. Scale 1:7000 *28 June 1969*

with the work of the Land Resources Division of the Overseas Development Administration, and of the Overseas Division of the Road Research Laboratory and of the Institute of Geological Sciences.

As mapping, like development, is a continuing process it will be appreciated that some areas have been photographed more than once and will be photographed again in the future so that an historical record is being built up in the air-photo libraries of the principal map producing agencies which may well become valuable sources of geographical research material. This may seem an odd statement to make in a chapter dealing with the construction of maps which may be expected to have archival value in their own right. The explanation is very simple. Maps are invariably made to a pre-determined specification. The cartographer selects only those items from the photographs which a particular map specification requires him to record. To him all other information recorded by the camera is superfluous until such time as a new need or a new user is identified whose requirements can then be met by a re-appraisal of the photographs.

Typescript received December 1973

REFERENCES

American Society of Photogrammetry (1966) *Manual of Photogrammetry* Vols 1 & 2, 3rd edn Washington

Hallert, B. (1960) *Photogrammetry* London

Kilford, W. K. (1973) *Elementary Air Survey* 3rd edn London

Read, D. *et al.* (1973) 'Medium scale photogrammetric mapping at the Directorate of Overseas Surveys' *Photogrammetric Record* Vol. 7 No. 42

Wright, J. W. (1973) 'Air photographs for small expeditions' *Geographical Journal* Vol. 139 Pt 2

3 Air Photography and Geology

Lecturer in Geology in the University of Cambridge and Fellow of Churchill College

Nowadays any geologist will sooner or later find himself using air photographs, if only in quite elementary ways. If, for example, he is working in an area of poorly exposed rocks, he may use them as a means of finding outcrops. Again, in thinly populated areas, such as the Scottish Highlands, the published topographical maps may carry so little detail that he is obliged to take photographs into the field as a substitute.

The real importance of air photographs to geologists, however, lies in their use as primary sources of geological information. There are, of course, many important kinds of information which could never be obtained by this means. It is obvious, for example, that a personal visit is needed if anything is to be discovered about the fossils in a bed of sedimentary rock, or about the exact composition and detailed structures of a rock of any kind. Nevertheless, provided an area is not too thickly covered by superficial deposits or by vegetation, air photographs will generally reveal most large-scale geological features, enabling their exact location and extent to be established.

It is true that a field geologist with enough time to spare would eventually extract from an area all that air photographs could tell him and a good deal more. Time, however, is the important consideration. Air photographs may tell the geologist nothing about small features, but they may very rapidly provide him with all the information he needs about the larger features. Thus, an outline geological map can generally be produced only a few days after the photographs have been taken. The map will indeed be incomplete, for the exact age and nature of the rocks will usually be indeterminable and some parts of the area may be altogether concealed. Nevertheless, if prepared by a skilled interpreter it will be accurate within its own limitations.

Hence air photographs are now indispensable to all geological sur-

veyors, whether academic, commercial or in government service. Ideally they are used in conjunction with field-surveys, one source of information being used as a check upon the other. Sometimes, however, if time is pressing and the area difficult of access, a map based entirely on air photographs may be prepared and brought into use long before a ground-survey has been completed. There may not even be an actual map, for as a temporary measure it may be enough merely to show the information on a photographic mosaic.

Vertical cover with stereoscopic overlap is the photography most commonly used in geological surveying. Generally this is of much smaller scale than the photographs used for most other kinds of photographic interpretation: large-scale photographs will not only increase the cost of covering a given area but may actually obscure the existence of regional trends and features. Thus a scale of 1:20 000 is considered

Photo. 3:1 Pen-yr-Afr, North Pembrokeshire (SN 120486).
Low oblique views can sometimes provide far more geological information than vertical photographs. Most of the area is a level plateau with a thin but continuous cover of drift. A vertical air photograph could well give the impression that the underlying bedrock was of simple structure. Oblique views, however, reveal the steep coastal cliffs, which provide excellent sections showing that the rocks beneath the plateau are in fact intensely folded.

In country where most of the outcrops occur on very steep slopes, the use of oblique photographs may be the only feasible way of obtaining exact information about geological structures. A detailed examination of the cliffs of Pen-yr-Afr would certainly be very laborious and would probably require some mountaineering ability. The point is even more obvious where the outcrops occur on the slopes of high and inaccessible mountains.

GZ 7 *19 July 1951*

Photo. 3 : 1 Pen-yr-Afr

to be 'large', while scales of 1:50 000 or even less are not at all unusual. Oblique photographs are of limited value, as they cannot normally be viewed stereoscopically and may also include areas of 'dead ground'. There is, however, one purpose for which they alone can be used: the study of outcrops on very steep slopes (see Photo. 3:1). Black and white photographs are generally preferred for routine geological mapping, largely for reasons of expense. Colour photography, however, is known to be of value for some special purposes.

The interpretation of the photographs involves procedures similar in many ways to the collection of information on the ground, though of course far quicker. First, boundaries between outcrops of different kinds of rocks must be marked off, in so far as they can be distinguished. Next, if the outcrops are discontinuous, as a result of faulting, erosion or any other cause, some attempt must be made at correlation. That is to say, it must be decided which of the detached outcrops belong in reality to the same bodies of rock. In the field this would be done largely by the recognition of lithological details, with additional help from fossils in the case of many sedimentary rocks. Such methods are impossible with air photographs, but combinations of tone and texture on the photographic print will often serve the same purpose. A cover of vegetation may actually be an advantage, for a given rock type may support its own particular flora, which may have a characteristic appearance on the photographs.

All this may be done without any attempt on the part of the interpreter to name, or even describe, the rocks which he is studying. To do so, indeed, would often involve straining the evidence or even be impossible; but there are cases where a rock can be placed within some general category. For example, if an outcrop is easily eroded, carries pools of standing water and has given rise to mudflows or landslips, it must be composed of shale or clay. Again, country containing closed depressions, dry valleys and other signs of underground drainage, is almost certainly composed of limestone or dolomite (Photo. 3:2).

Once the pattern of outcrops has been established, structural features can then be examined. Faults may be immediately obvious: if exposed, they appear as displacements of outcrops; if concealed, their courses may still be deduced from topographical features such as scarps or valleys (Photo. 3:3). The directions in which sedimentary strata are inclined can easily be determined, and with a little trouble even the angle of the dip may be estimated with reasonable accuracy. In addition, the interpreter may be able to establish the patterns made by structures which are small but of regional importance, such as joints, cleavages and the lineations of metamorphic rocks (Photos. 3:2 and 3:4).

Thus within a very short time all the major structural features of an area (cf Photo. 3:5), and many minor ones, may be revealed. This is perhaps the most important of all geological applications of air photographs, for the collection of such information on the ground is a particularly long and laborious process.

Little has been said so far about the interpretation of topographical features, except as an aid to the identification of rock-types and the location of structures. In one branch of geology, however, it is of supreme importance. This is Quaternary geology, which deals with events during and since the last ice-age.

At the present day, different processes of erosion can be seen to produce different topographical forms (see Photos. 3:4 and 3:6), and the same is true of processes of deposition. This must have been so since the earth first became solid, but in general a form that owes its origin to one process is unlikely to survive for long before being modified or destroyed by another. Forms produced during the last million years may still, however, be partially or wholly preserved, and may bear witness to geological events for which no other evidence exists. Thus, when a glacier erodes a valley it produces certain topographical features which may still be recognisable

Photo. 3:2 The Burren, near Black Head, Co. Clare, Eire.
This is an area of flat-topped, steep-sided hills, separated by deep valleys. The beds of rock are nearly horizontal, the more resistant of them forming broad terraces on the hillsides.

The photographs illustrate two points particularly well. Firstly, many of the valleys lack streams. In an area of high rainfall this means that most of the drainage is underground, which in turn indicates that the rock is limestone. This is confirmed by the presence of several small closed depressions, the largest and deepest of which, elliptical in shape, is conspicuous even without a stereoscope. These are solution-hollows, among the most distinctive features of limestone areas. Secondly, all the areas of bare rock are scored with fine parallel lines running across the photograph (not to be confused with the numerous stone walls). As they run straight across country, disregarding the topography, they must be the outcrops of vertical planes, but since they do not disrupt the beds they cannot be faults. They are in fact joints: planes along which the rocks have broken but without much displacement. Joints are caused by regional stress, often, as in this case, too weak to cause folding or faulting, and may therefore provide valuable information about the dynamic history of an area. It is obviously important to measure their orientations, and this can often be done as easily from air photographs as on the ground, and in a much shorter time.

Vertical photographs supplied by Ambassador Irish Oil Co., Eire 62 / Run 2, print Nos. 9023-4. Scale 1:21 000 *14 April 1962*

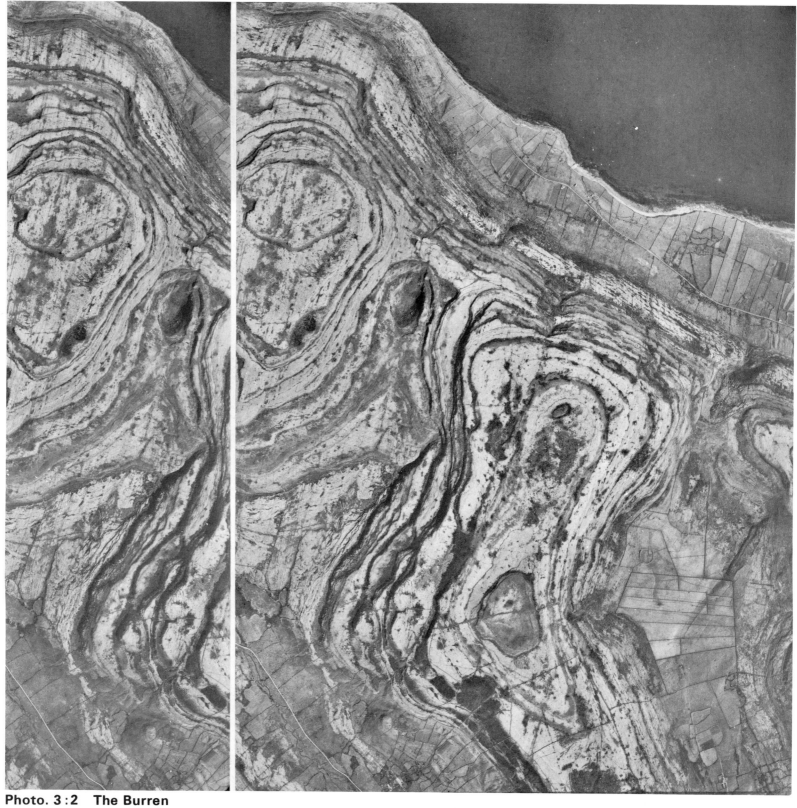

Photo. 3:2 The Burren

Photo. 3:3 Aden plateau

This area in South Arabia is a plateau cut out by a dendritic pattern of gorges, some deep and steep-sided. There is a little vegetation in the gorges but virtually none on the plateau itself. Apart from the gorges, the most obvious features on the photograph are the bands and patches of different shades of grey, the bands being arranged in parallel sets forming irregular closed loops. These mark crops following the contour-lines around small hills and the outcrops of different beds of rock. They are so well exposed and so distinctive in appearance that a fairly detailed geological map could be prepared from this photograph alone.

Even without a stereoscope it is easy to see that the beds throughout the area lie almost horizontally, the outcrops following the contour-lines around small hills and along the sides of valleys.

One other feature of structural interest is revealed by the drainage-pattern. For the most part this is irregular, but it can be seen that several small tributary valleys have disposed themselves along a single almost straight line, running down the photograph. This must be a line of weakness, and stereoscopic examination shows that it is in fact a fault, the rocks on the side nearer the left of the photograph having been shifted relatively downwards.

R.A.F. vertical photographs V 540/RAF/1751, print Nos. 0025–26. Scale 1:78000 26 November 1955

Photo. 3:3 Aden plateau

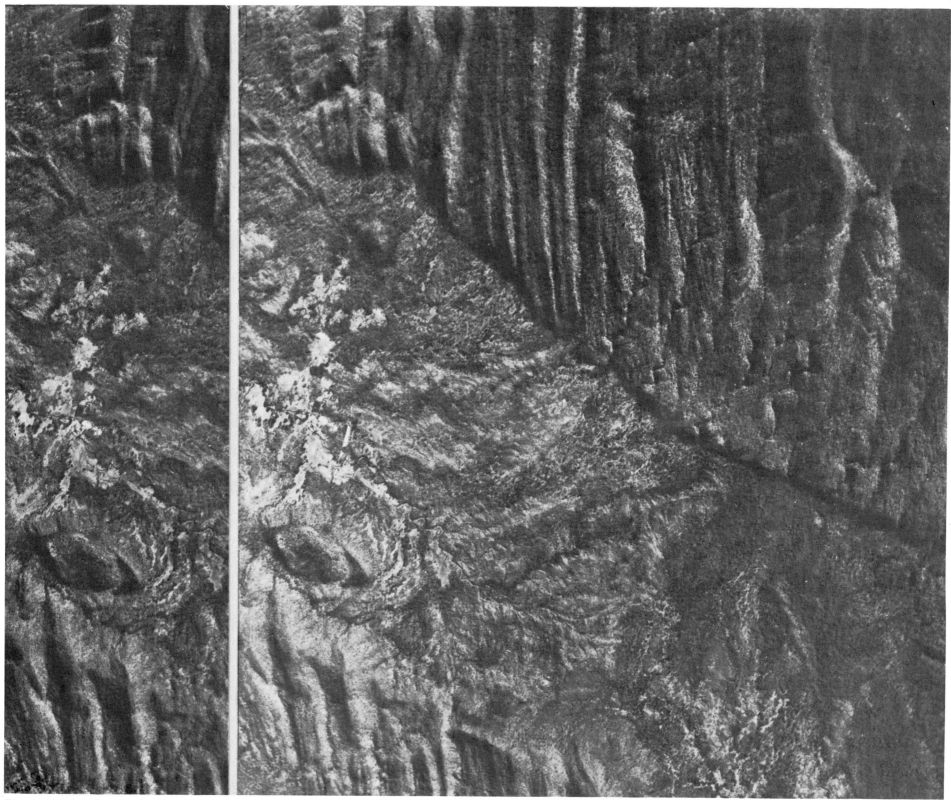

Photo. 3:4 Geological structures, Zambia *(see caption on p. 50)*

long after the glacier has melted. Similarly the cliff and wave-cut platform of a marine shore-line may survive even though the sea-level has sunk or the land risen, and the form of ancient sand-dunes in desert areas may denote prevailing winds different from those of the present time.

As with the 'solid' geology, all such features can of course be studied perfectly well without air photographs, and indeed the ideal procedure is always to carry out an orthodox topographical survey. Once again, however, the stereoscopic use of air photographs allows the investigation to be undertaken far more rapidly, if less accurately and perhaps with the loss of some detail. The method is particularly simple when a plan of the feature is all that is needed, but by the use of photogrammetric techniques

contour-lines may generally be added if necessary.

It is also worth mentioning that many features of geomorphological interest are defined by such small changes of level and slope that an observer on the ground might be unaware of their very existence. Air photographs, however, when viewed stereoscopically, enable the ground to be seen in greatly exaggerated relief. Hence, their use may lead to the discovery of subdued geomorphological features the existence of which had never been suspected, even in areas which are perfectly easy of access.

Typescript received 1972

Photo. 3:4 Zambia, 40 miles south-east of Mazabuka.

A broad flat-bottomed valley bounded on one side (top) by a plateau, on the other by a narrow range of hills. Most of the area is thickly wooded and little bare rock is visible, but it is still possible to reach certain conclusions about the geology.

The resemblance between the 'textures' of the two upland areas, with their strong corrugations, suggests that both are carved out of the same series of rocks. With a stereoscope it can be seen that the corrugations are the upturned edges of a series of alternating hard and soft strata. Except in the right-hand half of the plateau, dips are very steep as can be deduced, even without a stereoscope, from the straight courses of the corrugations.

The wide central valley can hardly be a simple erosional feature, as it cuts right across the structures of the upland areas. In fact, the long escarpment which forms its upper margin is so straight and steep that it could only be a fault-scarp, and it may be suspected that the opposite escarpment is of a similar origin. This, then, appears to be a rift-valley, formed by the lowering of a strip of the earth's crust, some two miles wide, between two great parallel fractures.

Outcrops of tilted strata are also faintly visible at a few places on the floor of the valley (adjacent prints show them more clearly). Here, however, they not only form less prominent features than those of the uplands but also run in different directions. These rocks must therefore belong to some quite different series, presumably younger than the 'plateau rocks' and underlain by them at depth. The probability is that they formerly covered the whole area, but have been removed by erosion except where preserved by down-faulting.

R.A.F. vertical photographs 83E/382/3, print Nos. 5071–2.
Scale 1: 34 000 *June 1951*

Photo. 3:5 Kenya, 100 miles north-north-east of Nanyuki.

This is a gently undulating area with a few broad and shallow stream-beds, most of them dry. Trees grow fairly thickly in some of the stream-beds but are elsewhere very scattered.

Throughout most of the area the ground is marked with fine parallel lines, and stereoscopic inspection shows that these are narrow ridges, made conspicuous by their shadows. They are the outcrops of the more resistant beds of rock, and from their disposition much can be learned about the structure of the area. Firstly, they can be seen to continue across valleys without the slightest deviation. This means that the beds themselves must be standing nearly vertical. Secondly, though not deflected by topographical features, they do nevertheless describe great sweeping curves. In other words, the beds have not only been tipped-up vertically but have also been folded. All this must have happened in the very remote past, as the whole area has since been almost flattened by erosion.

The most conspicuous of all the features on the photographs, however, are the irregular dark patches. These are volcanic cones with their associated lava-flows.
R.A.F. vertical photographs 15 KE/30 print Nos. 028–9.
Scale 1: 38 850. *30 February 1956*

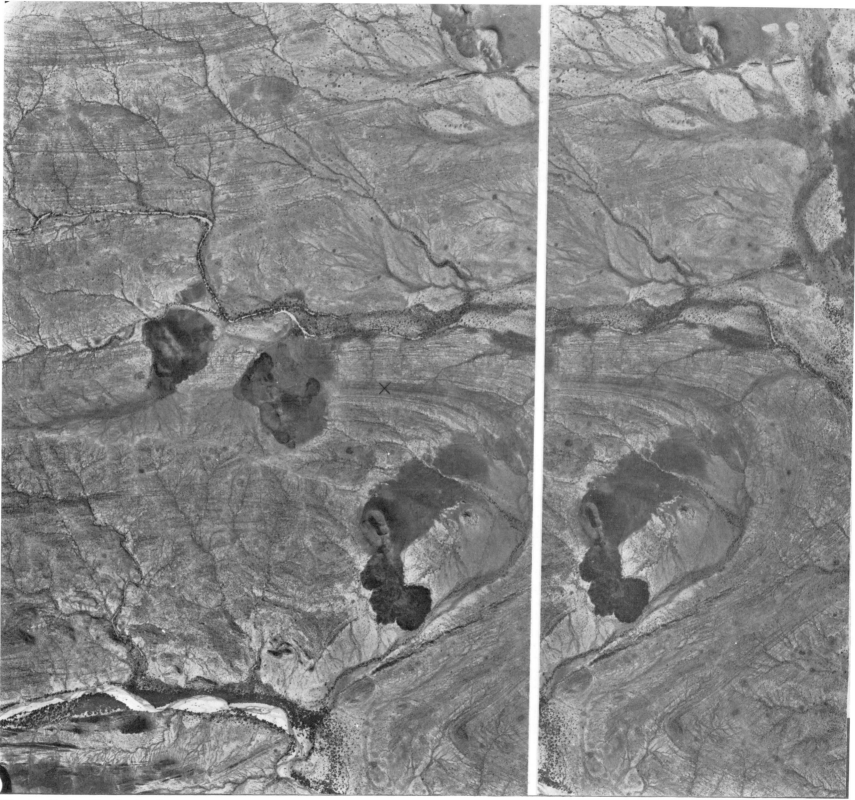

Photo. 3:5 Geological structures, Kenya

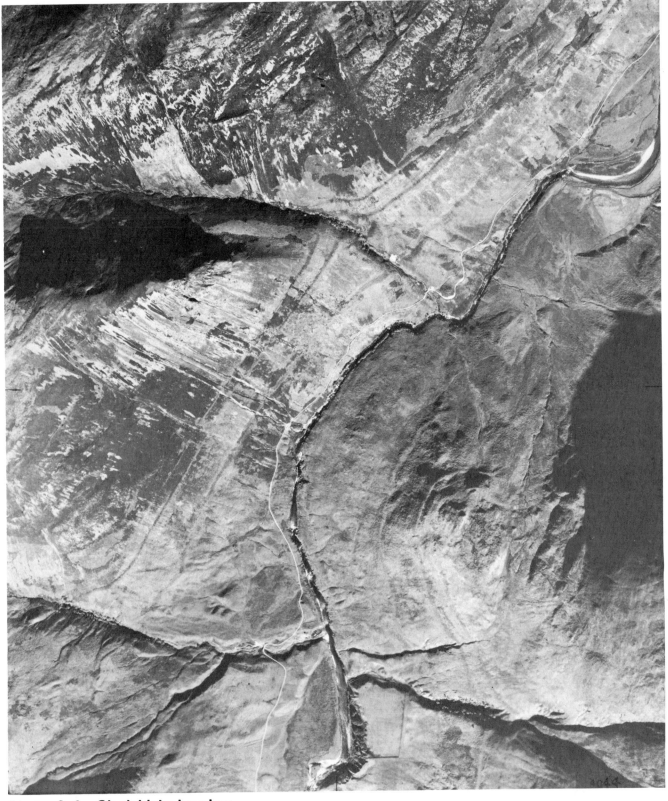

Photo. 3:6. Glen Roy, Inverness-shire (NN 303887)

The main valley shown on the photograph is Glen Roy, which is flanked on either side by mountains of the Grampian Highlands. Most of the area is covered with peat and drift deposits, and there is a good deal of low vegetation. For this reason the photograph provides little information about the solid rocks, except that they must be hard enough to stand up as steep slopes. They are in fact metamorphic rocks of Pre-Cambrian age, intensely disturbed by earth-movements.

The outstanding interest of the photograph lies in the series of three parallel lines visible on both sides of the valley, those on the left-hand side being especially continuous and distinct. These are the so-called 'parallel roads' of Glen Roy, each of which is in reality a narrow ledge, horizontal throughout its length. Long ago these were recognised as ancient shore-lines, representing successive levels of an ice-dammed lake which at one time filled the valley and its tributaries; eventually, evidence was found to show that the lake owed its existence to a shrinking glacier which once occupied the lower parts of the valley. A set of photographs covering the whole area would enable a map of the complete system to be made, while photogrammetry would demonstrate the horizontality of the 'roads' and give an estimate of their altitudes. In this way a geologist, without ever having visited Glen Roy, would be in a position not only to deduce the former existence of the lake but also to state its levels and extent at different stages.

R.A.F. vertical photograph CPE/SCOT. UK 177, print No. 3253. Scale 1:11000 *7 October 1947*

Photo. 3:6 Glacial lake beaches

4 Air Photography and Geography

P. F. DALE

Directorate of Overseas Surveys

The need to collect information, to measure and to interpret is fundamental to all social and physical sciences. Geographers studying distributions of phenomena have in the past relied upon the topographic map as a secondary source for much of their information. A map, however, is an abstract of reality in which a cartographer has represented the real world in simplified form by making both a careful selection of what is to be shown, and by the use of conventional symbols. An air photograph is a much more complete representation of reality, showing detail in a less familiar form, and thus demands a higher degree of skill in interpretation.

The study of air photographs may be divided into the two general headings of photo-interpretation and photogrammetry. Photo-interpretation involves the identification of features on the ground and the recognition of the spatial relationships between them. Photogrammetry is concerned with measurement of size, of shape and position: the special techniques involved are now used extensively in the making of topographic maps and are considered in Chapter 2. In general, photogrammetry makes use of stereoscopic pairs of vertical photographs to give a precision that depends upon the scale of the photographs, upon the accuracy of ground control, and upon the limitations of the cameras, film and measuring equipment. The techniques of photogrammetry may also be applied to oblique photographs: for example, a survey of the face of Edinburgh Rock was carried out by using photographs taken with an air survey camera mounted in front of the rock face. The resultant drawing depicted a vertical surface, having irregularities of the rock face delineated by 'contours'. The technique is applicable to buildings or to any vertical or steep surface such as a glacial moraine or scree-covered slope.

In photo-interpretation, use is made of both vertical and oblique air photographs. An oblique view of the ground is more easily understood than the vertical perspective, although the latter is of the greater value in studies of spatial patterns. Detailed interpretation of the terrain from vertical air photographs is a skill acquired only with practice for although the appearance of any object depends principally upon its nature, size, shape, colour, texture and illumination, it is also determined by the sensitivity of photograpic film to light within the visible and near infra-red parts of the spectrum, by processes of developing and printing, by the characteristics of the camera and lens system, and by the height of the aircraft. The technique of interpretation is one both of induction and deduction in which an interpreter seeks clues provided both by the object itself and by its setting: for example, the pattern of vegetation discernible on an air photograph may reveal significant distributions of soil that in turn provide a clue to differences in the underlying rocks.

The scale of photographs is the most important consideration in photogrammetry and photo-interpretation; the smaller the scale, the greater the area of ground covered by a photograph of given size, but the greater the difficulty in resolving points of detail. The amount of information recorded on an air photograph is so great that in comparison with the cost of collecting information by other means, the expense of air photography is relatively low. Photographic cover at suitable scales is relatively easy to acquire, though special sorties may involve extra expense if, for example, photographs of an area of tidal marsh are required at a specific state of the tide. In general, however, photographs of almost the whole of Britain and of many other countries, are already available and prints purchased from such official organisations as the Air Photographs Library at the Ministry of Housing and Local Government (for Britain), or from commercial firms, are relatively inexpensive.

The applications of air photography are as many and diverse as the

fields of geographical research. A three-dimensional representation of the ground such as is afforded by a stereoscopic pair of photographs cannot be provided by a conventional map. As a basis for the study of land-forms, air photography is extensively used by those interested in the geology and geomorphology of the earth's surface. Analysis of stereoscopic pairs of photographs may reveal details of the structural geology as well as many of the rock types present, besides serving to delineate basic physiographic units and to evaluate natural resources. For sedimentary rocks, the extent of bedding may be clearly seen (Photo. 3:2). Differential erosion between beds gives a distinctive banded appearance to the terrain which may be apparent either on exposed rock surfaces or in patterns of vegetation.

When viewing a pair of vertical photographs, an apparent exaggeration in the heights of objects seen in the three-dimensional picture of the ground is commonly noticed, an effect that helps the interpreter to distinguish horizontal beds from tilted or folded strata. This apparent exaggeration in the height is a result of the manner in which stereoscopic pairs of photographs are commonly viewed; in a strict geometrical sense, the distance flown by an aircraft between successive photographic exposures should be in the same proportion to the flying height as the effective width between the eyes of the viewer is to the distance from which the photographs are viewed. Normal stereoscopes seldom reproduce the correct 'eye-base'/viewing-height ratio, as determined by flying conditions, and there is then an illusion that the vertical scale is greater than the horizontal. Fortunately this illusion does not affect the accuracy of photogrammetric measurements and is often an advantage in interpretation.

Much of the basic information required by a geographer can only be obtained from observations on the ground, but an air photograph can both supplement this information and accelerate its collection. When studying geology, certain rock types are found to have clearly defined characteristics by which they may be identified; the appearance of solution holes on an air photograph would, for instance, suggest limestone as the underlying rock (Photo. 4:1). The distinction between sedimentary and metamorphic rocks is not, however, always clear although unconsolidated sedimentary rocks can usually be detected from their characteristic land-forms since alluvial fans, river terraces, eskers, sand-dunes and similar surface deposits are generally easy to identify. Igneous rocks also commonly give rise to easily identified characteristic features and are thus more readily recognised than metamorphic rocks which pose the most difficult problems of all in such geological interpretation. Evidence of

faulting or jointing may be seen on air photographs as distinctive linear features revealed by clearly defined depressions in the ground, by changes in the drainage-pattern or by variations in colour, tone or vegetation (Photo. 3:3). Clues to the identification of rock types are provided not only by land-forms but also by the shape and character of outcrops and the relationships between them, as well as by evidence of relative rates of erosion. Quantitative measurements of the size of boulders and of relative depths of weathering may be added by photogrammetric methods subject always to the availability of adequate ground control. Analysis of land-forms and their development may require contoured maps at a large scale, and once again photogrammetry is the best means of obtaining a large number of accurate measurements over a wide area with a speed and ease incomparably greater than would be possible by ground surveying alone.

With the exception of land-forms, the surface drainage pattern is probably the most consistent and reliable indicator of geological structure. The relationship between drainage and structure is complex and depends upon such factors as the character and position of underlying rocks, upon surface slopes and their cover of vegetation, and upon the types of soil. Drainage networks are described by such terms as lattice, dendritic, trellis, radial or annular, and each of these types has a distinctive appearance on a photograph (Photo. 4:2). An air photograph can reveal details of drainage networks and small variations in the surface far exceeding those commonly shown on a conventional map because a cartographer is constrained both by the need to smooth out the alignment of stream channels when fair-drawing the map and by the need to restrict the

Photo. 4:1 Part of Tolpuddle Heath, Dorset (centre of plate at SY 787921).

The southern third of the photograph includes a valley floor from which the land rises steeply as a scarp ending at the crest of the ridge, marked by the broad white line of a fire-break in the forest. The dip slope then runs away to the north (top). In the east half of the photograph, the plantations are all coniferous, whilst on the west there are mature deciduous trees around an old country estate which includes a walled garden. On the dip slope there are solution hollows seen either in the open fields, or as circular breaks in the tree cover. Stereoscopic analysis of the open field in the upper centre of the photograph shows that a number of the dark patches in the soil coincide with small depressions in the ground. Comparison of this photograph with the first edition Ordnance Survey map shows that at least one of the major hollows did not appear to exist at the turn of the century.
Vertical photograph RC8-X 12. Scale 1:6300 *3 May 1971*

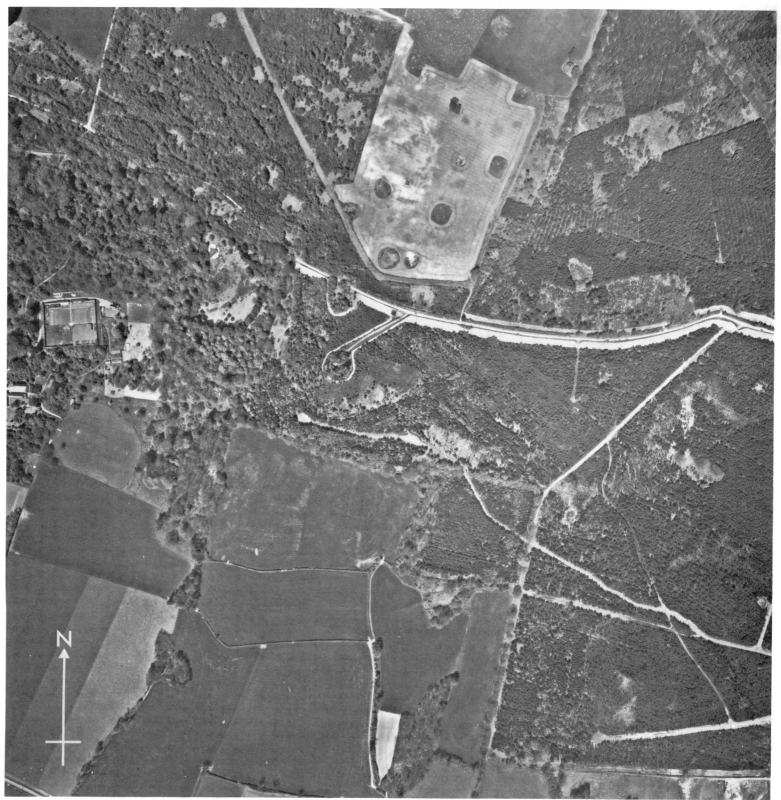

Photo. 4:1　Tolpuddle Heath

amount of hydrological information to an acceptable visual level. The main constraints on a photographic interpreter are imposed by the scale of the photographs and the sensitivity of the film since different photographic emulsions are sensitive to different parts of the spectrum. In a study of the Dyfi Estuary, the drainage network within the tidal marsh was photographed on five different types of film which showed that of the total length of stream channels determined by combining all the information, only 60% appeared on panchromatic films, while 80% was revealed by colour and infra-red films. Both figures are, however, much greater than would be derived from measurements on a conventional topographic map. The constraints of scale are also much less severe on a photograph which may be enlarged or viewed through a magnifier, revealing greater detail especially in the form, orientation and angularity of stream-channels and allowing angles of stream junctions, stream-sinuosity and the depth of dry channels and gullies to be measured. In a study of the marshes at Scolt Head on the Norfolk coast, there was an apparent watershed between two branches of the drainage network. On the ground the whole area appeared flat, but photogrammetric measurements proved that there was a ridge 0·5 metres high between the branches.

The facility with which features can be identified and accurately measured makes the air photograph an essential tool in the study of the varied stages of a drainage network from 'first order' streams through meander flood-plains down to tidal marshes and deltas. In studies of shore-lines and beach-profiles where there may be rapid changes of form, series of air photographs repeated at regular intervals will give detailed information about such changing processes. When changes are suspected in sectors of coast-line that have been photographed but not mapped in detail, the earlier form may be recovered, whereas ground survey offers no possibility of returning to the past to gather measurements omitted at an earlier date. Similarly, the geographer studying the initial stages of stream development may wish to map rills, gulley-flows and small streams. These often have steep and irregular gradients, and the complexity of their form creates problems in mapping which can only be solved by air photography. In Japan, photo-interpretation studies of land-forms and drainage densities have been made as part of a programme for flood prevention and control. Stream widths can be measured and the velocity and course of surface currents may be calculated from time-lapse photographs of floating markers. From photographs of the Everglades, Florida, not only could quantities of water and rates of flow be measured, but also boundaries between fresh and salt water, and ecological changes caused by flooding and drought. Air photographs have also assisted the location

of supplies of fresh ground-water leading to the selection of suitable sites for boreholes.

The efficiency of such studies may be improved by employing other forms of 'remote sensing' than conventional photography, depending for its results upon the visible and near infra-red parts of the spectrum. One such technique, known as infra-red linescan, involves the use of either the middle or far infra-red wavelengths. With such equipment, the average emission of heat from the surface is sensed by a device which scans successive narrow strips of ground as the aircraft flies along. The results are presented on film as pictures showing the thermal patterns of the surface. Although these patterns vary diurnally, nevertheless differences in heat emissions may readily be determined, revealing, for example, the discharge of waste or coolant water from a factory or power-station. The size of the area scanned at any moment depends both upon the height of the aircraft and the distance of any particular point from the flight line. The system has at present various technical and interpretative limitations, but nevertheless it notably extends the range of phenomena which can be monitored from the air. Thus, infra-red linescan has already been used to detect aspects of pollution, to assist the identification of geological structures and of rocks, to reveal moisture patterns in soils, to distinguish types of land use, to locate human beings and animals, and to differentiate between moving and stationary vehicles.

Further information about the environment may be gathered by use of radar. In conventional photography, sunlight is reflected by the ground and recorded on the photographic film. Thermal sensing depends upon the detection of heat emitted from the surface. In radar surveys, signals transmitted from an aircraft and reflected by objects on the ground are recorded by appropriate apparatus so that a picture of the terrain can be obtained by scanning the ground on either side of the flight line of

Photo. 4:2 Salt marshes at Burnham Overy, north Norfolk coast (centre at TF 843449).

The intricacy of the drainage network is clearly apparent. Precise photogrammetric measurements can be taken of the stream sinuosities, stream widths and junction angles and of variations in level across the marsh. The size, shape, orientation and distribution of the salt pans can also be measured. Note the linearity of these features in the south west corner of the photograph, as also the variations in the vegetation throughout the area, especially along the edges of the main water courses. Study of changes in this marsh will be greatly facilitated by comparison between this photograph and one taken at some future date.

Vertical photograph RC8-B 69. Scale 1 : 5400 *3 August 1967*

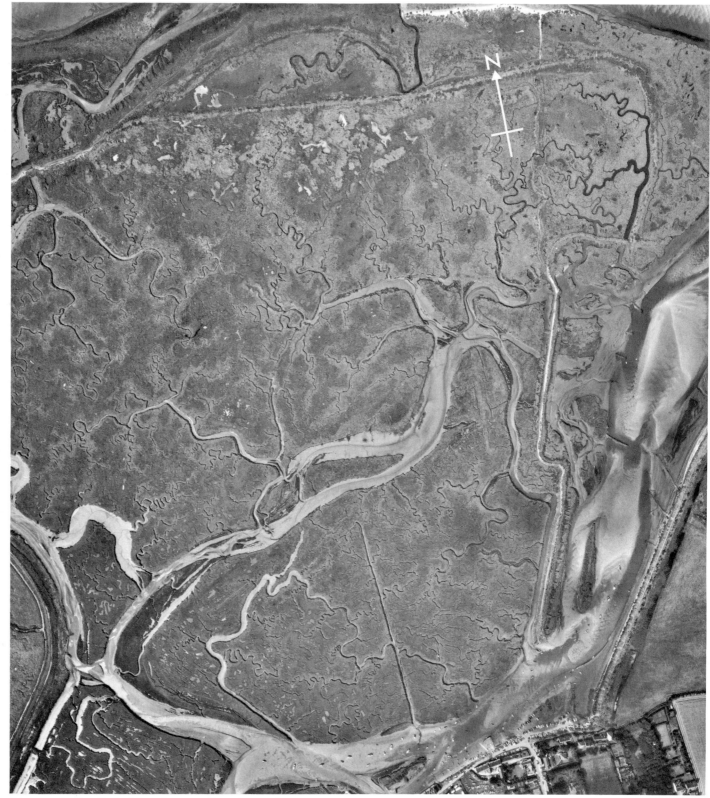

Photo. 4:2 Salt Marshes at Burnham Overy

the aircraft. The method is known as Sideways Looking Airborne Radar (SLAR), since the scanning of the immediate flight line is precluded for technical reasons. Radar, which can penetrate clouds, has been used for survey work in areas such as the Darien Province of Panama where persistent cloud cover makes conventional photography impractical. This method of sensing has been used to map surface drainage and topography, to distinguish basic vegetation patterns, and to assist engineering surveys. Elsewhere SLAR has proved of value in such diverse subjects as the census of traffic, the tracking of locusts, studies of the formation of ice packs, and even for distinguishing principal types of vegetation.

An aircraft is no longer the only vehicle capable of carrying 'remote sensors' of the environment since artificial earth satellites now monitor many of the earth's natural resources and provide observations of specific areas at regular intervals of time, recording information within the visible and near infra-red wave-band. Earth satellites have already brought a new dimension to meteorology and climatology by the rapid provision of information on weather conditions all over the world by tracking both small and large scale atmospheric movements in a manner never before possible (Photo. 4:5). Extravagant claims have been made for the advantage of satellites in collecting information but whether the information to be obtained about other aspects of the environment will prove so valuable in economic terms is still an open question. The problem of maintaining orbits which provide complete photographic cover of specified areas, the loss of information by cloud obscuring the field of view or by limitations in the resolving power of the camera lens, and the difficulties in retrieving any records that are obtained have much more simple solutions with conventional airborne systems, but whether these claims can be fully realised remains to be seen.

Conventional air photography has greatest relevance to research in geography, which most commonly calls for photographs at scales between 1:5000 and 1:50000 and although points of detail can only be resolved at suitably large scales, there are many applications for photography at much smaller scales. The overall view presented on such photographs can reveal processes which are less apparent when viewed at close range; for example where tectonic forces have played an important role in the formation of landscape, the resulting land-forms are often distinctive (Photo. 3:4). There are instances where the effects of massive landslides have so modified a landscape that the extent of tectonic movements was not realised until small-scale photographs of the area were examined. In Alaska, photographs taken after a series of earthquakes revealed the extent of uplifting of shore-lines where land-slides had overridden old beaches.

In similar fashion, photographs can give a rapid and accurate picture of the extent of devastation following a hurricane.

Detailed analysis of many atmospheric phenomena gains more from the use of cameras mounted in an aircraft, or a balloon or even on a simple tripod than from those in an earth satellite. For instance, meteorologists have measured the form and size of clouds using photographs taken from two stations on the ground at a known distance apart. Photographs taken at intervals provide information about the rates at which clouds form and in studies of atmospheric pollution: photogrammetry has been used to analyse the speed of diffusion and dispersion of smoke from chimney-stacks.

Changes that are a result of present or past volcanic activity lend themselves particularly well to study by air photography since igneous rocks consolidated as dykes or cones have a distinctive appearance, in general easy to recognise, even when greatly modified by erosion. Air photography has also assisted the study of desert land-forms, making available a wealth of detail which would be impossible to amass on the ground. Photographs taken at intervals have been used to measure the structure of sand-dunes and their rate of movement and to follow the progress of encroachment of a desert upon previously fertile areas.

Glaciers are amongst the most difficult of objects to survey and map, and here air photography has much to offer, though there are considerable problems in obtaining photographs under the right conditions of lighting (Photo. 4:3). Not only does the method provide a means of recording all visible features, but comparison of photographs taken at intervals should reveal the extent of surface movement on each part of

Photo. 4:3 Skeldal, Greenland. 72° 45′ N, 24° 25′ W; looking south-east.

Mountainous terrain with retreating glaciers. The light-toned rock towards the foot of the slope across the middle of the photograph is evidence of the retreat of the glaciers To left of centre, morainic material from fluvio-glacial deposits dams a pro-glacial lake (white). In the left foreground the irregular surface with small lakes indicates an area of melting stagnant ice and kettle-holes. In the right middle distance the black medial moraine is formed from the lateral moraines of two confluent glaciers. In the mountains beyond snow lies on north-facing slopes. Elsewhere in the middle distance are valleys from which glaciers have completely disappeared.

Photograph 653 G-Ø No. 12309. Reproduced by permission (A.23/76) of the Geodetic Institute, Denmark *19 August 1950*

Photo. 4:3 Skeldal, Greenland

the glacier. Lines of stress within the ice can be observed, and if coherent light (e.g. a laser beam) is passed through a transparency prepared from a vertical photograph, diffraction patterns will be seen. Suppression of a part of these patterns by use of suitable filters enables the photographs to be reconstituted to show systems of surface crevasses impossible to discern on the original photographs because of the maze of detail. In areas where detailed maps of the ground surface already exist, photo-grammetric surveys in winter provide information about the depth and volume of snow, essential to the study and possible prevention of avalanches.

Applications of air photography to detailed identification of soil types and to delimitation of soil boundaries are discussed in Chapter 5. Knowledge of the inter-relationships between different phenomena is vital in pedological studies: for example, one investigation showed that the colour of cotton leaves gave an indication of the salinity of the soil. Boundaries between soil types are relatively straightforward to recognise on photographs but the identification of soils is much more difficult. Random or systematic sampling of soil conditions by a ground party should be undertaken to establish the general characteristics of an area and this information then used as a standard for comparison with other areas. The same approach can be adopted in land evaluation and land-use studies, leading to a reasonable degree of accuracy, provided that adequate checks are maintained. Given some general knowledge of the character of a particular area, an interpreter who also has opportunity to examine samples of the terrain both on the ground and on air photographs can achieve a more accurate assessment of information concerning soils, vegetation or land-use than by ground or by photogrammetric surveys alone.

In land evaluation studies, identification of soil conditions is of prime concern and work of this nature is proving most valuable in under-developed countries where the struggle to win land for agriculture from bush-covered waste has too often resulted in loss of fertile soil. The patterns and extent of shifting agriculture or the degree of termite infestation are but two examples of the detailed information to be obtained from air photographs of such terrain. Soil erosion may be detected and its causes identified with a view to remedial action, suitable areas for agricultural or urban development may be chosen. Air photographs may also be used as a basis for land-title surveys, for although property boundaries are not always visible from the air, land owners may be encouraged to plant hedgerows, or to mark the corners of their properties with posts large enough to be recognisable on photographs. When this is not possible,

observations on the ground of significant points will enable these to be identified on photographs and subsequently measured so that they provide fixed points for both a photogrammetrist and surveyor on the ground. Cadastral surveying by such means has been used to rationalise frag-mented land-holdings, and to consolidate and regroup holdings into more economic units.

In planning and development, one of the first requirements is an appreciation of available resources. All projects involving the use of land are concerned with a balance of interests and must therefore start from knowledge of existing land-use. In much of western Europe there are well-established field-patterns having some degree of permanence, and virtually all parts of the land are readily accessible so that the problems of collecting information for mapping land-use are essentially those of speed and economy. In underdeveloped countries, however, the problems are very different as access is difficult, suitable base maps may be lacking, and field patterns may vary from season to season. Before the advent of air photography, only very limited areas could be recorded in detail but given photographs at a suitable scale and a minimum of information obtained from observations on the ground, land-use maps may now be compiled more quickly and at less cost than by ground survey alone. In just such a survey of Malawi, three basic categories of land were identified – cultivated, uncultivated and uncultivable. Each category was divided into sub-groups with cultivated areas classified either as dry land cultivation, as flood plain cultivation, as areas where a high water-table meant freedom from total dependence upon variable rainfall, or as estates and plantations. Each of these sub-groups had a distinctive appearance on air photographs. The uncultivated areas were described as recently cultivated, seasonally waterlogged, or as areas of poor soil, while those which were uncultivable were classified according to whether they were excessively steep or rugged, or suffering severe soil

Photo. 4:4 Fenland near Ramsey, Huntingdonshire (TL 288851), showing the old town and the adjoining fenland.
The top of the photograph is to the north-east. Former water-courses which flowed before the drainage of the Fens into a long abandoned channel of the River Nene are clearly visible. The ground lying north-east of Ramsey was formerly an 'island', standing slightly higher than the surrounding peat fens. The pattern of small hedged fields on this island is in marked contrast to that of the peat fens, where large rectangular fields owe their origin to seventeenth century, and later, drainage.
Vertical photograph RC8-H 161. Scale 1:23600　　　　　*3 August 1969*

Photo. 4:4 Fenland, near Ramsey

erosion, or whether the areas were under water or built upon. To some extent these categories of land-use had to be modified to take account of problems of photo-interpretation but, in general, where ground checks can readily be carried out, such classifications may be more complex. Inevitably, confusion may arise in the identification of farm crops or of vegetation in its natural state, but ground reconnaissance is not free of such problems, and no land-use survey is likely to be completely accurate. Air photographs provide information not only on crop types and cropping practices, but also on soil fertility, whilst photographs taken at an optimum time of the year have been used to assess crop yields and those taken in successive seasons to show changes in land-use, new land being reclaimed, old land despoiled or hedgerows being cleared.

Over 90% of the images that appear on an average air photograph are expressions of vegetation. For accuracy in mapping vegetation, fieldwork combined with photo-interpretation is essential and once the main plant groups have been identified on photographs at a suitable scale, their relative distribution may be plotted. As a first phase, the compilation of vegetation maps can sometimes be carried out largely from air photographs, even though plants of the same species may differ more in colour and tone than plants of differing species. Colour and tone are but two variables to be considered before the distribution of any species can be fully identified.

Different photographic films portray different types of information; the objectives of any given survey will determine which films are best used, whether panchromatic, colour or infra-red. The optimum solution is obtained with multi-spectral photography, that is the use of a device (whether involving one camera or more) arranged to expose at the same moment several different films, each sensitive to a different part of the spectrum. Where such an elaborate system is not available, opinion is divided as to the most appropriate film, though for general geographical interpretation the use of colour seems desirable. For studies of water resources and ecology, the best results appear to be achieved using infra-red 'false colour', but the increased cost and unfamiliar appearance of the terrain militate against the use of this film for interpretation of other geographical phenomena. In California, a survey using panchromatic film of over one hundred square kilometres of 'wild land' showed that over 80% of significant soil boundaries corresponded with vegetation boundaries and that delimitation of such boundaries depends as much upon the topography, drainage, field patterns, settlement areas or road networks, as upon colour.

The applications of air photography within an urban environment are as extensive as those already described for rural areas. In socio-economic studies, they include land-use surveys involving the mapping, for example, of derelict land or of the quality of residential housing. As to buildings, maps do not ordinarily portray more than the floor space, whereas the three-dimensional view afforded by a stereo-pair of photographs distinguishes between tall and low buildings, or between single-family or multiple-family residences which in turn can give a broad indication of population densities. In a comparison between ground and air survey methods for assessing housing densities in Birmingham, Alabama, the two sets of statistical data collected from seventeen sub-areas had an extremely high level of agreement. In comparing the data on the proportion of single-family homes an equally high correlation was achieved and 99% of a total of 3623 residential structures were correctly identified. In similar studies, air photographs have been used to assess the percentage of land in urban districts used for communications, for residential, commercial or industrial purposes or the extent to which the pattern of residential housing depends upon the motor car or upon public transport. Comparisons have been made between the quality and residential desirability of different areas of a town and the technique has even been used to assess the extent of poverty within urban districts since decay and disorder within a house may be reflected in conditions concentrated behind rather than in front of a building. Poverty and the extent of slum dwelling may be estimated more precisely by supplementing census data with information based upon air photographs.

Studies of the morphology of an urban area often require knowledge of the intricacies of its land-use that may be traced and plotted from air photographs. Considerations of the location of industry, and its effects on the environment may be greatly assisted by detecting sources of pollution, such as the discharge of smoke or waste whilst surveys of derelict land despoiled, for example, by rubbish or refuse tips, are a prerequisite to planned reclamation. Traffic and transport problems can be seen in true perspective especially when photographs are taken during periods of peak traffic so that areas of maximum congestion can be identified,

Photo. 4:5 Anticyclone over the Pacific Ocean, photographed from Apollo 9, from an altitude of 80 miles.

This remarkable spiral arrangement of cloud which spans several hundred miles is typical of a meteorological depression. Considerable cumulus and altocumulus have developed.

United States National Aeronautics and Space Administration. Photograph from satellite Apollo 9. *March 1969*

Photo. 4:5 Anticyclone over the Pacific Ocean

enabling their influence on other lines of traffic flow to be traced. Forward planning for development requires the maintenance of an up-to-date record of all relevant aspects of the urban environment, much of which can be obtained at short notice from air photographs.

The problems of gathering census data in undeveloped countries and in remote parts of the world are well known. Sometimes air photographs may be the only effective source for the estimation of population statistics since there is a close correlation between the density of dwellings, land-use intensity and population density. Air photographs can show the location of present settlements and the number of individual housing units within an area where difficulty of access or local hostility makes a direct assessment of statistics impossible. Even in the most ordered society population figures tend to be under- rather than over-estimated due to loss of information or omission of data. In a study of the results of a census in Jamaica, air photographs served as a valuable check on the initial findings and revealed various inadequacies. For example, in one particular district an excess of settlement appeared in comparison with the anticipated value but an examination of air photographs showed that the only structures within the district were cattle byres. Similarly in certain urban areas the apparent growth rate of the population between two census enumerations was much lower than expected, but photographs showed that the boundary definitions for each census were illogical in terms of the structure of the areas.

The applications of air photography to historical geography are discussed further in Chapter 11. The distant vantage point enables an air photograph to reveal not only the existing cultural landscape, but the way in which this has been determined by topography. The evolution of a town may be largely apparent from the distribution and age of its buildings, or evidence of former settlement-patterns may be apparent not only in terms of surviving structures, but also in variations in the colour, tone and texture of the soil. Many long abandoned settlements, where there are no longer any visible features above ground, have been identified in this manner whilst evidence of ancient field systems, and the extent of 'open field' farming have been traced from a close analysis of photographs. In a more recent setting, a striking picture of the changing pattern of land-use can often be compiled if photography has been repeated over a number of years revealing the wholesale rebuilding of urban areas, the redevelopment of densely packed housing, the expansion of new housing-estates and changes in communications. Air photographs will in the future come to be regarded as a record of the greatest value for history.

For all branches of geographical enquiry which require information about the earth's surface, air photography is a means of research of which few people yet realise the full potential. To a skilled interpreter, photographs can provide information with such detail and completeness that no conventional map can ever achieve. Air photography is a means of collecting large amounts of information with economy and precision, and at a speed unmatched by ground survey by permitting the results of limited observations on the ground rapidly to be extended over wider areas. In addition, the photographs remain available for future reference so that suspected sources of error can be readily checked. Technical advances, especially with infra-red linescan and radar sensing, tend to progress faster than the applications of these techniques, and further developments in remote sensing will undoubtedly occur. In geography however, conventional air photographs can already be regarded as a fundamental source capable of yielding information at a high degree of accuracy for a wide variety of studies.

REFERENCES

General

Colwell R. N. (Ed.) (1960) *Manual of Photographic Interpretation* American Society of Photogrammetry, Washington

Colwell, R. N. (1969) 'Aerial photography—a valuable sensor for the scientist' *American Scientist* Vol. 52 16–49

Stone, K. H. (1964) 'A guide to the interpretation and analysis of aerial photographs' *Annals of the Association of American Geographers* No. 54 318–28

Walker, F. (1967) 'Geographical applications of photography' *Liverpool Essays in Geography* 525–46

Particular

Bauer, A (1967) 'The application of optical filtering in coherent light to the study of aerial photographs of Greenland glaciers' *Journal of Glaciology* Vol. 6, No. 48

Burry, M. G. (1969) 'Air survey methods—their application to physical planning' *Town Planning Review* Vol. 38 135–50

Cooke, R. U. and Harris, D. R. (1970) 'Remote sensing of the terrestrial environment—principles and progress' *The Institute of British Geographers Transactions* No. 50 1–23

Eyre, A. *et al.* (1970) 'Census analysis and population studies' *Photogrammetric Engineering* 36 460–66

El-Ashry, M. R. and Wanless, H. R. (1967) 'Shoreline features and their changes' *Photogrammetric Engineering* No. 33 184–89

Fagerlund, E. *et al.* (1970) 'Physical studies of nature by thermal mapping' *Lund Studies in Geography* Ser. A, No. 47

Howard, J. A. (1965) 'Small scale photographs and land resources in Nyamweziland, East Africa' *Photogrammetric Engineering* No. 31 287–93

Jones, A. D. (1969) 'Aspects of comparative air-photo-interpretation in the Dyfi Estuary' *Photogrammetric Record* Vol. 6 No. 33 291–305

Jones, R. G. B. and Keech, M. A. (1966) 'Identifying and assessing problem areas in soil erosion surveys using aerial photography' *Photogrammetric Record* Vol. 5 No. 27 189–97

Mott, P. G. (1973) 'Mapping from Earth Resources, Technical Satellite and imagery' *Paper presented to the April meeting of the British Interplanetary Society.*

Stobbs, A. R. (1968) 'Land use survey in Malawi' *Cartographic Journal* Vol. 5 107–10

Symposium on Glacier Mapping (Nov. 1966) *Canadian Journal of Earth Sciences* Vol. 3

Veress, S. A. (1970) 'Air pollution research' *Photogrammetric Engineering* No. 36 840–48

5 Air Photography and Soil Science

R. M. S. PERRIN

Lecturer in Soil Science in the University of Cambridge and member of the Geologists' Pool, R.E.

Important developments in the application of air photography to soil science have taken place since the first edition of this book. Today, most soil surveyors regularly use stereoscopic photographs in the reconnaissance, planning, field-work and compilation stages of routine surveys. The physiographic and parametric approaches to the assessment of conditions at unvisited sites (terrain evaluation) by photo-interpretation have been further developed and tested. The relative efficacy and cost of panchromatic, infra-red black and white, 'true' colour and infra-red false colour films have been evaluated and camera installations have been perfected for the simultaneous exposure of films carrying differing emulsions.

Although there has also been rapid progress in other remote sensing methods such as infra-red linescan and sideways-looking radar, which may prove, in particular circumstances, valuable supplementary soil information, it is still true that 'there is no proven way of storing information which can compare with photographic film and no other means of airborne image remote sensing which can equal air photography for resolution, definition and clarity' (Lambott 1970).*

The following brief account is intended for the general reader but some references to recent work are given for those who wish to pursue the subject in greater depth.

The Scope of Soil Science

In its widest sense soil science is concerned with the nature and genesis of, and the detailed processes within, the whole weathered mantle

(regolith) down to bedrock. A distinction is often made between pedology, the scientific study of soils as a group of natural objects, which is divisible roughly into soil physics, chemistry, mineralogy and biology; and soil mechanics, the study of soils as engineering materials. Although this distinction is obviously arbitrary, and sometimes misleading, soil is regarded by the pedologist as the upper and most weathered part of the regolith acted on by solar energy, precipitation and biological agencies; by engineers as that part of the earth's crust which can be bulldozed without recourse to blasting, and by ecologists and agronomists as the rooting medium of plants and the habitat of numerous animals and micro-organisms.

In the modern world fundamental and empirical soil data are increasingly demanded in a very wide range of field studies and practical problems. The following list, which is by no means exhaustive, may give some idea of the scope of the subject and its applications, many of which are aided by air photographic techniques: characterisation of the soil component of natural and semi-natural terrestrial eco-systems; assessment and control of nutrients and toxic substances in agricultural soils; land reclamation, for example of coastal marsh, peats or dune sands; maintenance of soil structure and control of erosion; planning of irrigation schemes and land drainage; disposal of sewage effluent; construction of earth dams and reservoirs; location of raw materials such as gravel, sand or laterite; estimation of the characteristics of soil for foundations, and planning the course of railways, roads and transmission lines for water, gas, oil and electricity; prediction of off-road mobility or 'going'; location of areas liable to landslip; conducting inventories of soil resources and planning the rational use of land for agriculture, forestry, building or conservation; investigation of archaeological sites; and even the solution

* A list of references quoted in this chapter is printed on p. 84–5.

of problems in forensic science. It will be seen that there is in most of these applications considerable overlap of expertise; the control of salinity in irrigated land, for instance, may involve simultaneously the efforts of the geologist, pedologist, agronomist and engineer. This *integrated* approach becomes especially important when air photographs are applied to these problems, as will be discussed below. For this reason the view of soil science adopted in this book is broader than that in the first edition.

The Occurrence of Soils in Nature

In order fully to appreciate the application of air photography to soils it is necessary to deal very briefly with their occurrence in nature.

From the pedological viewpoint, a soil* is a three-dimensional body, developing in time, of which the vertical section, or *profile*, is more or less distinctly divisible into layers, or *horizons*, lying roughly parallel to the land surface. Unless caused by episodes of geological deposition, the detailed morphology of each horizon reflects the combined effects of the physical, chemical and biological processes which have operated in the soil at that depth over a period of time. These processes in turn are a result of the local interplay of the following factors: (i) the nature of the parent material (rock or weathered rock debris, except in the special case of peat soils), in particular its mineralogy, grain size and permeability; (ii) the integrated influence of the climate, or sequence of climates (precipitation, evapo-transpiration and thermal regimes), over (iii) the period of time during which the soil has developed on that site; (iv) the present topography, which influences the current balance of surface erosion or deposition and present drainage conditions, and the residual effects of relief as it existed in the past; (v) the associated biological population, particularly of higher plants, and (vi) land-use and other human activities. These factors are discussed in detail in standard works on pedology.

Although for some special purposes soils may adequately be classified and mapped using one or more simple criteria such as particle size distribution†, drainage properties, plasticity index, salinity or content of organic matter, the most widely useful systems are those based on the

* A soil is not an individual with definable boundaries like a plant or animal but merges with its surroundings both laterally and downwards. In the following simplified treatment this difficulty is ignored.

† 'Particle size distribution', or 'mechanical composition', is a measure of the relative proportions of particles of different size, from coarse (sand), to medium (silt) and fine (clay), in the soil matrix.

characteristics of the profile as a whole and of its constituent horizons. Since these depend on the environmental factors listed in the preceding paragraph, in a given geological and climatic context soils do not occur in a random array but in recognisable topographic sequences, or *catenas*, of which the individual components, often classified as *soil series** appear in the landscape in a predictable order.

Conventional soil surveys performed by ground traverses using spade and auger have long made use of this principle in locating and interpolating minor mapping units such as series. In small-scale surveys of large areas, however, the most useful mapping unit is often the catena itself (e.g. Milne (1935), and see Photos. 5:2 and 5:5).

The engineer will often be able to ignore pedogenic horizons unless they are exceptionally deep and show extreme changes in particle size distribution or in cementation, as in the development of murram† and laterite in some tropical soils. He will, however, still have to bear in mind the catenary succession of soils in relation to ground-water levels, spring-lines and such bulk characteristics as surface moisture content, shear strength and compressibility. From his standpoint soils may simply be unconsolidated geological deposits such as Keuper Marl, boulder clay, volcanic ash, beach or blown sands, glacial or terrace gravels, or peat. The occurrence of such materials depends on the geology of the area and can be ascertained from the appropriate maps and memoirs where these exist.

The Application of Air Photography to Soil Studies

For purposes of discussion the uses of air photography may be divided into reconnaissance and systematic survey and mapping.

Reconnaissance

One main object of reconnaissance is to discover patterns representing soil phenomena hitherto unknown, or very imperfectly known, on the ground. Discoveries of this kind may be made by visual observation from the air, preferably from slow-flying aircraft, followed by photography (e.g. the patterns shown in Photo. 5:1, or by systematic search of photo-

* A soil series is defined as a group of soils with similar profiles formed from lithologically similar parent materials under presumably similar conditions of development. The name is usually taken from a type locality.

† Gravelly concretions cemented by iron oxides.

graphs that already exist or which have been taken specially. The same photographs may then be used to assist in the location of critical sites for detailed investigation on the ground (Photos. 5:1 and 5:3) and perhaps to produce contoured plans, provided the accuracy required is not so great as to make ground levelling essential.

Patterns indicative of special soil features such as old beachlines or stream courses, fossil ice-wedges or signs of past human occupation, may be of purely academic interest at first, although practical implications may emerge subsequently (see Photos. 5:2 and 5:4). On the other hand they may be of immediate practical importance, for example as evidence of peaty patches of poor bearing capacity in alluvial tracts, of incipient erosion, of potential landslips, or of variability in crops associated with a limiting soil condition.

Another form of reconnaissance is the preliminary assessment of terrain either in preparation for conventional soil surveys or as an object in itself (landscape or terrain evaluation). This will be discussed below.

Soil survey and mapping

Air photographs may be used in soil surveys in three main ways:

(i) as a base map;
(ii) as an additional aid in conventional ground mapping;
(iii) as a source of soil data by photo-interpretation.

In practice (ii) and (iii) are not clearly distinguished and in many modern surveys the two approaches merge, as some examples will show.

(i) Air photographs as a base map
When printed topographic maps are lacking, obsolete or carry insufficient detail, this application can be important. In unmapped country where soil survey is required, special-purpose air photography may be provided at a fraction of the effort for a normal topographic survey unless the area concerned is very small. Even when good maps are available, air photographs show much additional detail that can be of great value.

Photographs are most often used in the field or office for recording soil boundaries and other data as the mapping proceeds, but they may also be reproduced as half-tone mosaics overprinted with the soil pattern as the final published maps. They are used in this way by the United States Soil Survey, the photo-maps usually being at a scale of 1:20 000. Once the ground survey is complete they can be produced much more

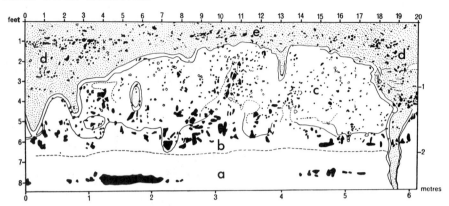

Fig. 5:A Section at A on Photo. 5:1
a Chalk *in situ* with bedded flints
b Highly disturbed and puddled chalk
c Sandy-chalky drift with scattered flints and other stones
d Acid sandy soil over deep sand pocket
e Calcareous sandy soil over chalky 'swell'
Flints are shown black and other stones open.

After Watt, Perrin and West

Photo. 5:1 Soil patterns revealed by heather and chalk grassland on Eriswell High Warren, Suffolk (TL 779797)

Soil patterns are widespread in southern England but are especially well developed in the Breckland district of East Anglia, where variable depths of very sandy drift overlie the chalk. These are generally considered to have been produced by subsurface periglacial contortions; they may be recognised on air photographs by varying tones of surface soil on bare ground, by differential crop growth or, as here, by patterns in semi-natural vegetation. Further examples are to be seen in Photos. 6:2 and 6:5.

The dark stripes of the heather *vulgaris* rooted in acid soils on deep sand pockets and the paler areas are of chalk grassland on soils developed over chalky 'swells'. The subsurface structures are shown in the section, the site of which is seen at A on the photograph.

Vertical photograph V-AJ 8. Scale 1:1225 *17 August 1961*

Photo. 5:1 Eriswell High Warren

Photo. 5:2 Ouse valley and Chalk Boulder Clay landscape north-east of St Neots, Huntingdonshire. (Centre of photograph approximately TL 217627). Interpretation by C. A. H. Hodge.

The photograph shows two valleys leading westward to the Bedfordshire Ouse each showing a valley-side re-entrant pattern. The area is mainly covered by heavy soils on Chalk Boulder Clay, but with medium-textured soils on the terraces adjoining the Ouse, where there are many gravel workings. (Note the white bare surfaces and dark-toned pits filled with water, on the left of the photograph).

The higher ground between each valley (A) appears in relatively dark tones, but the steeper valley sides with slopes greater than about 2° show as pale tones (B). On these slopes the soils are shallower and the paler tones are probably due to the high carbonate content of the surface soil, which may be as much as 40%, and the presence of many white chalk stones. The palest tones are on the north side of the valleys, suggesting that the shallowest soils are on the south-facing slopes. This is a common feature in landscapes where periglacial erosion has occurred.

Re-entrants in the valley sides are marked by dark-toned bars representing strips of deeper, more loamy and only slightly calcareous or non-calcareous soils which were developed in a late drift, probably of wind-blown origin. The strips, which may sometimes bifurcate up the slopes, run to the valley centre-line, which is marked both by a ditch with hedge and line of trees and by a continuous darker tone marking heavy-textured 'head' (solifluxion debris) along the valley bottom.

The photograph was taken in autumn when most of the ground surface was bare after ploughing; this interpretation would have been very difficult or impossible on photographs taken in the summer.

The soil sequence is shown diagrammatically in Fig. 5:B.

Vertical photograph by Fairey Surveys Ltd., 9523/6631.
Scale 1:19500 *5 November 1969*

rapidly and cheaply than colour-printed maps and in many areas, though not all, are more easily read by the non-specialist.

(ii) Air photographs as an additional aid in conventional ground survey
Although air photographs may be used simply as a base map, their particular value in soil survey was recognised as early as 1932 by Bushnell, and nowadays is usually fully exploited. Their general use is described in a number of readily available works, e.g. Colwell (1960), U.S. Department of Agriculture (1966), Strandberg (1967), Smith (1968), Howard (1970).

At the stage of reconnaissance or pre-fieldwork planning of a soil survey, the whole area may be scanned, ideally using a combination of mosaics or single photographs at a small scale (e.g. 1:60000 to 1:80000), and stereo-pairs at an intermediate scale, often 1:10000 to 1:20000.

Fig. 5:B Diagrammatic representation of Photo. 5:2.

Inferences from the tone, texture, pattern and stereo-image will enable a surveyor to visualise the landscape and to establish, with varying reliability depending on circumstances and on his own experience, features of the terrain likely to be closely correlated with soil patterns. These will include the main geological structure, where the soil cover is not so deep as to obscure them (see p. 46); the landforms, drainage patterns and relief; the vegetation types; and the forms of human settlement shown by patterns of land-use, field size and shape, road density and alignment and so on.*

An experienced surveyor who has background knowledge of the region as a whole, will at this stage be able to make useful predictions; these will include the likely scale and complexity of the soil patterns, and thus the optimum density of boring and sampling, a rough estimate of the number

* Quite simple criteria are often of use; for example the original boundary between the silts and peats in the Fen Basin is clearly shown by the contrasting road patterns although the peat may now have been destroyed by oxidation. The same feature, together with the shape and size of fields and the presence of water in old marl pits, also shows where sandy topsoils in Norfolk and Suffolk are underlain by boulder clay.

Photo. 5 : 2 Ouse valley, north-east of St Neots

Photo. 5:3 Edge of the Fens south-west of Chatteris, Cambridge-shire, from Woolvey Farm (W) (TL 332815) to New Barn Farm (X) (TL 334833). Interpretation by R. S. Seale.

The upper part of the photograph shows a pattern of former watercourses which once traversed the estuarine clay (Fen or Blue Buttery Clay) underlying the fresh-water peat-swamps of the Fens. The watercourses were lined with calcareous alluvium, ranging in texture from fine sandy loam, in the larger courses (A_1), to clay loam in the smaller (A_2). After the draining of the Fens, wastage and shrinking of the peat has caused the larger watercourses now to be seen as banks up to 1 m high, known locally as 'roddons' or 'rodhams' (see Fig. 5:D). Ground survey of these areas would be extremely laborious and expensive, but they may be mapped from air photographs taken in winter when the ground is bare. The contrast between the light-coloured alluvium of the roddons and the dark peat or humose clay between them, is then most clear.

The limit of the roddons corresponds roughly with that of the Fen Clay which has been marked on the photograph by a continuous white line. The actual limit can only be mapped on the ground. At A_3 the Fen Clay fills a re-entrant in the skirtland and extends up a straight, narrow valley to A_4, its course just being distinguished by the darker tone of the peaty surface.

The boundary between the clay soils (Peacock Series) of the skirtland and those of the upland (mostly Wicken Series) cannot be distinguished on the photograph, though on the skirtland field boundaries and ditches tend to be straighter.

The ridge of Foxhole Hill, about 20 m high, appears as a pale tone (for example at B). Some of the smaller re-entrant valleys and subsidiary knolls to the north are seen as darker tongues between pale spots (C). A light strip (D) parallel to the north face of the hill marks the position of slightly more acid soils (Aldreth Series) formed from drift overlying the Jurassic clay.

Vertical photograph by Fairey Surveys Ltd. 1 929 6705.
Scale 1:10000 *13 March 1967*

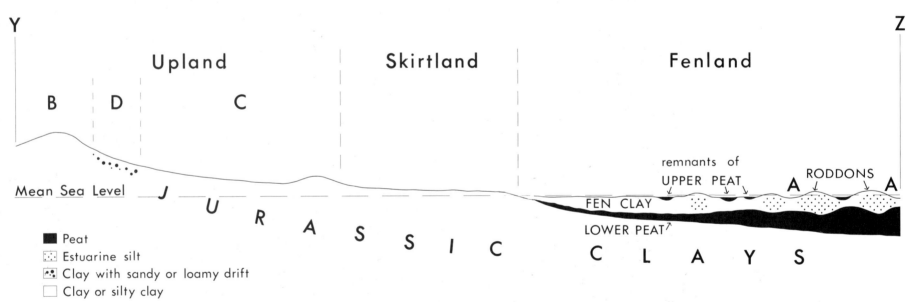

Fig. 5:C Schematic section of the Fenland border between the points YZ on Photo. 5:3.
The section represents a horizontal distance of about 700 m, while the vertical scale is exaggerated, especially in the Fenland, the better to show the arrangement of the deposits.

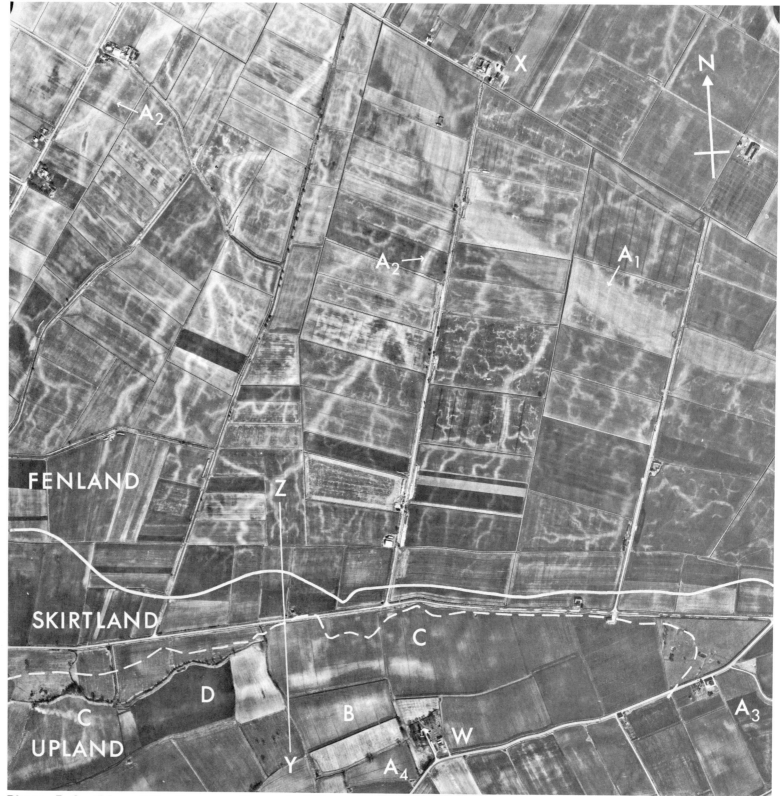

Photo. 5:3 Edge of the Fens, south-west of Chatteris

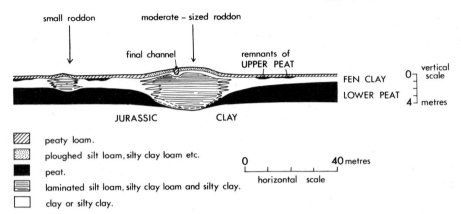

Fig. 5:D Section of typical roddons.

peaty loam.

ploughed silt loam, silty clay loam etc.

peat.

laminated silt loam, silty clay loam and silty clay.

clay or silty clay.

The stages in the development of the soils have been found broadly to correspond with those of the vegetation. Apart from a few small areas of samphire (*Salicornia herbacea*) the main coloniser of the lower, coarser sediments is cord-grass (*Spartina townsendii*), which is replaced as the dominant species on better drained sites at higher levels by sea poa (*Puccinellia maritima*). This in turn gives way to sea-couch (*Agropyron pungens*) on the best drained sites along levees and at the highest part of the outmarsh.

Reclamation of the area of salt-marsh may be attempted when a sufficient depth of fine-textured sediment has accumulated, reaching a height of about 3 metres above mean sea level. The sea is then excluded by constructing a bank from marsh sediments on each side of the area to be reclaimed. The inner borrow trench is retained as a 'sock' (=soak) drain and the enclosed creek system is rationalised, a few of the larger creeks being retained as major drainage channels and the rest filled in.

A. Zone of frequently inundated silty loam under *Spartina* (cord grass) with dark-toned *Puccinellia* (sea poa) on better-drained areas along the creeks. Note the very light colour of *Spartina* in mid-summer; at other seasons it appears much darker.

B. Zone of less-frequently inundated silty clay loams — with dominant *Puccinellia* showing very dark tones.

C. Clearly defined pale-toned area of *Agropyron pungens* (sea-couch) developed on well-drained soils adjacent to creeks in the *Puccinellia* zone.

D. 'Sock' or soak drain, used for conveying drainage waters to tidal sluices (F) and checking seepages of salt water under the bank.

E. Pattern of old infilled creeks on reclaimed land. Note that these become much more difficult to detect under a crop in the adjacent field.

F. Tidal sluices.

Air photographs are of special value as a base map in the complex outmarsh and, if taken at intervals, greatly assist in reconstructing its history. Because of the parallel development of soil and vegetation and the well defined photo-images of the latter, indirect soil mapping can be carried out very rapidly. However, not all aspects of profile morphology are unambiguously determined; for example the depth of fine-textured topsoil appears to have no direct influence upon the vegetation.

The size and depths of the creeks can be readily measured from stereo-pairs. This greatly facilitates the choice of major creeks for drainage ways, in the siting of tidal sluices and in estimating the material and labour for infilling the minor creeks.

Study of the intricate chemical changes which occur in soils after reclamation requires samples taken from sites unaffected by former creeks. When these have been filled in they may be difficult to recognise on the ground, but they remain clearly visible on air photographs, which are thus of great value in a sampling programme.

Vertical photograph V-AT 86. Scale 1:3100

5 June 1962

Photo. 5:4 Outmarsh and reclaimed land at North Wootton, Norfolk (TF 605255). After D. A. Macleod.

Since Roman times, sand, silt and clay have been continually deposited round the margins of the Wash by incoming tides. The coarse particles are deposited first to form sand-flats and banks; as the transport velocity decreases closer to land, finer particles are laid down. When sediments have accumulated to a certain height, colonisation by marsh plants gives rise to a band of salt-marsh bordering most of the coastline of the Wash. The marsh is drained by a dendritic pattern of creeks bordered by low levees.

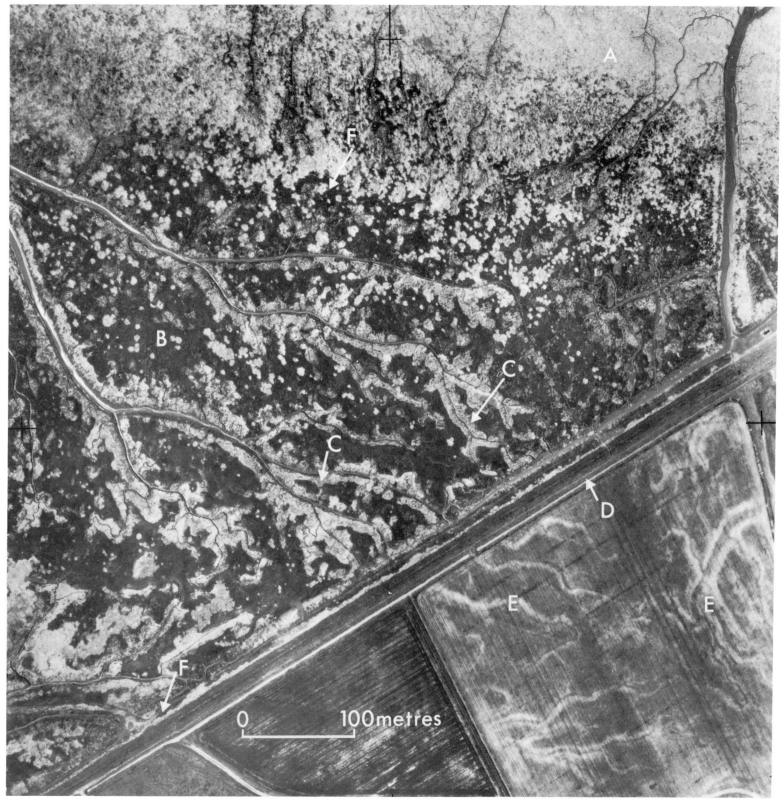

Photo. 5:4 Outmarsh and reclaimed land, North Wootton

of mapping units that will be needed and perhaps even some of their names in an existing system of classification.

Further search will suggest areas and sites likely to be critical for the placing of soil boundaries or the recognition of new mapping units, or which may contain patterns too complex to be mapped at the scale prescribed for the survey. Finally, the preliminary scanning may reveal completely new soil phenomena, such as those mentioned above, which may prove to be important in planning the survey methods to be employed (Photos 5:1 and 5:3). Even though the preliminary assessments will be rather subjective, and some may later prove to be wrong, the broad appreciation of the soil patterns and the location of critical areas will certainly improve the speed and facility of the subsequent ground mapping.

In the field-work stage, ground survey and consultations of air photographs become completely integrated, the definitions of mapping units and the physical placing of boundaries being checked continually back and forth, to achieve the best possible 'fit' at the scale of the survey and within the time and budget allowed.

Once the survey staff are thoroughly familiar with the local correlations between photographic patterns and soil catenas, mapping can be greatly speeded up by interpolation if some diminution in reliability may be accepted. This method was used in an early survey in the Sudan (Gunn 1955) and was employed to specially good effect in the soil survey of Uganda where much of the routine mapping was performed by interpolation on air photographs between widely spaced ground traverses (Chenery 1960). It allowed reasonably accurate maps to be produced very quickly and has been much used elsewhere since.

Extrapolation from a set of results for one district into another is obviously less reliable and depends much on the surveyors' background knowledge of the relationship of soils to the geology, climate, vegetation and land-use of the region. An early example was the survey for the Central African Rail Link Development Scheme (Colonial Office 1952) where photo-interpretation was combined with the field examination of very widely spaced sampling sites. The maps so produced, although not very accurate, gave a useful general inventory of resources and showed where more intensive effort was justified. Extrapolation will also be favoured when there is a reduction of scale, as in the current policy of the Soil Survey of England and Wales to produce generalised county maps at 1:250000 by drawing upon detailed maps at scales of 1:63360, 1:25000 and 1:10000.

Lastly, at the compilation stage, even if air photographs are not to be reproduced as the final base map, much of the soil data may be drawn up most easily on large-scale photographs subsequently to be transferred to a printed map. This will be specially true in terrain of great soil complexity such as the 'roddon' areas of the Fens (Photo. 5:3).

Thus at all stages of a conventional ground survey air photographs have a most important role to play in increasing the certainty and speed of mapping. The saving of time is important, as by far the most expensive part of soil survey is the employment in the field of skilled personnel, which commonly accounts for about three-quarters of the total cost. From a study in the Pennines, the Soil Survey concludes that in Britain the greatest value of air photographs is likely to be in the rapid mapping of upland areas at a small scale (e.g. 1:250000).

(iii) Soil mapping by photo-interpretation

The preceding section prompts the question whether photo-interpretation can replace ground survey entirely. This prospect is specially attractive when speed and economy are more important than a high degree of accuracy, as in the rapid preparation of inventories of national resources for development plans, or in selecting approximate areas for later detailed study; when the inherent value of the land is very low and cannot justify a high-cost survey, for example in high moorland or semi-desert; or when access on the ground is difficult or impossible as in mountains or, in a military application, in hostile territory.

Direct observation of soils. In contrast to land forms or vegetation patterns, soil *profiles* can never be observed on an air photograph; even the soil *surface* is only visible in favourable circumstances such as on eroded or freshly cultivated land, desert, beaches or the lower parts of coastal marshes. Here observed differences in tone may be related to variations in chemical or mineralogical composition (e.g. amounts of calcium carbonate or other crystallised salts, iron oxides, quartzose sand, stones of various colours, or organic matter); or to moisture content (which is related to particle-size distribution and pore-space relationships in the soil, and to topographic situation).

Surface tones may be correlated with underlying soil profiles when interpolating in well known areas (see Photos. 5:2 and 5:3). Such correlations can be improved by colour photography (see p. 80–82, below) but in the total absence of ground control may become little more than guesswork.

Indirect interpretation of soils. It has already been noted that extrapolation can often be made over limited distances according to the experience

Photo. 5:5 Soil catena 20 miles north-west of Dodoma, Tanzania.

The surface of large tracts of the African continent consists of crystalline basement rocks and their debris.

This photograph and idealised section illustrate a land system on such materials, the individual physiographic units or facets being lettered A to E. Since characteristic soil-forming factors are associated with each facet, this sequence also represents a catena of soils and their associated vegetation.

A. Bare rock surfaces: shallow immature soils on steep slopes and deeper soils in pockets. Little vegetation except in the pockets.
B. Red soils (loamy sands to sandy loams), fairly shallow and freely or excessively drained. Open woodland (B_1), or savannah, but often cultivated (B_2) and then subject to erosion in varying degree.
C. Pale yellowish-brown ('pallid') soils. Loamy sands over sandy loams containing variable amounts of concretionary iron oxides. Imperfectly drained in the wet season. Savannah or in cultivation.
D. Pale grey-brown medium or coarse sands over loamy sands at depth. Poorly drained in the wet season. Often practically bare of vegetation.
E. Dark grey or black clays. Seasonally flooded — such areas are known as 'mbugas'. Grass-covered (E_1) or bare sufaces (E_2); often fringed with *Acacia seyal*, etc. (E_3).

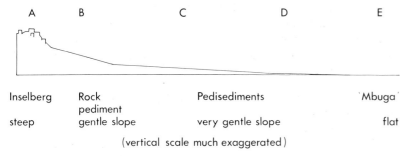

Fig. 5:E **Idealised section of soil catena A–E on Photo. 5:5.**

The 'mbuga' shown is of unusually small size and clearly defined elongated shape. These features may be the result of recent faulting approximately parallel to the long axis of the 'mbuga'. Perhaps this is a reason why the catena here extends over a much shorter distance than usual, the red soils locally coming very close to the edge of the 'mbuga'.

This interpretation is based on examination of good quality stereo-pairs and could not have been carried out on single prints, or without local knowledge of the relationships of soils to topography and vegetation. Once this knowledge has been acquired, however, deduction by analogy can be made in other occurrences of the same land system (MEXE 1965).

R.A.F. vertical photograph 82A/263/TAN, print No. 5055.

Scale 1:33 000 *11 August 1949*

Photo. 5:5 Inselbergs. Dodoma, Tanzania

of the interpreter. The results of early attempts to extrapolate much beyond the range of ground control were frequently disappointing. In all but arid lands the major source of difficulties was often the choice of vegetation and land-use as chief diagnostic criteria. These are unstable features of the landscape and sensitive to factors other than soil characteristics, such as cutting or burning in the case of the first, and economic pressures in the second.*

There are two possible approaches to this problem – the *landscape* or *physiographic* and the *parametric*. The first is based ultimately on the convictions of early workers such as Bourne (1931) and Unstead (1933) that, in a given landscape, units with the same physiography would also show close similarity in such features as hydrology, soil development and biotic potential.†

The method has been to recognise and to define from air photographs recurrent landscape patterns or *land systems*, that may be mapped at scales between 1:250000 and 1:1 M, and their constituent *facets,* mapped at scales between 1:10000 to 1:100000, according to the nature of the terrain (see Photos. 5:6 and 5:7). Facets are components of the landscape related to each other in a regular way like the series on a soil catena. They are either reasonably homogeneous for land-use, engineering or military purposes, or, if variable, vary consistently in the same, predictable, sense. Once defined, land systems and their facets can be used both as mapping units‡ and as categories for the recording of terrain information

* In areas of intensive production, patterns of cropping sometimes depend less on soil conditions than on the presence of a major market outlet or specialised food processing plants, such as pea-vining or sugarbeet factories. In seasonally dry regions soil interpretation can be made much more difficult by patterns of charred vegetation.

† This physiographic approach has been developed by many others particularly by the CSIRO Divisions of Soils and of Land Research and Regional Survey in Australia (Christian 1958, Christian and Stewart 1953, Mabbutt *in* Stewart 1968), the CSIR National Institute of Road Research in South Africa (e.g. Mountain 1964), and the Military Engineering Research Establishment (MEXE) in Britain in association with the Geologists' Pool, RE and the Universities of Oxford and Cambridge (e.g. Webster 1963, Beckett and Webster 1965, Perrin and Mitchell 1969, and numerous other MEXE reports).

‡ Small-scale maps of large areas will normally only show land systems, the mode of occurrence and generalised properties of the associated facets being given in notes. At a larger scale, facets will be the normal mapping units. This is broadly similar to the respective use of catenas and series in conventional soil mapping at small and large scales.

in a data store. This is an *integrated survey* approach, since such a store can contain every conceivable type of information on terrain, both fundamental (physiographic, geological, pedological, botanical and so on), and applied, as for example special parameters relevant to the cross-country mobility of vehicles. A store containing all types of terrain information is of obvious value to the solution of many practical problems involving soil which demand an interdisciplinary approach. On the other hand, unlike a soil map, a physiographic map does not directly indicate soil properties of agricultural and engineering significance; these must be obtained for each mapping unit from the data store, or from a simplified key. Once the store has been established, if a land system can be recognised in an unvisited area, the occurrence and the properties of its facets may be predicted; the accuracy of such predictions will be limited by the amount of information recorded for the same units in known areas. Detailed statistical tests of the accuracy of such predictions have been made in the South Midlands (Beckett and Webster 1965), in Central Wales (Areola 1974) and in the hot desert regions of the world (Perrin and Mitchell 1969). In very general terms the approach seems to give reasonably valid predictions of physical properties for geographically restricted

Photo. 5:6 South-west Hadhramaut, Saudi Arabia and South Yemen (centre of photograph approximately 15° 30′ N, 47° 15′ E). Interpretation by C. W. Mitchell.

A satellite photograph, covering a very large area and more than one land system, gives a much better overall view of the terrain than a mosaic, despite the indifferent photographic quality.

A. Wadi Hadhramaut.

B. Dunes of Ramlat Sabatain.

C. Jol Plateau country of gently dipping dissected Lower Eocene sediments (Jeza Formation). These overlie Palaeocene and Cretaceous formations which are exposed in the deeper wadis and on the scarp face.

D. Wadi Mayfa'ah.

E. Approximate outline of Photo 5:7 to show its relative scale, and position of the Wadi Jirdan.

F. Ayadh salt dome (see Photo. 5:8).

G. Pre-Cambrian or Lower Palaeozoic crystalline rocks.

H. Tertiary volcanics.

I. Town and cultivated area of Ayadh (Photo. 5:8).

United States National Aeronautics and Space Administration. Gemini 7 Photograph No. 25–19 (colour transparency).

Scale approx. 1:5 000 000 *5 December 1965*

Photo. 5:6　South-west Hadhramaut, Saudi Arabia and South Yemen

occurrences of a land system ('land system local form') but fails when intercontinental extrapolation is attempted. The prediction of chemical properties is generally less reliable.

The physiographic approach can also be used to support ground survey; the Directorate of Overseas Surveys, for example, has used land systems to facilitate the mapping and description of large areas in Nigeria (Bawden and Tuley 1966) and Lesotho (Bawden and Carroll 1968). The Road Research Laboratory has shown how land systems in Nigeria originally recognised for agricultural purposes can be used in planning highways (Dowling *in* Stewart 1968), thus further emphasising the value of the integrated approach to terrain.

The *parametric* method, which has been developed mainly for military purposes by the United States Army Waterways Experimental Station at Vicksburg, seeks to establish land types by quantitative measurement of certain key attributes of the land (Mabbutt *in* Stewart 1968). These parameters must be selected, and class limits defined, for each activity envisaged; for instance those considered relevant to airfield construction might be slope, surface texture, soil moisture content, depth to bedrock and mean basal cross section of vegetation (related to difficulty of clearance) (Benn and Grabau *in* Stewart 1968). Provided that methods can be devised to measure and plot these parameters, using air photographs or other means of remote sensing, the suitability for the particular activity of an unvisited site can be predicted. This method will be favoured when only a very few activities are to be considered and where the few parameters which are at present actually measurable are sufficient. Further requirements involving an increase in the number of relevant parameters add to the complexity but, in contrast to the relatively qualitative and somewhat subjective physiographic approach, the basic information is numerical and thus well suited to electronic data-handling. This has led to suggestions that the method will entirely replace the physiographic approach, and to a large extent also the human contribution, as new methods of remote sensing and data processing are developed (Mabbutt *in* Stewart 1968, Gibbons and others *ibid*). It is, however, difficult to see how many important soil parameters could be measured by remote sensing in the foreseeable future. Since the only alternative is to infer them by analogy using the physiographic system the two methods are best regarded as complementary, to be used in differing degrees according to the particular application. Many aspects of the problems are discussed in Stewart (1968) and in Mitchell (1973).

Photographic Requirements

Type and scale of photography

Although the soil scientist may use oblique photographs for recording new observations, for illustrating reports or for teaching, the normal requirement is for high quality vertical photography with 60% forward and 20% lateral overlap affording full stereoscopic vision of the area.

No single scale is adequate for all purposes. In detailed examination of small or complex areas, scales between 1:2500 and 1:10000 are usually best, but for general work, mapping at the level of short catenas, soil series or facets, photographs at 1:10000 to 1:20000 carry less confusing detail and are much cheaper and less cumbersome in use. These in turn are unsuitable for the recognition of such major features as geological structures or drainage patterns likely to influence the distribution of soils, for which prints at 1:60000 to 1:80000 are more useful. Satellite photography enables broad regional patterns at the level, for instance, of whole land systems to be accommodated on a single photograph which is often preferable to a prepared mosaic (e.g. NASA 1967, Lambott 1970 and Photos. 3:3 and 5:6).

Film type

Until recently nearly all soil interpretation has been based on prints* made from *panchromatic* film (with a spectral range from 0·4 to 0·7 μm)

* Diapositives are not generally used unless detailed contouring is essential for special purposes such as drainage or irrigation works.

Photo. 5:7 Edge of Jol Plateau Country, South Yemen (15° 00′ N, 47° 00′ E). Interpretation by C. W. Mitchell and R. M. S. Perrin.
A vertical photograph, of which the approximate position is shown on Photo. 5:6, allows accurate recognition and delineation of facets within a land system.
 Note the very sharp boundaries in this arid terrain.
1. Foot-slopes and *bajadas* on soft undifferentiated Cretaceous sandstones of the Tawila Group.
2. Steep scarp slopes on the Palaeocene Umm Er Radhuma Formation.
3. Plateau top on Lower Eocene limestone with Jeza Formation.
4. Pliocene – Recent terraces and alluvial valley fill with some settlements and scattered vegetation in Wadi Jirdan.
R.A.F. Vertical photograph No. V540 RAF 1748; 0035.
Scale 1:41500 *2 November 1955*

Photo. 5:7 Jol Plateau Country, South Yemen

exposed with a minus-blue filter. This film has been highly developed; prints are cheap, exactly reproducible, durable and well suited to stereo-viewing, even in the field, and interpretation of them has been developed to a high level of expertise. It has been claimed to be the most effective emulsion for the penetration of shallow, turbid, saline waters (Pestrong 1969). In general, however, panchromatic film is inefficient, reducing about 20 000 tones that can be distinguished by the human eye to about 200 tones of grey (Evans 1948).

Infra-red monochrome (black and white) film extends the range of the recorded spectrum to about 1 μm. It has better haze penetration than panchromatic film and greater sensitivity to soil and sub-surface moisture conditions; it also improves the identification of vegetation type and patterns of crop performance which are often related to soil factors.

There has been a very rapid increase in the application of *'true' colour* film to pedology and to engineering, and a number of comparative studies have been published (Anson 1966, 1968; Jones 1969; Parry, Cowan and Heginbottom 1969; Grimes and Hubbard 1971). The following main advantages have been claimed:

(i) More features can be recognised; better delineation of patterns of drainage is an important instance.

(ii) Different colours of vegetation are unlikely to be confused with those of bare soil whereas tones on black and white photographs can be ambiguous.

(iii) Vegetation types, and hence associated soil conditions, are more easily identified, and differences in height of vegetation are less likely to be misinterpreted as minor topographic variations.

(iv) Soil boundaries can often be placed more exactly, especially in areas of low relief.

(v) On bare surfaces the rock or topsoil is more readily identified and areas of incipient erosion or slip are often easier to locate.

(vi) Colour filters can be used with transparencies as a further aid to interpretation.

(vii) The easier recognition of features leads to greater confidence, accuracy and speed of interpretation, particularly in complex terrain.

There are however, some important limitations. Colour films are about four times more expensive than panchromatic, less flexible in exposure and about five times as costly to process; transparencies are too valuable, delicate and awkward for use in the field; prints also are costly and colour reproduction is unreliable (although colour differentiation

is in fact often more important than strict fidelity). But film technology will undoubtedly improve; and in large projects the cost of photography is only a small percentage of the total budget, part of which may in any case be recovered by greater efficiency in interpretation (Latourneaux 1969).

Infra-red false colour film (0·4–1·0 μm) has perhaps the widest potential in soil studies. As with infra-red monochrome, the haze penetration is better than with true colour or panchromatic. Its merits are similar to those of true colour with, in addition, a capacity to distinguish more effectively between vegetation types and between bare surfaces and incipient vegetation, such as emerging crops or coatings of algae on tidal flats (Jones 1969, Grimes and Hubbard 1971). There is clearer identification of bare rock surfaces, of wet soils, of drainage patterns and water bodies; and it is also able to give a measure of sedimentary load in streams and estuaries since clear water is recorded as black, and sediment as blue. False colour suffers from the same disadvantage, as true colour, while to visualise the terrain directly from the photographs is more difficult, and soil colours on bare ground are not recognisable (Anson 1966, Sorem 1967, Smith 1968).

In recent years *multi-band* camera installations have been developed to take advantage of the respective merits of different emulsions by making simultaneous exposures with various combinations of films and filters. Some are very elaborate, giving nine or even more exposures, but recent work suggests that the four film types described above meet most normal needs. Consideration of space and weight dictate that small format cameras, e.g. 70 mm, are commonly employed (Lambott 1970). Whatever emulsions are used there seems to be scope for further improve-

Photo. 5:8 Ayadh and Hayd al Milh (Ayadh salt dome) South Yemen (15° 03′ N, 46° 50′ E). Interpretation by C. W. Mitchell.
Note the fine detail visible in this generally rather featureless terrain which cannot be observed in Photo. 5:6. The photograph is at a scale suitable for mapping facets.
1. Ayadh salt dome, with limestone and gypsum surrounding shale and rock salt.
2. Salt-affected outwash area.
3. Dry wash with (a) shrubs and (b) cultivation around Ayadh.
4. Braided channelling on the outwash from the Jol Plateau to the east.
5. Wind-sorted patterned ground.
R.A.F. Vertical photograph No. V82 RAF 1347; 0005.
Scale 1:31 000 *20 January 1956*

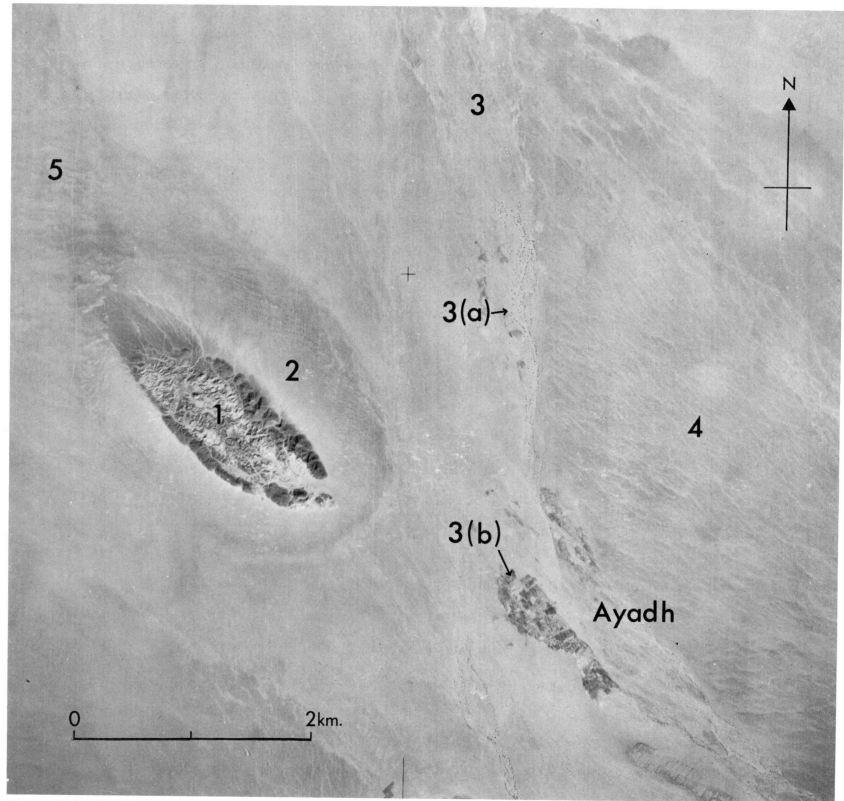

Photo. 5:8 Ayadh and Hayd al Milh, South Yemen

ment in interpretation by scanning photographs with a microdensitometer which will distinguish between finer differences in tone (Pestrong 1969). Such scanning has been suggested as a way of interpreting terrain patterns and features automatically (e.g. Rib and Miles 1969).

Season

This is of obvious importance whenever soil interpretation has to be based principally on patterns of natural vegetation or land-use (Steiner 1966). In the United Kingdom, for example, the author finds that photographs taken in June–August are most satisfactory for soil mapping in Central Wales, in coastal marshes January appears to be best (Grimes and Hubbard 1971), while patterns such as those in Photos. 5:2 and 5:3 can only be observed on bare ground, normally in the winter. In general, when the season for photography is not restricted, choice will be based on empirical observations.

Other Forms of Remote Sensing

Very rapid progress has been made in the last few years, under the stimulus of NASA satellite programmes (e.g. Pardoe 1969), in developing methods of sensing using wave-bands outside the visible spectrum (e.g. Colwell 1968, Parker 1968, McLerran 1968, Simonett *in* Stewart 1968). Although in the present book attention is largely confined to air photography, two of these methods must be briefly mentioned since they are likely to be employed increasingly, together with conventional photography, in the earth sciences and in engineering. These new techniques are expensive and their use may not be justified in every project, since it is interpretation rather than the acquisition of data that often causes delay.

Infra-red linescan (IRLS) is a method of sensing infra-red radiation of wave-lengths between 3 and 5·5 μm and between 8 and 14 μm, emitted from the earth's surface. A sensor converts the radiation that strikes it into electrical signals, which may be fed into a cathode ray tube to reproduce imagery on photographic film, or be recorded on tape for handling by computer. The latter is specially suited to the parametric approach to terrain evaluation. By measuring thermal emissivity, IRLS is capable of distinguishing some rock types and delineating soil moisture conditions, sub-surface drainage-lines and moisture-stress in crops. However, interpretation is difficult since thermal emissivity is not constant for a given soil but depends on the time of day, and upon immediately preceding meteorological conditions, as well as upon other factors which are not yet fully understood.

Side-ways looking airborne radar (SLAR) uses radiation in various wave-lengths between 5 mm and 20 mm. In contrast to photography and to infra-red linescan, this is an 'active' method of sensing in which pulsed radiation is emitted from an aircraft and reflected back from the ground surface. The imagery, which can be recorded photographically, is subject to scale distortion as in an oblique photograph. Radar has a great advantage in that its operation is independent of weather conditions and can be used in regions of persistent rain and cloud, where conventional photography and infra-red linescan are precluded. For soil studies, the method is still very much in an experimental stage, but shows much promise in tracing drainage-networks and patterns of land-use. The employment of SLAR for mapping soil boundaries has not been entirely successful, but there is hope that it will come to be a useful complement to photography (Simonett *in* Stewart 1968).

The future will see a great increase in the continuous acquisition of terrain data by various satellite-borne remote sensors, and the production of information could well outrun the possibilities of interpretation.

Typescript received June 1974

REFERENCES

Anson, A. (1966) 'Colour photo comparison' *Photogrammetric Engineering* Vol. 32 286–97

Anson, A. (1968) 'The use of colour aerial photography in the reconnaissance of soils and rock' *Materials, Research and Standards* Vol. 8 No. 2 8–16

Areola, O. O. (1974) 'Photo-interpretation of land facets as a soil-mapping technique' *Geoforum* No. 20 25–38

Bawden, M. G. and Tuley, P. (1966) 'The land resources of southern Sardauna and southern Adamawa Provinces, Northern Nigeria' *Land Resources Study* No. 2 Ministry of Overseas Development, London

Bawden, M. G. and Carroll, D. M. (1968) 'The land resources of Lesotho' *Land Resources Study* No. 3 Ministry of Overseas Development, London

Beckett, P. H. T. and Webster, R. (1965) 'A classification system for terrain' *MEXE Report 872*

Bourne, R. (1931) 'Regional survey and its relation to stocktaking of the agricultural and forestry resources of the British Empire' *Oxford Forestry Memoirs* Vol. 13

Bushnell, T. M. (1932) 'A new technique in soil mapping' *American Soil Survey Association Bull.* Vol. 13 74–87

Chenery, E. M. (1960) *Introduction to the Soils of the Uganda Protectorate* Dept. of Agriculture, Uganda

Christian, C. S. (1958) 'The concept of land units and land systems' *Proc. 9th Pacific Sc. Congress* Vol. 20 74–81

Christian, C. S. and Stewart, G. A. (1953) 'General report and survey of Katherine–Darwin region, 1946' *CSIRO Aust. Land Res. Ser.* Vol. 1

Colonial Office (1952) *Report on Central African Rail Link Development Survey* (2 vols) London

Colwell, R. N. (Ed.) (1960) *Manual of Photographic Interpretation* American Society of Photogrammetry, Washington

Colwell, R. N. (1968) 'Remote sensing of natural resources' *Scient. Am.* Vol. 218 No. 1 54–69

Evans, R. (1948) *An Introduction to Colour* New York

Grimes, B. H. and Hubbard, J. C. E. (1971) 'A comparison of film type and the importance of season for interpretation of coastal marshland vegetation' *Photogrammetric Record* Vol. 7 38

Gunn, R. H. (1955) 'Use of aerial photography in soil survey and mapping in the Sudan' *Soils and Fert.* Vol. 18 104–6

Howard, J. A. (1970) *Aerial Photo-ecology* London

Jones, A. D. (1969) 'Aspects of comparative air photo-interpretation in the Dyfi estuary' *Photogrammetric Record* Vol. 6 No. 33 291–304

Lambott, P. (1970) 'Some aspects of photography in airborne sensing' *Photogrammetric Record* Vol. 6 No. 35 434–45

Latourneaux, P. J. (1969) 'Improving quality of aerial colour prints' *Photogrammetric Engineering* Vol. 35 147–52

McLerran, J. H. (1968) 'Infra-red sensing of soils and rock' *Materials, Research and Standards* Vol. 8 No. 2 17–21

Milne, G. (1935) 'Some suggested units of classification and mapping, particularly for East African soils' *Soils Res.* Vol. 4 No. 3 183–98

Mitchell, C. W. (1973) *Terrain Evaluation* London

Mountain, M. J. (1964) *Report on Soil and Engineering Map of an Area in the Immediate Vicinity of the Etosha Pan, Ovamboland, S.W. Africa* CSIR, South Africa, NIRR, Cape Town

National Aeronautical and Space Administration (NASA) (1967) Earth photographs from Gemini III, IV and V. Washington

Pardoe, G. K. C. (1969) 'Earth resources satellites' *Sci. Jnl.* Vol. 5 No. 6 58–67

Parker, D. C. (1968) 'Developments in remote sensing applicable to airborne engineering surveys of soils and rocks' *Materials, Research and Standards* Vol. 8 No. 2 22–30

Parry, J. L., Cowan, W. R. and Heginbottom, J. A. (1969) 'Soils studies using colour photos' *Photogrammetric Engineering* Vol. 35 44–56

Perrin, R. M. S. and Mitchell, C. W. (1969) 'An appraisal of physiographic units for predicting site conditions in arid areas' *MEXE Report 1111*

Pestrong, R. (1969) 'Multiband photos for a tidal marsh' *Photogrammetric Engineering* Vol. 35 453–70

Rib, H. T. and Miles, R. D. (1969) 'Automatic interpretation of terrain features' *Photogrammetric Engineering* Vol. 35 153–64

Smith, J. T., jnr. (Ed.) (1968) *Manual of Colour Aerial Photography* American Society of Photogrammetry, Washington

Sorem, A. L. (1967) 'Principles of aerial colour photography' *Photogrammetric Engineering* Vol. 33 1008–18

Steiner, D. (1966) 'Investigation of seasonality as a factor affecting the photo-interpretation of rural land-use' *Arch. Int. Photogrammetrie* Vol. 16 No. 2 67–80

Stewart, G. A. (Ed.) (1968) *Land Evaluation*, Melbourne

Strandberg, C. H. (1967) *Aerial Discovery Manual*, New York

United States, Department of Agriculture (1966) *Aerial-photo Interpretation in Classifying and Mapping Soils* Agriculture Handbook 294, Washington

Unstead, J. F. (1933) 'A system of regional geography' *Geography* Vol. 18 175–87

Webster, R. (1963) 'The use of basic physiographic units in air photo interpretation' *Arch. Int. Photogrammetrie* Vol. 14 143–8

6 Air Photography and Plant Ecology

D. E. COOMBE

Lecturer in Botany in the University of Cambridge and Fellow of Christ's College

Plant ecology can be defined as the study of the mutual relationships between all forms of plant life and their diverse and complex environments. Only a very small fraction of the earth's vegetation exists more than 100 m above the land surface, or more than 100 m below the surface of the oceans. Although the plants of the open seas are of enormous importance, their microscopic size, and the relatively low light transmission of water compared with air, precludes their study by air photography to the extent which is possible with land plants. Nevertheless, much information can be gained from the air about the marine environment (e.g. surface water temperatures) by modern remote sensing techniques. It remains true however, that most work on the uses of air photography in plant ecology has been done on the vegetation of the earth's land surfaces, or of relatively shallow coastal and fresh waters.

When Pigott (1966)* wrote the first edition of this chapter, air photography was seen as a method of teaching and research in plant ecology, and in the surveying and conservation of plant communities. However, the number of published accounts of applications to specific problems was limited. Since then it has become an indispensable adjunct to almost every study of terrestrial plant communities. This is reflected by the appearance of the textbook *Aerial Photo-ecology.* (Howard 1970), which has, however, a bias towards the ecology of forest trees. Meanwhile, a wide range of new techniques has been developed, e.g. infra-red false colour film, multi-band photography, density slicing†, and linescan thermography (summarised

by Grimes and Hubbard 1972).

The emphasis in this chapter, therefore, is on actual situations in which air photography has been of outstanding importance in recording and interpreting vegetation, and where the areas concerned have been studied in detail on the ground by a number of ecologists, including the writer.

The limitations of air photography

It has already been mentioned that most oceanic plants (phytoplankton) are microscopic; in addition, many intertidal seaweeds require the use of the microscope for accurate identification. A hand-lens is still part of the essential equipment of the land-based botanist; a plant can rarely be identified from an air photograph with certainty, and then only in a particular context if the components of the vegetation have already been studied on the ground by an expert. Thus in Photo. 6:2 the remarkable, whitish, ring-worm-like patches of vegetation on Lakenheath Warren, in the Breckland of West Suffolk (TL 7780), suggest to an ecologist familiar with the East Anglian Breckland that they consist of the sand sedge (*Carex arenaria*); but only careful study of this ungrazed grassland on the ground (by Dr A. S. Watt, Mrs G. Crompton, the writer and others) confirms this tentative identification.

Vegetation survey and mapping

Since the turn of the century British plant ecologists have been mainly concerned with seeking to understand the processes of change in vegetation; with the relation of vegetation to past and present environmental factors in limited but intensively-studied areas (e.g. Lakenheath Warren, Photo. 6:2 and Wicken Fen, Photo. 6:3); with the response of individual species to their environment; with the structure and regeneration of plant com-

* A list of references quoted in this Chapter is printed on p. 102.
† Density slicing is a process which enables parts of the image having equal density of tone to be reproduced independently of the rest. The technique requires the use of special 'selective' film.

munities, and with the experimental elucidation of these phenomena in terms of biochemistry and physics. The growing appreciation of the fact that the world's vegetation is fragile, expendable and diminishing has only recently aroused sufficient interest in Britain for ecologists to attempt a complete inventory of whatever of importance survives, and where. Air photography is an indispensable aid in providing this information: the photograph of East Walton 'Common', West Norfolk (Photo. 6:6) is a good example. This area is outstanding not only physiographically but also for its living and fossil plants (Sparks, Williams and Bell 1972; Sparks and West 1972); yet it was known to few botanists outside Norfolk until recently, and is still not fully described. Very extensive use has indeed been made of air photography in recent years by various organisations and individuals concerned with ecological research and with conservation, but much of this work is still unpublished.

Britain is so well mapped by the Ordnance Survey that an ecologist preparing a vegetation map generally needs neither sophisticated knowledge of optics or geometry, nor particularly expensive apparatus. Even low altitude oblique photographs can often be used as a basis for survey when a sufficient number of natural features can be identified both on a photograph and on a large-scale map (as, for example, in the case of Wicken Fen, Photo. 6:3). In featureless terrain ground markers can often be put down before a flight is made. A surprisingly high degree of accuracy for areas of low relief can be obtained by projecting a 35 mm transparency of a vertical air photograph through an ordinary slide projector on to the appropriate 25 inch (1:2500) O.S. map if reference features (roads, hedges, tumuli, etc.) are sufficiently well-defined. Parallax errors are negligible for this purpose, especially when high resolution film is exposed at a scale of about 1:10 000 and at intervals chosen to give a fair degree of overlap. Only the central part of each photograph need then be used and compensation for slight changes in scale can readily be made by adjusting the distance of the projector from the map. Dr Oliver Rackham and the writer, with students from Cambridge University Botany School, have mapped in this way the 200 acre (80 ha) reserve of the Cornwall Naturalists' Trust on the Lower Predannack Downs, Cornwall (SW 6814) at a scale of 1:2500, constantly referring back and forth between the results of field survey and air photographs from a number of different sorties. In some respects the revised 1:2500 O.S. map of 1907 is shown by these air photographs to be less accurate than a survey made in 1693 and 1694 by Joel Gascoigne for the 2nd Earl of Radnor (the Lanhydrock Atlas, still kept at Lanhydrock House, Cornwall; see Pounds 1945). In this instance, as in many others, the air photographs show very small variations in the composition of the vegetation and the presence of prehistoric features such as ancient boundaries, cultivation patterns and sites of habitation, previously undetected on the ground.

A further advantage of air photography for the mapping of vegetation is that it avoids damage to fragile vegetation and provides a visual record of areas difficult of access. This is well exemplified by the patterned blanket mires of Silver Flowe, Kirkcudbrightshire (Photo. 6:7), in which the bog mosses (*Sphagnum* species) are easily damaged by trampling and the terrain is almost impossible to map on the ground. Similar considerations apply to coastal saltmarshes and many other types of vegetation: the reedswamps of the Norfolk Broads, for example (Photo. 6:4).

Vegetation structure

Most terrestrial plant communities are stratified into many layers, both above ground and below. Air photographs provide little information on this aspect of vegetation, although stereoscopic pairs reveal the contours of the visible surface, from which in some cases valuable information may be gained (especially in forest ecology; Howard 1970). Such stratification above ground is a familiar feature of woodlands (tree, shrub, herb and moss layers), but the equally important stratification of underground organs (roots, rhizomes, bulbs, etc.) is much less obvious (cf. Woodhead 1906). Both types of stratification can only be studied on the ground.

Very few plants are distributed horizontally in anything approaching a random manner, but on the other hand, regular spacing is generally a result of man's activities. Most plants in natural or semi-natural vegetation occur in patches in individuals or shoots (clumped or 'overdispersed'; Greig-Smith 1964; Kershaw 1964); often there are several scales of patchiness even for a single species. Very small-scale patchiness, e.g. the clumps of shoots (tillers) of a perennial rhizomatous grass such as the bent (*Agrostis tenuis*) may only be detectable by painstaking quantitative analysis on the ground (Kershaw 1958); even so, quite small-scale patterns (of the order of a few decimetres) can be picked up under favourable conditions (cf. the mole-hills in Photo. 6:5, at a scale of 1:667). On the other hand, some complex large-scale patterns are virtually undetectable and almost impossible to measure on the ground: for example, the two major scales of pattern of the sand sedge (*Carex arenaria*) so clearly shown in Photo. 6:2 are very difficult to see except from the air, whereas the small-scale pattern of this species due to the clumping of the aerial shoots at every fourth node of the creeping underground stems (rhizomes), can only be detected on the ground and elucidated by excavation of the underground organs. Sometimes patterns may only be detectable at a particular season or under

special conditions of grazing or relaxation of grazing; thus *Calluna* stripes on the Breckland, barely visible as long as rabbit-grazing was intense, have become very obvious (cf. Photo. 6:2) in a number of places in the Breckland since the incidence of myxomatosis in 1954. Conversely, a former pattern may subsequently have been destroyed, but a record exists in an air photograph (Photo. 6:4).

Air photography can also throw light on the causes of pattern. Approximately circular patches of vegetation, dense and vigorous at the margins, sparse and senescent at the centre, are almost invariably due to the growth of individual plants with horizontal underground stems radiating from the point where the plant became established: the youngest parts are at the margins, the oldest at the centres of the patches (cf. Watt 1947, Figs. 8 and 9). Each large patch (up to 200 m in diameter) of sand sedge in Photo 6:2 is a single individual; similar patterns due to the morphology and life-history of the plant itself can be seen in the cord-grass (*Spartina* × *townsendii*, *S. anglica*) of coastal mudflats. Concentric rings of growth have been observed in *Spartina* in the Exe estuary in Devonshire. 'Fairy rings', so familiar in air photographs of old pasture, are a manifestation of a similar phenomenon among fungi.

Just as striking in air photographs is the patchiness due to heterogeneity of the environment, particularly of the soil (see Chapter 5), although it may also arise from the activities of animals (grazing, trampling, defecation, burrowing, etc.); these may then give rise to microclimatic heterogeneity (e.g. on the opposite sides of an ant-hill). The sand sedge shows an intermediate scale of pattern of reticulations some 10–11 m in diameter on deep, non-calcareous sand on level ground, and is sparse on, or absent from, the circular patches of calcareous soil. On gentle slopes the pattern is one of alternating stripes with and without the sand sedge; each unit of the pattern is then about 6–7 m along the contours (Photo 6:2). Numerous examples are known in East Anglia of soil-vegetation patterns ('stripes and polygons') caused by periglacial solifluction during the last glaciation (Photos. 6:2 and 6:5; Figs. 6:A and 6:B); attention was first drawn to the stripes by Watt (1955), although he had observed faint stripes in *Calluna* on Cockley Cley Warren, West Norfolk (TF 8204), in the late 1930s (pers. comm.). Stripes and polygons have been described in more detail in papers by Williams (1964) and by Watt, Perrin and West (1966), illustrated with photographs from the Cambridge Collection. Superficially similar patterns in East Anglia were correctly ascribed by Trist (1952) to fossil ice-wedge polygons; these were formed by contraction at very low temperature of deeply frozen ground and not by the pressures developed in a freezing mass of subsoil over a permafrost. Other

Photo. 6:1 Part of the Goonhilly Downs, Cornwall, looking north-west from the eastern corner (A) of Croft Pascoe (SW 732201).

One of the best-preserved elevated marine platforms in the British Isles, with a general height of about 100 m above sea level. The rock underlying most of the ground within this view is serpentine. The combination of exposure to severe salt-laden gales, the relative infertility and waterlogging of the soils, and centuries of grazing, turf-cutting and burning have kept the plateau relatively treeless, probably since Neolithic times. The darkest unenclosed areas (e.g. B) represent a species-poor community of heathers (*Erica tetralix*, *Erica cinerea*, *Calluna*), of Welsh gorse (*Ulex gallii*) and of the grasses *Molinia* and *Agrostis setacea*. These are growing on an acid gley-podsol developed on about 1 m of wind-blown loess consisting of minerals derived from neighbouring areas of Hercynian granite. The light-coloured areas which occur in shallow depressions (e.g. C) represent a remarkable community of *Schoenus nigricans*, *Erica vagans* (the Cornish heath) and many other species on the heavy water-logged clay derived mainly from the serpentine (Coombe & Frost 1956a, b). Relatively early enclosures (e.g. Croft Pascoe, left foreground) have irregular and sinuous boundary banks or 'hedges', (as at D); later (eighteenth- or nineteenth-century) ones (e.g. Croftnoweth, the 'new croft', centre, E) tend to have geometrical outlines. These later crofts usually occur on the deep silty loess, always more amenable to improvement than the heavy clays which are shallower and wetter; some of these isolated crofts were under cultivation in 1962. At the extreme top left of the photograph is the relatively fertile and sheltered landscape (F) on the deeply weathered hornblende schists around Bonython (SW 7201). An ancient parish boundary 'hedge' between Cury to the north-west and Mullion and Grade-Ruan to the south-west is evident about a quarter of the way down from the top of the photograph at G; such banks often support a varied flora including the interesting ferns *Osmunda regalis* and *Dryopteris aemula*. Another ancient boundary, first defined in a perambulation allegedly of 977 A.D., follows the north-west margin of Croft Pascoe (the present parish boundary of St Keverne); it is marked by a set of trackways across the Downs, visible on the photograph (H); these are referred to in manuscripts dated 977 and 1290 A.D. These trackways (some of which may go back to Neolithic times) are of great ecological importance as the habitat of many rare plants (e.g. *Juncus mutabilis*). Air photographs can thus locate the only possible habitats of many of these plants on the Lizard Peninsula. The shallow pool at the bottom left of the photograph (J) has a rich aquatic flora: although now known as Croft Pascoe Pool it was recorded in 1290 A.D. as 'Grelynbesek', which is Middle Cornish for dirty cattle pond (Henderson 1932). Subsequent panchromatic and infra-red false colour vertical photographs taken in 1968 and 1971 emphasize the rapid pace of the destruction of the unique vegetation and soil profiles of this area of such outstanding scientific and archaeological interest.

AFF 5 *8 June 1962*

Photo. 6:1 Goonhilly Downs

patterns are formed by differential weathering along joints of a limestone substratum; such karstic features are more obvious in the 'clint and grike' of limestone pavements in north-west England and in the Burren in County Clare in Ireland (Photo. 3:2). Man as an agent of environmental pattern should also be mentioned here; controlled burning of moorland or scrub, strip-ploughing leading to ridge and furrow, which in heavy soils provides alternating bands of well-drained ridges and waterlogged furrows, and ancient peat-diggings are but a few examples.

These patterns may be revealed in sown crops as well as in natural or semi-natural vegetation; this is well shown by the pattern of cock's-foot grass and Dutch clover (*Dactylis glomerata* and *Trifolium repens*) in Photo. 6:5 and Figs. 6:A and 6:B. Barley (*Hordeum vulgare*) in East Anglia provides a particularly striking example in some seasons. When a late spring drought is followed by a wet July and August, as happened in 1966, the barley on the calcareous elements of the 'stripes and polygons' soil pattern does not suffer markedly from the drought because of the high water-retaining capacity of the chalk, and produces a good crop of ripe yellow ears (say 4–5 metric tonnes per ha). On the deep, sandy, non-calcareous elements of the pattern the first ear of each plant aborts because of drought, but the plant does not completely die: during the summer rains it produces new basal axillary shoots (called tillers) with green foliage and immature ears with little or no ripe grain at the time of harvest. The resultant pattern of golden yellow and deep green is very striking in colour photographs in late July and early August. Heavy dressings of lime, nitrogen, potassium and phosphorus do not prevent these patterns developing in barley; on the other hand, heavy manuring inhibits the development of pattern in *Dactylis*, since the failure of this grass on the deep sands is due more to nutrient deficiency than to drought (this is very evident from the oblique photograph reproduced in Williams (1964), in which the foreground had been heavily manured with lime and sewage sludge). Somewhat similar patterns can be detected in crops of wheat (*Triticum aestivum*) and lucerne or alfalfa (*Medicago sativa*).

East Walton 'Common', Norfolk (Photo. 6:6) provides a recently described example of a physiographic pattern and soil-vegetation mosaic determined by ground ice action in the Late-glacial (Late Weichselian) period. The details of formation are uncertain although the structures have been compared with the pingos of Arctic Canada; but like the East Anglian stripes and polygons this remarkable type of patterned ground cannot be exactly matched with any forming in the Arctic at present (Sparks, Williams and Bell 1972). Nevertheless, the air photograph provides a vivid and objective record of a remarkable topography and vegetation.

The zonation of vegetation along an environmental gradient represents a special but very widespread example of patterning. This may very commonly be observed and even mapped from photographs. Zonation may be relatively static over long periods (e.g. the soil-vegetation catenas of plateaux, slopes and valley bottoms; or the zonations above and below high water mark on rocky coasts); or it may reflect relatively rapid vegetational changes (plant successions: e.g. on saltmarshes, or the 'sere' from open water communities of lakes through reedswamps of various kinds

Photo. 6:2 Part of the eastern end of Lakenheath Warren, West Suffolk (TL 7880), looking north.

Forestry Commission plantations of Corsican pine (*Pinus nigra* subspecies *laricio*) and Scots pine (*Pinus sylvestris*) are seen at the extreme top edge (in the former parish of Wangford), and a corner of Eriswell High Warren (cf. Chapter 5 by R. M. S. Perrin and Photo. 5:1) in the foreground (uncultivated); the arable crop in the bottom right-hand corner is lucerne (*Medicago sativa*). There is no evidence of any kind to suggest that this part of Lakenheath Warren has ever been cultivated, although an area to the east, beyond the right-hand margin, was probably under oats (*Avena sativa*) during and just after the First World War. Parallel lines and divergent trackways evident on the photograph were caused by a variety of military activities during the Second War (information from Mrs G. Crompton). The light patches of vegetation forming mottled and striped patterns are of the sand sedge (*Carex arenaria*). This seldom grows from seed, but a plant once established rapidly spreads radially by creeping underground stems (rhizomes); as in the case of many such rhizomatous plants, the nearly circular patches tend to be more vigorous at the margin, and die out in the older central part. The sand sedge also remains vigorous longer where the soil is deep and sandy, but dies out sooner where it is shallow and calcareous. Like the heather (*Calluna*) in Photo. 5:1 and the various species in Photo. 6:5, the sand sedge reveals the heterogeneity of the underlying soil, but also shows a larger scale of pattern dependent on the life history and growth of the plant itself: the large patch in the centre of the photograph is a single plant some 200 m in diameter. This photograph was taken shortly after the dramatic decline in the population of rabbits following the outbreak of myxomatosis in 1954; hundreds of abandoned rabbit-holes and scrapes are visible in the photograph as white flecks. Had the rabbits been present to graze the sand sedge this pattern would probably not have been visible. The vegetation of Lakenheath Warren has changed dramatically in the twenty years since myxomatosis reduced the rabbit population, notably by the invasion of trees, bushes, heather and the coarser grasses; these changes can be followed on the numerous air photographs of the Warren.

PP 37

14 April 1955

Photo. 6:2 Lakenheath Warren

to wet woodland as shown in Photo. 6:3). A single air photograph records the zonation at a given time; photography repeated over a period indicates whether the vegetation pattern is relatively stable or changing. This topic is considered further in the next section.

The rate of change of vegetation

Few people appreciate how rapidly vegetation can change with time, either by cyclical processes within an apparently stable community (Watt 1947) or in response to changes in the environment (called allogenic succession) such as those drastic changes which followed the outbreak in 1954 of myxomatosis in rabbits, or by changes induced by the plants themselves (autogenic succession), for example by the accumulation of peat in waterlogged habitats, as in the Norfolk Broads. In fact vegetational change commonly involves all three types of process. Changes in land-use and vegetation occur so rapidly that past editions of Ordnance maps soon become out of date in this respect. The increased use of air survey in cartography ensures that current maps are kept more up to date than their predecessors; nevertheless, no maps, however large the scale, can convey such precise information as an air photograph taken on a known date.

The fact that much of Britain has been repeatedly covered by air photography over the last three decades is of the utmost value to students of vegetation dynamics. A study of most areas may begin with the Royal Air Force vertical cover. These invaluable photographs are available in most County Planning Offices as well as at the National Monuments Record in London. Exceptionally, some areas have been covered time and again. Thus, Wicken Fen, Cambridgeshire (Photo. 6:3), has been photographed by the Cambridge University Department of Aerial Photography no fewer than thirty-six times since 1948, providing a unique record of the drastic changes in vegetation there over the past quarter of a century, and oblique photographs of the Fen taken fifty years ago have been discovered recently.

H. Hamshaw Thomas (1924) was one of the first to discuss in detail the value of air photography in recording rapid changes in physiography and vegetation, especially on sand dunes and saltmarshes; he recorded that Blakeney Point, on the north Norfolk coast, was photographed three times in 1921 (May, October and December), and he reproduced the sketch-map published by Salisbury (1922) which was based on those photographs.

The fifty-seven photographs taken in the spring and summer of 1924 and published in *Wessex from the Air* (Crawford and Keiller 1928) include

Photo. 6:3 Part of Wicken Sedge Fen, Cambridgeshire (TL 5570), looking north-west from Wicken Lode (D).

The photograph shows the extent of colonization by bushes in 1950; most of them are alder buckthorn (*Frangula alnus*) and have grown up since the 1920s. The sites of Professor Sir Harry Godwin's long-term experimental plots are visible: (A) is the 'Godwin triangle' first surveyed in 1923 and 1924 when much 'mixed sedge' (*Cladium* and *Molinia*) was present; again in 1934 when bushes of alder buckthorn and purging buckthorn (*Rhamnus catharticus*) covered most of the plot (see Tansley 1939 pp. 658–659); and most recently in 1972 when the 'mixed sedge' had totally disappeared and had been replaced under the bushes by such plants as ground ivy (*Glechoma hederacea*), nettle (*Urtica dioica*) and the grass *Poa trivialis* (Godwin *et al.* 1974). (B) Godwin's experimental plots to investigate the effects of the frequency of mowing on the composition of a 'litter' community dominated by *Molinia*; detailed observations were maintained from 1929 to 1941, and as seen in the photograph some of the plots were still being mown in 1950. Since then mowing has ceased, alder buckthorn has invaded all the plots, killing the *Molinia*. Numerous calcifuge mosses (*Sphagnum, Polytrichum, Campylopus,* etc.) which have become established on the acid remains have recently been discovered by Dr J. M. Lock. (C) Godwin's plots designed to investigate the effects of the frequency of mowing on the composition of 'mixed sedge' (see Godwin 1941 for a detailed record from 1929 to 1941), and currently maintained for teaching purposes. The control plot, not mown since 1929, is now completely dominated by *Frangula*; the plot mown annually, by *Molinia; Cladium* survives in the plots mown less frequently (at 2, 3 or 4 year intervals), but has declined in vigour as the fen surface has increasingly tended to dry out. (E) a small area of old 'carr' similar to (A), dominated by purging buckthorn, but partially destroyed for the construction of an observation tower in 1957. (F) the last site, within living memory, of deep peat-cutting on Wicken Sedge Fen; *Cladium* is now (1973) very vigorous in the old trenches and colonization by bushes is sparse or absent. Much of the area between (A) and (F) was accidentally burnt on 31 May 1951, and slight damage was done to the 'Godwin triangle'; most of the area (except for the deep peat-cuttings) is now covered with even-aged alder buckthorn. (G) Gardiner's Drove, with heaps of mown litter left to encourage invertebrates. (H) Drainers' Dyke, with some open water (dark), but mostly overgrown with reed (*Phragmites*); this was subsequently dredged and deepened in 1962. (J) one of the two sites of bog myrtle (*Myrica gale*) on the Fen beside Sedge Fen Drove (K). (L) Verrall's Drove. (M) planted birch (*Betula*) freely regenerating, with some planted alder (*Alnus*) less freely regenerating. (N) northern corner of Verrall's Fen where bush colonization was checked by pumping water onto the Fen.

EZ 13 *10 June 1950*

Photo. 6 : 3 Wicken Sedge Fen

many chalk grassland sites which are outstandingly rich in species; at least fourteen show areas of the especially interesting *Carex humilis* type of grassland which occurs on very shallow rendsina soils; in Britain this is concentrated on the chalk of south Wiltshire and north Dorset (but it is almost entirely absent from Hampshire). Much can be inferred, for example from the superb photograph of Hod Hill, Dorset (Crawford *et al.* 1928 Plate I). Rabbits were evidently very abundant on the steep west-facing upper slope above the River Stour, keeping down the scrub which has invaded the grassland since myxomatosis. *Carex humilis* and the many interesting associated species (one of them the food of a rare butterfly) are now restricted to those areas which have not been cultivated or occupied for some 1900 years, especially the steep south-facing slopes of the Iron Age ramparts, counter-scarps and quarry-pits, and of the embankments and ditches of the Roman fort. Nearly half (the western part) of the Iron Age enclosure was turf-pared and ploughed in 1858; by 1865 the enclosure within the Roman fort had been ploughed. By 1913 the whole area had reverted to pasture; in 1924 the air photograph still showed the straight furrows of the 1858 ploughing, but no signs of ploughing were obvious within the Roman fort. During and after the Second World War further areas of the Iron Age enclosure were deeply ploughed, leaving only 14% still (1973) unploughed. Most of the area is once again cattle-grazed grassland. Further details and the relevant literature are given by Crawford and Keiller (1928) and by Richmond (1968).

Incidentally, another chalk grassland site for *Carex humilis* was photographed by Sharpe from a 'war balloon' in 1906 (Sharpe 1907): namely Stonehenge, where the plant still (1973) exists in small quantity despite the trampling of 636 700 visitors in 1973 alone and the close mowing of the turf by the Department of the Environment.

Photographs of saltmarshes at Calshot, Hampshire, were taken from a captive balloon in 1907 and published by Thomas (1924).

Another classic set of early photographs with much to interest ecologists has been preserved in Jones and Griffiths (1925). This consists of a mosaic, probably taken in the summer of 1922, covering more than 200 square miles of south Cambridgeshire, reproduced at a scale of 1·53 inches to the mile (1:41 400). Despite the apparent loss of the original negatives and prints, much valuable information about changes in grassland, scrub and woodland over the last half-century can be gleaned from the reproduction.

Environmental factors

There are many environmental factors that control the growth and distribution of plants other than the soils on which they grow. These can be recorded and in some cases assessed from the air. They may have been operating at the moment a photograph was taken: examples are grazing intensities and grazing preferences of identifiable animals, either domestic or feral (cf. the sheep preferentially grazing the *Dactylis* areas in Photo. 6:5). Other effects may have been determined by details of the recent treatment of the land, such as the addition of fertilisers or manure to pastures; the regrowth of vegetation after fire; mowing at various times and intervals (cf. Wicken Fen, Photo. 6:3); ploughing, the furrows remaining visible for decades, as noted for Hod Hill in the previous section; and the destruction of walls, hedges and woodlands. Tank tracks and other disturbances created during the Second World War may remain visible in air photographs at least two decades after they were made, as they do on Thetford Heath and Lakenheath Warren (Photo. 6:2). The great increase in recreational activities in recent years is evident in the erosion of sand-dunes by trampling and the effects of car-parking on heaths and cliff-tops.

Even microclimatic factors may be inferred from photographs showing differential snow-lie which arises from differences in irradiation or soil

Photo. 6:4 Barton Broad, Norfolk (TG 3621), looking north.

This photograph was first reproduced in the classic work by Lambert *et al.* (1960) which demonstrated beyond reasonable doubt that the Norfolk Broads are flooded medieval peat-cuttings mainly excavated before the fifteenth century. The peninsulas and islands of reed-swamp, mainly of the lesser reedmace (*Typha angustifolia*), the bulrush (*Schoenoplectus* or *Scirpus lacustris*) and the reed (*Phragmites communis*), mark the positions of submerged balks of peat between adjacent excavations. The six well-marked parallel lines in the foreground lie in the former parish of Irstead; it is significant that the three less distinct parallel lines to the north, in the former parish of Barton Turf (so named in medieval times), lie at a different angle. The approximate line of the former parish boundary between Barton Turf and Irstead is indicated by a solid white line. Below this line, to the left, is part of Heron's Carr, a very wet alder (*Alnus glutinosa*) 'swamp carr'; this and the aquatic vegetation of Barton Broad were first described by Miss Marietta Pallis in Tansley (1911, Chapter X). More recent photographs of Barton Broad show that this convincing visual evidence for a man-made origin has been almost totally obliterated by the combined effects of the coypu (*Myocaster coypus*) and the great increase in motor-boating in recent years.

HI 83 *11 June 1952*

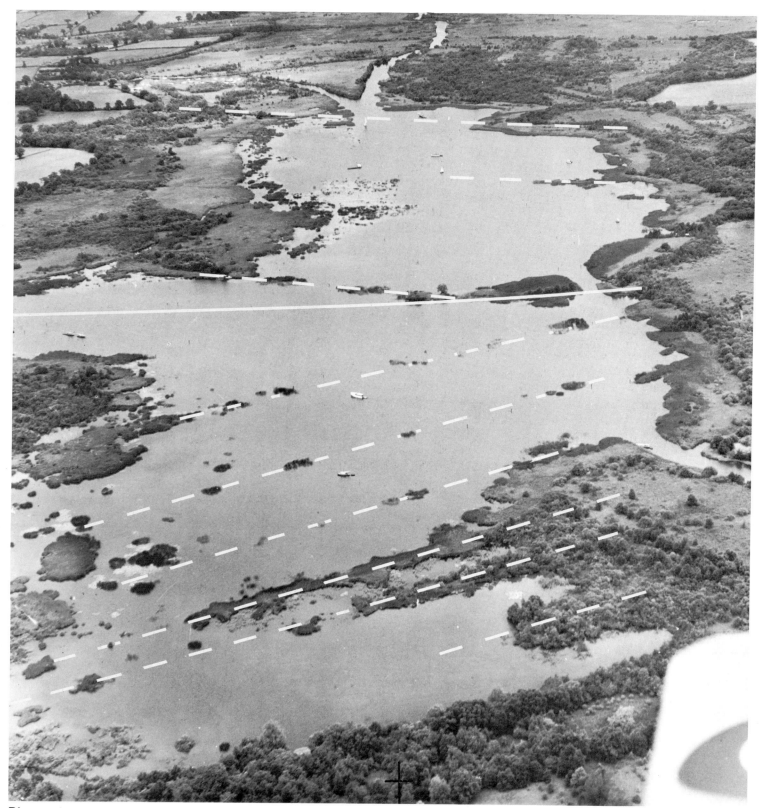

Photo. 6 : 4 Barton Broad

Fig. 6: A and B

Fig. 6:A (left) The distribution of calcareous polygons (above) and stripes (below), with transitional patterns between, at the brow of a gentle slope in the 50 × 25 m plot indicated in Photo. 6:5 at The Drove, Brettenham. Calcareous stripes and polygons with sown *Dactylis* and *Trifolium repens* are shown white; the deep (1–2 m) acid sandy infilling between them, dominated by *Holcus mollis*, *Agrostis canina*, *A. tenuis* and *Ulex europaeus*, is cross-ruled. Mole-hills shown as circles: 698 occur in 554·5 square metres of *Dactylis* and *Trifolium*, and only 65 in 695·5 square metres of *Holcus-Agrostis-Ulex*.

Fig. 6:B (right) The same plot showing that *Ulex europaeus* (in black) is almost confined to the acid sandy *Holcus-Agrostis* areas: this may not arise directly from soil differences, but to less competition between the *Ulex* seedlings and the sparser grasses on the sandy soil. The asymmetry of the *Ulex* pattern (particularly evident in the photograph) depends on the fact that ploughing has moved the topsoil some 80 cm laterally; the direct or indirect effects of moving calcareous topsoil over non-calcareous subsoil and of moving non-calcareous topsoil over calcareous subsoil are quite different in their effects on the growth of *Ulex*. In Figs. 6:A and 6:B the boundaries of the *Dactylis* and *Holcus-Agrostis* areas were mapped on 24 and 25 August 1961 by J. K. Moore; the mole-hills and *Ulex* were plotted independently on the same days by W. K. Henson.

Photo. 6:5 Patterned vegetation caused by soil structures formed under periglacial conditions in East Anglia at The Drove, Langmere Hill, Brettenham, Norfolk (TL 917840).

This enclosure was ploughed in 1958 and reseeded uniformly with a mixture mainly of cock's-foot (*Dactylis glomerata*) and white clover (*Trifolium repens*). By August 1961 these plants were completely absent from the deep acid sandy component of the soil pattern, being replaced instead by the wild grasses *Holcus mollis*, *Agrostis canina* and *A. tenuis* (which appear grey in the photograph), and bushes of gorse or furze (*Ulex europaeus*), which appear black. On the calcareous polygons, on level ground towards the top of the picture, and stripes, on a gentle slope towards the bottom, the sown crop has persisted and shows light in colour; small white dots on the calcareous polygons are mole-hills; larger oval white objects are sheep. The superimposed rectangle is the 50×25 m plot mapped in detail in Figs 6:A and 6:B.

V-AJ 34. Scale 1:667 *17 August 1961*

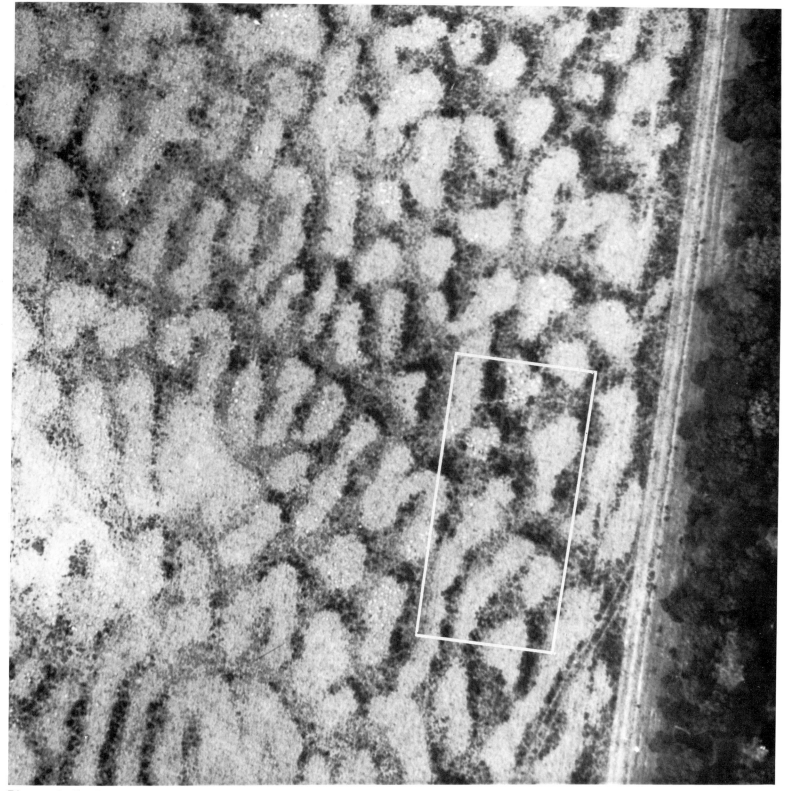

Photo. 6 : 5 Langmere Hill, Brettenham

temperature, or from visible frost damage to vegetation; for example, to young beech (*Fagus sylvatica*) and oak (*Quercus* species) foliage following late frosts in temperature inversion hollows. Trees damaged by wind and lightning have often been detected in air photographs.

The effects of pathogens on plants are considered by Rishbeth in Chapter 7; the recording of the progress of Dutch elm disease may be mentioned again here as a particularly striking and informative use of air photography, especially in true colour.

The structure and composition of present day vegetation also owe much to the effects of events in the distant past. Examples already mentioned are the profound effects of Weichselian (Glacial and Late-glacial) frost action (Photos. 6:2, 6:5 and 6:6), and of man's activities in prehistoric and historic times. Other examples, often only recorded in air photographs, are the evidence of ploughing two thousand or more years ago ('Celtic' fields), or more recently in the formation of strip lynchets, which may be medieval in origin, although the terraces of many are still under the plough; medieval peat digging is now recognized as the origin of the Norfolk Broads (Photo. 6:4); while many air photographs of the Lizard peninsula, Cornwall, appear to show the results of turf-paring for fuel; this practice has ceased only within living memory (about sixty years ago). Anglo-Saxon parish boundaries are often marked by curving or sinuous hedgerows, very rich in woody species, in contrast to the straight and less diverse hedges planted during the last few centuries. Here the plant ecologist and the historian work together to their mutual benefit, elucidating details of the history of the landscape with the aid of air photographs.

Conservation

Air photographs frequently give much more up-to-date and much less ambiguous information on the survival or destruction of vegetation than the most recent maps. The latest (1968) issue of the 1 inch Ordnance Survey Sheet 136 (Bury St Edmunds) and the 1966 reprint of the 1:25 000 Sheet TL 95 show most of the original extent of the ancient Monkspark Wood (TL 9257), once the property of the monastery of St Edmundsbury; true colour photographs taken on 17 October 1969 show this wood in the process of destruction; panchromatic vertical photographs taken on 10 November 1969 show that 70% had then been obliterated. Fortunately the adjacent Felshamhall Wood (TL 9357), in a different parish, is now owned, conserved and managed by the Suffolk Naturalists' Trust. Similarly, two spectacular series of vertical infra-red false colour photographs of the heaths and adjoining areas of the Lizard peninsula taken

Photo. 6:6 Part of East Walton 'Common', West Norfolk (TF 735165).

This is an area which is outstanding both for the preservation of presumed ground-ice depressions, of which other less well preserved examples are widespread on the Chalk-Fenland margin, and, more especially, for the mosaic of fen vegetation and calcareous grassland. The depressions probably date from the Late-Glacial (Late Weichselian) and are sometimes equated with the 'pingos' of the Mackenzie delta in arctic Canada; for their probable origin see Sparks, Williams and Bell (1972) and Sparks and West (1972).

The steep calcareous rims of the depressions are seen as paler loops or sinuosities rising some 3 m above the waterlogged hollows. The rims are only lightly grazed by cattle and bear a calcareous grassland flora rich in such characteristic species as *Asperula cynanchica*, *Cirsium acaulon*, *Filipendula vulgaris*, *Helianthemum chamaecistus*, *Hippocrepis comosa*, *Plantago media*, *Poterium sanguisorba*, *Primula veris* and *Scabiosa columbaria*. The depressions, which generally appear darker in the photograph, may exceed 100 m in diameter. They were formed some ten to fifteen thousand years ago by the melting of lens-shaped masses of ground-ice and are now partially filled with a few metres of peat which is mainly neutral or alkaline so that *Sphagnum* species are limited in extent; the fen vegetation on the peat includes many interesting species (*Cladium mariscus*, *Schoenus nigricans*, *Eriophorum angustifolium* and at least eleven species of *Carex*). Most of the trees (pedunculate oak, birch, ash, wych elm and alder) appear to be 'pioneers' which have invaded the grassland on the drier ground at various times over the last seventy years when grazing by rabbits and domestic animals was light. The numerous shrubs include hawthorn (*Crataegus monogyna*), blackthorn, purging buckthorn, gorse (*Ulex europaeus*), privet, sallow and guelder rose. The distinctive tree at A is a fine specimen of crab apple (*Malus sylvestris* subspecies *sylvestris*), illustrating the point that while a species cannot usually be identified with certainty from an air photograph alone, attention may be drawn to a particular individual which might be overlooked on the ground.

The depressions contain Late-Glacial organic remains which include abundant macroscopic fragments of *Betula nana*, as a native plant in Britain now restricted to northern Scotland, and pollen of *Juniperus*, now surviving very sparsely in East Anglia, and of *Empetrum*, *Polemonium* and *Saxifraga oppositifolia*, nearly or quite extinct in the south and east of Britain (F. G. Bell in Sparks *et al.* 1972).

It should be noted that this 'Common' is private and that there is no access except by permission of the owner who has kindly agreed to the publication of this account.

AWD 68 *30 July 1968*

98

Photo. 6:6 East Walton 'Common'

in September 1971 and June 1973 show all too clearly how rapidly these unique *Erica vagans* heaths, so rich in species, as well as the fascinating 'Short Heath' with its remarkable soil profile (Coombe and Frost 1965a, b), are being destroyed by ploughing, drainage and building construction. Even the ancient Cornish 'hedges' (variously constructed of turf, earth, worked stone or boulders), all of which are *refugia* for rare plants and animals, are no longer immune from the bulldozer. Air photography records, as no other method can, the relentless destruction in Britain of vegetation of scientific and aesthetic value, which until recently was erroneously regarded as 'safe'.

The ever-increasing pressures of public recreation on the remaining areas of open land, sand-dunes, heaths and cliffs have already been mentioned. The damage wrought in various ways by the large numbers of motor-boats on the Norfolk Broads can be gauged by comparing the picture of Barton Broad (Photo. 6:4), taken on 11 June 1952, with later photographs from which almost all the evidence of medieval peat-balks has now disappeared.

The evidence of such drastic changes emphasises the urgency for conserving what remains; biologists, archaeologists and Quaternary geologists frequently have a common interest in the preservation of important sites; ploughing, for example, destroys vegetation, surface features and soil profiles, all of which are irreplaceable. The grazing of cattle instead of sheep on old chalk grassland causes both a deterioration of the turf and the serious erosion of barrows by the herding together of animals in hot weather. On the other hand, under-grazing of long and round barrows is equally serious from the botanist's view-point.

Conservation is a complex process which involves the identification of promising sites; the description of their content of plants, animals and soils; the delimitation of boundaries; the acquisition of the land or effective control of its use; management; and continuous monitoring of change. Air photography can play an important part in most of these activities.

Teaching

Tansley's choice of an oblique air photograph of Beachy Head and the Sussex countryside for the frontispiece of his classic *The British Islands and their Vegetation* (1939) is significant. A good photograph is not only visually attractive but also, being so full of information, is intellectually stimulating, solving some problems and raising others. A good teacher is never at a loss for something interesting to say about an air photograph of vegetation: a good student never fails to ask intelligent questions. An

oblique photograph, especially one in colour, makes an immediate impact even on a layman; a vertical infra-red false colour photograph is immensely exciting from one aspect or another to any trained plant biologist.

The future

Vegetation is in a continual state of change, whether as a result of evolution, migration, climatic variations, man's activities, or other causes. Air photography, in common with other methods of remote sensing, has provided and will continue to provide the plant ecologist with one of the most convenient and powerful techniques for recording these changes in detail. Nevertheless, survey, inventory, analysis and experiment on the ground will remain as complementary methods; the permanent plot or quadrat will never be wholly superseded (see the legend to Photo. 6:5). While accurate identification of species will remain essential, just how fine and subtle are the distinctions which can be made from the air is still not widely appreciated: for example, between alternate 'stripes' on Weeting Heath, Norfolk (TL 7588) dominated by the closely related grasses *Festuca ovina* and *Festuca rubra*. These two species are frequently confused by otherwise competent ecologists, but they differ greatly in texture and tone ('shaving-brush' versus 'door-mat', dark versus light) and are clearly distinguishable even in panchromatic photographs. No doubt the new techniques of multi-band photography and 'density

Photo. 6:7 Long Loch Bog, Silver Flowe, Kirkcudbrightshire (NX 471843).

Silver Flowe comprises several areas of bog described as 'patterned blanket-mires'. This example, lying near the head of the valley called Cooran Lane, or the Cauldron of the Dungeon, shows very clearly the arrangement of pools and hummocks aligned along the contours. The whole of Silver Flowe was described by Ratcliffe and Walker (1958) in a paper in which this and other air photographs were published to illustrate the complicated morphology of the mires. To investigate and map in detail the surface vegetation of such difficult terrain would be impossible on foot; from the air the essential features can be readily observed. The area is dominated by various species of the bog-moss *Sphagnum*, which cover 80–90% of the surface of Silver Flowe. Long Loch Bog shows more evidence of erosion, due to burning and to lowering of the water-table, than the other parts of Silver Flowe; hence pools with white edges of *Sphagnum* are fewer than elsewhere in the valley, which in general is notable for being relatively undisturbed. Many oceanic species of plants characteristic of north-west Scotland have their southernmost limit of distribution here.

UV 24 *30 May 1957*

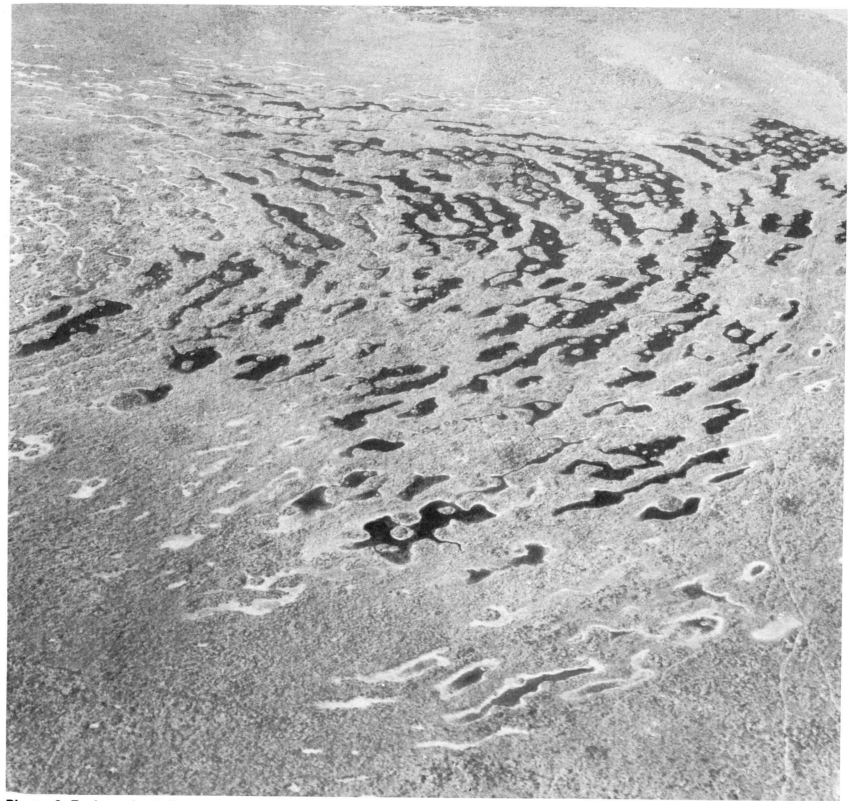

Photo. 6 : 7 Long Loch Bog, Silver Flowe

slicing' will enable further fine distinctions to be made.

The introduction of a cheap method of making colour plates for publication that entailed no loss of the fine detail that can be achieved on a good 9 inch (230 mm) square colour transparency is very desirable. The cost of conventional colour prints is almost prohibitive for general use, and the loss of detail serious. 35 mm colour transparencies remain the cheapest form of reproduction for study in the field.

Infra-red linescan, sideways-looking airborne radar (SLAR) and 'density slicing' will no doubt find ecological uses. The first is already showing promise in such applications as the study of leaf temperatures, which may be either below or above the ambient air temperature, and hence the water relations of vegetation. Over-cooling by ground frost is well-known in its effects; overheating of foliage may be an equally important ecological factor but has been much less studied. Hadfield (1968) found that the leaves of tea bushes (*Camellia sinensis*) in Assam can reach temperatures of 40–45°C in full sunlight when the ambient temperature is 30–32°C; photosynthesis declines sharply above 35°C, and 48°C is lethal. Oliver Rackham (pers. comm.) has also observed lethal overheating in the leaves of the herb *Mercurialis perennis* in a Cambridgeshire wood in full sun when the humidity is high. Such local overheating, which occurs, for example, in forest clearings, may be detectable from the air. Hot water effluents from industrial plant, or relatively warm water from sewage works, can have a profound affect on aquatic plants, and can readily be detected by linescan. The chief drawback of linescan, apart from expense, is its low resolution, and it will probably never achieve the recording of fine detail which is so valuable a feature of current panchromatic, colour and infra-red air photography.

Typescript received November 1973

REFERENCES

Coombe, D. E. and Frost, L. C. (1956a) 'The heaths of the Cornish serpentine' *J. Ecol.* Vol. 44 226–56

Coombe, D. E. and Frost, L. C. (1956b) 'The nature and origin of the soils over the Cornish serpentine' *J. Ecol.* Vol. 44 605–15

Crawford, O. G. S. and Keiller, A. (1928) *Wessex from the Air* Oxford

Godwin, H. (1941) 'Studies in the ecology of Wicken Fen. IV. Crop-taking experiments' *J. Ecol.* Vol. 29 83–106

Godwin, H., Clowes, D. and Huntley, B. (1974) 'Studies in the ecology of Wicken Fen. V. Development of fen carr' *J. Ecol.* Vol. 62 197–214

Greig-Smith, P. (1964) *Quantitative Plant Ecology* 2nd edn London

Grimes, B. H. and Hubbard, J. (1972) 'Aerial survey of natural resources' *Endeavour* Vol. 31 130–4

Hadfield, W. (1968) 'Leaf temperature, leaf pose and productivity of the tea bush' *Nature*, London Vol. 219 282–4

Henderson, C. (1932) 'The topography of the parish of St. Keverne. Part II (Rosuick-Tregonan)' *Royal Cornwall Polytechnic Soc.* Vol. 99 185–92

Howard, J. A. (1970) *Aerial Photo-ecology* London.

Jones, B. M. and Griffiths, J. C. (1925) *Aerial Surveying by Rapid Methods* (Preface by H. Hamshaw Thomas) Cambridge

Kershaw, K. A. (1958) 'An investigation of the structure of a grassland community. I. The pattern of *Agrostis tenuis*' *J. Ecol.* Vol. 46 571–92

Kershaw, K. A. (1964) *Quantitative and Dynamic Ecology* London

Lambert, J. M., Jennings, J. N., Smith, C. T., Green, C. and Hutchinson, J. N. (1960) *The Making of the Broads* Royal Geographical Society Research Series No. 3 London

Pigott, C. D. (1966) 'Air photography and plant ecology' Chapter VI in *The Uses of Air Photography* (J. K. S. St Joseph, Ed.) London

Pounds, N. J. G. (1945) 'Lanhydrock Atlas' *Antiquity* Vol. 19 20–6

Ratcliffe, D. A. and Walker, D. (1958) 'The Silver Flowe, Galloway, Scotland' *J. Ecol.* Vol. 46 407–45

Richmond, I. A. (1968) *Hod Hill* Vol. 2 London

Salisbury, E. J. (1922) 'The soils of Blakeney Point: A study of soil reaction and succession in relation to plant covering' *Ann. Bot.* London Vol. 36 391–431

Sharpe, P. H. (1907) 'Photographs of Stonehenge, as seen from a war balloon' (Communicated by J. E. Capper) *Archaeologia* Vol. 60 Art. XXIII, Plates LXIX and LXX

Sparks, B. W. and West, R. G. (1972) *The Ice Age in Britain* London

Sparks, B. W., Williams, R. G. B. and Bell, F. G. (1972) 'Presumed ground-ice depressions in East Anglia' *Proc. Roy. Soc. London* A Vol. 327 329–43

Tansley, A. G. (1911) *Types of British Vegetation* Cambridge (In which the alder 'swamp carr' and the other aquatic vegetation of Barton Broad were first described by Miss Marietta Pallis.)

Tansley, A. G. (1939) *The British Islands and their Vegetation* Cambridge

Thomas, H. Hamshaw (1924) 'Some features in the present position of aerial photographic survey' *J. Roy. Aeronautical Soc.* Vol. 28 475–500

Trist, P. J. O. (1952) 'Frost cracks' *Trans. Suffolk Nat. Soc.* Vol. 8 26–9

Watt, A. S. (1947) 'Pattern and process in the plant community' *J. Ecol.* Vol. 35 1–22

Watt, A. S. (1955) 'Stone stripes in Breckland, Norfolk' *Geol. Mag.* Vol 92 173–4

Watt, A. S., Perrin, R. M. S. and West, R. G. (1966) 'Patterned ground in Breckland: structure and composition' *J. Ecol.* Vol. 54 239–58

Williams, R. G. B. (1964) 'Fossil patterned ground in eastern England' *Biul. Peryglacjalny* No. 14 337–49

Woodhead, T. W. (1906) 'Ecology of woodland plants in the neighbourhood of Huddersfield' *J. Linn. Soc. Bot.* Vol. 37 333–406

7 Air Photography and Plant Disease

J. RISHBETH

Reader in Plant Pathology in the University of Cambridge and Fellow of Corpus Christi College

Plant diseases cause serious losses both in agricultural crops and forest stands, and as a result of demands for increased productivity there is a growing need for improved control measures. Adequate detection of disease by means of ground surveys always was difficult in the case of forests, but in agriculture too, with increased mechanisation leading to ever larger fields, this problem has become acute. The ways in which aerial photography might help to solve such problems were first seriously considered about fifteen years ago; during the past few years its range of application has been increased considerably, and an excellent review has appeared (Brenchley 1968).* Before considering specific applications to the study of plant diseases, it may be helpful to outline the basis of the valuable technique provided by infra-red photography from the air.

The pioneer work of Colwell (1956) with cereals such as oats has shown that a high proportion, at least 80%, of the infra-red part of the spectrum is reflected by a young healthy crop, so that the crop appears light in tone when photographed with infra-red film in combination with a deep red filter to eliminate the visible part of the spectrum. Very soon after oats become infected with the rust fungus *Puccinia graminis*, however, the amount of infra-red radiation reflected from the leaves declines, probably because the fungus invades the internal leaf spaces. Therefore infected plants still normally green in appearance, and indistinguishable from healthy ones on panchromatic photographs, appear dark-toned with infra-red film by contrast with light-toned healthy plants. Two to three weeks elapse before reflection of orange and red light by diseased plants increases sufficiently for them to become easily distinguishable on panchromatic photographs. The ability to detect early stages of

* A list of references quoted in the chapter is printed on p. 113.

disease has proved useful not only for agricultural crops but also in forests.

A further advantage of infra-red film is that the tone contrast between healthy and diseased plants is maintained with photography at increasing altitudes up to 10 000 ft, whereas with panchromatic film such contrast is often reduced as a result of haze. However, infra-red film is less suitable for photographing late stages of disease in herbaceous plants: not only do healthy crops reflect much less infra-red radiation as they approach maturity, but diseased ones actually reflect more if leaf-fall is pronounced, owing to exposure of the soil (Manzer and Cooper 1967).

At its present stage of development, aerial photography assists the plant pathologist in several ways. Detection of disease, especially at an early stage, is often facilitated. Large areas, sometimes not easily accessible, can be surveyed rapidly, and in certain instances the extent of damage can be assessed. Special interest is attached to the development and spread of infection, an understanding of which is often essential for control. The speed at which some diseases develop tends to limit the usefulness of observations made solely within the crop, and even with those that spread relatively slowly, characteristic patterns of development may be overlooked. Aerial photographs often show these patterns clearly and may also indicate that a disease is associated with particular soil conditions. Finally, evidence can be obtained about the effectiveness of control methods. In the account that follows, examples are given of diseases for which aerial photography has provided these different types of information.

Firstly, let us consider detection. Potato blight, caused by the fungus *Phytophthora infestans*, is a common disease that varies greatly in severity

both with district and season, largely according to weather conditions. Formerly, little was known about the way in which blight epidemics build up, and in particular there was virtually no information about the number and distribution of early disease foci from which many outbreaks develop. However, from experience in Holland it has been estimated, on the basis of their known susceptibility to blight, that the potato varieties King Edward and Majestic might have one initial infection-focus in about 500–1000 and 2000 acres respectively. The chance of detecting more than a very few such foci on the ground is minimal, and Brenchley (1966) therefore undertook aerial surveys in the fenland area of Britain where these two varieties predominate. *Phytophthora* is chiefly a leaf-infecting fungus, and as with cereals infra-red film was used to detect early stages of disease. In 1963, for instance, 4200 acres of potatoes were photographed and seven early outbreaks of blight detected; of these, three were probably initial foci, giving an area per focus of 1400 acres, which is of the same order as that predicted.

Detection from the air is also valuable in the case of oak wilt, caused by the fungus *Ceratocystis fagacearum*. This has spread far from initial outbreaks in Wisconsin, partly as a result of transmission by bark-feeding beetles, and causes great concern because oaks are an important source of timber as well as providing shade and ground cover. Early detection of wilting trees is essential for control. Aerial surveys have generally been conducted without the aid of photography (Fowler 1951, and True *et al.* 1960). In flat terrain, for example, one observer could survey about eighteen square miles of forest per hour; areas that had no wilted trees were eliminated from further study and ground crews were only sent into areas where disease symptoms had been seen. However, colour photography from the air has also been used for detecting oak wilt (Roth *et al.* 1963). Infected trees could be located more accurately than by air survey without photography and the risks of low-level flying involved in such surveys were avoided. On the other hand, correct identification of wilt was more difficult and the method was very expensive. In Minnesota Dutch elm disease, caused by *Ceratocystis ulmi*, has been photographed successfully with colour infra-red film: a remarkably high proportion of dead and dying trees could be detected and results were obtained far more quickly than from ground surveys (Meyer and French 1967).

Aerial photography has been used to detect killing of pines by the root-infecting fungus *Fomes annosus*. Infections occur chiefly from stumps, the fungus passing from stumps to roots of living trees in contact with them; this may lead to progressive killing around the original centres. Pines planted on sites formerly bearing conifers are often attacked within the first year or two, since infected stumps are already present. By contrast, plantations on former heath or arable generally remain healthy for fifteen years or more, attacks developing only after sources of infection are created. These arise mainly as a result of rack-cutting, in which two rows of trees are removed to allow access, and thinning: the stumps so produced are often colonised by air-borne spores of *Fomes annosus*. In Britain serious attacks have developed on light sandy soils, especially in East Anglia, where the number of deaths often increases steadily from the second thinning onwards. Severe outbreaks have also occurred in south-eastern states of the U.S.A.

In 1946, when this type of attack had only recently developed in East Anglia, aerial photographs taken from 10000 ft showed openings of the tree canopy in many places at which root disease had not been reported. A ground survey showed that the majority were in fact new infection centres, though these were not always distinguishable on the photographs from openings due to other causes. In 1968 a plantation of thirty-year-old Scots pines in the same area, about thirty-five acres in extent, was photographed with Aero-Ektachrome and Aero-Ektachrome infra-red films (Rishbeth 1968). The plantation had been used for an experiment by the Forestry Commission Research Branch seven years before, some plots having been thinned and others left unthinned. Photographs (scale 1:2000) taken with Ektachrome film showed 120 trees with brown and 34 with greenish-yellow foliage, indicating respectively those recently killed or severely affected by *Fomes annosus*. On photographs of the same scale taken with Ektachrome infra-red film all except six of these trees were visible, their colour being bright green and bluish green respectively. In addition, 140 trees appeared blue, indicating ones killed less recently that had lost their needles. A subsequent ground survey showed that this last number was an under-estimate, chiefly because on photographs of this scale single dead trees were indistinguishable from small groups. However, for trees recently killed and still having needles attached, there was exact agreement between counts obtained from photographs and those made on the ground. All except five of the dead or severely affected trees were in the thinned plots, as would be expected from the relation with infected stumps already described, but the few occurrences in unthinned plots were unexpected. These were found to have arisen from infection of suppressed trees through wounds caused by brashing, an operation in which dead or dying branches are removed from the lower part of the stem: such infection was followed by the characteristic root-to-root spread. This was only the second time that brashing had been shown to lead to *Fomes* attacks on neighbouring trees;

Photo. 7:1 The use of infra-red film to record plant disease.

An initial infection of potato blight (A) in a field of the variety 'Red King' near Lakenheath, Suffolk (TL 712790) appears on the photograph as an area of darker tone, contrasting with the healthy (light-toned) plants elsewhere. Secondary infection-centres have developed nearby (B) in a field of the same variety. Still further spread of the disease has occurred from these secondary patches, giving them a blurred appearance.

Vertical photograph. Scale 1:4400 *16 July 1960*

Photo. 7:1 Potato blight near Lakenheath

Photo. 7:2 Infra-red photograph of fields near Wisbech, Cambridgeshire.

The upper field shows an advanced attack of blight on potatoes, the disease patches again appearing diffused as a result of secondary infection by wind-borne fungal spores. The lower field, in which dwarf beans were growing, was affected by halo blight; the disease was limited to very discrete patches because the active bacterium is distributed mainly by rain-splash.

Vertical photograph. Scale 1:1380 *August 1964*

Photo. 7:2 Potato blight near Wisbech

Photo. 7:3 Corsican pines near Croxton

Photo 7:3 A plantation near Croxton, Norfolk, severely infected by *Fomes annosus.*

This was taken on a dull day in July when the virtual absence of shadow allowed a clear picture to be obtained of the extent to which the tree canopy had been affected. Corsican pines twenty-one years old are growing on the site of a young pine plantation destroyed by fire, where many stumps became infected by *Fomes annosus.* The soil is alkaline, a condition often associated with severe outbreaks of the root disease: irregular light areas represent grassy patches where all the trees have died. Moreover, the fungus is still advancing, as indicated by the lighter-toned trees around the edges of gaps; these represent pines in various stages of attack. The few larger, light-toned trees well outside the gaps are broad-leaved trees, such as birch.

Vertical photograph V-AE 76. Scale 1:250 *14 July 1961*

moreover, these infections had been missed in the ground survey. For this plantation, therefore, colour infra-red film gave the more accurate record of damage caused by the root parasite, although colour film reliably detected trees with recent crown symptoms.

In 1971, at the request of the Forestry Commission, some sixty-two square miles of forest in East Anglia were photographed in colour at a scale of 1:10000. The aim was to discover whether such photographs would provide sufficient information about *Fomes* outbreaks substantially to reduce dependence on ground surveys. In fact, the method proved very satisfactory for this purpose, and in addition clearly showed the relationship between heavy incidence of the disease and sites that were formerly arable. The photographs incidentally revealed other features of interest to the pathologist, notably recent attacks by *Brunchorstia pinea,* a fungus causing die-back of Corsican pine, and local failures in the establishment of second-rotation crops probably associated with frost damage.

In other investigations 93% of short-leaf pines killed by *Fomes* in five plantations in Illinois were detected by photography with Ektachrome infra-red film, as were 100% of red pines in eleven stands situated in Rhode Island and Connecticut (Hadfield 1968). Infected but still living trees could not be detected in these instances, whereas in North Carolina a few such trees appeared on similar photographs (scale 1:1580) of white and loblolly pines, in addition to those with obvious symptoms (Cordell *et al.* 1965). In this state, photography with the same type of film detected a proportion of trees known to be infected with another root-inhabiting fungus, *Phytophthora cinnamomi,* and of trees attacked by one or other of two insects.

Photo. 7:4 Wangford Warren, Suffolk (TL 767820).

Seven-year-old Scots pines (SP) on former woodland and twenty-year-old Scots pines and Corsican pines (CP) on former grassland, the soil in each case being alkaline. In the younger Scots pines (1) the irregular light patches represent grass: fully a quarter of the trees have already been killed by *Fomes annosus*. A portion of the older Corsican crop (2) had been thinned the previous year by removing whole rows at regular intervals. Much of the remaining area was taken up by a thinning experiment in which different proportions of trees were removed four years before the photograph was taken. The various plots are shown as follows: heavily thinned CP (3); unthinned CP (4); lightly thinned CP (5); very heavily thinned CP (6); very heavily thinned SP (7); unthinned SP (8); lightly thinned SP (9).

R.A.F. vertical photograph 3G/TUD/UK 59 Part IV, print No. 5400.
Scale 1:4700 *5 February 1946*

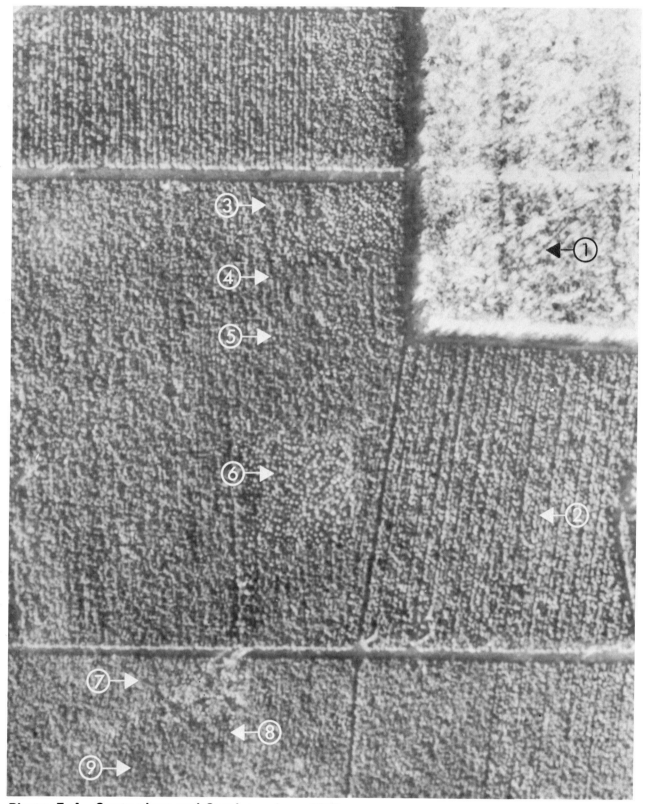

Photo. 7:4 Scots pines and Corsican pines, 1946

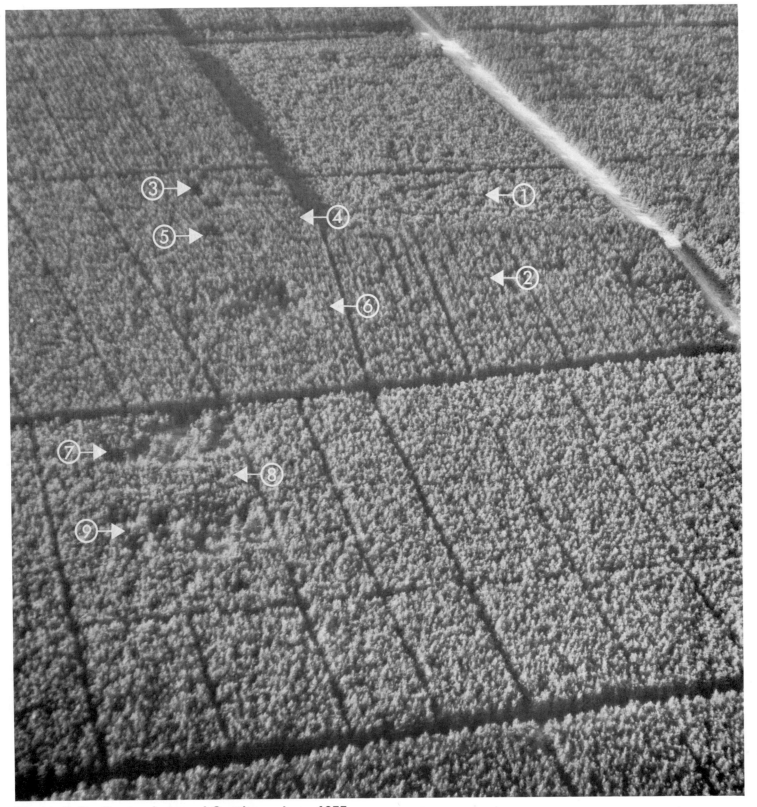

Photo. 7:5 The same area of Wang-ford Warren nine years later.
The Scots pines on former woodland (1) show irregular gaps due to *Fomes* attack, but much of the canopy is beginning to close. In the line-thinned Corsican pines (2) little disease is apparent because very few of the stumps became infected with *Fomes*. No attack has developed in the unthinned plots (4, 8). Trees have been killed in all the thinned plots (3, 5, 6, 7, 9), following stump infection by *Fomes*, attacks being somewhat heavier in the more susceptible Scots pines.
PC 55 *18 March 1955*

Photo. 7:5 Scots pines and Corsican pines, 1955

Photo. 7:6 The same area of Wangford Warren sixteen years after Photo. 7:4.

The Scots pines on former woodland (1) show almost complete closure of the canopy despite the initial heavy *Fomes* attack. The line-thinned Corsican pines (2) are still healthy. Surviving Corsican pines in one of the thinned plots (3) are closing all but the largest gaps in the canopy. There is no disease in the un-thinned Corsican pines (4); the tops are small and crowded.

Vertical photograph V-BA 14.
Scale 1 : c. 900 *28 June 1962*

Photo. 7:6 Scots pines and Corsican pines, 1962

There are a few other examples of diseases known to be detectable by aerial photography, two of the more interesting being those caused in citrus orchards in Florida by four types of virus (Norman and Fritz 1965), and that brought about by a parasitic flowering plant, dwarf mistletoe, ones on colour infra-red photographs, and small newly-developed disease dead or dying trees could readily be distinguished from healthy ones on colour infra-red photographs, and small newly-developed infection centres could also be detected. Aerial photography was particularly useful in this instance because black spruce often occupies extensive wet sites not easily accessible to ground surveys.

The correct identification of disease, as opposed to mere detection, may present considerable difficulty. With potato crops in Maine, Manzer and Cooper (1967) found that blight could be confused with wilt, caused by another fungus, if colour infra-red film alone was used, and there was even some possibility of confusion with drought damage or nutritional disorders. In the case of oak wilt, already mentioned, colour film is preferable to colour infra-red because the latter shows many trees that are unhealthy but not affected by wilt (Roth *et al.* 1963). Pine trees severely infected by the rust fungus *Peridermium pini* appear very similar to those recently killed by *Fomes annosus* on photographs taken with colour or colour infra-red films, and therefore in certain areas of East Anglia where both diseases are prevalent correct differentiation by air photography alone would be very difficult. A disease can be recognised with certainty if it is the only one affecting the particular plants in the area being photographed. Otherwise, as Brenchley (1968) points out, positive identification depends on the disease reacting specifically with a particular combination of film and filter, or giving characteristic differential reactions with a series of these. Such problems serve to emphasize the necessity for coordinating aerial photography with observations on the ground.

The distribution of disease in a crop may yield information about factors pre-disposing it to infection. Brenchley (1968) provides an excellent example of this in the case of wheat grown near Cambridge. In 1963 an aerial photograph on infra-red film of a crop infected with *Ophiobolus graminis*, the fungus causing the disease known as 'take-all', showed an unusual distribution pattern: light areas corresponded to places where nearly all the wheat plants had died and which weeds had invaded. These situations were also unusually wet, but the reason for this was obscure until the area was re-photographed nearly three years later; then, despite the bare soil, lighter-toned areas still appeared in the pattern shown by the diseased wheat. These proved to be lower lying and more silty than the main portion of the field and had therefore become waterlogged after the exceptionally severe winter of 1962–63.

The first attempt to assess severity of disease by aerial photography was made by Colwell (1956), who obtained colour photographs of black rust of wheat, caused by *Puccinia graminis,* in small experimental plots. By studying colour tones on these photographs it was possible to estimate the severity of the disease and obtain results which differed on average from those obtained on the ground by less than 10%. Moreover the photographs sometimes indicated error in ground assessment. Brenchley (1968) studied potato blight in small plots that had been treated with various fungicides or left untreated. Subjective estimation of photographic tones was avoided by recording them photometrically. Certain difficulties were encountered, but in general there was excellent agreement between loss of reflectance by the plants, measured from the photographs by a micro-densitometer, and percentage blight on the leaves, as estimated on the ground. A field of wheat affected by 'take-all' was also photographed from the air, but in this case local soil variations prevented assessment of the effects of disease alone. However, the photographs clearly demonstrated the combined effect of 'take-all' and soil conditions on crop yield, which is most important for practical purposes.

In New Zealand, colour photography from the air has been used to estimate the area and intensity of infection by *Dothistroma pini* in plantations of *Pinus radiata* (Gilmour 1967). This fungus often causes severe defoliation, leading to reduced growth and occasionally to death of the trees. The excellent control obtained by spraying copper-based fungicides from the air during the growing season has also been successfully recorded by photography. For attacks by *Fomes annosus* on pines, vertical photographs are specially useful for showing the extent to which openings have been made in the tree canopy. Photo 7:6, for example, shows a plantation in which some of the original gaps have coalesced as a result of prolonged tree killing. Quite apart from assessment, aerial photography is valuable in the case of tree diseases for illustrating characteristic types of attack, often poorly shown by ground-level photographs. Photo. 7:4 shows two types of gap, caused by *Fomes* in a pine plantation, which originated from stumps created by thinning and rack-cutting respectively.

Perhaps the most valuable contribution of aerial photography to the study of plant diseases arises from information about the ways in which they spread throughout agricultural and forest crops. Photo. 7:1 is a vertical photograph, taken in mid-July with infra-red film, which shows an initial infection focus of potato blight in a field near Lakenheath in Suffolk. This had first been reported twelve days earlier, but by the time

Photo. 7:7 Bracken on Ilkley Moor, Yorkshire.
There is a prominent penannular patch of degenerate ferns, with a small extension to the left of the path. In the lower left-hand corner the bracken fronds are clumped, an early sign of degeneration.
Vertical photograph V-KN 25. Scale 1:c. 710 31 July 1968

Photo. 7:7 Bracken on Ilkley Moor

the photograph was taken some fifty new patches were discernible in a field lying to the north (Brenchley 1966). From previous knowledge of the disease, it seems certain that these were all derived from the original focus by dispersal of air-borne *Phytophthora* spores. Moreover, since such dispersal occurs only under certain conditions of temperature and humidity, the actual day on which it happened could be determined with reasonable accuracy from weather records. The photograph also provides evidence of spread from the new patches, which have a blurred extension to the south-west. These represent plants with earlier stages of disease that were probably infected when conditions again favoured spore dispersal and the wind was north-easterly. In this, as in other instances reported by Brenchley, aerial photographs revealed a pattern of blight development which would have been almost impossible to determine on the ground. Somewhat similar observations were made on spread of yellow rust, caused by the fungus *Puccinia striiformis*, in fields of wheat (Brenchley 1968). It was noteworthy that infra-red photographs clearly revealed the original over-wintering infection foci at a time in early July when the whole field was infected and a panchromatic photograph showed no sign of them.

A very different pattern of spread is shown by organisms which are dispersed by splashes. Brenchley also took infra-red photographs of a field of dwarf beans infected with halo blight, caused by the bacterium *Pseudomonas phaseolicola*. Here the initial infections result from sowing contaminated seed, and since subsequent dispersal arises chiefly from bacteria in rain-water splashed over short distances, secondary infections are limited to neighbouring plants. This explains the very discrete patches appearing on an aerial photograph of the disease, Photo. 7:2, by contrast with the diffuse ones already described for the air-borne *Phytophthora*.

Yet another type of disease is recorded on recent photographs, not of a crop but of semi-natural vegetation on Ilkley Moor in Yorkshire. Photo: 7:7 shows degeneration of bracken, which occurs locally in Britain and may be caused by a mycoplasma-like organism (Hull 1969), though this interpretation is open to doubt (Watt 1971). The striking crescent shape of the affected areas of bracken may provide some clue to the pattern of development of this condition.

The slow rate at which many forest pathogens spread necessitates a vastly different time-scale for periodic photography. Three stages in the spread of *Fomes annosus*, which often grows at about 2 feet per year in East Anglia, are shown in Photos. 7:4, 7:5 and 7:6: these span a period of sixteen years. In the younger of the two pine plantations, on ground formerly bearing conifers, infected stumps were already present and

trees soon began to die. But although just over 30% had been killed after ten years, the plantation started to recover and after twenty-three years the tree canopy had almost closed: this is shown by the third photograph. In the older stands on former grassland, by contrast, infection appeared much later, corresponding to the entry of *Fomes* into thinning stumps: the pines by this time were probably weakened by intense competition on the dry, shallow soil and the disease spread very rapidly. By the time the second photograph was taken, some thirteen years after thinning, over 70% of the remaining trees had been killed in some of the plots and the stand was irretrievably damaged.

A technique, briefly mentioned earlier, in which the colour intensity of photographs is measured, has been used to good effect with pine plantations in eastern Ontario (Murtha and Kippen 1969). The images of trees known to be infected with *Fomes annosus* that appeared on colour infra-red film gave much higher intensities than those of healthy trees some distance away, as expected. Interestingly enough, moderately high intensities were recorded for trees adjacent to these known infected ones, almost certainly indicating that the former were affected by early stages of root disease. The author suggests that this method might provide information about the spread of a root parasite in plantations.

Space does not permit mention of more than a few of the agents that cause disease in forests. Steady progress has been made both in detecting damage of different kinds, and in estimating its extent. A comprehensive guide to the interpretation of damage to forest trees as revealed by air photography has been published recently (Murtha 1972), and the author emphasises the impetus that the development of aerial survey has received as the cost of ground survey has increased. The prospects for further advance in the subject as a whole seem good. Modern developments in multi-spectral analysis of vegetation from the air, which are very promising for the recognition of specific crops (Shay 1967), might eventually lead to the automatic detection and recording of plant diseases. In the immediate future, however, the major contribution will probably come from existing techniques, improved by standardisation and use of modern equipment. Photography from the air will almost certainly supplement ground surveys to an increasing extent, though it can seldom if ever entirely replace them. Repeated photography, with an appropriate time interval, seems an exceptionally promising tool for studying the spread of plant disease. In so far as plant pathologists are increasingly concerned with diseases caused by non-living agents, especially those resulting from air pollution, valuable information can be obtained by photographing vegetation in the vicinity of potential sources such as smelters and refineries

(Kenneweg 1971). Ideally photographs should be taken before these come into operation and at intervals afterwards. For controlling plant diseases, the importance of rapid detection by aerial photography in some instances has already been stressed. Increasingly the method should allow rapid assessment of control measures, such as crop spraying, and it might also provide information about the degree of resistance to disease shown by new crop varieties.

Typescript received February 1972

REFERENCES

Brenchley, G. H. (1966) 'The aerial photography of potato blight epidemics' *Jnl. R. Aeronaut. Soc.* Vol. 70 1082–5

Brenchley, G. H. (1968) 'Aerial photography for the study of plant diseases' *A. Rev. Phytopathology* Vol. 6 1–22

Colwell, R. N. (1956) 'Determining the prevalence of certain cereal crop diseases by means of aerial photography' *Hilgardia* Vol 26 223–86

Cordell, C. E., Astin, J. S. and Franklin, R. T. (1965) 'An evaluation of aerial colour photography for detecting forest diseases and insects' *U.S. Dep. Agric. Rep.* Vol. 65 1–9

Fowler, M. E. (1951) 'Surveys for oak wilt' *Pl. Dis. Reptr.* Vol. 35 112–18

Fowler, M. E. (1952) 'Aircraft scouting for pole blight and oak wilt' *Jnl. For.* Vol. 50 191–5

Gilmour, J. W. (1967) 'Distribution impact and control of *Dothistroma pini* in New Zealand' *Sect. 24. Congr. Int. Un. For. Res. Org.,* Munich 222–48

Hadfield, J. S. (1968) 'Color infra-red photography effectively detects pines killed by *Fomes annosus*' *Sect. 24. Int. Un. For. Res. Org.* Third International Conference on *Fomes annosus,* Aarhus 37–42

Hull, R. (1969) Private communication

Kenneweg, H. (1971) 'The problem of recognising and demarcating fume damage on aerial photos', In 'Fume damage to forests', *For. Commun. Res. Dev. Pap.* No. 82 24

Manzer, F. E. and Cooper, G. R. (1967) 'Aerial photographic methods of potato disease detection' *Maine Agric. Exp. St. Bull.* 646

Meyer, M. P. and French, D. W. (1967) 'Detection of diseased trees' *Photogrammetric Engineering* Vol. 33 1035–40

Murtha, P. A. (1972) 'A guide to air photo interpretation of forest damage in Canada' *Canad. For. Serv. Publ.* No. 1292

Murtha, P. A. and Kippen, F. W. (1969) '*Fomes annosus* infections centres are revealed, on false-colour aerial photographs' *Bi-m. Res. Notes Dep. Fish. For. Ottawa* Vol. 25 15–16

Norman, G. G. and Fritz, N. L. (1965) 'Infra-red photography as an indicator of disease and decline in citrus trees' *Proc. Fla. St. Hort. Soc.* Vol. 78 59–63

Rishbeth, J. (1968) Unpublished data

Roth, E. R., Hellar, R. C. and Stegall, W. A. (1963) 'Color photography for oak wilt detection' *Jnl. For.* Vol. 61 774–8

Shay, J. R. (1967) 'Remote sensing for agricultural purposes' *Bioscience* Vol. 17 450–1

True, R. P., Barnett, H. L., Dorsey, C. K. and Leach, J. G. (1960) 'Oak wilt in West Virginia' *W. Va. Univ. Agric. Exp. St. Bull.* No. 448T

Watt, A. S. (1971) 'Contributions to the ecology of bracken. VIII. The marginal and the hinterland plant: a study in senescence' *New Phytol.* Vol. 70 967–86

8 Air Photography and Zoology

J. MILTON AND SIR FRANK FRASER DARLING
The Conservation Foundation, New York

For the field naturalist one of the outstanding advances of the last forty years has been the use of air reconnaissance for ecological research. Given the right method of approach and the necessary skill in interpretation of the results, the use of aircraft makes possible the accurate study of migrations even of large and fast-moving animals in remote and difficult terrain, with immense saving of time to the trained scientist. Nevertheless, air reconnaissance and photography does not remove the need for much hard work on the ground. An aircraft can guide, select, and broaden the view, or possibly even solve a problem at a glance, but it should never stop the biologist from examining at first hand the results of this exciting new method of research.

One of the earliest uses of aircraft and later of air photography was the census of mammals, birds and even fish, in a wide variety of habitats. The species which have been studied in this way include pronghorn antelope, beaver, caribou (Photo. 8:3), moose or elk, deer, mountain antelope or goat, musk ox, bighorn sheep, wildebeeste (Photo. 9:1), topi, oryx, lechure, giraffe, Grant's gazelle, zebra, elephant (Photos. 8:2 and 9:3), wolf, northern fur seal, walrus, harp seal (Photo. 8:4), hooded seal, grey seal, ostrich, grouse, gannet, geese and ducks of several kinds, flamingo, bald eagle, oyster-catcher (Photo 8:5), and salmon.

Not all such census work has been successful and accurate. Attempts to count grey seals and red deer in the difficult light of the Scottish autumn were most disappointing. The coat-pattern of the seals against wet rock and stony ground made them extremely difficult to pick out, though improvement in photographic method will doubtless set this right in the future, and the deer were practically invisible against the sombre terrain of heather, sedge and dark rock. In contrast, the pattern of herds of zebra in the brilliant light of Africa produces a dazzling effect

that makes them difficult to count except by vertical photography. Wildebeeste, on the other hand, are easy to count either directly or from photographs (Photo. 9:1), as each dark animal has a lighter patch on the back which serves the observer like a lamp.

Leedy (1948)*, in an article on air photography and interpretation, identified a number of potential values for wild life management:

Maps; evaluation and determination of game range; censusing game animals; locating refuge-sites; law enforcement; studying areas damaged by fire, floods, insects or disease; determining hunting pressure; locating, mapping and planning potential dam sites; plotting land-use and wild-life problem areas; determining changes in vegetative cover and land-use over a period of years; planning the locations of roads, trails, fire lanes, and other developmental features of newly acquired areas; making special studies of rare or vanishing species in which permanent records of habitat types are desirable; conducting lake surveys, including the mapping of emergent and floating aquatic flora, and possibly the contour mapping of lake bottoms; plotting tax-delinquent lands in connection with acquisition of land for game refuge and management areas; and recording pictorially the features of breeding grounds newly discovered in remote areas.

* A list of references quoted in this chapter is printed on p. 123.

Photo. 8:1 Tsavo National Park, south-east Kenya.
Part of a typical breeding herd of buffalo (*Syncerus caffer*) that has been disturbed by the aircraft. The extensive tree damage, attributed to the high elephant population, is a serious problem for the Kenya National Parks administration.

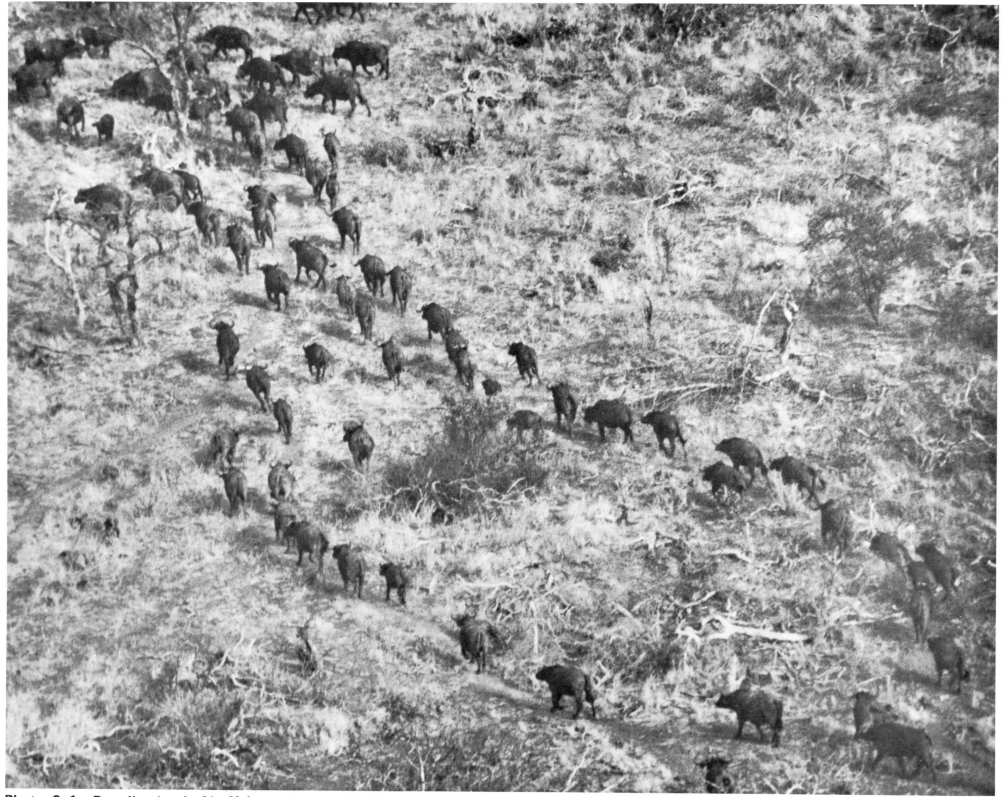

Photo. 8:1 Breeding herd of buffalo

Our view is that though more use of air photography has been made for census work than in other fields of animal ecology there is still a great deal to do. There are many potentially suitable species for which a census by air photography has never been attempted, and there is room for a manual on method. Aircraft have been particularly useful for the census of massed aggregations, where photographs could be checked at leisure. For example, Spinner (1953) found that when fifty-two ornithologists looked at an air photograph of 13 494 greater snow geese in Delaware Bay, individual estimates ranged from 3000 to 28 000 birds, with an average around 9000. When comparisons of two other pictures of the same flock were made, one showing the geese rising from their feeding grounds and the other showing the same flock settled in a compact group on the water, observers overestimated the population in the first photograph and underestimated the count in the second. Although air photographs are often a useful tool for such census work the task of counting may prove tedious and even yield inexact results.

In an unpublished report to the Conservation Foundation in the spring of 1950 Per Host reported on aerial studies of the seal herds off Newfoundland. Earlier work by Mr Host had indicated that hooded seals were in particular danger of extinction.

The air survey, with Dean Fisher in charge, was made between 4 and 10 March 1950, using a DC-3 aircraft, under the aegis of the Canadian Fisheries Department. As a result of his observations and photographs from the air, Mr Host concluded that the herd of harp seals did not seem to be in any immediate danger (cf. Photo. 8:4). On the other hand, the hooded seal appeared to be in serious trouble off Newfoundland. On a basis of observations from the air and of hunting statistics Host recommended the establishment of a closed season for the latter species.

The California Division of Fish and Game has also used air photographs for wild-life inventories. William P. Dasmann, a Game Range Technician with the Bureau of Game Conservation, has stated:

In game inventories herds of animals or flocks of birds are photographed from the air, usually with a (Fairchild) K-20 camera. The prints are enlarged, and the game species counted on the picture, sometimes with the help of magnifying glasses. Sometimes counts are randomised by blocks on photos where the individuals are numerous, viz., waterfowl.

He went on to mention the value of using such photographs as maps 'to determine both topography, cultural features, and vegetation types'. Indeed, one great advantage of the technique is the ease with which wild-life habitat can be determined. Zoological studies should include detailed analysis of all habitat components.

Other chapters in this book emphasise the importance of air photography in the mapping of vegetation, soils, and geology, and here it need only be stated that the value of air photography for the mapping of vegetation is, for example, often just as important to the study of animal ecology as the census of the wild life itself.

Norman Carls (1947) has listed three advantages that an air photograph has over a map:

It has a wealth of detail no map can equal. It is reliable. Floods and other features, as they existed at the time the photograph was taken, are shown in their true relationships to one another. Usually it is more up to date than the best map available.

All of these advantages hold for the use of air photographs in the mapping of wild-life habitat; Schultz, however, enumerated two major disadvantages:

The relatively high cost of reproducing, in quantities, a finished map containing the details available on air photographs, and the large number of individual air photographs needed for coverage of an extensive area (which prohibits their direct use on a 'practical' mosaic) (Schulz 1952).

In their paper on 'The use of aerial photographs and ecological principles in cover type mapping', Wilson and Berard (1952) noted that 'many wild life biologists are unaware of the extent to which ecological principles can be applied in the interpretation of aerial photographs. Acquired knowledge and technique in the use of photographic interpretation, comparable to the development of mapping in the field of forestry, does not yet exist in wild life management'.

The North-Eastern Forest Experiment Station (1949) has developed extensive type-mapping of forest cover to a high degree, particularly by relating the distribution of forest types to topography. Throughout their work, foresters have shown increasing technical ability in the classification of 'cover types' which lead to elucidation of ecological factors involved.

Photo. 8:2 Kenya National Park; small group of elephants *(Loxodonta africana)* **comprising four adults and six young.**
A photographic survey by the Army Air Corps for a census of elephants in 1963 yielded a total of 15 000 head, as against the highest estimate of 10 000.

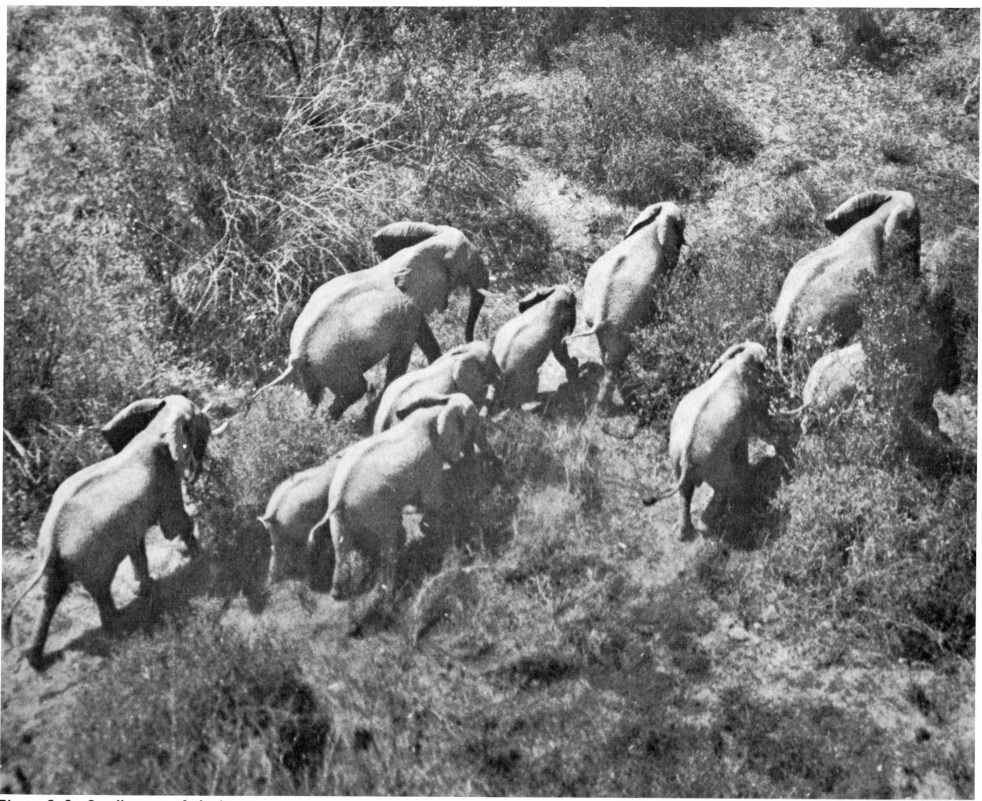

Photo. 8:2 Small group of elephants

Particularly strong emphasis has been given to the identification of tree species by the recognition of seasonal differences. The identification of plants used by wild life for cover is most easily made in the temperate zone during the autumn (Petrides 1953). Moreover, at other times of the year, patterns of vegetation marking water-courses, differing soil types, the incidence of fire, etc., can be quickly mapped with the help of air photography. A research worker armed with detailed photographs of the plant-communities in any area has his task of mapping boundaries of wild-life cover types made considerably easier. Even though the identification of many plant species may not be possible from air photographs, at least the dominant members of the various plant-communities can usually be picked out, not to mention 'indicator species'. With this information, identification of plants on the ground is greatly facilitated; and if sample plots are carefully selected in the major communities recognisable on air photographs, the detailed information obtained can often be applied more generally in interpreting the photographs for the purpose of mapping.

With the definition of these methods in plant ecology it is but a short step to relating wild life to its habitat through air photography (Photo. 8:1). To be of value in animal ecology, however, such air surveys of plant communities are often correlated with observations of migration, distribution, dispersion, food-habitats, etc. Many of these supporting studies can also be carried out from the air, but in the majority of cases a great deal of basic ground-observation is still necessary.

One of the greatest problems in biology has been the determination of migratory patterns in birds, fishes, mammals, and insects. Much of the information that has been accumulated to date has come to hand through the collection of dates and routes of migrations. Griffin and Hock (1949) have discussed the ability of birds to perceive environmental clues as a guide to direction. The authors' hypothesis was that many bird species have a well-developed topographical memory, 'so that having flown over an area in migration or in natural wanderings they can thereafter orient themselves within that familiar territory by means of landmarks'.

In order to test this idea the author released a number of gannets (Morus basanus) 213 miles inland from their nests, and followed their return journey by aerial observation. The results indicated that 'homing from unknown territory may involve extensive exploratory flights which for a time take the birds away from home rather than towards it'. Thus the hypothesis that 'birds' (specifically the gannet) find their way home through the use of familiar landmarks was strengthened, since the artificially transported individuals invariably explored a wide area, often heading in incorrect directions, until they reached familiar landmarks. Although no photographs were taken, the study is of particular interest in showing how important observations from the air can be in migrational studies. Similar values were derived by Banfield (1955) in his investigations of barren-ground caribou in Canada. He used air photographs to determine the migration-habits and range of Rangifer arcticus, as well as data on numbers, sex, and age. Clearly, however, the potential value of air photography and observations in work on migration has only been partially realised. In future studies of migration all aspects of the record presented on air photographs should be fully considered.

Aside from population census (to which photography from the air probably makes its most important single contribution), habitat mapping, and migration, there are a number of other potential fields within animal ecology where air photography can be usefully employed. A list of such fields would include, among others:

Age distribution of populations.
Density of populations.
Distribution and dispersion.
Record of population fluctuations.
Record of population dispersal.
Population structure: territoriality, isolation, aggregation.
Food–habit surveys.

One of the most interesting examples of a survey of food-habits was graphically described in an article by D. L. Allen and L. Mech (1963) on the wolf–moose relationships on Isle Royale. The authors observed from the air the winter predation of a pack of fifteen wolves on the island's moose population. They were able to watch Canis lupus 'in every phase of daily activity: trekking, sleeping, mating, playing, and hunting and killing moose.'

In the process of air observation Allen and Mech have been able to utilise colour photography to make a permanent record of their work. Of particular interest are the photographs illustrating the pattern of attack on moose. Although the cinematograph would have provided an even more informative record, these photographs clearly demonstrate the way in which the pack 'tests' each moose, rejecting the vigorous animal as a poor prospect in favour of a weaker individual.

Photo. 8:3 Herd of caribou (Rangifer caribou) **at Ghost Lake, MacKenzie District, Northwest Territories, Canada. 1949**

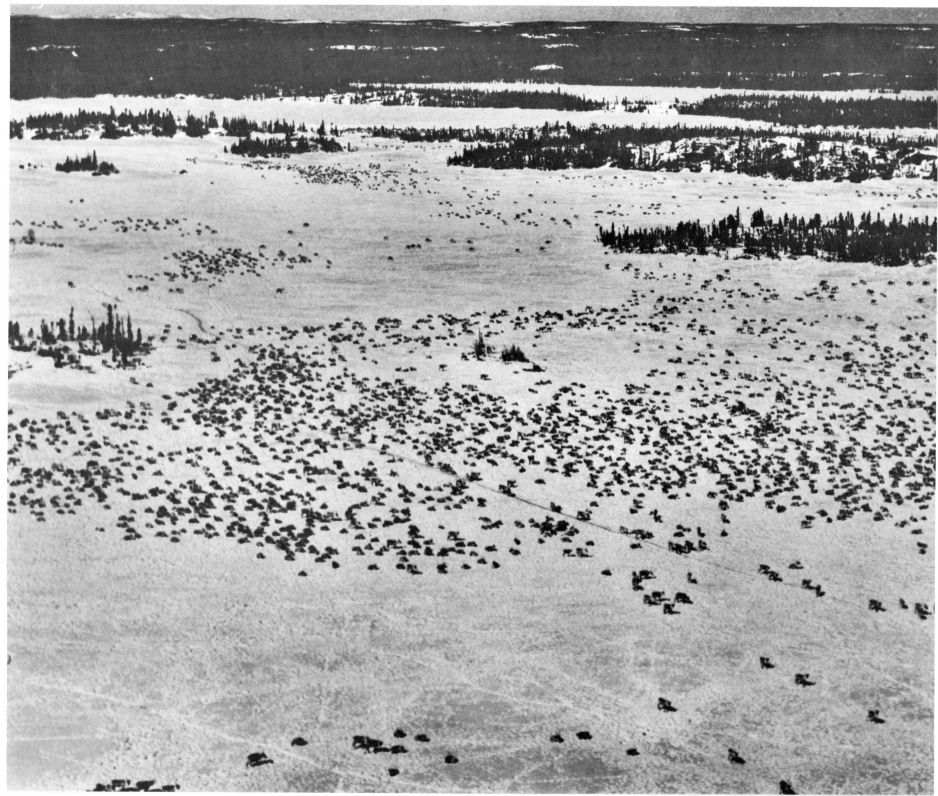

Photo. 8:3 Herd of caribou

Photo. 8:4 Moulting harp seals on pack-ice *(see caption on p. 122)*

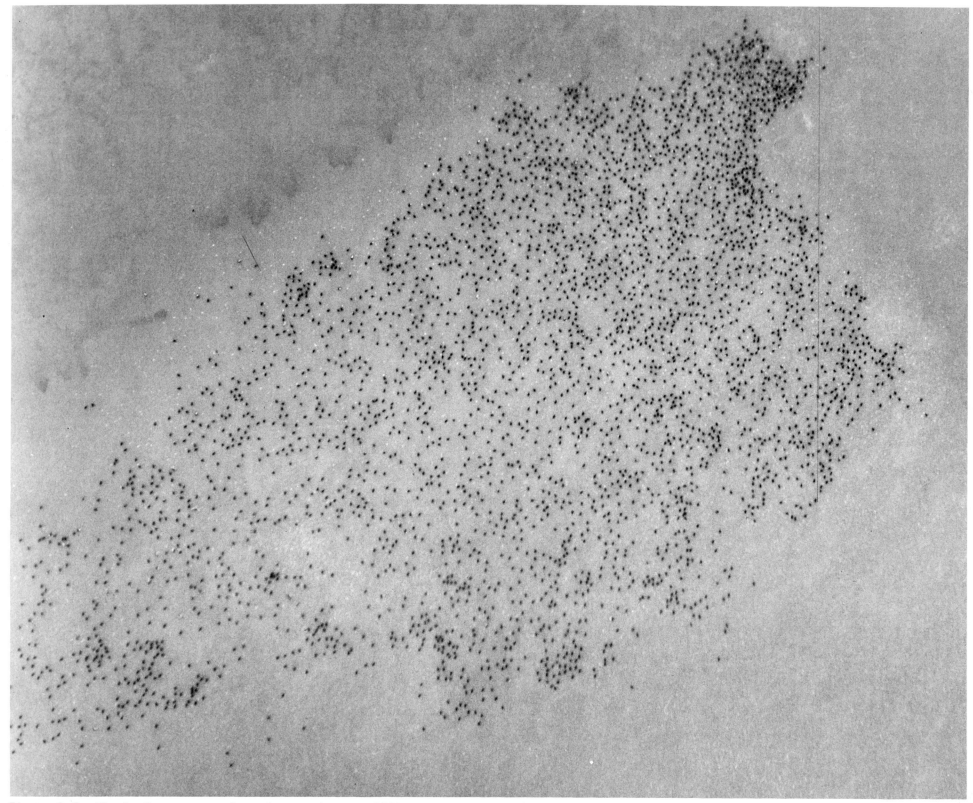

Photo. 8:5 Flock of oyster-catchers *(see caption on p.122)*

Photo. 8:4 Moulting harp seals *(Phoca groenlandica)* **on pack-ice east of Labrador.**

In 1960 air photography yielded an estimate of 327 000 breeding adults in the Gulf of St Lawrence and on the 'Front', the area east of Newfoundland and southern Labrador. This figure is reported to represent a decline of over 50% in ten years. Population studies based upon the evidence of air photographs are indispensible for devising a system of control of commercial sealing, essential if stocks are not to suffer virtual extinction.

Aero Photo Inc. vertical photograph A446, print No. 47.
Scale 1:1900. *22 April 1963*

This discussion of the value of air photography in biology has been limited to 'still' photography; cinematography, however, has additional value in wild-life research which should be briefly mentioned. Through slow-motion projection, the researcher is able to examine in detail locomotion in individual animals, as well as rapid movements in whole populations. Just as normal air photography has not yet been utilised as extensively as direct observation from the air, so air cinematography in biological research has been relatively little used in comparison with photographs individually taken.

So we come to our conclusion. Although the use of air photography in biological work has increased significantly in recent years, there is much room for expansion and ramification. Up till now the major use of air photographs in biology has been in vegetation mapping and for census work, particularly of big game and waterfowl. Other uses have also emerged as significant: game-range determinations, lake and stream surveys, successional studies, habitat surveys, law enforcement, refuge locations, food–habit surveys, population–age distribution, and records of population behaviour.

For the greatest returns negative as well as positive aspects of the technique must be taken into account. The needs and limitations of air photography in wild-life studies have been evaluated by Leedy as follows:

Much is to be learned regarding the type of aircraft, camera equipment, film, filters, and conditions under which aerial photographs can be taken most effectively for use in the fields of wild-life and recreation. Consideration must be given to cost of operations; season of the year and best time of day for photography to distinguish between vegetation-types or show concentrations of game species; the height at which an aircraft can be flown above animal concentrations such as waterfowl-flocks without disturbing them; and the amount of ground checking necessary to obtain the desired results (Leedy 1952).

Progress has already been made in the use of these methods, but, we must reiterate, their full potential application is yet to be realised.

Photo. 8:5 Flock of some 3500 oyster-catchers *(Haematopus ostralegus)* **on mud-flats at Red Bank, Morecambe Bay, Lancashire (SD 467680).**

The object of this survey, repeated at intervals through the winter, was to study variations in the size of the flocks with a view to controlling their depredations on local oyster beds. The bird-roosts were photographed at high water from an altitude of a few hundred feet, a task presenting its own problems, especially if the birds were not to be disturbed.

Vertical photograph V-CG 10. Scale 1:330 *17 December 1963*

REFERENCES

Allen, D. L. and Mech, D. L. (1963) 'Wolves versus Moose on Isle Royale' *Nat. Geogr. Mag.* Vol 123 200–19

Anderson, M. and Murdy, R. (1953) 'A comparison of methods of estimating duck brook density' 15th Midwest Wild-life Conference

Banfield, A. W. F., Floock, D. F., Kelsall, J. P. and Loughrey, A. G. (1955) 'Aerial survey technique for northern big game' *N. Amer. Wild-life Conference* Vol. 20 519–32

Brown, D. L. (1954) 'Census and management of central Montana antelope' *Proc. 34th Ann. Conf. Western Assoc. State Game and Fish Commissions* 211–15

Cain, S. (1963) 'Aerial survey studies of natural resources' *Arid Zone* Vol. 21 8–9

Carls, N. (1947) *How to Read Aerial Photographs for Census Work* Dept. Commerce, Bureau of the Census

Chase, D. and Spurr, S. H. (1955) 'Photo-interpretation aids' U.S. Forest Service, Lake States For. Exp. Sta. Report No. 38 *Wild-life Review* Vol. 81 2

Chattin, J. E. (1952) 'Appraisal of California waterfowl concentration by aerial photography' *N. Amer. Wild-life Conference* Vol. 17 421–6

Crissey, W. F. (1949) 'The airplane in fish and game work' *Fish and Wildl. Inf. Bull.* No. 4, New York Conservation Dept. 1–20

Darling, F. Fraser (1960) 'An ecological reconnaissance of the Mara Plains in Kenya Colony' *Wild-life Monographs* Vol. 5

Edwards, R. Y. (1954) 'Comparison of an aerial and ground census of Moose' *Jnl. Wildlife Management* Vol. 18 403–4

Eng, R. L. (1954) 'Use of aerial coverage in Sage Grouse strutting ground counts' *Proc. 34th Ann. Conf. Western Assoc. State Game and Fish Commissions* 231–3

Fuller, W. A. (1953) 'Aerial surveys for Beaver in the Mackenzie District, Northwest Territories' *N. Amer. Wild-life Conference* Vol. 18 329–35

Griffin, D. R. and Hock, R. J. (1949) 'Airplane observations of homing birds' *Ecology* Vol. 30 176–98

Holweg, A. W. (1954) 'Aerial Beaver survey' *N.Y. Sta. Conservationist* Vol. 8 13

Host, Per (1950) 'Report on studies of the Seal herds off Newfoundland, Spring 1950' Unpublished report to the Conservation Foundation

Katz, A. H. (1948) 'Aerial photographic equipment and applications to reconnaissance' *J. Optical Soc. Amer.* Vol. 38 604–10

Kelez, G. B. (1947) 'Measurement of salmon spawning by means of aerial photography' *Pacific Fisherman* Vol. 45 46, 49–51

Kenyon, K. W., Scheffer, V. B. and Chapman, D. G. (1954) 'A population study of the Alaska fur-seal herd' *U.S. Fish and Wildlife Service Special Sci. Repts.* Vol. 12

Leedy, D. Y. (1948) 'Aerial photographs, their interpretation and suggested uses in wildlife management' *Jnl. Wildlife Management* Vol. 12 191–210

Leedy, D. L. (1952) 'Aerial photo. Use and interpretation in the fields of wildlife and recreation' *Photogrammetric Engineering* Vol. 19 127–37

Matteson, C. P. (1952) 'Five-year summary report, central flyway aerial waterfowl counts in Colorado' *Colorado Game and Fish Department, Current Report* Vol. 29

Petrides, G. A. (1949) 'Applying principles of naval aircraft recognition to wildlife study' *Jnl. Wildlife Management* Vol. 8 258–9

Petrides, G. A. (1953) 'Aerial deer counts' *Jnl. Wildlife Management* Vol. 17 97–8

Schultz, V. (1952) 'An application of aerial photography to land-use and cover mapping' *Jnl. Wildlife Management* Vol. 16 227–8

Spinner, G. P. (1946) 'Improved method for estimating numbers of waterfowl' *Jnl. Wildlife Management* Vol. 10 365

Spinner, G. P. (1953) 'Efficiency of the photographic guide method in increasing accuracy in estimating numbers of waterfowl' *Proc. Washington D.C., Section Wildl. Soc. 9th Ann. Conf.* 1–8

Wilson, H. L. and Berard, E. V. (1952) 'The use of aerial photographs and ecological principles in cover type mapping' *Jnl. Wildlife Management* Vol. 16 320–6

Wilson, H. L. and Berard, E. V. (1953) 'Autumn colours, an aid to wildlife cover mapping' *Jnl. Wildlife Management* Vol. 17 98–9

9 Air Photography in East African Game Management

R. M. WATSON

East African Wild Life Society, Kenya

The great National Parks of East Africa such as the Serengeti in Tanzania, the Tsavo in Kenya and the Kabalega (formerly Murchison) Falls in Uganda, exist to protect and preserve the wild-life of these areas of Africa in its natural surroundings. The parks enclose a total area of some tens of thousands of square miles within which many hundreds of thousands of head of game compete with each other and with the human population, for space, for food and for water. Careful planning is required to provide for the needs of vast animal populations without unduly disturbing the balance of nature, or restricting man's activities to an unacceptable degree. For many years scientists have been studying the ecology of the parks to discover details of the natural processes that operate within them, so that the effects of game-management practices may be analysed and the techniques improved for the future. The success or failure of wild-life conservation is measured in terms of the population figures. In all, millions of animals are involved and regular censuses of the commoner species, many of which are migratory and which live congregated in enormous herds, are essential not only for research but as a basis for planning.

Aerial survey is the only practicable method in this terrain, much of it semi-arid, where travel on land is slow, the distances to be covered are great, and the animals elusive. Photography from the air has enabled accurate and rapid counts to be made of the herds of large animals in the parks and, moreover, provides permanent records of the animals themselves, and of their natural background. The most important aspect of the use of air photography in these studies, however, has been the development of techniques for monitoring the sizes of animal-populations to new limits of accuracy and in circumstances where any count of heads was previously almost impossible; for example, where animals are closely grouped in large herds, or are found scattered over a wide area. In the counting of large East African herbivores two distinct methods are employed. Total counts, using oblique overlapping photographs taken with a hand-held camera, are favoured for very gregarious animals such as wildebeeste and buffalo. (Photo. 9:1). On the other hand, animals that typically show a more scattered distribution are now counted by some statistical sampling method from which a figure for the total population is calculated. In essence the sampling method involves counting all the animals within sample strips selected at random; the areas of the strips must be precisely known. These counts may be performed from a series of overlapping vertical photographs, or alternatively the animals may be counted visually through some optical device that imposes fixed limits on the observer's angle of view. Whichever method is used, the aircraft is flown at a fixed altitude and the area sampled may then be calculated. The author (1967)[*] has shown how fiducial limits may be set for the results of censuses by these methods, and so an ecologist is at last in a position to detect significant changes in the numbers of these vast freely-moving populations. The results of a census of wildebeeste in the Serengeti region of Tanzania taken in each of the four years 1963, 1965, 1966 and 1967 were respectively 322 000 ($\pm 7\%$), 381 875 ($\pm 6\cdot5\%$), 334 425 ($\pm 7\cdot5\%$), and 350 000 ($\pm 8\cdot5\%$). These are the results of total counts. Zebra were counted in 1966 by a sampling method which yielded a figure of 270 501 ($\pm 35\%$). The scale of the problem will be appreciated from these figures; it is true to say that, until comparatively recently, ecologists, despite their claims, have failed to achieve reasonable estimates of the sizes of these large populations in the Serengeti because of deficiencies in their techniques (Grzimek and

[*] A list of references quoted in this chapter appear on p. 128.

Photo. 9:1 One of a series of overlapping oblique photographs from about 1500 ft which was used in the 1966 wildebeeste census.

The straight lines drawn on the negative represent the limit of overlap with adjacent frames, so that for purposes of census the animals outside the lines on this photograph are not counted. The tracks made by the passage of several tens of thousands of wildebeeste are evident. A circular space in the middle of the photograph is being avoided by wildebeeste, as the animals suspect a lion may be lying in long grass, represented by dark patches on the photograph. The animals also stay clear of the line of natural drainage at the top of the picture; this is marked by growth of longer grass, which would be ample cover for a predator.

Serengeti National Park, Tanzania June 1966

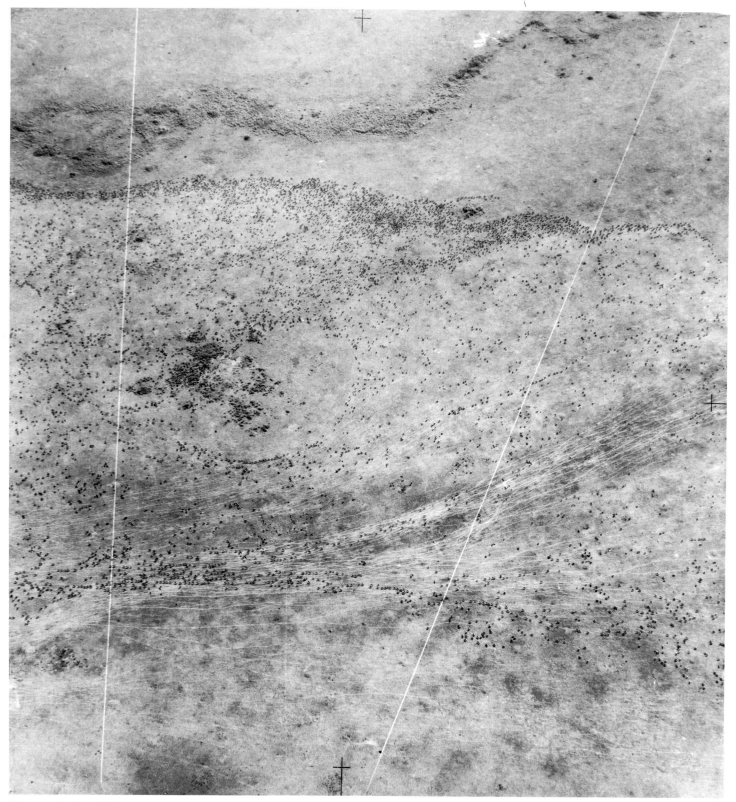

Photo. 9:1 Wildebeeste

Grzimek 1960, Steward and Talbot 1962).

An air photograph presents a permanent record, and the animals included on a photograph may be counted any number of times, by different observers, under relaxed conditions. In this way errors inherent in the counting process may be minimised and incorporated into the fiducial limits of the result.

A rather special problem in counting is provided by the Nile crocodile, a species commonly found in shallow water or a few yards offshore, and many animals will be lying on the bottom. Photography of crocodiles beneath the choppy surface of Lake Rudolf was greatly assisted by fitting a polarising filter to the camera to cut out reflected light. In the stiller water of the Nile below Murchison Falls a complete count of crocodile was made from overlapping vertical photographs taken in strips up both banks of the river (Photo. 9:2). In view of the commercial potential of crocodile, to have an accurate census has been particularly important. Crocodiles are cryptically coloured, and a high proportion of young animals are not recorded on super XX film because of their very low tonal contrast. Use of infra-red film may yield even more precise counts.

Introduction of vertical photography permits accurate measurement of the size of animals. This in turn has given the ecologist a rapid and convenient means of assessing the structure of a population through size-group frequencies, and ultimately age-group frequencies, of representative samples. The largest African vertebrates, such as the elephant (Photo. 9:3) and crocodile (Photo. 9:2). grow almost throughout life, so that vertical photographs may be used to give complete age-structures of certain populations, provided the scale of the photographs is known with great accuracy. For a survey of crocodile in the Nile, a large number of white boards exactly 2 ft across were distributed along the bank before photography. Measurement of the size of the images of these boards enabled the scale of the photograph to be precisely calculated. The smaller, more rapidly growing animals, such as buffalo (Photo. 9:4) and wildebeeste, achieve maximum body size relatively early in life. Vertical photographs of such species provide information about the proportion of young animals in a herd from which the 'recruitment rate' of the herd could be estimated, rather than on the complete age-structure of the population. The average adult body size may serve to indicate the scale of the photographs.

A further use of vertical photographs of large herbivores is in assessing the physical condition of animals. Buffalo in Lake Manyara National Park live at a very high density (Watson and Turner 1965) and in more than 80% of these animals the pelvis, spine and ribs are prominent, indicating their poor condition (Photo. 9:4). This quantitative record of the condition of the population may throw light on the nature of the relationship between the animal and its environment. Successive records of changing conditions in a population or in a herd may, for example, be related to seasonal changes in the availability of food. The condition of the buffalo in Photo. 9:4 was the result of a long-term increase in population density induced by the limitation of available land and the elimination of the disease enzootic rinderpest, which formerly held the population at a lower level. The sceptical Park authorities were convinced by the evidence of air photographs that the high density of buffalo in the Park would ultimately threaten the continued high productivity and the range and diversity of the ecosystem.

Air photography of vegetation is, by contrast, less spectacular, but no less important. The Tsavo Research Project in Kenya now sponsors photography at regular intervals, of more than thirty fixed transects about fifteen miles long, at a scale of a little under 1:2000. These transects are recorded by trained interpreters in such a way that the dynamics of the vegetation along the transect can be described from successive series of photographs. For example Photo. 9:5 shows the destruction of some individual trees in a stand of *Acacia xanthophloea* near the Seronera river in the Serengeti National Park, Tanzania. These trees have been pushed over by elephant. It is clear from this picture that they may be counted and are already permanently recorded for comparison with subsequent photographs. The establishment of transects for repeated air photography seems to be the most important technical advance of the decade in the field of plant ecology applied to these vast semi-arid ecosystems. By using photographs taken from low altitudes the plant-ecologist is able to record and store for future analysis vast amounts of information. Subsequent records of a particular transect may show changes that call for re-assessment of the original data. This is very simply done through reference to previous photographs. Occasionally a single air photograph

Photo. 9:2 A vertical photograph, taken from about 800 ft, of crocodile in the White Nile.

The various resting positions of crocodiles are clear: some are basking on the shore, some have their tails in the water, some are floating on the surface, with heads just above water, and one is lying on the bottom. A school of hippopotamus can be seen a little further away from the bank in peaceful co-existence with the crocodile. The largest crocodile in this picture is nearly 17 ft and the smallest about 9 ft long. *Kabalega (formerly Murchison) Falls National Park, Uganda.*
Scale 1:c. 430 *May 1967*

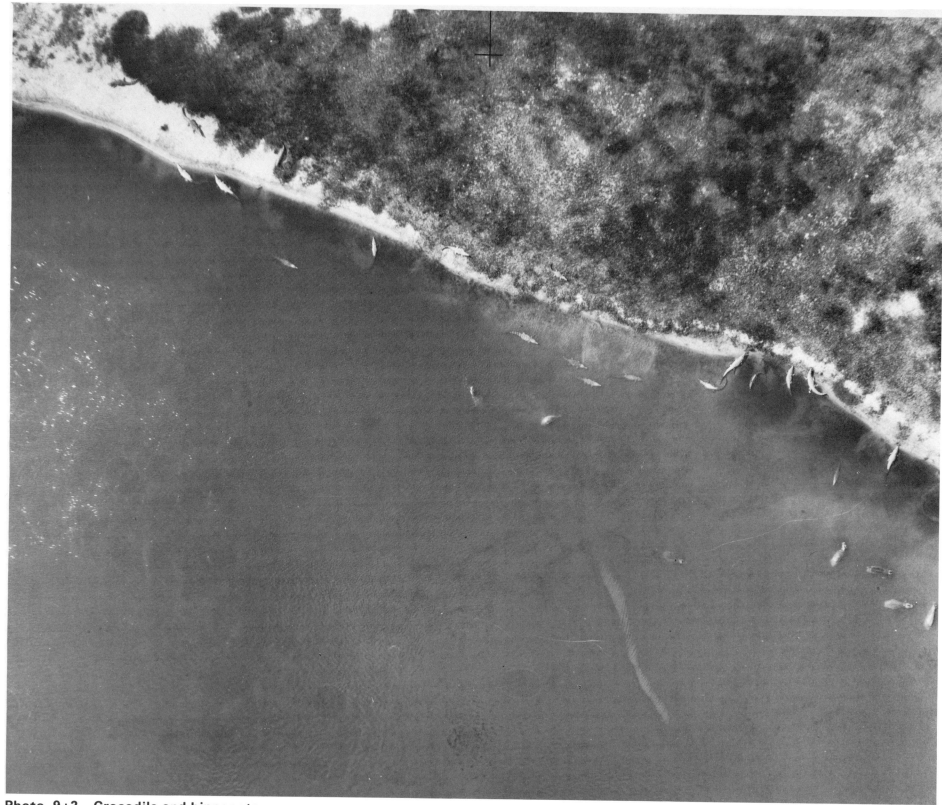

Photo. 9:2 Crocodile and hippopotamus

will show evidence of a progressive change in vegetation, or in drainage patterns. In Photo. 9:6 the four successive roads round the head of an erosion gulley in black cotton soil bear testimony to the speed with which the gulley is moving up the slope. Even the tracks of wild animals make a detour to pass across the head of the gulley.

The greatest threat to the existence of an abundant, undisturbed flora and fauna in East Africa comes from the pressure of an expanding indigenous population. Air photography can be used to investigate and demonstrate many special features of the methods of land-use currently practised. The impact of expanding human populations can be mini-mised through the more efficient planning of land-use. Photo. 9:7 is an example of a photograph which might assist investigations into the size and economy of primitive rural communities. When supplemented by a limited amount of co-ordinated survey on the ground, such air photo-graphs can yield accurate estimates of human populations, of their stock, and of the areas of cultivated land. In 1965 an air survey of human activities in the Grumeti Controlled Area, bordering the Serengeti National Park, very quickly yielded the information necessary to achieve an advan-tageous re-organisation of the pattern of land-use. Photo. 9:8 demon-strates the degree of adaptiveness of many of the tribes in Lake Province,

Tanzania, in regard to their existing practices in use of land. A single environmental feature, in this case soil type, determined absolutely the livelihood of the people living on it.

The foregoing examples show clearly the importance of air photography in many aspects of game management and research. The advances in this technique since 1964, when the first edition of this book was prepared, are evident. Further advances in the next few years may confidently be predicted, especially in the field of interpretation. Devices to enable rapid quantitative interpretation of large numbers of photographs must be introduced before the technique can play its full role.

REFERENCES

Grzimek, M. and Grzimek, B. (1960) 'Census of plains animals in the Serengeti National Park, Tanganyika' *Jnl. Wildlife Management* 24 27–37

Steward, D. R. M. and Talbot, L. M. (1962) 'Census of wildlife on the Serengeti Mara and Loita Plains' *E. Af. Agr. and For. J.* 28 58–60

Watson, R. M. (1967) 'The population ecology of Wildebeeste in the Serengeti' Ph.D. thesis, University of Cambridge

Watson, R. M. and Turner, M. (1965) 'A count of the large mammals of the Lake Manyara National Park: results and discussion' *E. Af. Wildf. J.* 3 95–98

Photo. 9:3 Part of a herd of elephant photographed with the aim of assessing recruitment rates, and the structure of the herd by age.

About 11 of these elephants are less than one year old (a little under 5%). The other size groups, equivalent to age groups, are present in numbers that fit well with the known survival curve.

Kabalega (formerly Murchison) Falls National Park, Uganda

Vertical photograph. Scale 1:c. 1050 *May 1967*

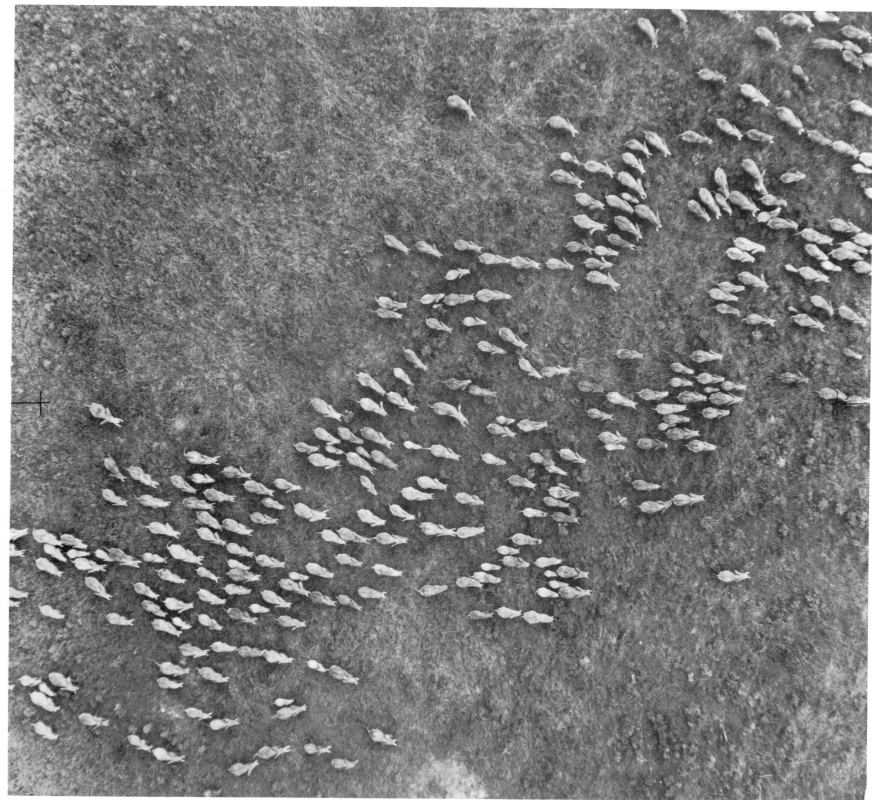

Photo. 9 : 3 Elephant

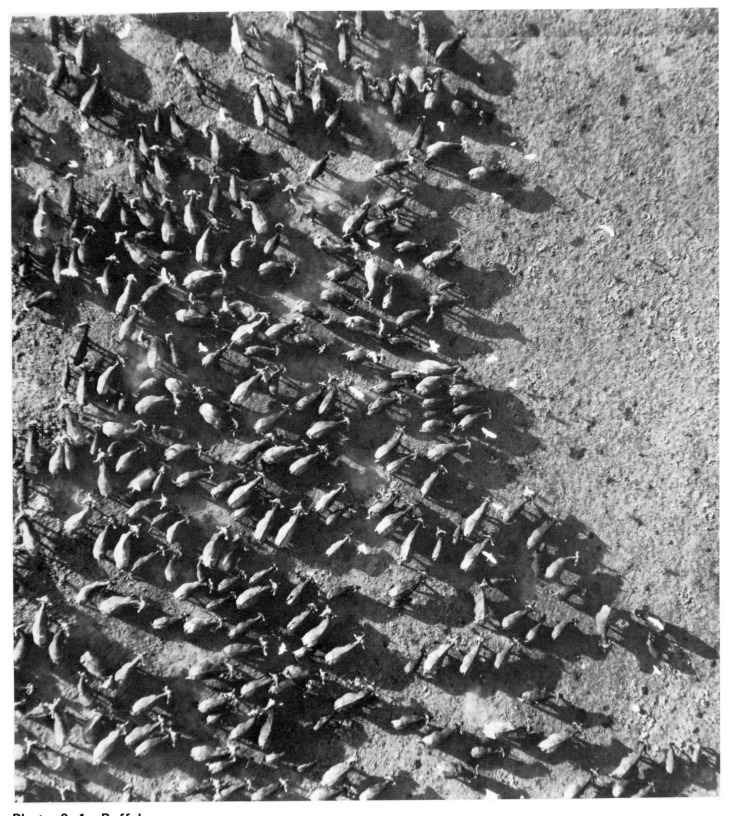

Photo. 9:4 Vertical photograph of part of a herd of buffalo.

Young animals up to about three years old can be distinguished by their size, and the shape of their horns. Over 80% of these animals have been judged to be in poor condition, from the protuberant pelvis, spine and ribs. The aircraft has disturbed some cattle egrets which were perched on the buffalo and only one retains its position, the others are in flight.

Lake Manyara National Park, Tanzania
Vertical photograph. Scale 1:300 *October 1965*

Photo. 9:4 Buffalo

Photo. 9:5 A stand of immature *Acacia xanthophloea* **trees, through which a herd of feeding elephants has recently passed.**
Some trees have been completely flattened and uprooted; others still lean precariously. A little over half (66 out of 121) of the immature trees have been killed.
Serengeti National Park, Tanzania.
Vertical photograph *December 1965*

Photo. 9:5 Trees damaged by feeding elephants

Photo. 9:6 **The advance of an erosion gulley up a black cotton soil slope has caused four successive dirt tracks to be abandoned.**

Much of the gulley floor is temporarily colonised by vegetation which may now retard further movement. The tracks of animals can be seen making an obvious detour — further evidence of the speed of erosion.

Serengeti National Park, Tanzania
Vertical photograph. Scale 1:c.1000 *April 1965*

Photo. 9:6 Land erosion

Photo. 9:7 Patterns of rural life in Lake Province, Tanzania.

The large huts are occupied on the average by between five and six people. The smaller conical roofs cover food stores: each holds the produce of about 0·2 acres of maize. The dark patches surrounded by a circular or square thorn fence are night pens for stock. At the bottom of the photograph is the communal water-hole, at which a few goats are drinking.

Plough furrows in arcs and concentric circles serve to channel run-off water after heavy rain. Well marked foot-paths caused by the tread of human feet record the daily activities of the people, one of whom stands outside the dwelling hut near the middle of the photograph.

Ikoma, Tanzania.
Oblique photograph from 1000 ft *May 1965*

Photo. 9 : 7 Rural settlement

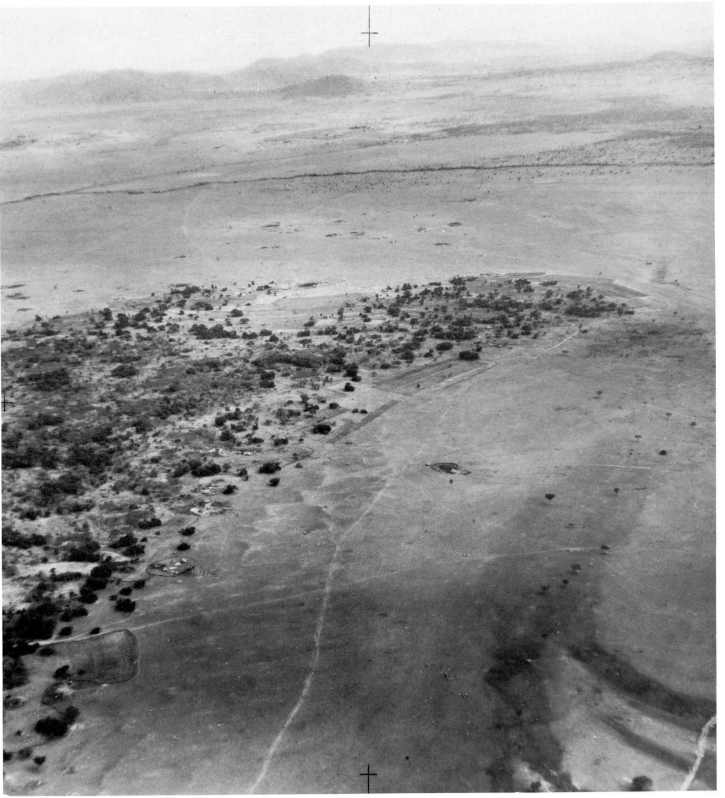

Photo. 9:8 The landscape of a mixed agricultural economy.

The wooded ridge is composed of relatively light and well drained soil suitable for cultivation.

The surrounding grassland occupies an area of heavy soils with impeded drainage, best used for grazing stock. Night pens, or 'bomas' can be seen dotted over this grassland.

Oblique photograph from 1500 ft June 1966

Photo. 9:8 Agricultural landscape, Ikorongo, Tanzania

10 Air Photography and Archaeology

J. K. S. ST JOSEPH

Professor of Aerial Photographic Studies and Director in Aerial Photography
in the University of Cambridge and Fellow of Selwyn College

The application of air photography to archaeology goes back to the 1914–18 war, when the opportunities for flying then available brought new awareness of the comprehension conveyed by the aerial view*. The same skill required for scrutinising the surface for signs of enemy activity could be applied to interpreting natural and artificial features of the landscape. The value of air photography for the study of ancient sites was soon appreciated by a number of airmen, by no means all of them archaeologists. There were, for example, Colonel Beazeley, a professional soldier who secured some of the earliest air photographs of the great buried cities of the Mesopotamian plain; Major Allen, an engineer who subsequently formed a pioneer collection of air photographs of the Oxford region; and Dr Crawford, later the first Archaeology Officer of the Ordnance Survey, who became the chief exponent of this method of research in the period between the wars. As applied to archaeology, the aerial camera is a remarkably versatile instrument, capable of recording with precision and emphasis not only visible features, but also buried sites of which no traces whatever are ordinarily visible to an observer on the ground.

The work of these pioneers established the principles of this method of research. Under suitable conditions an air photograph can show both the existing landscape, and earlier stages of its long development by Nature or man. Thus, photographs may reveal many past and present human activities, and also innumerable aspects of the natural background. For the greater part of the Stone Age no man-made structures ordinarily survive, but air photography proves of value for the study of early periods, since it can effectively display geographical factors that have determined a choice of site, thus limiting the search for ancient settlements.

Far more rewarding, however, is the application of air photography to the discovery and elucidation of man-made structures of all periods from the Neolithic to modern times. The technique depends upon the nature of the remains. When there are upstanding features like mounds, banks and ditches, the most effective photographs are obtained by paying attention to sunlight and shadows (Photos. 10:2 and 10:9). Oblique sunlight can emphasise small differences in relief: with a complicated site, several photographs from different directions and at different times and seasons may be necessary. The multiplicity of earthworks surviving in Britain, particularly those of the Middle Ages, can only be appreciated when flying at a relatively low altitude under conditions of crisp clear sunlight in early morning or late evening. Minor variations in the surface are then picked out in a detail which never fails to astonish, so that the form of the ground assumes new meaning.

Modern agriculture induces many far-reaching changes in the landscape. Repeated deep ploughing, the uprooting of hedges so that land can be worked in larger units, the reclamation of 'marginal land' now being first brought under cultivation, inevitably causes many ancient sites to be progressively levelled or even obliterated. In such instances no features remain to guide the field-observer and history is buried in level ploughed fields. Even so, ancient sites may be visible from the air

* A list of references quoted in this chapter is printed on p. 153.

For a brief account of the early history of air photography as applied to archaeology see Crawford and Keiller (1928), and St Joseph (1957). The journal *Antiquity* includes *passim* many air photographs of archaeological features, while a number of Major Allen's photographs have been published in *Oxoniensia* (1936, Vol. 1, onwards)

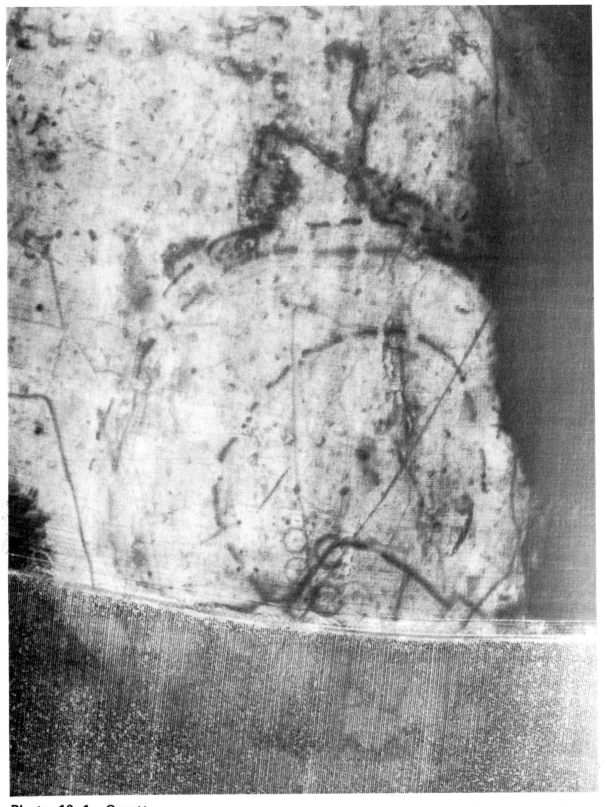

Photo. 10 : 1 Orsett, Thurrock parish, Essex (TQ 651805).
Crop-marks in corn reveal three circuits of interrupted ditches on level ground forming part of the 30 m (100 ft) terrace of the river Thames in south Essex. The inner circuit measures between 80 and 95 m across, and there is an interval of 30 to 40 m between the inner circuit and the next one. The purpose of these enigmatic enclosures within the context of the Neolithic occupation can only be settled by excavation. At Orsett, the occurrence of a faint mark parallel to the inner of two large circuits of ditch, and a few metres within it, may indicate a narrow trench for a palisade with breaks matching gaps in the accompanying ditch.
Vertical photograph K17-U 118. Scale 1 : 1200 *13 June 1970*

Photo. 10:2 Hill fort, Herefordshire Beacon, Malvern Hills (SO 760401).

The view is to the south: an area of some 2·8 hectares at the summit is defended by a single rampart and ditch. Careful siting of the defences at a change of slope ensures that the rampart, in spite of its relatively insignificant size, rises high above the ditch. Two wing-like extensions occupy the ridge-crests running north-east and south from the summit. Over much of the interior, both of the main work and of the extensions, small depressions can be seen: these are presumably hut-positions. With a surface of varying slope, the angle of illumination needed to pick out such small features may be very critical. The small earthwork crowning the hill is usually regarded as the remains of a Norman earth and timber castle.

AJC 30 *19 June 1964*

Photo. 10:2 Herefordshire Beacon, Malvern Hills

as patterns in bare soil and in vegetation. Thus, variations in the colour of freshly ploughed land can be a valuable source of information, particularly when a marked colour-contrast is in question. In the chalk country of southern England remains of 'Celtic fields', the small arable plots that continued in use up to the Roman invasion, are commonly seen by reason of the difference in colour between the white chalk of the field-banks, and the darker soil elsewhere (Photo. 10:3). Equally striking effects are provided by the contrast between the white chalk of a barrow-mound and the dark earth filling its surrounding ditch, or between the light silts in the Fenland and the black peaty soil of ditches cut through the silts.

Perhaps the most important source of new information is provided by differences in the growth of vegetation responding to hidden differences in the soil beneath. Thus, the increased depth of soil filling pits, hollows, post-holes and trenches may produce a denser and taller growth of crop than the average. Foundations, floors and road-metalling, relatively impenetrable to roots, cause poor or stunted growth. The effect is complicated: much depends upon the weather during the whole growing season, upon the soil, and upon the type of vegetation (Photos. 10:1 and 10:4 to 10:8). A dry season yields the most striking results, especially when the vegetation is a long-rooted cereal like wheat, oats or barley. In general, cereal crops are the most sensitive, root crops much less so, while hay and meadow-grass seldom respond in an average year. The effects are enhanced by dry weather, while exceptional drought accompanied by high temperatures may yield results on a scale hardly to be matched in a dozen normal years. Under such conditions, crops may reveal an astonishingly accurate plan of buried features, extending to such details as individual post-holes of a building, or a ring of stake-holes surrounding a barrow mound. The most sensitive stage of growth comes in the second half of the growing season, that is, in Britain, usually between the end of May and early July. The development of the growth differences, or 'crop-marks' as they are called, may be watched until the clearest definition is attained: the growth over buried ditches and hollows is then usually taller and darker than normal. As the crop ripens the effect may persist as patches of green, contrasting with the yellow of ripening corn, or the colours may become bleached. In extreme drought, vegetation normally unresponsive may give results, so that accurate plans of buried foundations can be seen, even in grass. Nor should it be thought that the crops already mentioned are the only ones worth study. Under favourable conditions growth differences occur in other types of vegetation and at other seasons.

Repeated reconnaissance is essential if the best results are to be obtained. Often a given archaeological site is covered by several fields, under a variety of crops, as the agricultural rotation brings different crops to each field in turn. Buried sites may remain invisible for many years, until a chance combination of favourable weather in the growing season, with sensitive crops suited to the soil, gives an unexpected result.

In any view on the ground, the man-made elements in the landscape seem to predominate in the lowland zone of Britain. In the countryside, these artificial features mostly reflect the activity of many generations in working land for agriculture. From an altitude of a few thousand feet the pattern of fields and villages is the most distinctive feature that catches the eye. The existing field-system is for the most part no older than the last few hundred years, having come into being after the break-up of the medieval system of 'open field' agriculture. The age of villages varies: some are comparatively recent plantations set in rural surroundings, some existed at the time of the Domesday survey, some have their origins in Saxon settlements, some are built upon Roman or earlier remains. The appearance of most ancient villages has been completely changed by successive rebuildings in more durable materials with stone, brick and slate replacing timber, daub and thatch. Such rebuildings normally destroy or mask all earlier features: but such is the persistence of rights-of-way, of building-lines and of property-boundaries that much of the old fabric of a town or village may still be discerned from the air.

Of especial value to archaeological studies is the quality of comprehension easily attainable only in a distant view. A prospect of a great building becomes more meaningful if the structure to be studied is seen in its natural setting: a castle perched upon precipitous crags, or a country house in its surroundings of gardens and parks. So, too, with ancient features, questions such as the relationship of earthworks to some significant aspect of the topography, or the type of soil on which a given site lies,

Photo. 10:3 Tidpit Common Down, Hampshire (SU 071181).
Celtic fields with remains of settlements on chalk downland at the Hampshire–Dorset border. Earthworks survive in relief over a small area near the centre of the photograph. This is surrounded by newly-ploughed land where soil marks reveal an elaborate system of Celtic fields. This vertical photograph illustrates very well the encroachment of ploughing upon land never previously cultivated in modern times. Autumn is a good season for photography of these features, since the sun is at a low enough angle to pick out earthworks, while contrasting tones in the soil show clearly in ploughed fields.
Vertical photograph RC8-AA 181. Scale 1:6000 *27 October 1971*

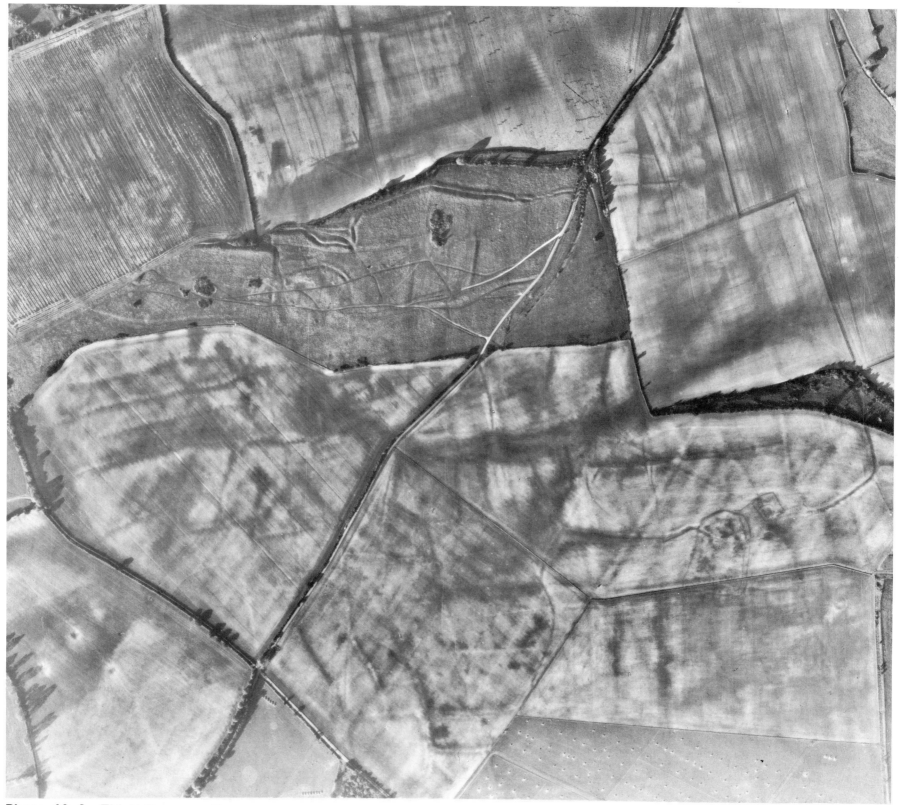

Photo. 10:3 Tidpit Common Down

may be posed and sometimes answered by reference to air photographs. The earlier the period being studied, the fewer the artificial disturbances of the surface large enough to have left any mark now visible from the air. Some of the first significant man-made changes, like the clearance of scrub and the burning of forests, will have left no discernible trace, so that in early phases of archaeology the main value of air photographs comes from their use in reconstructing the natural background. Recognition of long drained peat-bogs or marshes from the spread of black soil marking their extent, or of the distinction between heavy clay land, formerly forested, and more freely draining gravels and sands, helps to narrow the search for early settlement sites.

Britain is one of the best surveyed countries in the world. However, the existence of Ordnance maps, in a wide range of scales and styles, obscures the fact that many details of the topography highly significant for studying settlement history are so small as to be unrepresented, for the most part, on maps, however large the scale. Such details of the Quaternary landscape as river-terraces and raised beaches, shorelines of long vanished lakes, natural levees or 'roddons' of the Cambridgeshire Fenland, islands of gravel in a clay valley (Photo. 10:8), may all be valuable guides in a search for ancient sites, but find little expression on maps, as any experienced field archaeologist knows. Even the closest contour-intervals in general use (O.S. maps at 1:25 000 scale with contours 25 feet apart) are too wide to represent these minor land-forms. Here, air photographs come into their own, for they record all visible features. Compared with maps, they require a greater degree of interpretation, and may even be misleading. Characteristic vegetation or black soil pointing to marshy ground; shadows picking out slight scarps of limestone beaches, of old strand-lines or of river-terraces; erosion hollows on chalk or limestone slopes marking former spring lines related to a water-table very different from that now prevailing, are all of potential interest to the field archaeologist. The record may be obscured by the very multiplicity of information, but most misconceptions can be avoided by detailed study of the ground.

The natural features just mentioned are visible on air photographs by reason of differences in tone, between sunshine and shadow, between light and dark soil, or between varying patterns of vegetation. When artificial disturbances of the surface are in question, an interpreter may have to pay even closer attention to detail. Man-made disturbances surviving from early periods of archaeology are small in scale, and thus easily masked or even destroyed by the treatment of the land surface in later ages. The mechanisation of agriculture by steam ploughs in the nineteenth century and by tractor-drawn ploughs at the present time, has been particularly effective in smoothing the surface, so that all earthworks are progressively levelled (Photo. 10:3). A systematic programme of photography under suitable conditions of all areas in the lowland zone of Britain untouched by modern ploughing is a matter deserving of high priority.

When there are no remains in relief, as is true of most ancient sites in Britain, the recording of archaeological features calls for special skill in observation. The principles involved in the identification of buried sites must be thoroughly understood, if the limited opportunities for flying are to be used to best advantage. The whole of Britain has been photographed from the air, much of it time and again, and the question may thus be asked, what need is there for further photographs? Regional vertical survey with photographs in overlapping series, principally serves needs of land-use and mapping, and provides information for those engaged in a search for raw materials. Single vertical photographs can be of great use to a field-worker for positioning himself on the ground, particularly in moorland areas where maps show little detail. Such surveys, made at any time of year when there is good flying weather, have, from their very completeness, a value for the archaeologist in that they may draw attention to sites that have escaped previous notice because of remoteness from the beaten track. While most vertical survey is undertaken by commercial firms, archaeological observation from the air involves setting out to observe and to photograph features not previously known to exist. It is thus in the nature of reconnaissance; the best results will be obtained when an archaeologist skilled in observation from the air is responsible for the direction of the work, and himself undertakes the photography. In such an operation, photographs are not taken at random and subsequently examined to see if they show archaeological features: the sites are identified from the air and are then recorded on film or in note-book to best advantage.

In Britain, the temporary settlements of the migratory hunting–fishing communities of the Mesolithic period are recognised chiefly by scatters of artifacts, mainly in flint, but occasionally in less durable materials, as well as by shell middens. When there was no convenient rock-overhang or cliff-face to provide shelter, a few holes might be made in the ground for boughs or withies to form a wind-break. Holes for such supports have been found by excavation: the chance that they might be identified from the air is remote. Even in the Neolithic period (third and early second millenia B.C.) settlement sites are not easy to find: the best known structures are concerned with ritual, or with the disposal of the dead.

**Photo. 10:4 Orton Waterville, Hunting-
donshire (TL 146975).**

These crop-marks reveal an extensive archaeological
site south of the river Nene on a gravel terrace above
flood-level. The photograph was taken late in the
evening when differences in height of growth in the
corn were emphasised by shadows. The result is a
picture of a settlement site of unexpected complexity.
The features lie within the area designated for the
Peterborough new town, and are now being des-
troyed by gravel quarrying. The existence of the
photograph meant that excavation could be under-
taken in advance of destruction.

AOL 26 *21 June 1966*

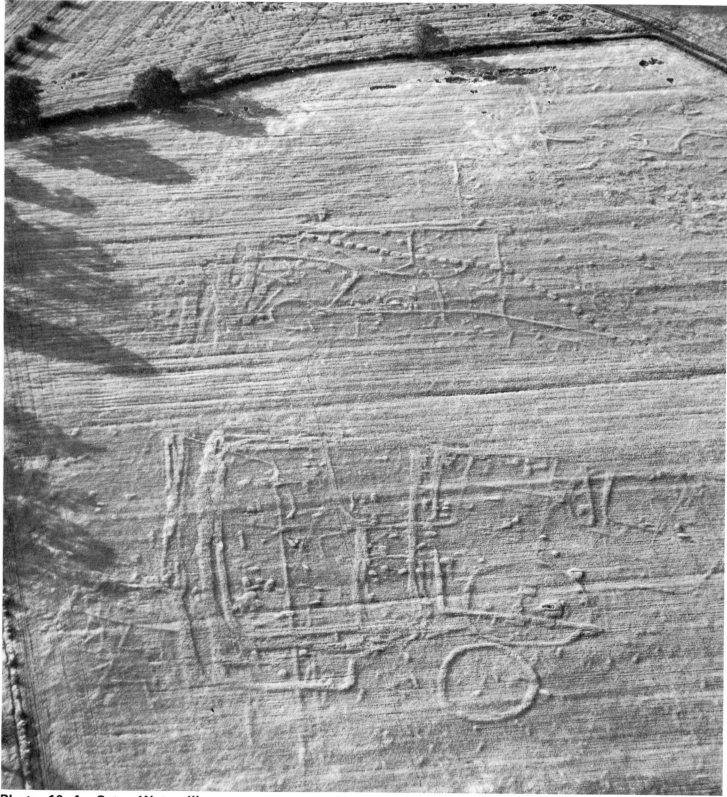

Photo. 10:4 Orton Waterville

Circles or alignments of standing stones, and elaborate monuments, like Avebury and Stonehenge, excited the interest of antiquaries long before the days of scientific archaeology. That other sites formerly existed there seemed to be no question, and in the pioneering days of archaeological reconnaissance from the air the matter was determined beyond doubt by the discovery of buried structures of a related kind, namely, enclosures with bank or ditch and holes for timber uprights. The last thirty years have seen the discovery of many further examples of these ritual monuments, called 'henges'; also of long rectangular enclosures (*cursus*) resembling airfield runways in their proportions, and of interrupted ditch-systems, whatever purpose these may have served (Photo. 10:1).

Construction of the larger examples of these features must have involved a considerable proportion of the total endeavour of the neolithic population. No doubt more henges, perhaps only comprising settings for timber uprights, await discovery, but that there can ever have been very many of the largest sites is unlikely. The gain from air photography lies not only in the fact that more examples of these sites are now known and are available for study by excavation, but also that consideration of their distribution in relation to geology, to soils, and to other types of structure, can be based upon a much larger sample than before. There are also instances where air photography has thrown different features into visible relationship, either demonstrating their relative ages, or showing where excavation could tackle the problem.

The most distinctive visible evidence of the Bronze Age in Britain is the round barrow, amongst the commonest of ancient earthworks on the chalk lands of Wessex. On other soils, materials available for the construction of barrows are often more prone to weathering than compacted chalk, and less resistant to continued ploughing. Thus, on light soils scarcely any trace of barrows may remain in relief. When a barrow mound is composed of dark turf or light-toned gravel or limestone rubble, it will continue to be visible from the air as a soil mark, long after it has ceased to be noticed on the ground. More often still, the circular ditch round a barrow is visible by reason of a colour difference in soil or crops. Sometimes other features appear, perhaps an interment pit, cut into the old ground surface, and one or more circles of small holes for stakes or withies on the ground within the ditch of the barrow. But the principal additions to knowledge come from the very number of the discoveries. In the first edition of this book this point was illustrated by distribution maps of the barrows in a part of East Anglia. Reconnaissance over the last ten years has reinforced the pattern by many more examples, principally on river gravels, and this picture is repeated in valleys elsewhere.

The great concentrations of crop marks on the gravel terraces of the Thames, Ouse, Nene, Welland and Trent comprise many varied features often with different elements overlapping (Photo. 10:4). Settlement sites are common: they may take the form of circular or penannular marks, representing either a trench to hold upright timbers or a drainage gulley around a circular building. These marks occur clustered together, or in isolated examples. Detailed interpretation is tentative at best, for it should be remembered that only large disturbances in the soil may be rendered as crop-marks. Holes for the small posts, perhaps only 15 cm across, that formed the framework of a native hut can seldom be recognised from the air, since the disturbances of the subsoil are so slight as to be visible only in exceptional conditions. Similar caution is necessary in interpreting other types of marks; enclosures, linear ditches, post-holes, pits and large hollows or working-floors, often observed on river gravels or on chalk. Extensive linear or meandering ditches may have been farm boundaries. No doubt these ditches were accompanied by banks: how often dry thorn hedges were incorporated in such boundaries or were used to form corrals for cattle remains undetermined.

The marks that seem undoubtedly to represent settlements are of considerable variety, as is evident from results in Wessex. On gravels, too, there are regional differences, for example, between the upper Thames and the Ouse, Nene and Trent. These structures span a considerable range in time: some may fall within the Roman age. In a growing number of instances the proximity of a 'native' type settlement to a small Roman villa suggests that excavation should be able to trace the transition in farming practices and in type of settlement from the Iron Age to the Roman period (Photo. 10:6). Of the less regular settlements, crop-marks often suggest long successions of structures superimposed, as if there were repeated changes of plan (Photo. 10:5). The question at how early a date do these settlements on the river gravels begin, is as yet unanswered by excavation. Any structures contemporary with the numerous ring-ditches already mentioned, or signs of early working of the land for agriculture, are singularly elusive.

In England the greatest number of discoveries by air reconnaissance have so far come from the chalk of Wessex and of the Yorkshire Wolds, and from the gravels of the principal river systems, from the Thames to the Trent. In Scotland, glacial gravels forming the fertile soils of the Lothians and of the river basin of the Tweed have yielded a large number of crop-marks and the potential of these areas is only now beginning to be recognised. Elsewhere in the highland zone discoveries are more sporadic and the sites scattered. Any extensive development of arable

Photo. 10:5 Butterwick, Yorkshire, E.R. (SE 988710)

This site on the floor of a shallow dry valley in the Yorkshire Wolds is not readily matched thereabouts. The unexpected degree of detail visible in the crop may be due to a greater depth of gravelly subsoil in the valley floor than elsewhere. The patterns comprise seven or eight closely clustered elements, each some 50 m across, perhaps compounds containing huts. The marks suggest that several lines of ditch or palisade are present, as if the site had been replanned more than once: where this falls in the picture of Iron Age and Roman settlement in the Wolds is not yet clear.
BCM 91 *25 June 1970*

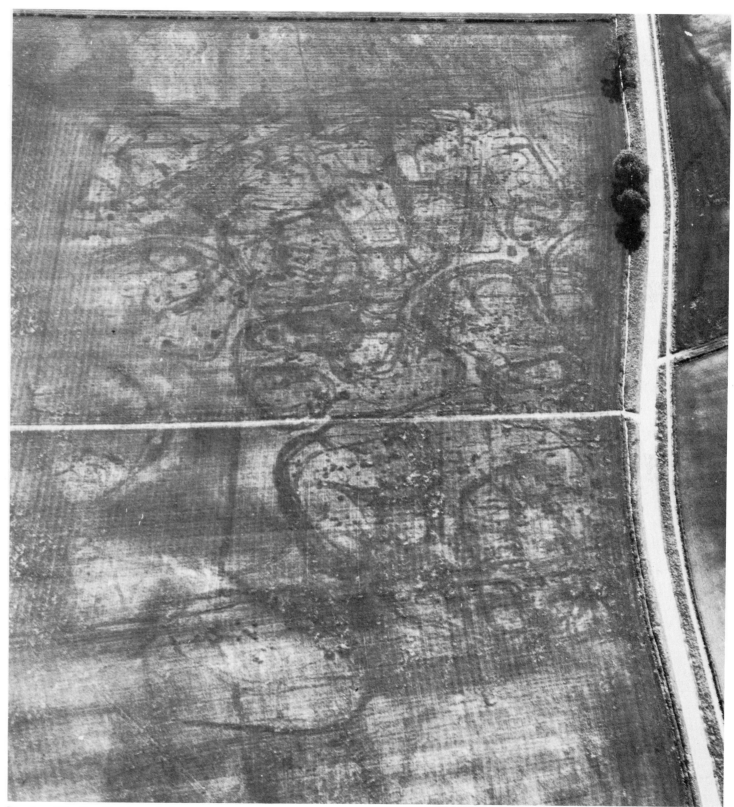

Photo. 10:5 Butterwick

land having a gravel subsoil of glacial or fluviatile origin is worth reconnaissance, but if best results are to be achieved, due consideration has to be given to local factors, such as uncertain weather, a later sowing and ripening of crops, and often the existence of free-draining soils. In the moorland areas of both Scotland and Wales many ancient sites remain visible as earthworks in relief, but as yet have not been recorded from the air.

In Ireland, crop-marks are most in evidence in the arable land of Leinster, with the terraces of the larger rivers providing most examples. If maximum flying effort could be arranged to coincide with rare conditions of drought, there is no doubt that much more would appear. But Ireland is especially remarkable for the multiplicity of its earthworks. No other country in western Europe had a population which only a century and a quarter ago was so much greater than now, with yet so small a proportion of its land at present under regular cultivation. Thus, there exist over large areas in Ireland earthworks of great diversity and in date ranging from pre-historic times to the nineteenth century (Norman and St Joseph 1969).

The extent of recent discoveries in Britain is by no means widely appreciated. Archaeological sites vary so greatly in character, appearance, and extent that no count of numbers is very meaningful. In thirty years of reconnaissance more buried and unknown sites have been discovered than the total number already known. The scale of these discoveries is perhaps best demonstrated by maps on which are plotted all crop-marks in a given area. Amongst the earliest of such maps are those published in 1938 by Major Allen. Recognition of the growing number of discoveries, especially in river-valleys, and of the threat of destruction posed by gravel extraction, prompted publication in 1960 of a survey by the Royal Commission on Historical Monuments for England: the survey included detailed plans of crop-marks in the Welland valley. Results of air reconnaissance of the valley of the Warwickshire Avon have been published by Webster and Hobley (1964). Since then a number of research committees have been active in different parts of the country, compiling a record of essential information from all available sources and especially from air photographs. Perhaps the most telling of recent surveys is that of the river gravels of the Upper Thames published by the Oxfordshire Archaeological Unit (Benson and Miles 1974). The fifty or so special maps demonstrate what air observers have long recognised. There are areas where buried features are so numerous that their mere outlines plotted on a large-scale Ordnance map completely overshadow the conventional symbols representing the current state of the land. And yet these special maps of the Thames valley do not attempt to show aspects of the medieval agricultural landscape. Many instances occur of concentrations of structures recorded in a given field while adjoining fields are blank. This is due to the chance that some fields may have been reconnoitred under favourable conditions, while neighbouring land, long in pasture, shows nothing. Even after thirty years of reconnaissance opportunities for discovery are by no means exhausted. The new knowledge provides in some areas a basis for study of the developing cultural landscape over several millennia.

The contributions of air photography to knowledge of Roman Britain are equally great. In the military sphere, the main gain in knowledge has come from discovery of numbers of camps and forts, the temporary and permanent works of the Roman army. An air observer sees the transition from pre-Roman to Roman Britain as a change from disorder in arrangement and irregularity of plan to an ordered scheme. Roman military works conform to standardized types, mostly comprising well-known structural elements, so that a camp or fort may often be identified from a minimum of evidence. Roman military works tend to be parts of an organised system, so that consideration of the known distribution of forts or camps may suggest where to look for missing members of a series, thus effectively narrowing the field of search.

In midland England and in the approaches to Wales many sites, unrecognised before, have come to light. The occurrence at Greensforge (Staffs.) and at Wroxeter (Salop) of several camps and forts emphasises the importance of these places as bases for advance into the more difficult hilly country to the west. Beyond the Severn, the Welsh Marches afford considerably greater obstacles to military advance than do the Midland plains. In Wales, Roman military sites have been discovered through air reconnaissance in the last thirty years at a rate of rather more than one a year. Their distribution is closely determined by geography. In the Marches, temporary camps point to lines of penetration, principally along river valleys. Amongst the forts, there are several instances where two

Photo. 10:6 Cromwell, Nottinghamshire (SK 803626).

Extensive crop-marks on a gravel terrace west of the river Trent show what seems to be a Roman villa surrounded by a series of enclosures suggesting repeated changes in the use of the land. Near the centre of the complex a range of rooms of a stone building is clearly visible, but rows of holes for posts can also be distinguished, so there may have been timber structures as well. Detailed interpretation of so complicated a site must await results with the spade. The special value of the photograph is to show a would-be excavator in general terms what he is going to find and where to find it.

Vertical photograph K17-U 187. Scale 1:2250 *22 June 1970*

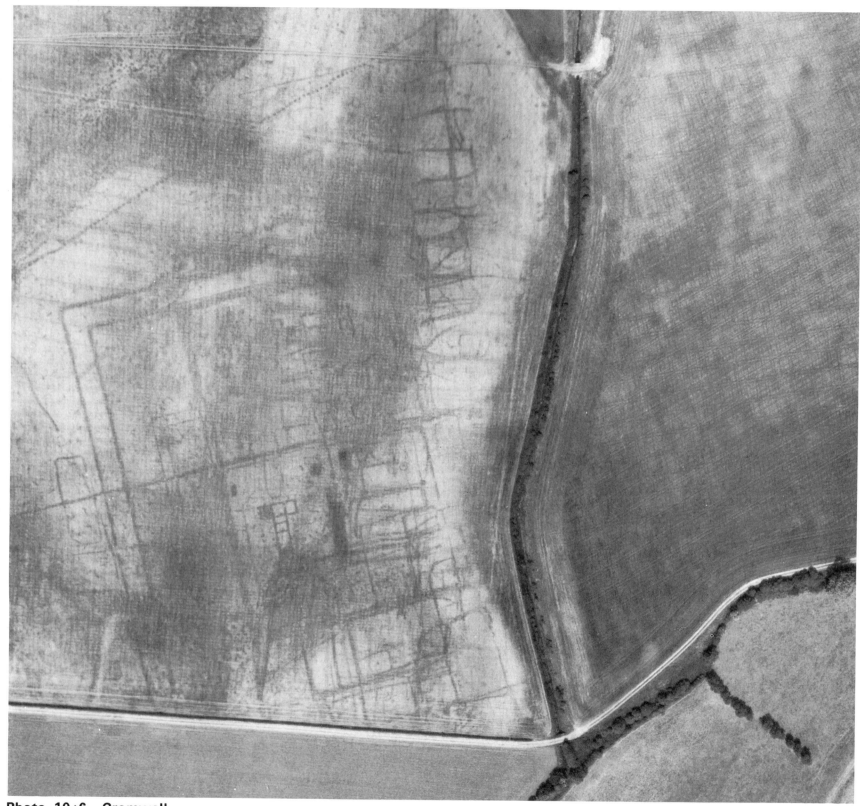

Photo. 10:6 Cromwell

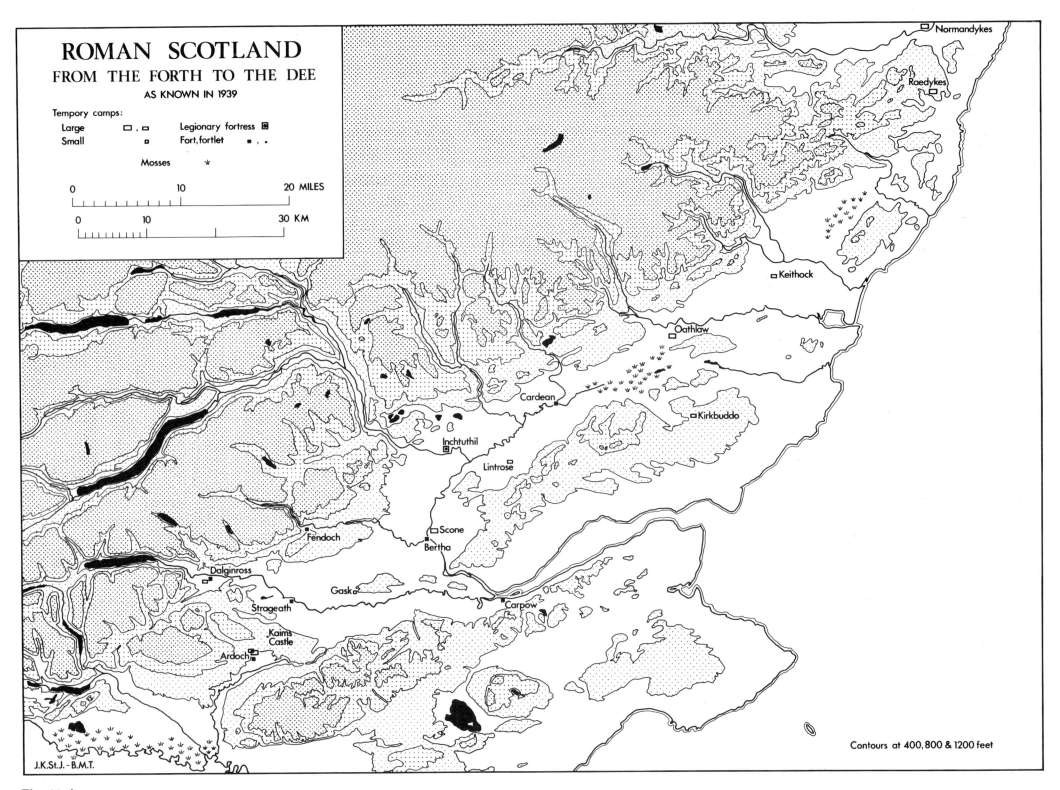

ROMAN SCOTLAND
FROM THE FORTH TO THE DEE
AS KNOWN IN 1939

Tempory camps:

Large ▭ , ▢ Legionary fortress ◨

Small ▪ Fort, fortlet ▪ , ▪

Mosses ⚘

| 0 | 10 | 20 MILES |

| 0 | 10 | 30 KM |

Normandykes

Raedykes

Keithock

Oathlaw

Cardean

Kirkbuddo

Inchtuthil

Lintrose

Fendoch

Scone

Bertha

Dalginross

Gask

Carpow

Strageath

Kaims Castle

Ardoch

Contours at 400, 800 & 1200 feet

J.K.St.J. - B.M.T.

Fig. 10:A

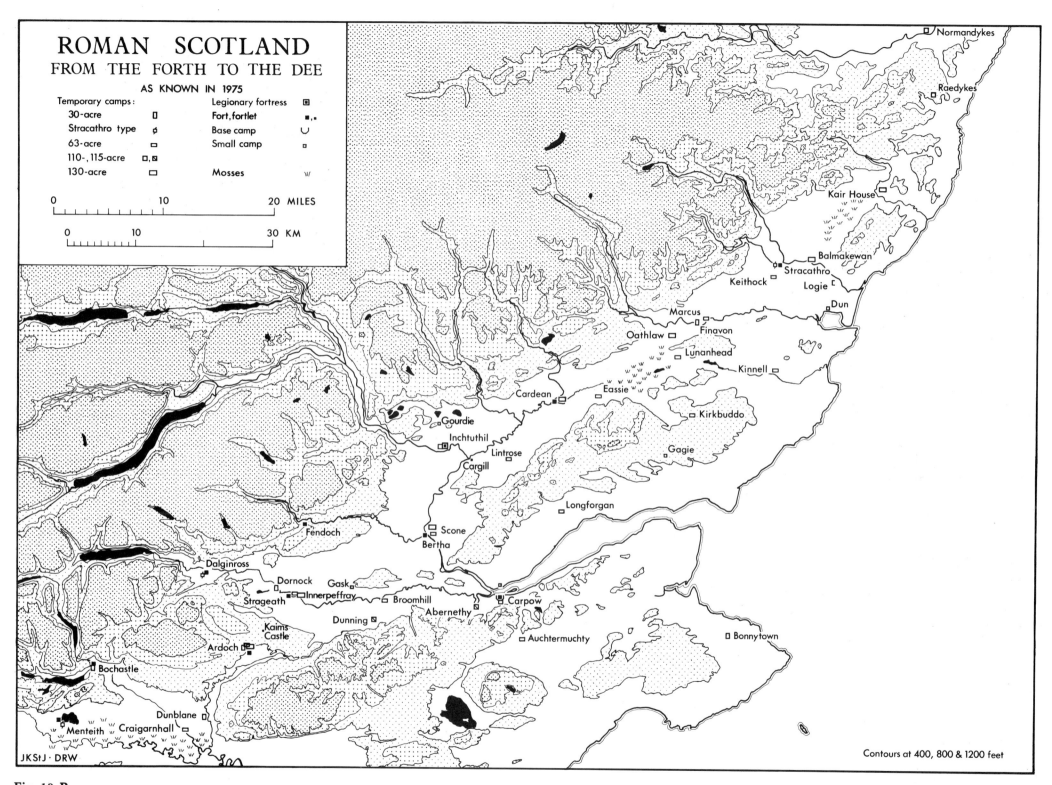

ROMAN SCOTLAND
FROM THE FORTH TO THE DEE
AS KNOWN IN 1975

Temporary camps:
30-acre
Stracathro type
63-acre
110-, 115-acre
130-acre

Legionary fortress
Fort, fortlet
Base camp
Small camp

Mosses

0 10 20 MILES
0 10 30 KM

Normandykes
Raedykes
Kair House
Balmakewan
Keithock Stracathro
Logie
Dun
Marcus
Oathlaw Finavon
Lunanhead
Kinnell
Cardean Eassie
Gourdie Kirkbuddo
Inchtuthil Gagie
Lintrose
Cargill
Longforgan
Scone
Bertha
Fendoch
Dalginross
Dornock Gask
Innerpeffray Broomhill Carpow
Strageath Abernethy
Dunning
Auchtermuchty Bonnytown
Kaims
Castle
Ardoch
Bochastle
Dunblane
Menteith Craigarnhall

JKStJ·DRW

Contours at 400, 800 & 1200 feet

Fig. 10:B

forts occur so close together that they can hardly be contemporary. The system, incompletely known as yet, probably reflects successive transient arrangements in the give and take of frontier warfare over the twenty years that preceded the Roman conquest of Wales (St Joseph 1973).

Reconnaissance of the military districts of northern Britain has literally changed the map. Further camps have appeared along the principal lines of advance, while appreciation of the extent of military penetration to the south-west of Scotland has become possible for the first time. This work illustrates the results to be achieved by aerial reconnaissance and field-observation combined. Sometimes an aerial photograph reveals a site where further information may come from study on the ground; sometimes field-work prompts further photography. Observation of crop-marks of buried features in arable land has yielded most discoveries, but the extensive tracts of uncultivated mountain and hill pastures contain many earthworks. Such terrain is less easy to reconnoitre in a light air-craft, nor may the gain in information justify the effort involved. In these circumstances, scrutiny of regional survey photographs, taken for quite other purposes, is well worth while, not least for the reason that they provide complete coverage. There are instances where examination of such photographs has led to important discoveries which otherwise would not easily have been made because they were situated in areas where Roman penetration had not been anticipated (Steer 1948).

That part of eastern Scotland beyond the Roman frontier of the Antonine Wall and south of the margin of the Highlands, comprises low-lying land divided by the Ochil and Sidlaw Hills (Fig. 10:A). Beyond these hills, Strathallan, Strathearn and Strathmore together offer the easiest route for any army advancing towards the north of Scotland. This territory saw Roman campaigning on several occasions in the 130 years following A.D. 80, and the distribution of camps and forts reflects Roman plans for conquest and control. Of these, history provides tantalizingly meagre information which may usefully be supple-mented by study on the ground. Over the last thirty years aerial recon-naissance has greatly increased our knowledge of the Roman occupation of the area. Comparison of the two maps (Figs. 10:A and B) shows that in 1939, a legionary fortress, eight forts (one of them small) and ten large temporary camps with one small camp comprised the total of known sites. In 1975, the number of forts had increased to twelve (two being small)*, and the temporary camps to forty-three. The greatest increase

* Of the additional sites in Fig. 10:B, it should be observed that the fort at Bochastle was established by field survey and excavation (Anderson 1956).

148

in numbers is in the camps, and here the gain in knowledge comes both from the much larger number available for study and from the fact that in some instances different camps occupy in part the same ground. Amongst the large camps (Fig. 10:B) four main series have been dis-tinguished by size, by axial proportions and by type of gate. At points where the defences of two camps overlap excavation may be able to determine their relative age. A map of military dispositions such as Fig. 10:B invariably conveys one aspect of the picture only. Understanding of military strategy calls for some knowledge of the distribution of the native population, whether in small settlements of family or larger groups, or in tribal centres. Here the principal contribution of air reconnaissance has been the discovery of numerous settlement sites of varying size and complexity in areas of arable land where modern cultivation has levelled all earthworks. In hilly districts where features still exist in relief, photo-graphy in oblique sunlight can be of great help in the interpretation of an elaborate site: evidence of date usually comes only from excavation.

The application of air photography to Roman military affairs has drawn mainly on examples within Britain (St Joseph 1951–73). In the very different terrain of the desert frontiers of the Roman Empire, the pioneer work of Father Poidebard in Syria revealed, forty years ago, varied aspects of the organisation of a frontier province (Poidebard 1934). Equally notable was the achievement of Colonel Barradez shortly after the war of 1939–45 in surveying from the air an entire Roman frontier system in Algeria (Barradez 1949). In both instances the remains in question are often visible on the ground, but by reason of their remoteness, of the considerable areas involved, and of difficulties of terrain, the only practical means of recording them was by air photography. It is interesting to note that just as in Britain, where the growth of the subject owed much to the interest of individual members of the Royal Air Force, so also Poidebard achieved his results by co-operation with officers of the French Air Force, then stationed in Syria, while Barradez was able to undertake photography that served the interests of the Directorate of Antiquities in Algeria.

Study of many other aspects of the Roman world has also been assisted by air photography. The opportunities, and the use that has been made of them, vary from one country to another. Thus the chance afforded by Mediterranean lands of surveying from the air entire Roman cities, with many of their larger buildings still upstanding, does not occur in northern France or Britain. Two particular fields in which air photography has made a notable contribution may be mentioned. Vertical survey photo-graphy, both during and after the last war, has revealed in Italy, Yugo-

slavia and Tunisia, unexpected details of Roman *centuriation*, the system of regular land division of territory assigned to important towns (Bradford 1957). The temperate climate of northern France, Belgium, West Germany (Scollar 1965) and Britain especially favours the development of crop-marks, which may reveal different aspects of the Roman economy, whether in towns or countryside. Amongst the most remarkable results are those obtained in Picardy by M. Agache, who has been able to recover in comparatively few seasons' flying an astonishingly complete picture of Roman rural settlement of which little was known before. The many hundreds of sites he has discovered include not only farms, but great villas with elaborate buildings grouped round several courts, temples, and enclosures in considerable variety, perhaps representing Gallic settlements from the time before the systematic development of the area for agriculture when it became a Roman province.*

In Britain, the first six centuries following the Roman period have seemed to yield rather meagre results to air reconnaissance compared with the age that preceded them. However, more intensive flying, greater awareness of what to look for, and more careful scrutiny of the surface than before, are together beginning to have effect. Anglo-Saxon settlements and even cemeteries, are now being recorded, though their identification from the air requires acute observation. Crop-marks suggesting the foundations of timber structures or the sunken floors of huts can be misleading, and with such material the evidence of photographs needs, in all but the clearest instances, to be confirmed by digging. Many more discoveries may be expected, particularly in those areas of eastern England most affected by Anglo-Saxon settlement, as opportunity comes for search under optimum conditions.

Earthworks of the Middle Ages are prominent features of the English cultural landscape (Beresford and St Joseph 1958). Defences in earth or stone, and grass-grown mounds that conceal the remains of a castle or a religious house come immediately to mind. The remains of settlements, hamlets and villages that have been abandoned, have changed their position, or have shrunk from their former size are amongst the most widespread of visible archaeological features. Villages that have vanished completely, or whose site is now marked only by an occasional building, alone number a few thousand, and at many villages still existing, disturbed ground or low banks and ditches, hardly noticeable except from the air, testify to changes in the built-up area. In the countryside the former extent of the medieval 'open fields' is marked by ridge and furrow which, in heavy clay land, is often visible in relief or, elsewhere, as marks in soil or crops. Access-ways to the fields, marl-pits, fish-ponds, windmill mounds, leets serving water-mills, scars of mining and quarrying, represent other aspects of the medieval economy. Increased practice in observation has brought a clearer realisation of the multiplicity of subjects to be observed from the air. The field-archaeology of settlement in the Highlands, and in particular the widespread remains that are witness to the Clearances of the eighteenth and nineteenth centuries, provide abundant opportunities for photography from the air, while some of the western islands yield a surprising number of earthworks. Reconnaissance of remote districts tends to be undertaken in the most settled weather of summer, but for much of the Highland zone summer may not be the best time for photography, as a widespread covering of bracken then at maximum growth effectively obscures minor earthworks.

This account has special relevance to Britain, but equally important discoveries can be made elsewhere, given suitable opportunities for the work, and appreciation of the limitations imposed by different vegetation and terrain. The light glacial soils in north Germany and in Denmark provide in all but the wettest summers brief occasions for recording the slender traces of prehistoric houses and cultivation systems. The sandy soils of west and north Jutland have been found to provide a favourable environment for such observation, since houses of the Iron Age or the Viking period appear as crop-marks which reveal the post-holes for their timbers, or their sunken floors (Photo. 10:7). In the Netherlands, the prevailing high level of the water-table does not, in general, encourage development of crop-marks, though the fact that these have been observed, as in Drenthe, suggests that they may well be found elsewhere. However, the low-lying marsh pastures in the polders of West Friesland, now being brought into arable cultivation, offer unusual chances of observing as soil marks both the systems of creeks that determined the choice of ground for settlement, and even traces of the settlements themselves. The geology of northern France resembles that of southern England, but much of the chalk plateau of the Pas de Calais has a covering of limon, a soil not unlike the loess of south-east Europe. A first impression is that there are fewer sites on the chalk than in Britain, unless the cover of limon is very thin, but in these special geological conditions, colour differences in the soil are best seen as the surface dries during a clearance after heavy rain, when the marks may be vivid indeed, as happens in the silt fens of Cambridgeshire and Lincolnshire. Thus in France, as in Britain, the best results come from seizing the opportune moment for photography,

* The results of M. Agache's surveys have been published in a number of papers in *Bull. Soc. Préhist. Nord.* 1962–70.

Photo. 10:7 Staa, north-west of Vester Hasing, Aalborg, Jutland

The outline of a number of houses appears by reason of the dark growth of corn over the area of their floors dug down into the gravel subsoil. The largest of the houses is some 35 m in length. Failing excavation, their date can only be conjectured: the boat-shaped plan of at least three of the structures might be taken to suggest that they belong to the Viking age. This photograph is a good illustration of the clarity of the evidence for such houses that has recently come to light in Jutland. Elsewhere, foundation-trenches or post-holes for timber uprights appear under favourable conditions, but the marks are often so faint that they are easily lost in the printing of a half-tone plate.

ASE 39 *27 June 1967*

Photo. 10:8 Biggleswade, Bedfordshire (TL 184445).

Crop-marks have developed in corn growing on a patch of gravel rising very slightly above the flood-plain of the small river Ivel, west of Biggleswade. The prominent circular feature 45 m or more in diameter to which two outer, less regularly shaped enclosures are attached, strongly suggests a motte and bailey fortification in earth and timber. Other enclosures of unknown age are also visible in this gravel 'island', but it is by no means common for medieval features to give rise to crop-marks of such clarity.

VQ 78

13 July 1957

Photo. 10:9 Kirkstead Abbey

a point long realised by the few French scholars dedicated to this work. In the Pas de Calais, Picardy and Ile de France, earthworks of the medieval agricultural landscape hardly appear, but earthworks may surely be expected in Brittany, whenever there arises someone who will pioneer research by air photography there. In Italy the effect of an arid climate on vegetation can produce crop-marks of exceptional contrast, though they may not persist so long through the growing season as in Britain. By using war-time photographs of Apulia, Bradford was able to amass an abundance of evidence for the settlement of the area in Neolithic and later periods. In Etruria, uneven retention of moisture in the soil has revealed entire Etruscan cemeteries seen in varying tones in the earth when the surface is bare, or by differential growth of vegetation (Bradford 1957). This brief review will have made clear that opportunities for research by air reconnaissance exist in almost all countries, but that success depends upon careful appraisal of the local conditions which have to be thoroughly mastered if useful results are to be obtained.

Between the wars, Crawford and Allen were, in Britain, almost the sole pioneers. Their combined collections of a few thousand photographs were valuably supplemented by occasional photographs taken by the Royal Air Force on training flights, or as opportunity offered. This total is now exceeded many times by the photographs taken in a single year. Discoveries by air reconnaissance show that there exists an astonishing variety of archaeological sites, rich in historical implication and information. Often no trace whatever is to be seen on the surface, and the growing public concern at the extent to which so many sites are under threat is well founded. These buried features, normally only visible from the air, have profoundly altered existing distribution patterns. Inevitably many of these newly discovered sites will be destroyed by the normal processes of agriculture or by changes in land-use. To ensure that the increased provision now being made by the State for study of threatened archaeological sites is deployed to fullest advantage, the widest possible view of the problem is essential. With growing care in making a search,

discoveries from the air will not always follow well-established lines, for a measure of surprise is a common element in aerial reconnaissance. The development of local flying is multiplying discoveries, but further arrangements are needed for large-scale survey photography, essential both for recording the plan of complicated features and for study of a site in its setting of Quaternary geology. Present surveys need to be matched by adequate provision for cataloguing, and for the retrieval of information from the growing collections, which will gain in value as the photographs from successive years' flying are compared, and the results are combined.

Typescript received September 1975

NOTES AND REFERENCES

Allen, G. W. G. (1938) *Oxoniensia* Vol. 3 169–71, fig. 20, pls. xv–xviii; ibid, 1940, Vol. 5, 164–5, fig. 10

Anderson, W. A. (1956) *Trans. Glasgow Arch. Soc.* Vol. 14, 35–63

Barradez, J. (1949) *Fossatum Africae* Paris

Benson, D. and Miles, D. (1974) *The Upper Thames Valley, an Archaeological Survey of the River Gravels* Oxon Arch. Unit

Beresford, M. W. and St Joseph, J. K. S. (1958) *Medieval England, an Aerial Survey* Cambridge

Bradford, J. S. P. (1957) *Ancient Landscapes*

Crawford, O. G. S. and Keiller, A. (1928) *Wessex from the Air* 3–7

Institut Géographique National (1954) *Atlas des Centuriations Romaines de Tunisie,* Paris

Norman, E. R. and St Joseph, J. K. S. (1969) *The early development of Irish Society*

Poidebard, A. (1934) *La Trace de Rome dans le désert de Syrie* (2 vols) Paris

Poidebard, A. and Mouterde, R. (1945) *Le Limes de Chalcis* (2 vols) Paris

Royal Commission on Historical Monuments (England) (1960) *A Matter of Time, an Archaeological Survey*

St Joseph, J. K. S., *Journ. of Rom. Stud.* (1951) 41 52; (1953) 43 81; (1955) 45 82; (1958) 48 86; (1961) 51 119; (1965) 55 74; (1969) 59 104; (1973) 63 214 (For summaries of the results achieved by the application of air reconnaissance to Romano-British studies in the last twenty-five years.)

St Joseph, J. K. S. (1957) 'A survey of pioneering in air photography' in *Aspects of Archaeology* (W. F. Grimes, Ed.) 305–15

Scollar, I. (1965) *Archäologie aus der Luft* Düsseldorf

Steer, K. A. (1948) 'Archaeology and the national air photograph survey' *Antiquity* 21 50ff

Webster, G. and Hobley, B. (1964) 'Aerial Reconnaissance over the Warwickshire Avon' *Arch. J.* 121 1–22

Photo. 10:9 Kirkstead, Lincolnshire (TF188617).

The earthworks that mark the site of this once important Cistercian abbey are not easy to comprehend on the ground. In a distant view the system becomes clearer: beyond the site of the church, its nave crossed by a white farm track, is a smooth square of grass marking the cloister, while the rest of the extensive conventual buildings are grouped round several courts.

AWX 35 *3 February 1969*

11 Air Photography and History

M. D. KNOWLES
Sometime Regius Professor of Modern History in the University of Cambridge

It may be thought that air photography as an aid to knowledge loses much of its value when history takes over from pre-history, for by definition this transition occurs when written material, as distinguished from all other physical records of the past, becomes available in adequate measure. It is true that in a fully historical epoch air photography becomes an ancillary rather than a primary source of information, but there are many topics in any period of history, even in our own contemporary life, where printed evidence is either hard to come by or is piled in masses of unmanageable size, and where an air photograph can show at a glance a particular process, such as the growth of an industrial town, isolated from all else.

In any case, we do not leap from pre-history to history in a year, or even in a century, and for much of English history before the Norman Conquest we depend upon sources other than written records. Sometimes, indeed, an air photograph can define and illuminate what is vague or insignificant in the written record. A striking example is the discovery of the historical relevance of the buildings revealed by crop-marks at Milfield and at Yeavering in Northumberland. These were first noticed and photographed by Dr J. K. St Joseph in 1949, and two photographs of the sites were published in 1953. They were subsequently identified with two royal vills mentioned by Bede the Venerable in his *Ecclesiastical History* (II. xiv) and excavations at Yeavering have revealed the foundations of large timber halls and of staging apparently for a tiered auditorium.[1]

In one department of history, that of the agricultural economy, air photography is particularly valuable. The standard or classical layout

Superior figures in the text refer to numbered notes on p. 166.

of a nucleated medieval village is familiar, with its arable divided into small individual strips cultivated with the 'two-field' or 'three-field' rotation of crops, with its leys or rich grazing land for cattle, and with its waste land valuable for timber or pannage. Once attention had been drawn to the systems of medieval agriculture surviving to the present day, relics were discovered and duly described and mapped. The most familiar instance is Laxton (Nottinghamshire),[2] to which attention has been directed by a book, *The Open Fields*, by C. S. and C. S. Orwin, and by subsequent filming and broadcasting. Within the past twenty years a number of early (sixteenth-century) field-maps have been published of other villages from all over the midlands and north-east England, showing the common fields and strips. Air photography has illustrated these maps in a striking way by revealing the marks of the plough at different angles corresponding to the arrangement of the strips within the area of large modern fields that have been for centuries turned over to grass. Even when the observer on foot is aware of the ridges he cannot obtain an overall sight of the terrain, nor see at a glance the correspondence between the cartographer's sketch and the lines of the furrows.

In this context an important achievement of air photography has been that of raising and solving the problem of the origins of the 'ridge-and furrow' surface familiar to all midland countrymen. A normal answer given to local enquiry was that this arrangement was made at some unspecified date for purposes of drainage—an answer which assumed that farmers at some remote date would have engaged upon drainage works on such a scale and so universally. Air photography shows not only that ridge-and-furrow land exists where the ploughed fields of the village once lay, but also that irregular and disjointed examples of ridge-and-furrow, which could not conceivably be drainage

works, exactly represent the irregular and staggered arrangement of the strips in early maps, while in many cases the original pattern of ridge-and-furrow can be seen to have been broken by subsequent (and in some cases even by medieval) buildings. No doubt examples of surfaces akin to ridge-and-furrow exist as a result of post-medieval ploughing or even of calculated drainage operations, but it is certain that in innumerable instances the ridge-and-furrow pattern is the unintentional outcome of medieval husbandry. Photos. 11:1 and 11:2 show the open fields of Padbury (Buckinghamshire), with part of the map of 1591 now in the possession of All Souls College, the owners of the land. It will be noted how the ridge-and-furrow of the open fields has been intersected by the hedges planted *c*. 1796. In the left of photograph and, beyond the medieval field-lane, towards the right-hand margin, furrows running at right angles to the main run of the strips are visible, precluding any explanation as drainage works. Comparison with the map provides incontrovertible proof of the medieval origin of the ridge and furrow. Similar patchwork patterns of strips can be seen still more clearly in photographs (with plans) of Ilmington and Crimscote, both in Warwickshire.[3]

One of the most spectacular discoveries in medieval economic history in the past thirty years has been that of the almost ubiquitous 'deserted' village. The sites of a few such abandoned settlements had of course long been known locally. Ancient tradition, the existence of a medieval parish church deep in the fields and far from human habitation, and in some cases even records of a village no longer in being had served to inform the local historian or antiquary, but in almost every case the date and cause of the abandonment were unknown, and the Black Death in one of its manifestations had been called in as an explanation. No attempt had been made to catalogue or compare the various examples. The great plagues of the fourteenth century were certainly responsible for some of the extinctions (an example is Tusmore in Oxfordshire)[4] but a more universal dissolvent was the change-over from arable to pasture between 1450 and 1550. Photo. 11:3 shows extensive earthworks first recognised as a result of air reconnaissance. They mark the site of a deserted village at Newbold Grounds, near Catesby, in Northamptonshire. This site has never been ploughed in modern times so that the earthworks are exceptionally well preserved. The lines of streets, the crofts and buildings and the bank and ditch marking the perimeter of the village may all be distinguished, as well as the contemporary fields in ridge-and-furrow. [Although unploughed in 1965 when Professor Knowles wrote this chapter, Newbold Grounds was seen to have been ploughed in 1967, when the site was photographed as soil marks. *Ed.*] In the eighteenth

century many open fields were enclosed 'by agreement', more or less voluntarily, or by a private Act of Parliament. The photograph of Padbury (Photo. 11:2) shows the hedges that were then drawn over the landscape. A few villages disappeared in the process. [Others were diminished, as seen on Photo. 11:5. *Ed.*]

In medieval England religious houses must often have formed the most prominent work of human hands in a landscape. Even now the cathedrals (once abbeys) of Peterborough and Gloucester stand out above their commercial and industrial surroundings, and they must have dominated the low medieval roofs as Ely cathedral still dominates its small city. Many of the six hundred abbeys and priories stood in small hamlets or in the open country, and as the church invariably stood on the highest point of the site they must often have been visible for miles. Only a small number are intact to any degree; the remains of the others have fallen into ruins in every degree of dissolution from the imposing fragments of a Rievaulx or a Fountains to the superficial disappearance of a Sempringham or a Croxton. Air photography is not necessary to display the beauty of these ruins, situated as they often are in surroundings of exquisite natural charm, but it is valuable in at least two ways. A vertical or almost vertical photograph can present the layout and the successive alterations made to the building in a way that neither a plan nor a view from the ground can hope to do. Thus a view of Kirkstall (Yorkshire, W.R., actually within the built-up area of Leeds) shows the typical, regular Cistercian plan to perfection; a view of Furness (Lancashire) makes the enlargement of the cloister and the repeated alteration of the refectory comprehensible at a glance[5]; while photographs of such sites as Easby (Yorkshire, N.R.)[6] and Haughmond (Shropshire)[7] show clearly the irregularities of design that might easily be missed on the ground. [An example of the remains of an Early Christian monastery in Ireland is shown in Photo. 11:4. *Ed.*]

Another use of air photography in this field is an application of a technique more commonly applied to sites of prehistoric or Roman times. A view taken under optimum conditions of lighting, of drought or of crop-growth may show the existence and plan of foundations not previously discovered or excavated. Several Cistercian abbeys of which little remains above ground can be reconstructed in this way. Thus Revesby and Kirkstead (Photo. 10:9), both in Lincolnshire,[8] and Sawtry (Huntingdonshire) could be excavated in the light of air photographs already available, while parch-marks in photographs of Robertsbridge (Sussex)[9] show the east end of the church and part of the infirmary invisible to one standing on the site. Pre-eminent in this respect is the

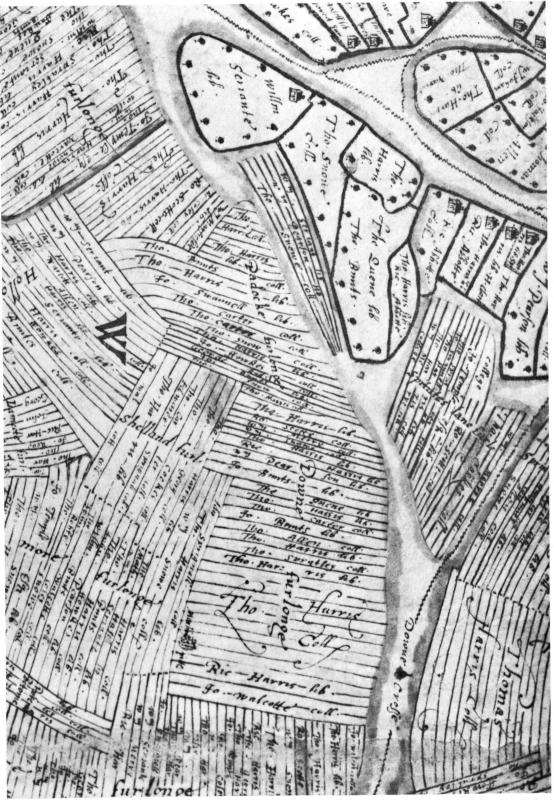

Photo. 11:1 Padbury West Field in 1591

Photo. 11:1 Padbury West Field in 1591, after Thomas Clerke.

Comparison of the air photograph (Photo. 11:2) with this map of the same area shows that it is possible to match each individual ridge with a corresponding strip on the Elizabethan map, which represents the 'open field' system in being as a going concern. The map thus demonstrates that the pattern of ridge-and-furrow visible today is that of the pre-enclosure strips, and gives in addition the names of the Elizabethan tenants.

Photo. 11:2 Padbury, Buckinghamshire (SP 717302).

Medieval ridge-and-furrow comprising a number of 'furlongs' in the West Field of Padbury. The ridges are picked out by the evening sunlight. The straight hedge-rows radiating from the village represent the work of the enclosure surveyors of 1796. Thus the photograph shows the modern field system superimposed upon the medieval landscape of 'open fields'.

LS 58 2 May 1953

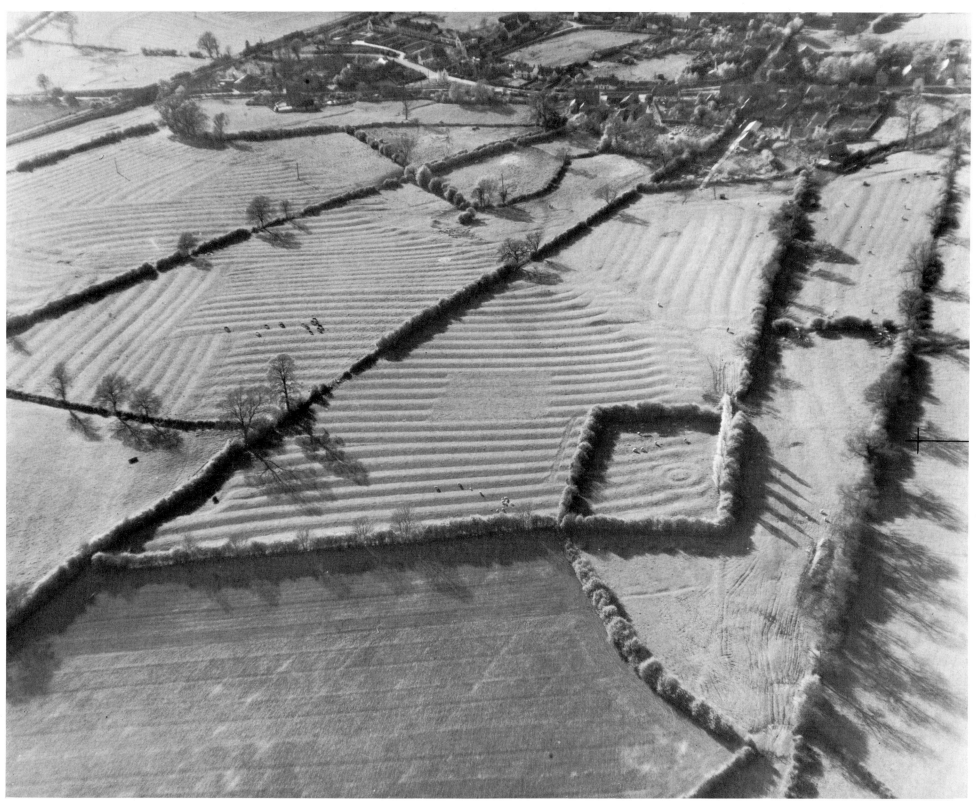

Photo. 11 : 2 Padbury West Field in 1953

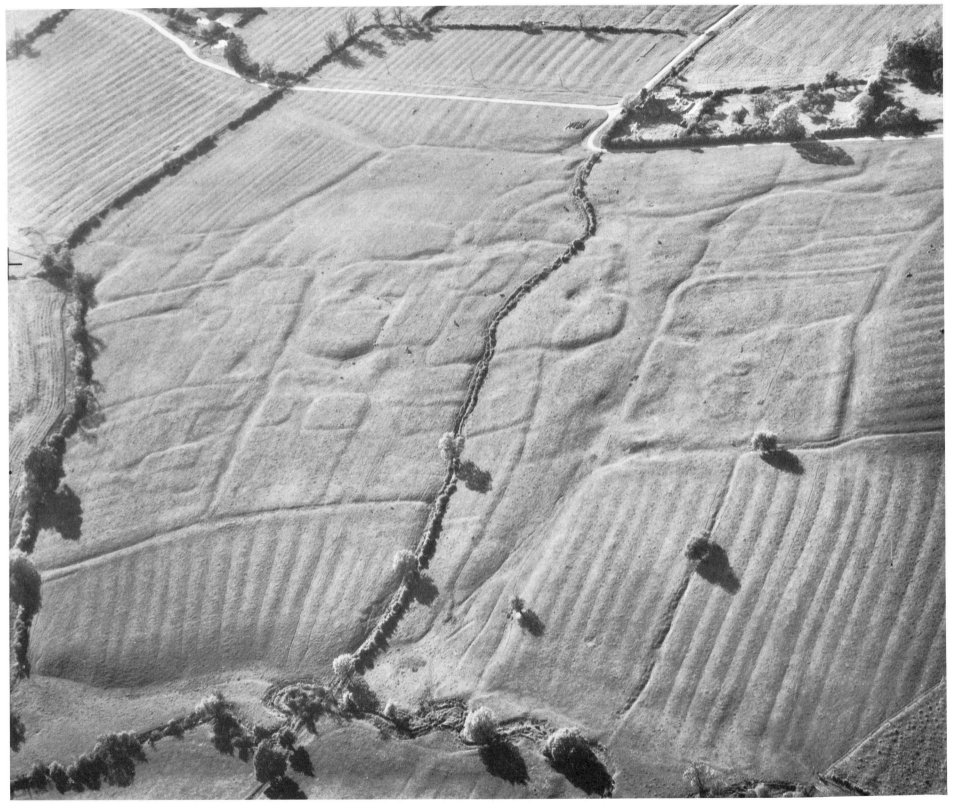

Photo. 11:3 Deserted medieval village, Newbold Grounds *(see caption on p. 160)*

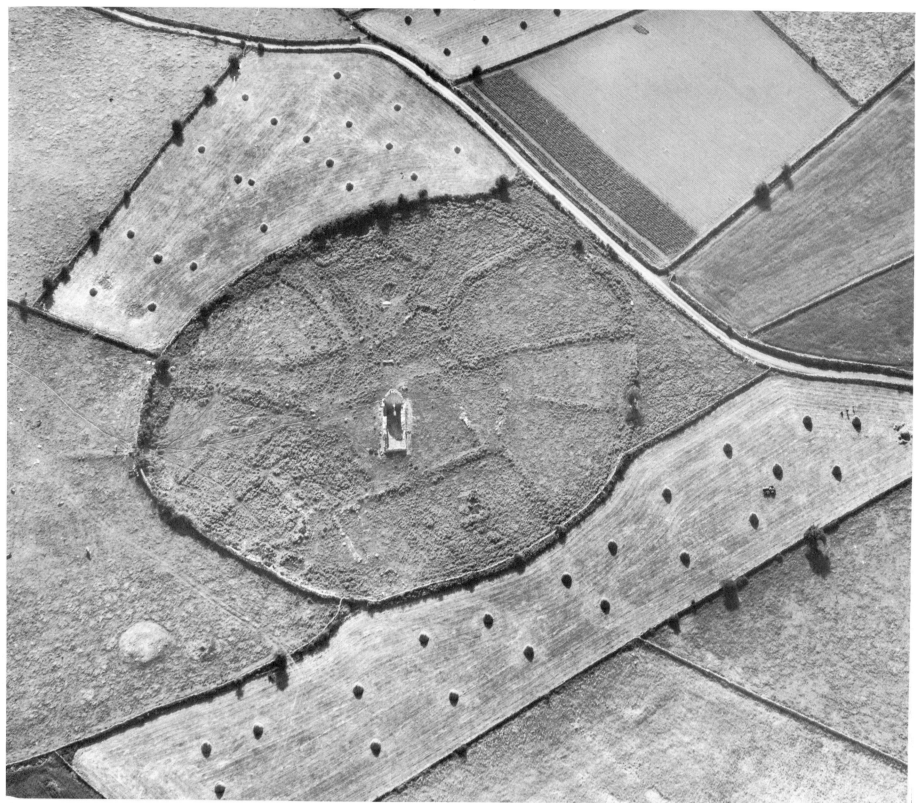

Photo. 11:4 Kiltiernan, Co. Galway *(see caption on p. 160)*

Photo. 11:3 Deserted medieval village, Newbold Grounds, Catesby, Northamptonshire (SP 517606).

The characteristic earthworks of a deserted village include sunken 'hollow ways' marking the lines of streets, banks and ditches defining the boundaries of crofts, and irregular low mounds covering the remains of buildings, of which the most substantial were the church and manor house.

AHG 33 *10 June 1963*

Photo. 11:4 Kiltiernan, Co. Galway, Eire (M 437155).

The remains of this Early Christian monastery survive in an unploughed island of pasture amongst arable fields. The ruined building is a pre-Romanesque church, probably of the late eighth or ninth century. It stands at the centre of its circular precinct, bounded by a thick dry-stone wall with a gateway to the south-east. The enclosed area (1·7 hectares) is partitioned by further walls, now overgrown with grass; some of the subdivisions contain foundations of monastic cells and other buildings. The square enclosure in which the church stands has been shown to be the monastic cemetery. Since its abandonment, the site has remained undisturbed by later medieval buildings or burials.

BDN 53 *15 July 1970*

site of the great double monastery of Sempringham (Lincolnshire), head house of the Gilbertine order. This wide complex of buildings, comprising two complete monasteries with cloisters, dorters, refectories and the rest, lying on either side of a large church in which both canons and nuns had separate choirs, must have dominated the flat landscape of the wide valley wherein it stood, and its tower or spire must have been visible from afar. All this had disappeared to the last stone, and all traditions of the site had vanished. It was even supposed that the buildings had lain some distance away near the small medieval parish church. As the site was under rough pasture before 1940 air photography was unrevealing, but the foundation trenches of the church were discovered in part by a process of cross-cutting in 1939. Then in 1950, when the land was under cereal crop, an air photograph revealed the outline not only of the church but of the claustral buildings to north and south, visible as lighter growth in the young herbage.[10]

Second only to monasteries as characteristic monuments of the medieval scene are the castles. Here air photography begins once more with its function of indication and revelation, and proceeds to that of general illustration. In historical times the castle, considered as a piece of military architecture as opposed to the camp or defensive earthwork, began as a wooden tower on an eminence, natural or artificial, surrounded by an irregular fence or ditch (Photos. 10:2 and 10:8). This was the so-called motte-and-bailey type, introduced to England shortly before the Norman Conquest and widespread in the century that followed. It multiplied above all in the reign of Stephen, with the so-called 'adulterine' castles, some of which have been revealed for the first time by views from the air. When these castles were razed or decayed, only the mound remained. One such site, unrecorded in print or on any map, is probably revealed by a photograph taken in 1963 of a site near the ancient road known as the Ryknield Street between Alcester and Wixford. This type of castle was rapidly overtaken by the stone keep enclosed by a defensive wall, and this again by the perfect type of fortress-castle evolved by the crusaders in such masterpieces as Crac des Chevaliers, carried back to France in such edifices as Château Gaillard, and perfected in it classic expression by the engineers of Edward I. The string of massive fortresses imposed upon the Welsh landscape after the Edwardian conquest, along the northern coast from Chester to Beaumaris, by Harlech (Photo. 11:6) to Pembroke and the marches of Monmouth and Herefordshire, is without peer in any country of Europe. Here the air photograph can show at a glance, as with the monastic ruin, the elaborate plan with its defences, curtain walls, masked entrances and concentric approaches and towers, while oblique views of Harlech or Carreg Cennen show the skill and purpose of the architects in the matter of siting. A photograph from the air can show the development of the later domesticated Compton Wynyates or Baddesley Clinton (Warwickshire) from the island-castles such as Bodiam or Herstmonceaux (Sussex).

With a series of photographs it is possible to trace what has been called the 'dissolution of the medieval landscape'.[11] Those of Laxton

Photo. 11:5 Ludborough, Lincolnshire (TF 295955).

Ludborough, at the foot of the eastern slopes of the Wolds, is almost surrounded by earthworks which suggest that the village was formerly more extensive. Among these earthworks, a series of three rectangular fishponds descend the slope in the foreground. Though now empty, their retaining walls and dams still stand, their sluices are yet clear to see. There is no stream close enough to provide water for the system, but a pool in one corner of the highest pond, and another visible among the earthworks on the right of the photograph, suggest that the ponds may have been fed from springs. Fresh fish was probably a more important item in the economy of such medieval communities than is generally realised.

AHC 81 *3 June 1963*

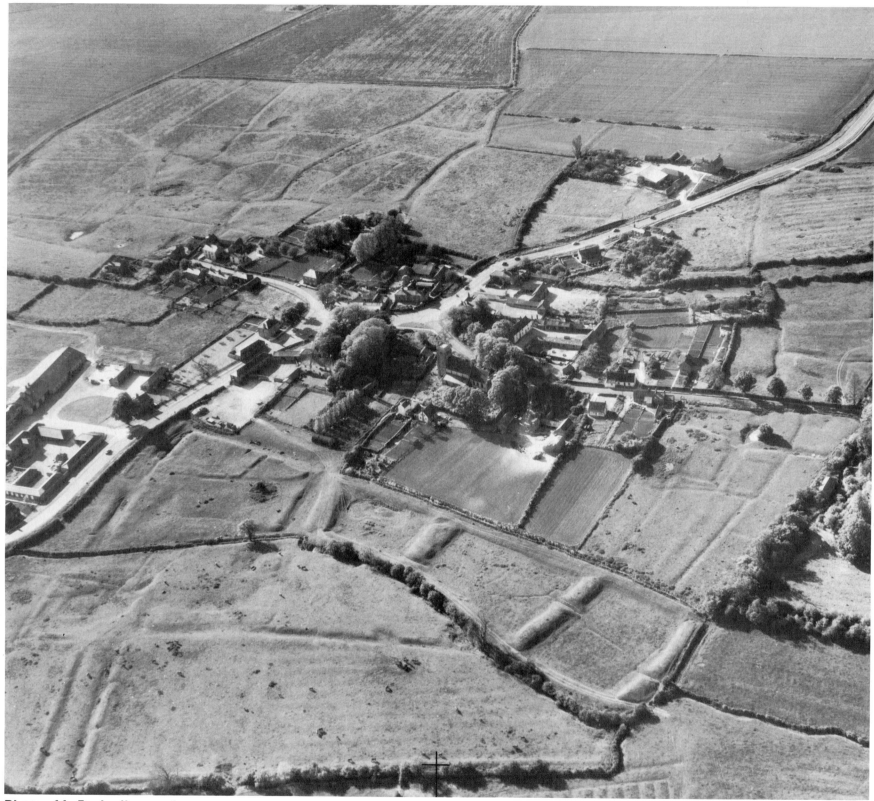

Photo. 11:5 Ludborough

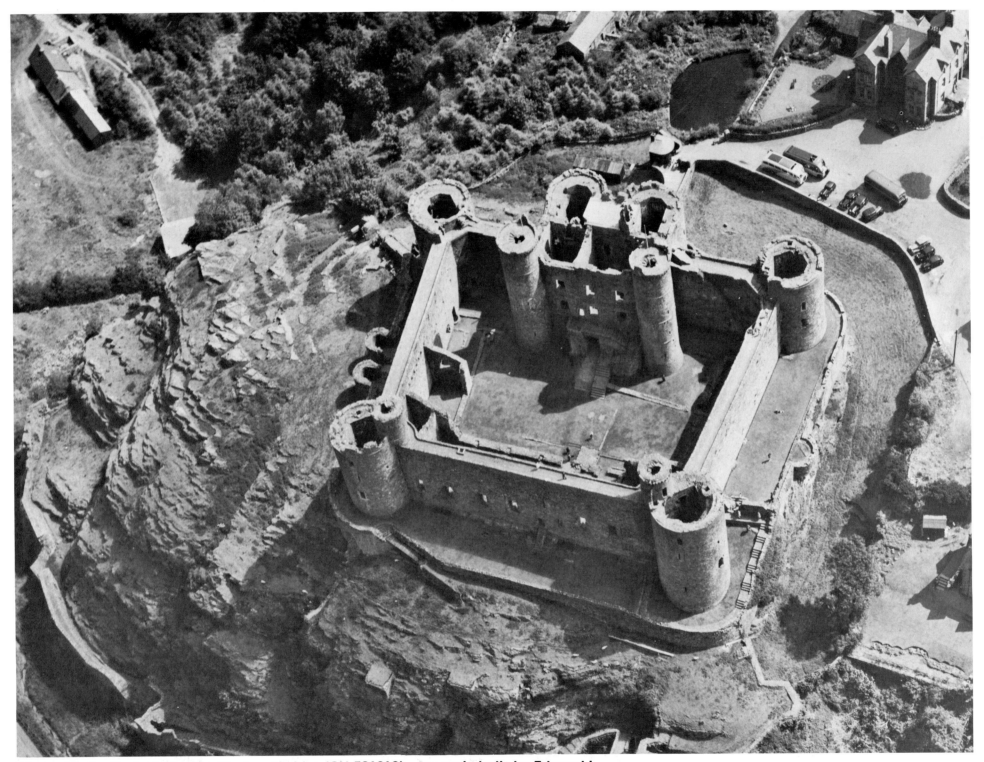

Photo. 11:6 Harlech Castle, Merionethshire (SH 581313) — a castle built by Edward I.
The photograph shows both the castle plan with its bastions and elaborate gate-house, and the site, perched upon precipitous crags.
BP 53

20 July 1948

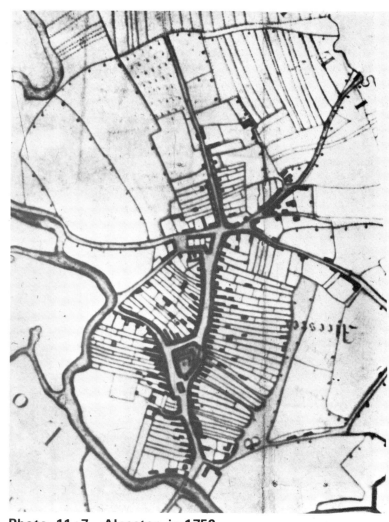

Photo. 11:7 Alcester, in 1752.
The plan should be compared with the air photograph (Photo. 11:8), which has the same orientation.
(Birmingham Reference Library, MSS 379051)

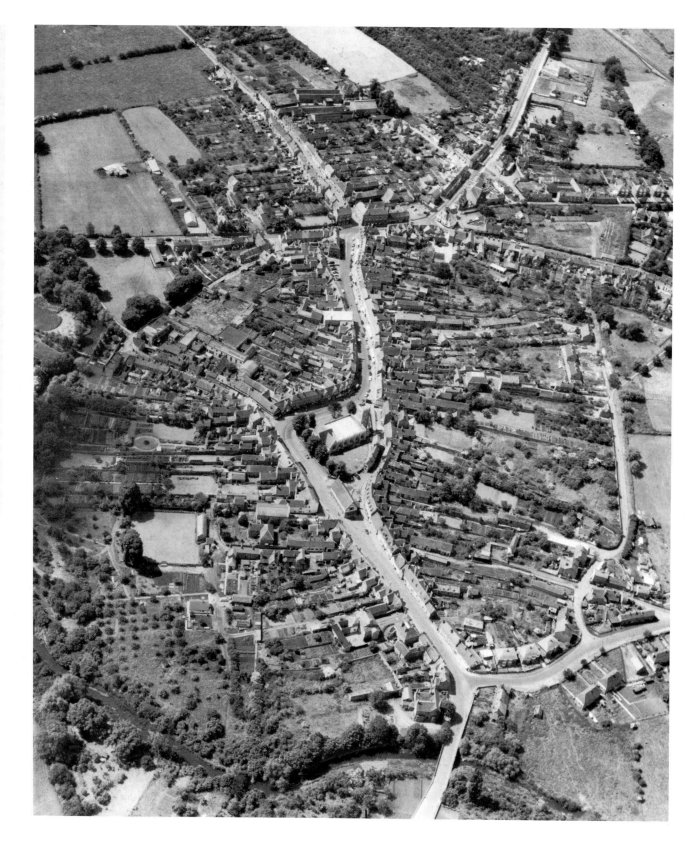

Photo. 11:8 Alcester, Warwickshire (SP 089573).
The view is to the south.
WO 59 *24 June 1958*

and Braunton (Devon)[12] show the open fields, no longer indeed split up into a multitude of strips but still, even after the consolidation of holdings, giving the unwary at first sight the impression of looking at the display of a nurseryman or a bulb-grower rather than at a variety of cereals and roots. At Middleton-in-Pickering (Yorkshire, N.R.) early enclosure 'fossilized' the strips with hedges that have since de-limited the narrow fields of an ordinary farm.[13] At Padbury, as we have seen (Photo. 10:2), the hedges of the enclosure radiate from the village across the grain of the furrows of the medieval fields.

Air photography, as is well known, was used in World War II on a vast scale in the preparations for air attack and to record the results of bombing. It combines the data of a photograph and of a plan; in addition, it often shows the historian at a glance the extent of the original medieval city or village, and of the various additions or shrinkages that have taken place. Thus a photograph of Milan shows the line of forti-fications of the late medieval and early modern city, while one of Gothenburg shows the extent of the seventeenth-century port and mart. A group of frontier towns and cities on the northern boundary of the France of Louis XIV show to perfection the principles of the French king's great engineers, who set the fashion for Europe in competition with those of the United Provinces. In England, views of York and Chester[14] show both the extent of the Roman fortress and of the late medieval walls, while at Berwick[15] the medieval wall can be seen en-closing a circuit considerably larger than that of the Elizabethan ramparts. York and other cities show also very vividly the maze of crooked streets that debouched upon the cathedral close.

Everyone is aware that the Romans, when planning a town, favoured the square or at least the quadrilateral shape, with numerous streets intersecting at right angles between blocks or rows of shops and houses. Such a plan could easily include the substitution of an open forum or a group of public buildings for one or more of the 'islands' between the roads. Medieval town-planning is less familiar, and visitors at ground level in the City of London or in York would think it a contradiction in terms. Nevertheless, there are in this country several examples of planned towns, which are seen to the best advantage from the air. Planning could take place only on a virgin site or a conquered place that called for drastic rebuilding. The textbook example is Winchelsea at the extreme of East Sussex. Though now left high and dry some two miles from the sea, it was created by Edward I *circa* 1280 as a port to replace Old Winchelsea which had undergone rapid erosion in the mid-thirteenth century, and it was designed and built on the virgin site of a grassy plateau to the west of the estuary that was later to be silted up. An air photograph shows part of the grid of rectangular street-lines originally enclosing some thirty-nine 'quarters' mostly occupied by houses with their crofts, but without any exit to the fields.[16] Besides Winchelsea Edward I planned or reconstructed a series of towns in North Wales, of which Flint is the most symmetrical,[17] and a number of Newtowns or Newmarkets or Newports were in origin 'planned', often by the founding lord or bishop, and can be recognised as such from the air.

Often an air photograph illustrates a long series of changes. Alcester, a small Warwickshire town on the western border of the county, is a descendant of the Roman settlement at the confluence of the rivers Arrow and Alne, and was from the twelfth to the mid-nineteenth century a busy market town and distributing centre for crafts of various kinds. Ultimately eclipsed by the growth of Birmingham, twenty miles away, it has now lost the two railways that at one time served its needs and trade, and its High Street stands somewhat aloof from the two main roads that now carry long-distance traffic (Photos. 11:7 and 11:8). The main street, with its church and churchyard and town hall on island sites, may have formed originally a section of the Romano-Saxon road running down the Arrow valley. After leaving the town to the south, by what is now a *cul-de-sac* bordering the site of the Roman cemetery, it crossed the Arrow at a ford near the medieval Oversley mill and later passed through the Avon at Bidford on its way to the Cotswold plateau. The site of the original mill at Alcester itself is preserved by the narrow Mill Lane, containing the town's oldest houses, which runs down to the river opposite the church. The houses of the main street, the modern High Street and Henley Street, can be seen from the air with their medieval crofts, now partly occupied by sheds and small workshops, terminated by the service lane that is a common feature of the English village plan. Beyond the lane in earlier times ran a stream that may have represented the original course of the Arrow. In a memorable flood in January 1900, the present river made a temporary 'cut-off' by this route, flooding the foot of High Street and carrying merchandise across the fields to rejoin the main stream south of the town. At some time in the medieval period the road system changed its character. Henley-in-Arden to the north-east, Evesham to the south and Stratford-on-Avon to the south-east became focal points. The ford on the Roman road was abandoned and overlaid with a mill-pond, bridges were built on the Stratford and Henley roads, and the Evesham road, turning westwards out of the town, took its course over high ground after leaving the valley beyond the hamlet of Arrow to run through what later became

Photo. 11:9 Wimpole Hall, Cambridgeshire (TL 335510), looking south.

Several of the leading eighteenth-century landscape gardeners had a hand in laying out the grounds of Wimpole, but it is the work of 'Capability' Brown that mainly survives. The photograph shows the boldness of these men in creating great sweeps of park-land, the double avenue of elms forming a vista of more than two miles from the house.

In the twenty-seven years since this photograph recorded the avenue in its maturity, old age and disease have taken their course. Whatever felling and replanting is now undertaken, the avenue may never be seen like this again.

ER 64 28 July 1949

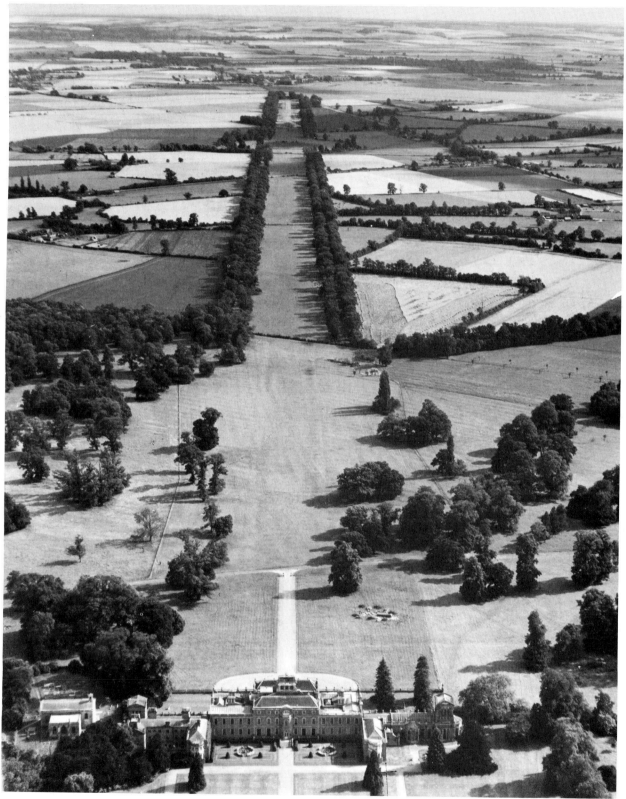

Photo. 11:9 Landscape gardening, Wimpole Hall

the enclosed park of Ragley Hall. To the north, in more recent times, the pull of Birmingham deflected the course of the old road and gave importance to its exit from Alcester. It does not touch the High Street and had few houses along its sides before it became the approach to the railway station in the 1860s. Meanwhile there is some evidence that the old market-place near the main cross-roads was built over, and the market transferred to the broad Henley Street around the Town Hall. Thus in the early modern period only one of the four main roads converging on Alcester passed through the market and High Street. The recent accretions at the perimeter are clearly visible in the photograph, with the line of railway, itself now an antiquity, beyond.

In the open country, also, an air photograph can show eventful changes. A view of Harewood (Yorkshire W.R.) shows how in the mid-eighteenth century a landowner could move a village, divert a turnpike road and replant his tenants in a 'model' village at his lodge gates.[18] At Harewood, when the park had been enclosed, the church was left standing alone not far from the new mansion, while the road running through the village was diverted, and the householders moved outside the enclosure into a housing estate devised to provide an expanding vista of the main entrance to the park. At Milton Abbas (Dorset) a small market town was extinguished by purchase and the rare inhabitants who clung to the land were housed in a much smaller 'garden village' out of sight of the landowner's windows.[19]

In addition to, or in combination with, such transferences of population the rural landscape of England in the mid-eighteenth century underwent a revolution comparable in scale to the industrial revolution that brought about a shift of population towards the new mines and mills of the north and north midlands. The widespread enclosures replaced the open fields with areas bounded by quickset hedges along which lofty trees were planted at intervals to give shade to the cattle. In almost every large parish a mansion with spreading gardens appeared, and the larger members of the species, of which the apex was formed by places such as Blenheim, Castle Howard or Wilton, were surrounded by wide tracts of well wooded parkland with avenues and lakes imposed upon the quilt-like pattern of ploughed fields or meadows. The social and administrative life in these mansions, inhabited by the lords of wide acres, their guests and their myriad retainers, remained almost intact till 1914, and is still prolonged here and there on a greatly reduced scale. An air view can show as no other the splendours of a vanished age. Wimpole Hall, a few miles south-west of Cambridge, was begun on a modest scale in 1632 and vastly extended in the eighteenth century by

Edward Harley, Earl of Oxford and Charles Yorke, Earl of Hardwicke. The surroundings were landscaped by Capability Brown between 1767 and 1773 and by Repton in 1801. The photograph (Photo. 11:9) shows the southern half of the park cut out of the rural pattern of Cambridgeshire, with the trees spaced to give a 'pleasing prospect'. A sham ruin, some half-mile from the house, gave interest to the view from the windows. The avenue runs down to the Old North Road (Ermine Street, now A14), the line of which can be seen forming an acute angle with the right-hand line of trees. Another ancient road, the Akeman Street, crosses the avenue at the third line of bushes, and the infant Cam a little further down. Air photographs of the park to the north of the house show the site of the old village surrounded by the ridge-and-furrow of its open fields. The village New Wimpole is off the plate to the left.

The plate of Wimpole reminds us that an air photograph can give new dimensions to a map by showing a Roman road striding across hill and dale. It can now show also the deficiences of the first hastily-planned railways, avoiding for some accidental reason a centre of population, as the old Birmingham–Bristol line by-passes Worcester, and the main London–Crewe main line avoids Northampton. In a very few years it will serve to show the lines of an outmoded system of communications, surviving only in what have proved to be the most permanent of all human works, the cutting or the embankment.

NOTES

1 For a sketch plan of Yeavering see H. M. Colvin, in *The History of the King's Works* (H.M.S.O. 1963), I, 3. A detailed report of the excavations is to follow.
2 Beresford, M. W. and St Joseph, J. K. S. *Medieval England, an Aerial Survey* (Cambridge 1958) 42
3 *Medieval England*, 26–9
4 *Medieval England*, 112–14
5 Knowles, D. and St Joseph, J. K. S. *Monastic Sites from the Air* (Cambridge 1952) 78–81
6 *Monastic Sites*, 160–3
7 *Monastic Sites*, 204–5
8 *Monastic Sites*, 126–9
9 *Monastic Sites*, 134–5
10 *Monastic Sites*, 242–5
11 *Medieval England*, 109
12 *Medieval England*, 42–9
13 *Medieval England*, 121
14 *Medieval England*, 158, 173
15 *Medieval England*, 178–9
16 *Medieval England*, 222
17 *Medieval England*, 216
18 *Medieval England*, 61
19 *Monastic Sites*, 34–5

12 Towns and Monumental Buildings

SIR IAN RICHMOND

Sometime Professor of the Archaeology of the Roman Empire in the
University of Oxford

In this day and generation it is almost a truism to say that the viewpoint of the air photographer has its own particular virtue. The reasons why this should be and the conditions under which the most advantageous pictures can be taken have also been frequently described, if not so widely absorbed. Among subjects, however, towns and great monumental buildings have their own characteristics and the advantages inherent in the application to them of air photography are correspondingly particular in kind. Subjects of this sort are in no sense new discoveries: they are normally well known and their historical significance is usually well appreciated. The value of the air photograph thus consists in offering a new point of view, from which can be obtained a conspectus of innumerable details presented in a unified perspective not attained in normal circumstances by any photograph taken on the ground.

These general results emerge very clearly in a view of the historic stronghold of Shrewsbury, in Shropshire (Photo. 12:1), the key to the medieval Middle March against Wales and the base from which the very heart of Welsh territory could be penetrated by way of the Upper Severn valley. Cartography will, indeed, convey very well the great loop of the river containing the town and its Norman castle, which seizes and occupies the hillock within the loop, making of it first a stronghold and then a bridgehead for movement either into Wales or along the borderland to north or south. Mapping, too, will demonstrate how the railway, spanning the neck of the peninsula, in due course met the same requirements of movement in terms of peaceful communication. But no map can even begin to impart the subtler relationships which give the town its character. First is perceived the river in its flood-plain, above which the fortress and town must rise, then the constriction exercised by its great meander, and the elegant fashion in which man has tamed the encroaching current

by reinforcing the town-ward bank with fine trees in a stately variation. Next appear the relation to the crowded town of the market-places for man and beast, the architectural domination of the town-heads by churches and the frequent usurpation of the ancient house-plots by commercial buildings. It becomes evident how precarious is the hold on the plateau of the two buildings, hospital and prison, for the physically and psychologically sick, now no longer subject to the out-of-date social factors which once exerted a necessarily centripetal attraction. Beyond the river the famous public school and the suburbs impress upon the scene their solutions of other hardly less recent social problems; while below the neck the industrial agglomeration emphasises what the coming of the railway meant to the manufacturer. The practical and theoretical aspects of all such factors and problems in a long history and in multifarious planning are rendered incalculably easier to approach and to appreciate through air photography. This is, moreover, a field in which the oblique photograph is superior to the vertical, for it arranges the points in more significant perspective, both literally and metaphorically.

More restricted but no less interesting problems of historic and urban development are suggested at Caernarvon (Photo. 12:2), where a trim Welsh borough, founded and shaped by King Edward I in 1284 to be the capital of the principality of North Wales, lies engulfed yet isolated in the modern town. The forecourt of the noble castle occupies the site of the Norman motte of 1090; its rearcourt and huge residential towers, dominated by the three seaward look-out turrets on the biggest tower of all, control the river-harbour of the Seiont. The sedate market-place outside the Castle gate was once the Norman outer bailey: it is now the modern town-centre, in which the only jarring note is the round feature towards the middle, but a rival place of concourse is the em-

Photo. 12:1 Shrewsbury, Shropshire, looking south-west (SJ 492123).

AIX 39 8 June 1964

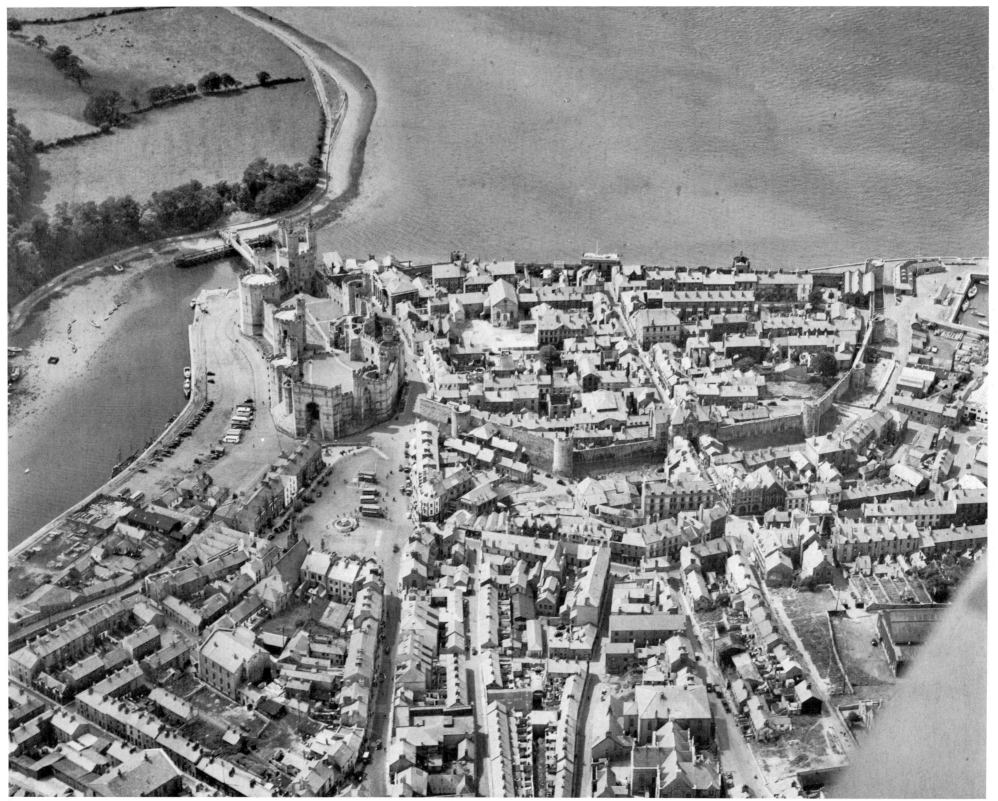

Photo. 12:2 Caernarvon, a town created by Edward I (SH 478626).

BP 86 20 July 1948

banked river-quay which covers the ancient strand. Edward's royal borough is still encompassed by its D-shaped defensive wall, within which the original street-plan survives, though rows of modern houses, a market-hall, local government offices, law-courts, prison and Nonconformist chapels have almost obliterated the older buildings. The fourteenth-century chantry chapel of St Mary in the north-west corner, and the modern hall over the East Gate which replaces the Principality's Exchequer, represent the only certain medieval internal buildings. The merging of the ancient land-plots into larger units by sale or inheritance can, however, be clearly detected in the modern house-divisions. Outside the town wall the wide strip on the site of the ancient ditch is once again almost free, thanks to an enlightened policy of clearances. The ancient roads, converging upon the market-place and the Exchequer Gate, have determined the lines of the modern town, here much less haphazard than it might look, though some highly individualistic ribbon-development lies outside the landward limits of the picture. The town-planner will be struck by the contrast between the densely crowded urban area and the gracious amenity of the meadows, woods and shore across the river; while the student of traffic problems will see in this picture, not taken at the height of the holiday season, the threat to amenity presented in the market square by the day-to-day omnibus, and on the strand by the long-distance coaches and private motor-cars. No view at ground-level and no town-plan can convey the scale and relationship of these highly diverse elements. In plan the castle is dwarfed by the ancient town, whereas in elevation it is itself the dominant. Again, the tightly-packed medieval street-system, well conveyed by a plan, cannot on plan be shown in devolution, to the story of which an especially incisive contribution is made by the architectural types of the buildings. Finally, the space–volume relationship of streets and houses to the parked traffic units is particularly well conveyed, with adverse augury for the future.

A completely different aspect of medievalism is presented by the remote cathedral city of St David's, in Pembrokeshire (Photo. 12:3), founded in the earliest days of Welsh Christianity. This 'lighted candle' was deliberately put by St David in a 'secret place', since he chose as his site a secluded glen, which supplied three important needs, namely, a water-supply, a position not obvious to sea-raiders and a solitude appropriate to early monastic life. It compares well with St Deiniol's site at Bangor, which, however, is much more heavily overlaid by modern buildings. At St David's the primitive monastery buildings, no doubt as devoid of architectural pretension as those of any other Celtic founda-

tions, were long ago superseded by a great Norman cathedral and bishop's palace, not to mention a subordinate church, all enclosed by a great walled precinct, entered through a massive towered gatehouse at the top of the slope. The township, as small a cathedral city as the North Welsh St Asaph, is elbowed on to the surrounding plateau. Here lies the market-place, at the junction of three approach-roads bordered by irregular garden-plots and houses of unambitious harmony, broken only by a garish Nonconformist chapel which turns its back upon the episcopal domain.

The vast cathedral, a pilgrimage church of great fame, bestrides a little coomb in the valley side and runs down its length, dropping in level from east to west. The site is so low that the great central tower does not rise above the gate-towers of the precinct, and the building makes its impact by surprise as well as by an intrinsic beauty. Decorated windows endow it with lightness as well as scale, in striking comparison with the late Romanesque architecture of the ancient Bishop's hall and church, which are ranged about a great quadrangle; the hall on the east, distinguished by its chequered masonry and machicolated eaves, and the church on the south, with a magnificent arcaded east façade. Alongside the cathedral lies the fourteenth-century collegiate church, of modest and dignified aspect befitting its ancillary function.

The outstanding general impression made upon the beholder at St David's thus derives from the aesthetic relationship of its varied buildings, which is not to be represented by either a comprehensive plan or elevations of the individual units. Only air photography will espy it. But in so doing, it will also record the imaginative and powerful aggrandizement of a Dark Age site at Norman hands, the intricate relation between a monastic cathedral and the adjacent bishop's establishment, and the successive eastward extensions of the great church as the Norman plan, of enhancing the attraction of the holy place to pilgrims, came to fruition. Finally, it will record the development of the little market-town outside the cathedral precinct, the impact of sectarianism upon it and its latter-day choice of a 'beauty of holiness' completely divorced from external grace.

The richness and dignified beauty of later Norman or Plantagenet architecture began to blossom early, but fruited late. What Caernarvon might have looked like in the twelfth rather than the thirteenth century is well shown by the Norfolk earthworks of Castle Acre (Photo. 12:4). Here the massive mounds and ditches of a great motte, an outer bailey and an attached borough still dominate the scene and harbour the village which has taken their place. On the ground, in the wide, flat valley of the Nar,

Photo. 12:3 St David's, Pembrokeshire, looking north-west (SM 754254).

TF 93 13 June 1956

no conspectus of the works can be obtained, and the buildings of the village inevitably obtrude upon any kind of general view. In an air photograph the hamlet takes its place in the background, while the earthworks, accentuated by the trees and bushes which clothe them, become the dominant pattern. In the middle of the bailey a line of massive foundations provides evidence for internal buildings of masonry, and the masonry defences of the developed castle crown the spreading earthworks with walls and foundations which in their turn fall into a pattern of narrower lines appreciable only from an altitude. A plan will indeed define such lines, but it can hardly evoke the subtleties of relief which convey the three-dimensional relationship between them.

The complete domination and ultimate submergence of an early borough, by the line of communication passing through it, is exemplified by Cowbridge, in Glamorganshire (Photo. 12:5). The place extends along a gentle ridge between streams, the crest crowned by the busy traffic which now disrupts rather than unites the community. The result is reflected in ribbon development, which, in an effort to disengage from the main road, is diverted into minor side-roads. In the foreground, to left of the road, is seen a more recent attempt to create secluded units in the form of closes, while to right is a zone of factories. The ancient borough, rectangular in plan, occupies the middle background, and a distant corner of its surrounding earthwork emerges to right of the sports field. The position of its ancient nearer gate is shown by a marked roll in the road where it crosses the earthwork. On leaving the town the road continues straight for a short distance and then swerves sharply to secure a stream crossing; and selection of a bridging point also accounts for the similar swerve and sharp bend in the foreground. The crisp ribbon-development at both ends of the town is evidently related to exploitation of ancient strips or messuages on either side of the road, which may be presumed to have been originally town-lands devoted to cultivation. The closely-packed buildings along the through road and the largely haphazard spread of buildings behind the road frontage have virtually eclipsed the lines of the ancient borough. But it can at once be observed how the air photograph gives the fullest value to the building pattern, by pinpointing the features on the ground and by relating them to contours so gentle as to convey very little in terms of lines on a map. Nor is the presentation of the character of the buildings themselves of any less value than in considering monumental architecture. Each type has its message to convey in terms of social history.

Striking evidence of planned social development is furnished by the new towns created in eighteenth-century Scotland. The neat rectangular burgh of Fochabers, near Elgin (Photo. 12:6), was established in 1798, when the old town was razed to make way for the parkland of Gordon Castle. It is bounded by streets as opposed to defences, and evidently originated as twelve oblong plots with a rectangular *piazza* carved out of the plots and setting off the town's public buildings on one side of it. The rectangular town-plan was later irregularly prolonged at each end in order to accommodate a hotel, the principal school or academy and a limited number of less crowded private houses. Still more erratic development followed on the riverward side of the town, and there was the inevitable ribbon-development along the main approaches. The original planners seem to have aimed at filling the frontages of each rectangle with contiguous houses, leaving space for gardens within, now attested, where they survive, by their trees. But there has been much encroachment upon the internal spaces, some of it plainly due, as in Wales, to the spread of sectarianism. An appreciation of this kind of development is essentially dependent upon viewing as a whole the different types and styles of building in relation to one another, so that a comprehensive assessment of planning development and stylistic criteria can be made rapidly and simultaneously. Only through the medium of air photography is this possible.

Houses of great estate can be viewed from the air with no less advantage. Audley End, in Essex (Photo. 12:7), though now only about one quarter of its original size, still offers a notable prospect of the architecture of the early seventeenth century, when the brave new vision which had so recently and so dramatically encompassed the earth was reflecting itself in the vogue for an expanse of glazed windows, letting in new light and opening up new prospects. The relationship of these vast windows to the fabric is impressively conveyed by the light and shade which defines the frame without the over-emphasis of an elevational drawing and picks out the translucent areas in dark reflection. The backward-looking choice of thick stone mullions at Audley End attests the strength of tradition and contrasts with the thinner wooden window-frames of the eighteenth century which make a new pattern of the glass. The problem of heating the rooms behind such an expanse of glass is emphasised by the clusters of chimneys concentrated over the sides of the principal rooms and diversified by the turrets and belvederes which give the great house its character and supply necessary access to the roofs for repairs and for cleaning of gutters. The eighteenth-century range, added across the top end of the court, serves as a main ground-floor corridor with picture-gallery above, but how ruthlessly it breaks the earlier harmony can be sensed far better through the bird's-eye view

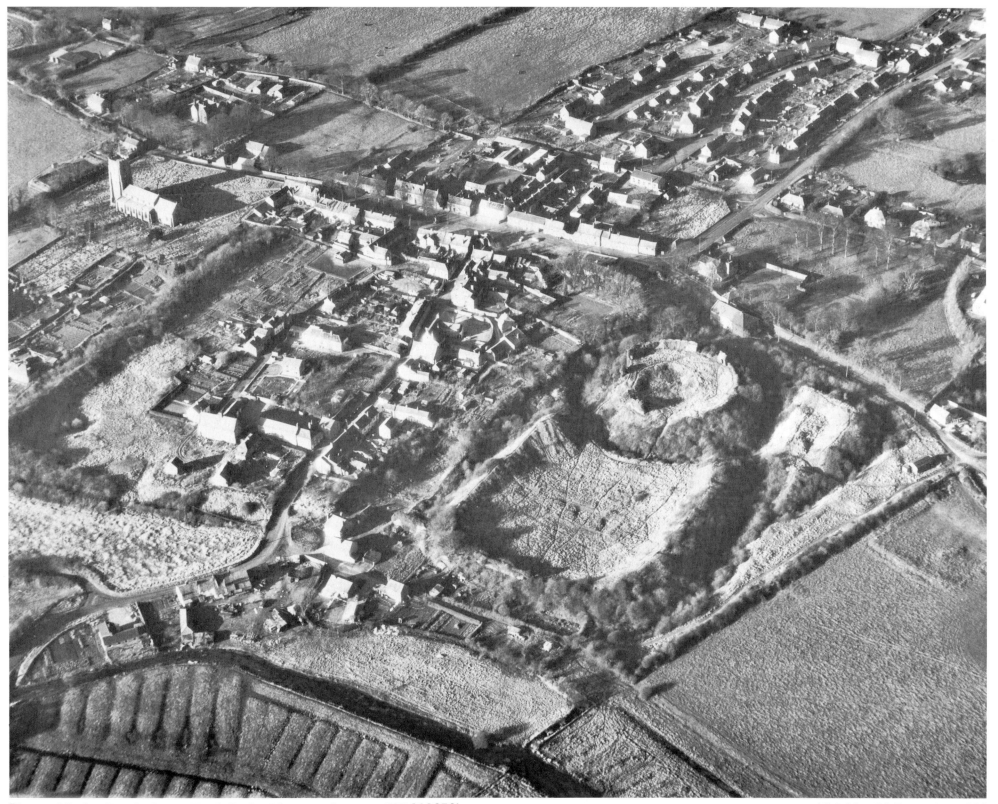

Photo. 12:4 Castle Acre, Norfolk, looking north-west (TF 818252).

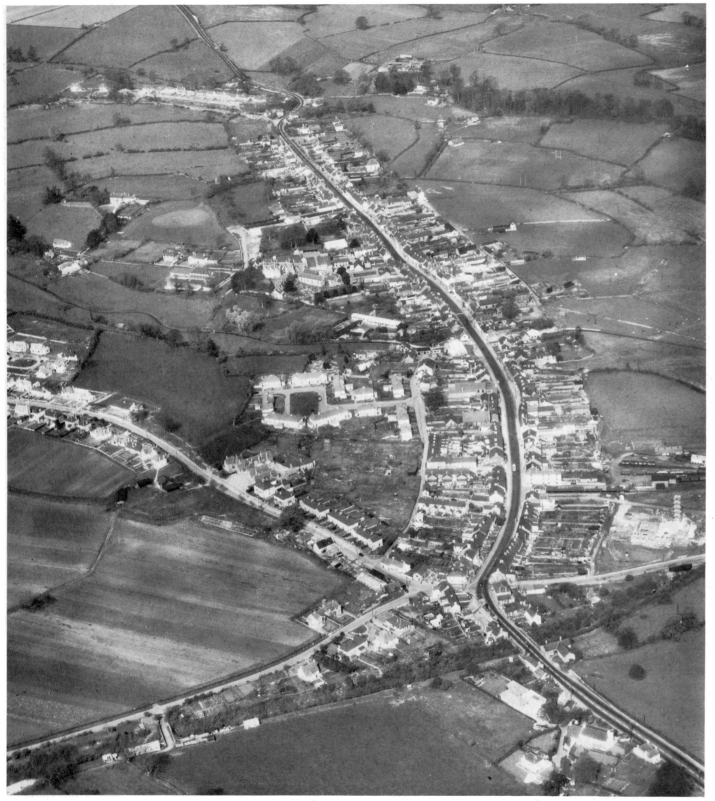

Photo. 12 : 5 Cowbridge, Glamorgan, looking north-west (SS 997746). *XW 77 19 April 1959*

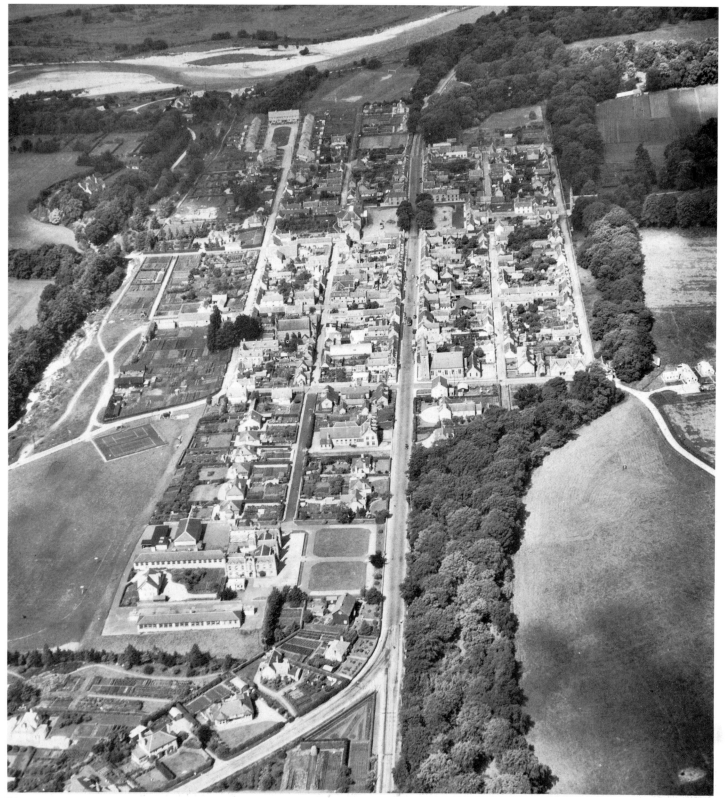

Photo. 12 : 6 Fochabers, Elgin, looking north-west (NJ 345587).

GQ 52 14 July 1951

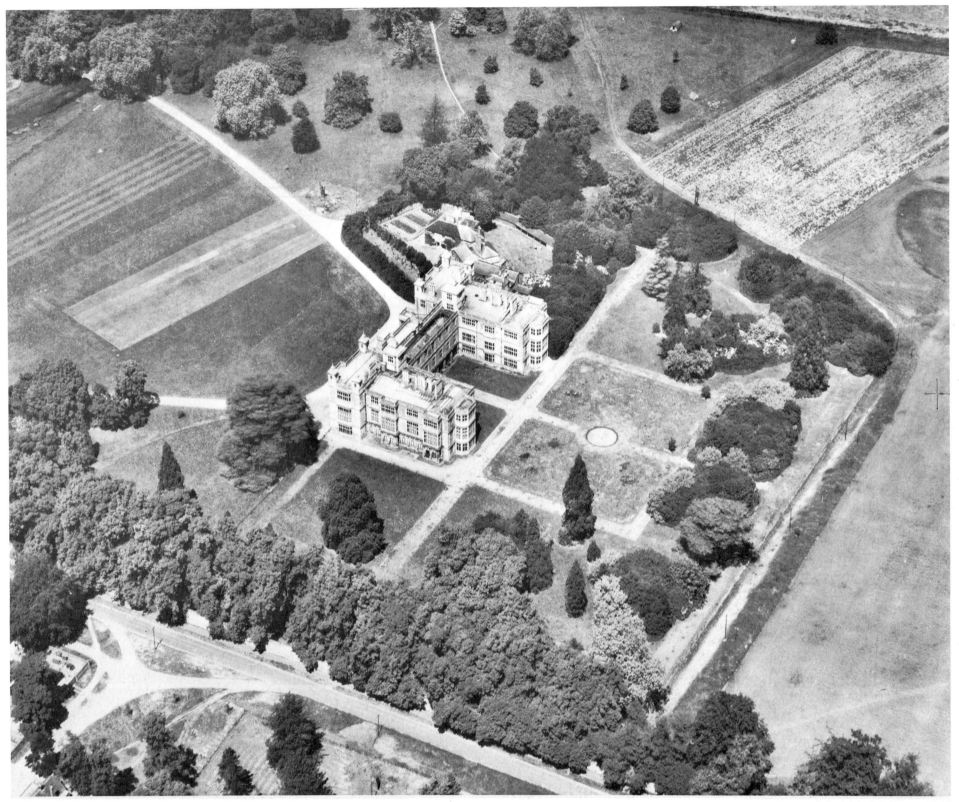

Photo. 12:7 Audley End, Essex, looking north-west (TL 524382).

CO 44 21 June 1948

Photo. 12:8 Nottingham University, the main buildings (SK 541380).

than through a plan or elevation, for it combines both of these and adds reality to them as well. The huge principal court, once seen to left of the existing house, has now vanished without trace, as has the east wing which made a closed court of the main block. Even the elaborate nineteenth-century garden-beds and paths only peep through the present-day grass-plots in a vague array. The formal Jacobean horti-culture has long disappeared and its place taken by noble trees which still reflect the eighteenth-century arrangement of the park-land.

The assured classicism of the eighteenth century represents the same social *milieu,* but a taste no longer tentative and governed by the hard Palladianism which the soft English light seems at once to demand and to offset. The first new buildings of Nottingham University (Photo. 12:8), created after the First World War, seem at close quarters to epito-mise this spirit of academic discipline, as necessary to the architecture of the building as to the training for which it is the centre. As an essay in twentieth-century traditionalism Nottingham is one of the most interesting examples of its style. The monumental façade of the great courtyard building is very wide, even without the two recessed flanking wings; and it is cleverly prevented from spreading by the extra storey, which forms a fenestrated attic above the central pedimental bay, while the central tower, kept well in the background, offers a really powerful focal point. The front wings are matched by less monumentally con-ceived rearward counterparts, creating two side courts. The problem of accommodating growing numbers of laboratories and class-rooms is temporarily solved by five long lines, discreetly kept low in a background partly screened by trees. By skilful use of the irregular outline of an informal lake, contrasted with a monumental stone-built terrace, the great building is deliberately transformed into an architectural back-cloth to the vista of the Trent valley which it itself enjoys, thus taking its place in that subtle interplay of designed formality and organised wildness which is the secret of the charm exercised by so many British buildings in a country setting. An aerial view conveys the whole essence of this relationship and forces home the lesson that in preserving, as in creating, such sites the building cannot be self-sufficient: it must unite with its wider surroundings of ridge and vale, and blend with its im-mediate parkland or lawn, and all must grow up and grow together if they are to make the impact intended by their designer.

It is evident, then, that in historic and monumental sites the subject and its content can be seized and appreciated far more comprehensively and in a far more complete vision through the aerial view than through any other medium. The historian will, perhaps, make the first claim upon its use; but in the present age, when the British landscape is changing so rapidly, geographers, and planners in town or countryside, will come close in the order of potential users. The rival claims of land-use jostle one another in the government office and stretch the application of social justice to breaking-point. Our ancient monumental heritage, having escaped the nineteenth-century Industrial Revolution, is in the twentieth threatened by the much more formidable Economic Revolu-tion. The presentation and evaluation of its claims are the factors which may be decisive for the very survival of every disputed item. Air survey is then the most effective means of recording the present state of our urban problems and all the circumstances of a country environment. Cogently and crisply it can illustrate the essential points upon which to evaluate the position, to plan it afresh and to take counsel for the nation.

13 Contemporary Planning

LORD ESHER

Rector, Royal College of Art, and past President of the Royal Institute of British Architects

To the contemporary planner (to use an unappetising expression which in fact means 'to the person with some responsibility for our future environment') air photography has three basic uses–in his education, in his practice, and as a check on his executed work. In this section I shall be dealing mainly with the second of these uses, because it is the largest and longest. But it must first be noted that the education of planners, which is in a state of ferment and flux even more marked than most fields of education, is nowadays very weak on its historical side. This is partly because of the pressure of other subjects, partly because while there is ample (though always obsolescent) text-book coverage of the *practice* of physical planning, there has been no good comprehensive textbook of its history since Abercrombie's miniature classic–unless of course one is so to describe Lewis Mumford's monumental trilogy, which it was certainly never intended to be. Consequently students have only the vaguest picture of the development of the Roman and Medieval landscape, of the revolutionary effect on the English scene of the Enclosures, of the origins of the village, of the different types of medieval town, or of the processes of growth of the modern one. Such students, in present conditions of acute shortage of trained people, soon find themselves in the offices of a development company or local authority, plotting major surgical operations on the heart of organisms whose anatomy and metabolism they have never studied. This certainly partly explains the sense we all have that something brutal is being done to the texture and grain of our cities and towns.

It is obvious that air photographs could enliven and illuminate such an historical study. It might be thought that so much of the world's surface has been worked over, so much destroyed, that no photographs of what exists now could tell us much about the past. We are lucky to live in an age when this is not so. Not only have we the well-known examples of old settlements and cultivation and fortifications 'grinning through' our fields (to use the house-painter's nice phrase); but if we look about the world we can find unspoilt examples to illustrate our own story from the beginnings of civilisation. African cities like Ibadan and Kano, Indian cities like Ahmadabad and Jaipur, not to mention familiar Mediterranean examples like Aigues-Mortes and Avila, are more evocative of our own Middle Ages than anything that survives in Britain. In this country nothing larger than a village has survived from any age complete as a fly in amber; most of our material is a complex web of strands from many centuries. Unravelling it is itself educative and surprising.

The simplest and earliest examples of the use of air photographs in teaching the history of our landscape and its settlement are the views of villages and fields collected and annotated by Beresford and St Joseph in their *Medieval England: An Aerial Survey*. The overlaying of one system of land-use by another and the patterns of settlement deriving from different local circumstances are the main lessons here, and are most clearly brought out by diagrams from the same viewpoint as the photograph. But it is tantalising to stop at the Tudors, and the story of the village needs to be carried right through to the present day, as was done in Thomas Sharp's *Anatomy of the Village*. There is a surprisingly large aggregate of unused or under-used space in the back-lands of our villages, mainly owing to the length of medieval crofts, which could make a significant contribution to alleviate the housing shortage without going out on to the exposed and much more conspicuous surrounding farmland (Photo. 13:2). But most modern architects and planners and all modern engineers and surveyors have utterly lost the free-and-easy

flair which their ancestors possessed for siting and designing new buildings in old villages. Air photographs bring out better than anything the insensitive, mechanical and boring patterns of modern housing estates alongside the 'instinctive' patterns of the past. They also revealingly show the slightly meandering short-cuts obstinately and even destructively taken by human beings when planners try to impose on them some sort of formal layout that only looks neat on paper. All this is highly educative.

The village is part of the man-made landscape, and cannot be isolated from it. Here air photography is even more revealing, because it gives their true importance to trees, which the Ordnance Maps must virtually ignore. One of the first lessons for the planner is that two-dimensionally the hedgerow pattern is the basic component of the English scene (Photo. 13:1), and three-dimensionally the full-grown individual tree or clump is a more important and monumental object in the landscape than any but the largest buildings. It dominates the ordinary house, whether one's viewpoint is alongside, or from a hilltop, or from an aircraft at any altitude. In planning new developments, whatever their scale, one ignores this pattern at one's peril. Of course it has been done, but only with success on a scale which virtually substitutes a new landscape for the old. The first examples are the great sixteenth- and seventeenth-century avenues and French-style formal gardens, as still survive at Windsor, Wimpole, Cirencester, Bramham and elsewhere. At Wimpole (Photo. 11:9) the great avenue is laid across the field pattern like a poker on a carpet, in a manner that was not to be seen again until the coming of the railways and motorways. In the eighteenth century, with the change of taste from formality to the romantic parkscape of William Kent and Capability Brown (Photo. 13:4), the handling of landscape form at least concedes something to existing contours (which it was bound to do if 'natural' lakes were to be formed), but again the utilitarian hedgerow pattern is swept aside, and we get unprecedented cases, as at Harewood, Milton Abbas or Nuneham Courtenay, of whole villages being removed from the scene of a new parkscape and neatly rebuilt close by. But in all these grandiose operations it was trees and not buildings which exercised the designer's imagination, and present-day air photographs show his vision in the final stages of realisation before its inevitable decay or replacement.

When we come, in our historical course, to the growth of the larger towns and cities, the use of air photographs is more supplementary to the use of plans and diagrams. But here also either tool without the other would be worth much less. Maps without photographs lose the third dimension and again, ignore trees and 'floorscape' generally, which in towns of any beauty are just as important as buildings to the total effect. Photographs, at any rate oblique ones, without maps obscure urban geometry and the precise configuration of outdoor spaces. Therefore to study the story properly the student needs town maps, site plans and vertical as well as oblique air photographs. Thus equipped, he will find the basic structure of some towns much easier to grasp than others. These will probably be either the quadripartite Roman cities like Chichester (Photo. 13:3), Gloucester or Chester, or the spider's web centripetal medieval city focused on castle, bridgehead or market-place (Photo. 13:5), or the Georgian sections of London and Edinburgh, Bath (Photo. 13:6), Bristol, Newcastle and so on. But the simple fact of dating mainly from a single period does not necessarily produce a simple plan, as he will find by looking down on the central areas of the great Victorian cities, which will stagger him by their ingenuity in avoiding clarity, or the interminable suburban expanses of the twentieth century, whose rationale will appear even more incomprehensible (Photos. 13:9, 10 and 11).

However, towns mainly associated with a single period are the exception. In the great majority of cases the centuries both overlie one another, as at York, Bristol or Norwich, and succeed one another in fairly distinct rings as one travels outward from the centre, as most obviously in London, but indeed almost everywhere. This is the European norm, and this is the process the planning student must understand in all its complexity. Fortunately for the analyst, the succeeding fashions in building and planning have always been virtually nationwide, at any rate south of the Border, so that a set of about a dozen well-chosen subjects should give him the complete story. The Roman crossroads, the Roman or medieval wall, the Cathedral in its green quadrant, the medieval street-grid with its market-place—all these will be found in a single photograph, but the student will note the more recent overbuilding on what were originally crofts and gardens, the erosion of quirks and bottlenecks, the breaches in walls, the embankment of rivers and, most recently, the broad swinging curves of motorways. Another picture will show the first, and probably

Photo 13:1 Hedgerow trees; a panorama near Bourton on the Hill, Gloucestershire (foreground at SP 183318).
The countryside the maps cannot convey, in which trees are more important features than buildings.
TO 25 *25 July 1956*

Photo. 13:1 Hedgerow trees

Photo. 13:2 Brackley, Northamptonshire (SP 585370)
A linear village with deep crofts and backland used for housing (left) and playing fields (right).
Vertical photograph R.A.F./B/63.
Scale 1:3250 29 June 1950

Photo. 13:3 Chichester, Sussex (SU 861049)
The city has retained the quadripartite plan of its Roman past enclosed within the ring road which follows the old city boundary. A high proportion of the town centre is given over to car parks.
Vertical photograph RC8-C 80.
Scale 1:6250 5 June 1968

Photo. 13:2 Brackley

Photo. 13:3 Chichester

still medieval, ribbon-development along the highways, often coalescing with adjoining villages, and the gradually more intense colonisation of the productive hinterland. Another will show the orderly Georgian and early Victorian accretions, with their terraces, squares, crescents, and later romantic villas embowered in vegetation. Then the surgical cut of the first railway, clumsy or ingenious in the individual case. A set of three or four photographs will illustrate piecemeal industrialisation, small-scale in one city, wholesale in another, the sprawl of goods-yards and sidings, the little black slum terraces jammed in between the factories and railways, then the far more extensive red or grey acres of deadly monotonous bye-law housing in mechanical rows, broken here and there by a Victorian park or a cemetery (Photo. 13:9). Further views would show twentieth-century Suburbia, in a New Town or elsewhere (Photos. 13:10 and 11), second-growth multi-storey housing in the L.C.C. or Coventry or Sheffield or Glasgow manner, or the new scale and elegant curves of the motorway age, destructive and at the same time creative like so many of the innovations of the past (Photo. 13:7).

Which brings us to the use of air photography in the contemporary day-to-day practice of the architect/planner. Here we must begin with a distinction familiar to him, between Survey and Plan. An immense amount of survey material of many specialised kinds can of course be built up by air photography, including the contoured maps and de-mountable working models, which most urban planners use as the basis for their work. Here I am concerned not with the techniques of aerial survey and mapping, vitally useful though these are to the planner, but with the uses he makes of air photographs themselves. I suggest that these uses, which we must regard as distinct from, but complementary to, the uses of maps and models, are fivefold.

1. Movement
Expertly interpreted air photographs, mainly enlarged verticals, have the unique advantage of revealing how people move about a landscape or townscape, whether on foot or on wheels. Large numbers of pedestrians, given freedom of movement in limited areas, as at Box Hill in Surrey or Carnac in Brittany, will produce vein-like patterns not unlike the drainage channels in a salt marsh or uncultivated desert. These organic patterns are at the opposite extreme from the geometrical and generally rectilinear patterns that result from the use of drawing instruments and of rectangular building components. This is a functional conflict which Le Corbusier, in his early idealisation of the Cartesian right-angle, disingenuously ignored. Of course, as soon as the planner gets to work on a virgin land-scape, even at the elementary stage of parcelling and fencing, free movement is checked and distorted by barriers or attracted to points of concentration, and a new hybrid circulation pattern emerges, in which necessity and choice co-exist in different proportions. The planner will note all these short cuts with care, and if they reflect a layout of public or popular buildings which he intends to retain, he will retain them too, or divert them as little as he can. He will thus be given a clue to the pedestrian, as distinct from vehicular, circulation system he ought to adopt. Its linear forms will tend to be slightly wavy but non-geometrical, hugging all external angles, with a variety of radials from fixed points and a general absence of parallel lines.

Motor vehicle patterns are quite different. Left free, as on a beach or at a race meeting, vehicles will trace interlocking regular arcs in turning, but will head pretty straight from point to point. The engineer knows all this, and provides for the vehicle's special characteristics with more science than he uses in providing for pedestrians. But even here pretty patterns and symmetry are liable to override functionalism, as one can see by observing in air photographs the actual tracks worn by vehicles in passing through a roundabout. One can also learn a great deal about the details of infestation of a town centre by parked cars from a vertical photograph which shows up every ingenious hideout (Photos. 13:3 and 7).

2. Vegetation and surface character
The geographer and the regional planner, particularly in under-developed areas, will obviously obtain a great deal of information on these subjects from air photography, but I am here mainly concerned with the use of air photographs in smaller-scale redevelopment within Britain. Here air photographs have two special uses, both time-saving. One is in giving an immediate and vivid picture of industrial dereliction, old pit-workings etc. in areas available for rehabilitation and redevelopment. The other is in conveying the character and distribution of trees and other vegetation in heavily wooded areas where ground survey would be far more expensive, slow or impracticable. These two types of development area will both incidentally be increasingly important as the growth of population and living standards force us to look for sites which are either already spoiled or well camouflaged, rather than the open farmland where development is too easy and visually damaging. In both cases photographs will need to be supplemented by ground information.

3. Scale

When an architect speaks of scale he does not mean size. Size is a merely dimensional term, without relativity, whereas scale means size in relation to a fixed unit, such as the height of a man. Thus a building can be merely big if it consists of a lot of small units on top of one another as in a block of flats; but if a building of the same size contains one unit, one storey only, like a cathedral or a power station, its scale as well as its size is immense. Scale is therefore one of the attributes of buildings that can be manipulated to produce a deliberate effect, or can be lost sight of with disastrous or absurd results. In most English towns, and of course pre-eminently in the cathedral cities, the house of God was deliberately given a superhuman scale, and its symbolic predominance has become traditional—so traditional in fact that in the larger cities where utilities like power stations and gasholders are in fact the dominating elements, we have learnt the knack of not seeing them: we still like to think of our town silhouettes as irregular serrated outlines broken only by towers and spires.

Air photographs, particularly low-level obliques, at once show up the true state of affairs. The town's great buildings dominate the scene, or if they do not we can see why. We can see the value of intricate small-scale buildings and spaces in setting them off, and if such buildings have to disappear, which in central areas is often the case, we can try out new proposals quickly and simply by superimposing them on the photograph.

4. Grain

Such bird's eye views of the intricacies of towns reveal much more than the relativities of scale. They reveal in townscape a texture and directional emphasis as in a woven material or a rough piece of wood. For this most indefinable but most essential characteristic of the fabric of towns architects have recently coined the word 'grain', because 'going against the grain' is a handy way of conveying its converse. Obviously the grain of towns as we have them is not always pleasant. We have acres of Victorian bye-law streets and miles of inter-war speculators' estates whose patterns are either so mechanical or so senseless that their study reveals nothing at all (Photo. 13:9). On the other hand we have in our best cities, towns and villages, from the centre of Manchester down to the smallest Yorkshire hamlet, a grain or theme or texture, call it what you like, which must be discerned if the planner is not to commit every kind of solecism. Air photographs are an indispensable visual aid to this discernment.

5. Synoptic vision

In analysing the uses of air photography in the teaching and practice of physical planning one inevitably puts the parts before the whole. But the whole is more important than the sum of the parts. It was significant that Sir Patrick Geddes, who was the first British writer on city planning to apply scientific method and intuition rather than aesthetic rule of thumb to its study, should have chosen for his home and workplace the Outlook Tower in Edinburgh, an eyrie on the crest of the Old Town with a panoramic view of the whole city. Before the existence of air photography we spoke and wrote of the necessity for what he called the 'synoptic vision' of the problems of physical planning, of the unified study of the impress of human settlement and cultivation on the earth's surface rather than of 'town and country planning' as conventionally defined. From the air, in which administrative and national demarcation lines are invisible and meaningless, and the distinction between town and country is blurred, we have no alternative to a sense of proportion. The practising planner who has not seen his problem from the air, and who is not, on any commercial flight, among the first in the race for a window seat, can only be falling down on his job.

It follows that we have in air photography not merely a tool of our trade, but a test of our achievement. Where, as in the Black Country or the South Lancashire conurbation or even, on a mercifully smaller scale, in the recent rebuilding of the City of London, we have made a mess of our environments air photography takes the lid off it. Where a new order is beginning to emerge, as in some of the latest work of the L.C.C., of Sheffield (Photo. 13:8), Coventry, Glasgow, of the most recent New Towns (Photo. 13:11), air photography dramatises it. One qualification only must be made. We do not live in aircraft, and the view they give us is not the final test. The final test of an environment for 'liveability' is by living in it. Air photography, which makes almost any pattern look pretty and tidies away the junk-yard, the pylon and the whole foreground paraphernalia that by the laws of optics dominate any earthbound scene, would be a snare and a delusion if it released us for one moment from this ultimate responsibility.

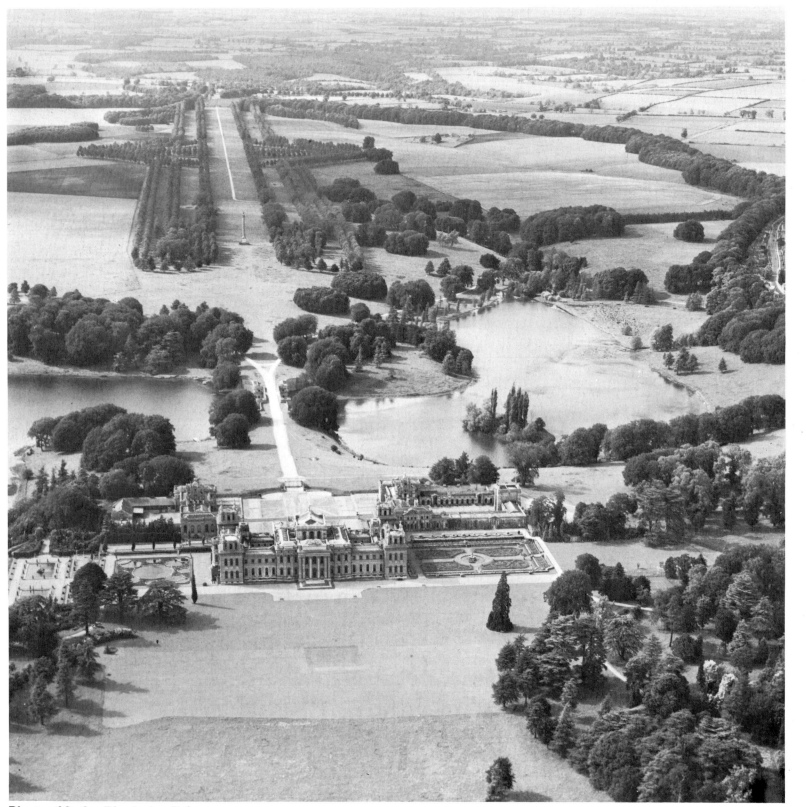

Photo. 13:4 Blenheim, Oxfordshire (SP 441161), looking northwest.

The formality of Vanbrugh's avenue contrasts with the free sweeping curves of Brown's lake and tree-clumps, showing in one view the two styles of English landscape design.

AN 88 16 June 1948

Photo. 13:4 Blenheim Palace

Photo. 13:5 Durham, looking north-west (NZ 273421).

This oblique photograph shows clearly how the growth of the city has been determined by its position within an incised meander of the river Wear. The Norman cathedral and castle occupy the crest of the promontory in the centre of the plate. Beyond lie the narrow, huddled streets of the medieval town. Once the restricted area within the meander had been built up, expansion of the city could only occur on the farther sides of the river. Durham has thus become heavily dependent on its bridges for communication between the old city and the newer, mainly nineteenth century, town of which the terraces can be seen rising in the background towards the railway viaduct.

UY 40 31 May 1957

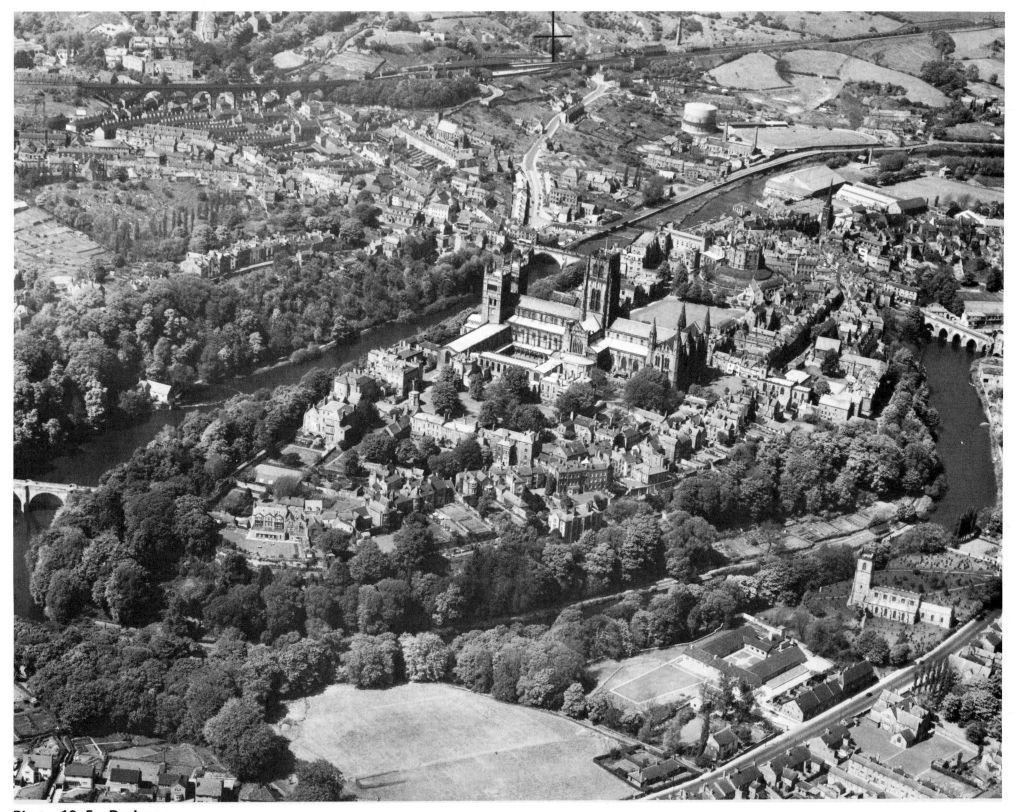

Photo. 13:5 Durham

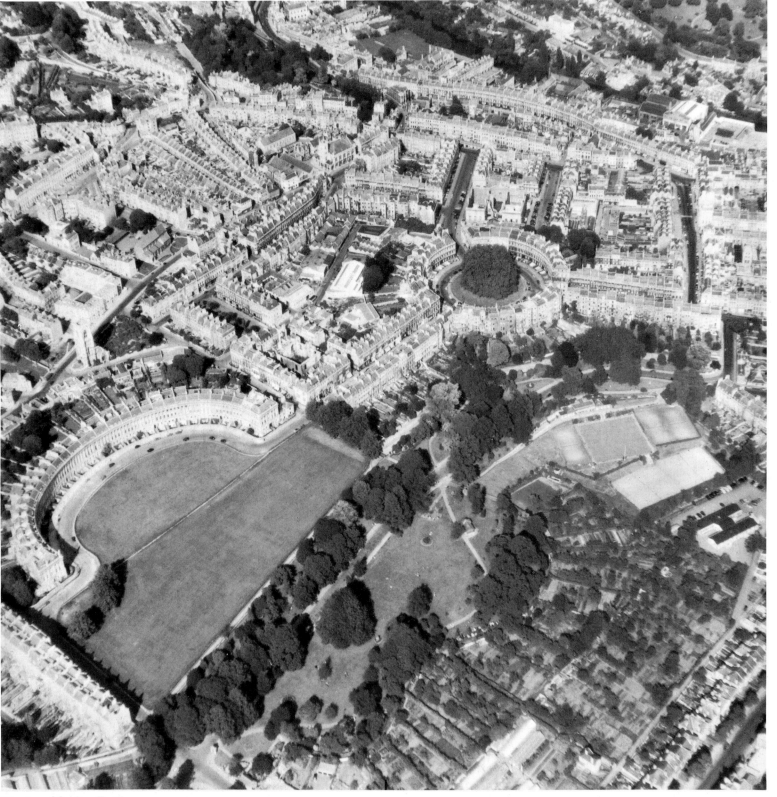

Photo. 13:6 Bath (ST 750650), looking north-east.

The brief age of urban order, with the landscape brought into the city and buildings unified by the use of a single material.

TL 28 *22 July 1956*

Photo. 13:6 Bath

The post-war Inner Ring, nearing completion, at last gives some definition to the city centre.
Vertical photograph RC8-J 219.
Scale 1 : 8600 *7 June 1969*

Photo. 13:7 Birmingham

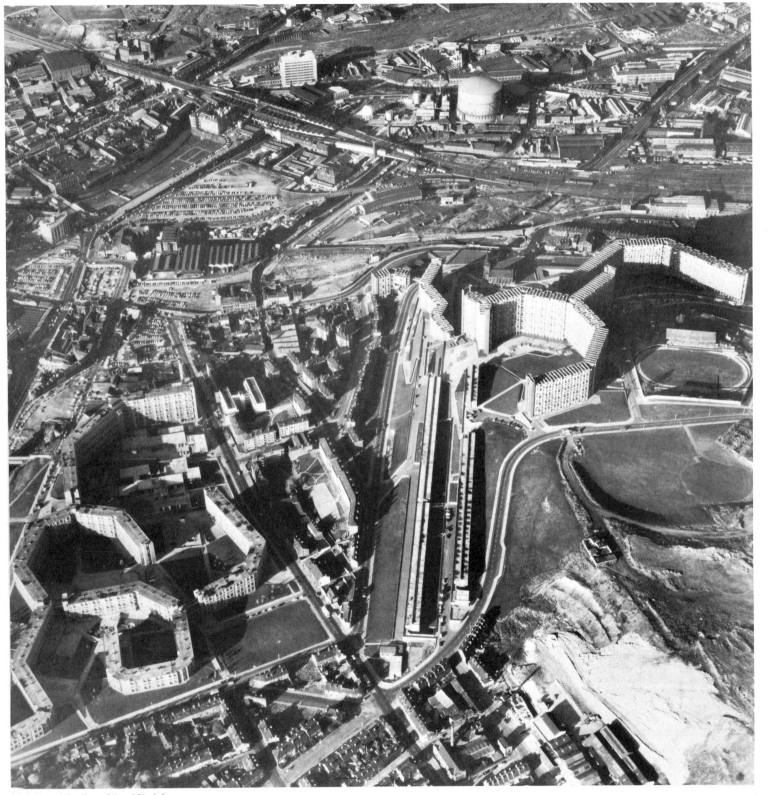

Photo. 13:8 Sheffield

Photo. 13:8 Park Hill, Sheffield, Yorkshire (SK 365873).
Housing development in an industrial city.
AZT 67 *29 October 1969*

Photo. 13:9 York, housing estates to south of the medieval city (SE 605507).
Late Victorian bye-law housing estates and inter-war speculative 'semis'—the negation of planning
Vertical photograph RC8-AI 30.
Scale 1 : 5600 *28 July 1948*

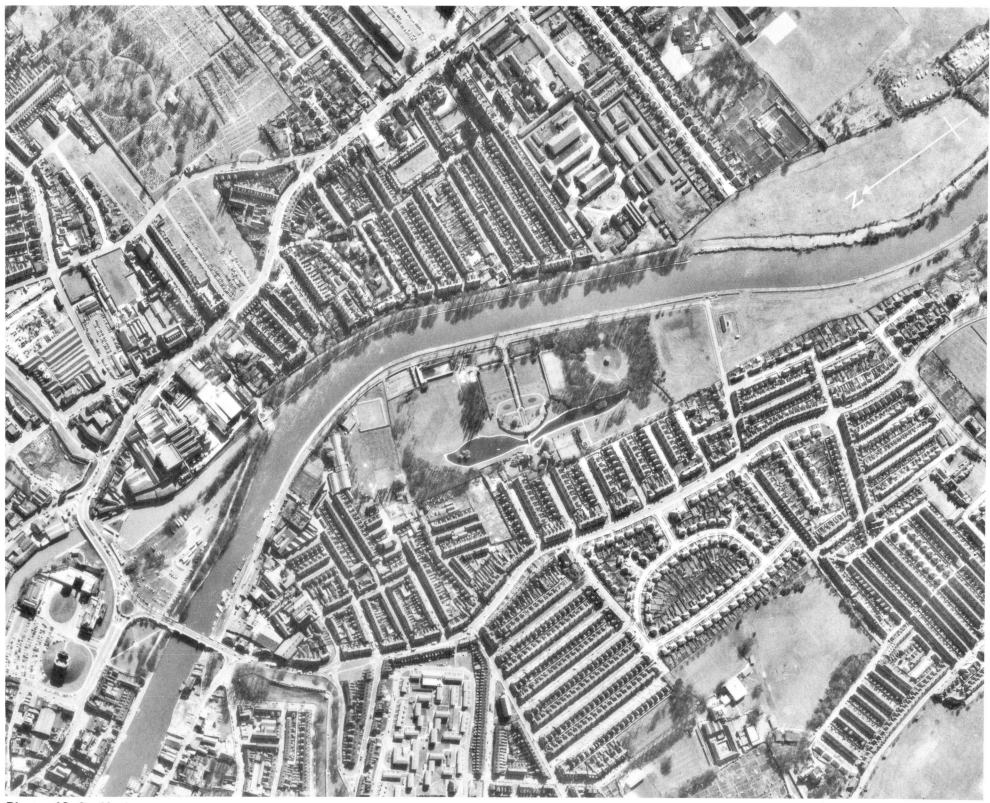

Photo. 13 :9 York

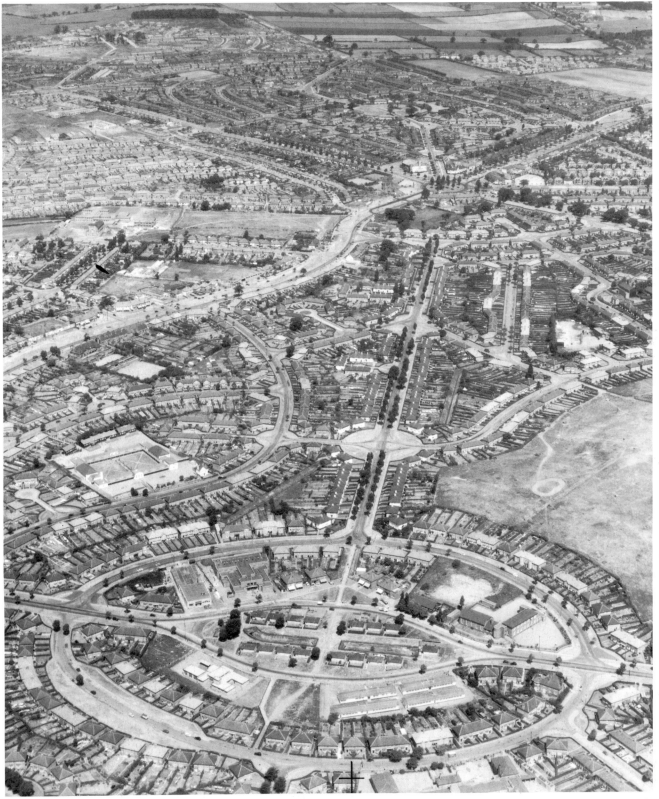

Photos. 13:10 and 11 Housing estates at Oscott and Telford.

Local authority housing can make patterns which are attractive to see on the drawing-board or on an air photograph, but this may not be so enjoyable, or even intelligible, on the ground.

Photo. 13:10 Oscott, north of Birmingham (SP 081943), looking north-west. *YP 31 20 June 1959*

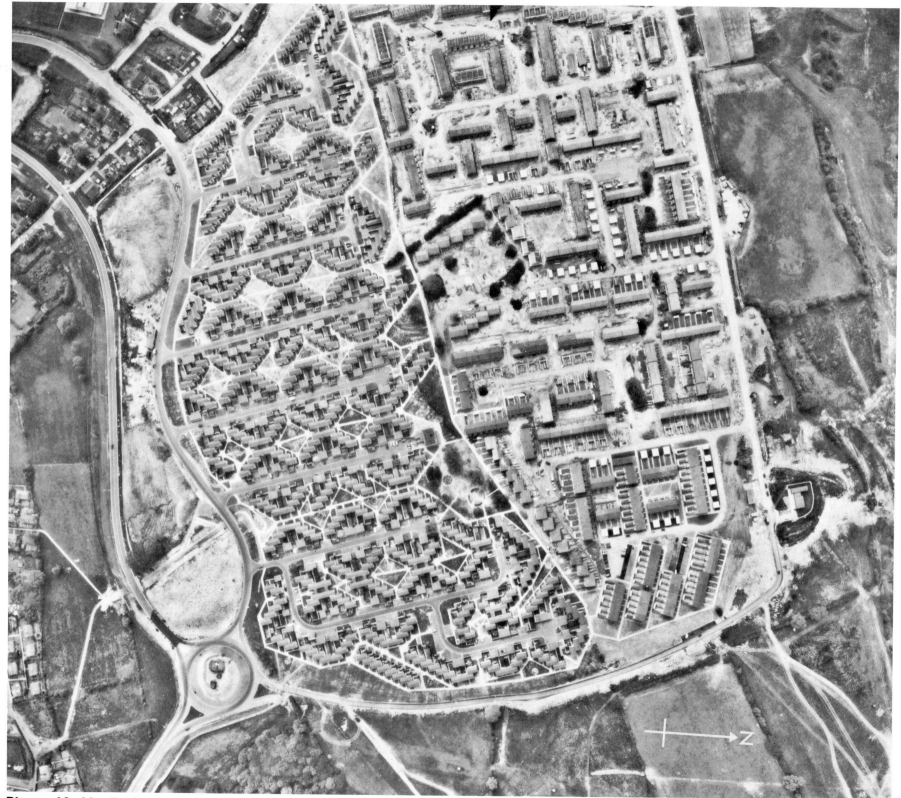

Photo. 13:11 Telford, near Wellington, Shropshire (SJ 692048). *Vertical photograph K17-U 115. Scale 1:4250 18 May 1970*

Index